W9-DGT-203

GEORGE
CRUIKSHANK
A REVALUATION

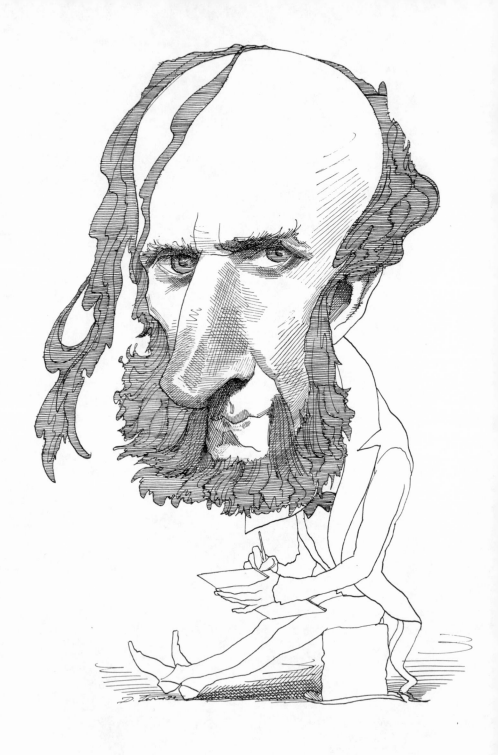

GEORGE
CRUIKSHANK
A REVALUATION

EDITED BY ROBERT L. PATTEN

PRINCETON UNIVERSITY PRESS

PRINCETON, NEW JERSEY

Published by Princeton University Press, 41 William Street,
Princeton, New Jersey 08540
In the United Kingdom: Princeton University Press, Oxford

Library of Congress Cataloging-in-Publication Data
George Cruikshank: a revaluation / edited by Robert L. Patten.
p. cm.
Originally published: Princeton, N.J. : Princeton University
Library, 1974. With new pref.
Includes index.
ISBN 0-691-00293-2 (pbk.: acid-free paper)
1. Cruikshank, George, 1792–1878—Criticism and interpretation.
I. Patten, Robert L.
NC978.5.C78G46 1992
741.6'092—dc20 92-12258

This book was first published as a hardbound double issue of
The Princeton University Library Chronicle XXXV, Nos. 1
and 2 (Autumn–Winter, 1973–1974), and is reprinted by arrangement
with the Princeton University Library

Princeton University Press books are printed on acid-free paper,
and meet the guidelines for permanence and durability of the
Committee on Production Guidelines for Book Longevity of the
Council on Library Resources

1 3 5 7 9 10 8 6 4 2

Printed in the United States of America

C O N T E N T S

The wood engravings on pages 34, 60, 92, 156, 188, 212 and 258 are from *Three Courses and a Dessert* (London, 1830).

ILLUSTRATIONS

CONTRIBUTORS

ANTHONY BURTON, formerly Assistant Keeper of the Library in the Victoria and Albert Museum, is now Head of the Bethnal Green Museum of Childhood.

WILLIAM FEAVER, author of many books on graphic art and illustration and of a monograph on John Martin, is art critic for the *Observer*.

JOHN FOWLES, who lives in Lyme Regis, has written several important novels, including *The French Lieutenant's Woman*. He has a long-standing interest in graphic and verbal satire.

JOHN HARVEY is Lecturer in the English Faculty at Cambridge University and a Fellow of Emmanuel College. He has written novels and a critical study of *Victorian Novelists and Their Illustrators*.

LOUIS JAMES, Professor of Victorian and Modern Literature at the University of Kent at Canterbury, is the author of *Fiction for the Working Man* and *Print and the People 1819–1851*.

E.D.H. JOHNSON, retired, was formerly Holmes Professor of Belles-Lettres and Chairman of the Department of English at Princeton University. He has written books on Victorian poets, on nature writers, on Dickens, and on *Paintings of the British Social Scene from Hogarth to Sickert*.

DAVID KUNZLE, who has published two of his projected three volumes of the *History of the Comic Strip*, is Professor of Art History at UCLA.

DAVID LEVINE, painter and watercolorist best known for his biting caricatures for the *New York Review of Books*, acknowledges his affinities and indebtedness to such nineteenth-century artists as Daumier, Tenniel, and Beerbohm.

ROBERT L. PATTEN is Professor of English at Rice University. He has just completed a two-volume biography of *George Cruikshank's Life, Times, and Art*.

RONALD PAULSON, Professor of English at The Johns Hopkins University, is the author of books on Swift, Fielding, Smollett, Rowlandson, and Revolutionary imagery, and has composed a catalogue and a newly-revised three-volume life of Hogarth.

RONALD SEARLE, internationally known artist and creator of St. Trinian's, has long studied and collected Cruikshank's work.

MICHAEL STEIG, Professor of English at Simon Fraser University, has written extensively on British graphic arts and on Dickens's principal illustrator, Hablot K. Browne ("Phiz").

HARRY STONE, Professor of English at California State University, Northridge, is a Dickens scholar who has published, among other books, *Dickens and the Invisible World* and *Dickens' Working Notes for the Novels*.

RICHARD A. VOGLER was Professor of English at California State University, Northridge, and a noted Cruikshank collector who organized exhibitions and published catalogues and reprints of Cruikshank's art.

Foreword to the 1992 Edition

BY ROBERT L. PATTEN

SINCE these essays were first published in 1973, George Cruik-
shank has indeed undergone extensive revaluation. He has been
the principal, or alternatively a principal, artist in a dozen exhibitions
in Europe and North America. Around the centenary of his death
(1978) a number of biographies and studies were issued. His prints
and illustrations crop up more frequently now as representations of
nineteenth-century British culture, and a few articles and books have
analyzed his contributions at some depth. Plans for celebrating the
bicentenary of his birth (1992) presage a further revival of apprecia-
tion. In all of these activities many of the contributors to this volume
have played important roles.

For the Arts Council of Great Britain William Feaver organized the
first comprehensive Cruikshank exhibition drawing largely on the
materials donated to the Victoria and Albert Museum by Eliza Cruik-
shank in 1884, with additions in 1887 and 1888 and a further bequest
received in April 1891. The exhibit ran at the V&A for two months
from 28 February 1974, and then a selection of the works traveled to
Edinburgh, Newcastle upon Tyne, Bolton, and Swindon. The witty
catalogue included a colored reproduction of Horace Mayhew's and
Cruikshank's accordion-folded 6' 9" comic strip, *The Tooth-Ache*
(Cohn 547). Feaver composed the catalogue entries and an essay,
"Cruikshank: The Artist's Role," which incorporates material from
his article herein.

Richard Vogler's superb collection supplied the examples for a cen-
tenary celebration entitled *George Cruikshank: Printmaker (1792–1878)*
which Richard Kubiak organized and catalogued for the Santa Bar-
bara Museum of Art. It ran from 4 April to 7 May 1978, then went
to UCLA, the University of Oregon, the San Jose Museum of Art, the
University of Wisconsin at Madison, the Dayton Art Institute, the
Munson-Williams-Proctor Institute at Utica, the University of Texas,
and the University of Illinois at Urbana-Champaign. Shortly before
his untimely death Professor Vogler arranged for his collection to go
to the Grunwald Center for the Graphic Arts, Wight Art Gallery,
UCLA, where it is now being catalogued.

European interest in Cruikshank is especially strong in Germany,

partly because the incomparable cartoonist Wilhelm Busch amplified many of his predecessor's images and themes. The Wilhelm Busch Museum in Hannover staged an exhibit of *George Cruikshank Karikaturist* from 2 October 1983 to 8 January 1984; this show was seen subsequently in Münster, Hamburg, Munich, and Stuttgart. The beautifully illustrated catalogue and the exhibition were supervised by Herwig Guratzsch. Ursula Bode and Jürgen Schultze contributed essays and Marianne Müseler prepared the entries. A second exhibition originating in Hannover, this time at the Institut Français in November–December 1985, featured Cruikshank among the artists who caricatured Napoleon. Ekkehard Eggs and Hubertus Fischer wrote the catalogue. Osnabrück, Hamburg, and Berlin also received the show.

In 1981 the Yale Center for British Art staged an exhibition of *Shakespeare and British Art*, with a catalogue by Geoffrey Ashton; it featured two of Cruikshank's oils, formerly the property of the American Shakespeare Theater at Stratford, Connecticut: *The last scene in 'The Merry Wives of Windsor'* (1857) and *The first appearance of William Shakespeare on the stage of the Globe with part of his dramatic company in 1564* (1864–1865). Three years later the Yale Center was one of four venues for an important exhibition of 205 British caricatures and graphic satires from 1620 to the present. Richard Godfrey, John Riely, and Lionel Lambourne organized and catalogued the show, which was also mounted at the Library of Congress, the National Gallery of Canada, and the V&A. A third exhibition at Yale, this time featuring watercolors and tinted glyphographs from Cruikshank's Temperance series, was *Hard Times: Social Realism in Victorian Art*, organized by Julian Treuherz with contributions by Susan P. Casteras, Lee M. Edwards, Peter Keating, and Louis van Tilborgh. It began at the Manchester City Art Gallery, 14 November 1987–10 January 1988, then went on to the Van Gogh Museum in Amsterdam and to New Haven.

Smaller exhibitions emphasizing one or another aspect of Cruikshank's œuvre have been presented at the Worcester Art Museum (*Monstrosities and Inconveniences*, 10 November 1986–23 January 1987; catalogue and exhibition by Norma S. Steinberg); the Lilly Library at Indiana University (*England through the Eyes of George Cruikshank*, 5 January–27 March 1989, and *Changing Images: Nineteenth-Century British Book Illustration*, January–March 1991, catalogue by Stephen H. Cape, materials from the Kenyon Starling Collection); and in Sep-

tember 1989 at the University Club Library, New York, which owns the H. Gregory Thomas Collection that Thomas began with purchases at the December 1941 Woodin sale and that he later augmented with items from Edwin Truman and A. M. Cohn. The February 1990 issue of the Club's publication, *The Illuminator*, prints an essay by the librarian, Andrew Berner, and a catalogue by Berner and Jane Reed.

Finally, the Berlin Technical University hosted an international symposium on book illustration in December 1989, just as the wall came tumbling down. Dr. Joachim Möller was responsible for preparing an exhibition, organizing the conference, and editing a handsomely illustrated catalogue containing essays by him, Stephen C. Behrendt, Horst Dolvers, and me, along with a reprint of Dorothy M. Richardson's 1930 article on "John Austen and the Inseparables." Unfortunately, the proceedings of the conference, including papers by four contributors to this collection—John Harvey, David Kunzle, Ronald Paulson, and me—could not be printed because of last-minute budget cuts due to the cost of assimilating East German educational institutions after reunification.

The context within which Cruikshank generated his work has been amplified not only by these exhibitions and catalogues but also by an assortment of studies about graphic satire and book illustration. Ronald Searle, himself an ardent Cruikshankophile, shared with Claude Roy and Bernd Bornemann in the production of a magnificent Skira volume, lavishly illustrated with pasted-down color plates, entitled *La Caricature: Art et manifeste*, which appeared in 1974 just after Searle completed the portrait of Cruikshank reproduced on our cover. His "reflections" by themselves are worth the price of the book: "La caricature doit se pratiquer avec l'adresse du chirurgien et les intentions du boucher" ("Caricature must be practiced with the finesse of a surgeon and the purposes of a butcher"). In 1977 William Feaver authored *When We Were Young: Two Centuries of Children's Book Illustration*, in which he surveyed the field and annotated 108 examples ranging from William Blake to Maurice Sendak. Four years later Ann Gould supervised a host of contributors who supplied biographical sketches of *Masters of Caricature from Hogarth and Gillray to Scarfe and Levine* for which Feaver wrote an introduction and intercalated commentary.

These efforts to acquaint the public with samples of comic graphics received considerable scholarly support from Simon Houfe's lengthy

introduction and comprehensive entries in his *Dictionary of British Book Illustrators and Caricaturists, 1800–1914*. First published in 1978 and revised in 1981, this invaluable resource makes use of the library of Sir Albert Richardson, architect, historian, and grandfather of Houfe, who has augmented his inheritance of illustrated books by purchasing original drawings relating to them. Rodney K. Engen's *Dictionary of Victorian Engravers, Print Publishers and Their Works* (1979) establishes the credentials of many of Cruikshank's artist and artisan contemporaries, though unfortunately it deliberately excludes wood-engravers, with whom Cruikshank was associated professionally and personally. He was also friendly with some of the foremost steel-engravers, such as Frank Holl and Francis W. Topham, with whom in the mid-1840s Cruikshank acted in amateur theatricals benefiting the Artists' General Benevolent Fund. In 1980 Basil Hunnisett published a learned, thorough account of *Steel-engraved Book Illustration in England*, which in a narrower field complements and amplifies Engen's *Dictionary*.

Many focused treatments of Cruikshank's life and art were brought out around the centenary of his death. First to appear was John Wardroper's *The Caricatures of George Cruikshank* (1977). Wardroper did considerable research—he is the first scholar, I believe, to discover Isaac Cruikshank's burial records—and in addition to a brisk, informative biographical introduction tracking the artist's life into the 1830s he supplies intelligent commentary on a selection of the broadsheet caricatures and etched-sketch books up to 1834. In 1978 Michael Wynn Jones, an editor of the *Spectator* and *Twentieth Century* and previously author of *The Cartoon History of Britain* and *The Cartoon History of the American Revolution*, issued *George Cruikshank: His Life and London*. This too is based on original investigation into Cruikshank archives in Britain and the United States, and while it contains some false conjectures (Eliza was neither the daughter of Charles Baldwyn nor a widow when she married George) it is briskly written, sympathetic, and shrewd in its assessments. Less reliable is the unfortunately titled *Man Who Drew the Drunkard's Daughter: The Life and Art of George Cruikshank, 1792–1878*, by Hilary and Mary Evans, also released in 1978. The commentary is inaccurate and out of date, but the illustrations, taken from the Mary Evans Picture Library, are plentiful and represent the whole range of Cruikshank's œuvre.

Missing the centenary by a year, Richard Vogler released his *Graphic Works of George Cruikshank* in 1979. With 279 annotated illus-

trations and an introduction in which Vogler provides a trenchant analysis of the artist's production from an art historian's and collector's viewpoint, this Dover Pictorial Archive publication allows up to six prints to be reproduced in other projects without fee or permission. It may have been the source for many of the Cruikshank pictures which have begun showing up in historical or literary studies of the Victorian period, and has thus contributed not only in its own right but also by its reproductive rights to the dissemination of the artist's images. A year later John Buchanan-Brown reproduced 249 prints in *The Book Illustrations of George Cruikshank*, accompanying them with a substantial introduction which corrects the myth of a quarrelsome and intemperate crank by quoting extensively from the hitherto unpublished archive of the publishers Bell and Hyman. Four of the seven volumes of Chadwyck-Healey's *The English Satirical Print, 1660–1832*, released in 1986, reprint images by Cruikshank; the series editor, Michael Duffy, and the editors of the individual volumes contribute valuable essays on the political and social functions of broadsheet caricature.

The circulation of Cruikshankian imagery widened in the theater. The drop curtain for *Sweeney Todd* and the program for the RSC production of *Nicholas Nickleby* both reproduced Cruikshank's "Penny Political Picture for the People," *The British Bee-Hive*. Cruikshank first sketched this image during the Chartist uprisings of the early 1840s; he revised it a score of years later during debates on the Second Reform Bill, publishing it as political propaganda against extending the franchise and in favor of a hierarchical society of cooperating classes industriously generating wealth under the Queen. Alan Bennett's 1990 National Theatre play, *The Madness of George III*, dramatizes many Regency images drawn by Gillray and Cruikshank.

Dissemination of valuable Cruikshank drawings, prints, manuscripts, and illustrated books was furthered by the sale at Sotheby Parke Bernet in 1978 of the items assembled by a Chicago collector, David Borowitz, a portion of which had been shown at the J. B. Speed Art Museum, Louisville, in 1968 in an exhibition catalogued and arranged by Nathalie T. Andrews and Margaret M. Bridwell, with an essay by Richard Vogler on "The Inimitable George Cruikshank."

Possibly the most important development in Cruikshank studies since 1973, however, has been the spate of major books establishing in various ways the significance of popular graphic art—both satirical and illustrative—in European culture. Jane R. Cohen's *Charles Dickens*

and His Original Illustrators (1980), which incorporates her earlier *Harvard Library Bulletin* papers on the Dickens-Cruikshank collaborations, stands unchallenged as the most comprehensive study of Dickensian illustrators. Two years earlier Michael Steig produced an original and impressive analysis of the work of Hablot K. Browne, *Dickens and Phiz* (1978). In *Dickens and the Invisible World: Fairy Tales, Fantasy, and Novel-making* (1979), Harry Stone elaborates the thesis he advances here about the causes of Dickens's dispute with Cruikshank over the ill-fated *Fairy Library* text and plates.

The study of book illustration has become a minor industry. Blake, a special case, has been served well by bibliographical, biographical, and scholarly studies. More general surveys have been issued by Hanns Hammelmann, John Harthan, Edward Hodnett, Eric de Maré, Brigid Peppin and Lucy Micklethwait, Gordon Ray, and Geoffrey Wakeman, while particular illustrators have been accorded monographs: in addition to Blake, Browne, and Cruikshank, there are new full-length studies of Walter Crane, George Du Maurier, Arthur Boyd Houghton, and John Tenniel. And novelists have had their own, and others', pictures analyzed: George Eliot, Thackeray, and Trollope in particular. In 1988 Joachim Möller published a collection of essays on English book illustration, *Imagination on a Long Rein*; it covers authors from Spenser to Washington Irving and artists from William Kent, Rowlandson, and Cruikshank to the Pre-Raphaelites, Pinwell, North, Walker, and Rackham. Möller also includes a useful, though by no means exhaustive, bibliography.

Cruikshank shows up more frequently now in history and literary criticism as one who documents or represents his age. Richard Altick treats aspects of Cruikshank's art in two magisterial books, *Paintings from Books: Art and Literature in Britain, 1760–1900* (1985), and *The Presence of the Present: Topics of the Day in the Victorian Novel* (1991). Martin Wiener uses Cruikshank, Rowlandson, and Frith to illustrate penal conditions in *Reconstructing the Criminal: Culture, Law, and Policy in England, 1830–1914* (1990). Richard L. Stein, in *Victoria's Year* (1987), his imaginative and original investigation of England's cultural map in 1837, embeds *Oliver Twist* in a dense matrix of contemporaneous stories about stolen children, stories that tapped anxieties about identities, family and class solidarity, and the power to control one's destiny. Stein reads Cruikshank's *Twist* vignettes better than anyone since Hillis Miller inaugurated a serious semiotic study of

them in his 1970 Clark Library lecture, "The Fiction of Realism: *Sketches by Boz, Oliver Twist,* and Cruikshank's Illustrations."

In 1983 Martin Meisel published a magnificently written and illustrated book, *Realizations.* This study of the interrelations of narrative, pictorial, and theatrical art is an intelligent and deeply pondered treatment of the formal and expressive conventions that nineteenth-century British novelists, artists, and playwrights shared. (Stagings of Cruikshank's book illustrations and temperance propaganda are thoroughly discussed.) It is well complemented by Judith Wechsler's account of physiognomy and caricature in the art and theater of nineteenth-century Paris, *A Human Comedy* (1982). Wechsler also guest-edited a special issue of *Art Journal* (Winter 1983) on caricature, printing essays by David Kunzle on cheap newspaper cuts during the reign of William IV and by me on conventions of Georgian caricature, along with several fine essays on European graphic satire, an analysis of the "Rationale of Deformation" by Rudolf Arnheim, and an appreciation of Saul Steinberg's wit by E. H. Gombrich. Another significant publication about French graphic satire is *French Caricature and the French Revolution, 1789–1799,* the catalogue prepared by James Cuno and Cynthia Burlingham for the Grunwald Center for the Graphic Arts exhibition, which was also displayed at New York University, the Bibliothèque nationale de France, and the Musée de la révolution française in Vizille, in 1988–1989. The essays on revolutionary caricature by Michel Melot, Lynn Hunt, Claude Langlois, Ronald Paulson, Albert Boime, and Klaus Herding extend the study of transgressive and counterrevolutionary iconography that Ronald Paulson so discerningly interrogated in *Representations of Revolution* (1983), and that are comprehensively explored with respect to verbal as well as visual satire by Vincent Carretta in *George III and the Satirists from Hogarth to Byron* (1990).

Finally, with the publication of the second volume of David Kunzle's *History of the Comic Strip: The Nineteenth Century* (1990), the scholarly study of European comic narrative graphics has come of age. By virtue of his definition—narrative sequences—and his perspective, which is Marxist, Kunzle finds little of note in the British tradition, apart from Cruikshank's *Lambkin,* a lesser imitation of Rodolphe Töppfer's vividly inventive story albums. (This is the aspect of Cruikshank's production that Kunzle studies in this volume.) Kunzle prefers art with more political pith, comedy that addresses the revolutionary ferments of the age and breaches middle-class boundaries.

But he demonstrates the pervasiveness of comic graphics throughout Europe and Russia and perceptively analyzes some of the most prominent techniques, themes, tropes, and means of production and circulation. Cruikshank and his English predecessors (Hogarth was separately treated in an earlier volume), contemporaries, and successors deserve more credit for inventing or revising earlier graphic formulas and for transmitting them to their Continental colleagues than they are given by Kunzle. For the first time, though, we have a book to anchor further studies, one that surveys the landscape, marks significant features, and offers a developmental cross-cultural history which can be emended and amplified by future commentators.

The bicentenary of Cruikshank's birth will be observed by a combination of exhibitions and scholarly studies. John Wardroper is organizing a major show that will open at the Museum of the Order of St. John in Clerkenwell, not far from where Cruikshank lived from 1823 to 1850; the exhibit will tour to several other galleries in Britain as well. Jonathan Hill, whose articles are notable for articulating the significant trends Cruikshank's art manifests, has initiated two North American exhibits: one at the University of Minnesota and the other at the Rosenbach Library in Philadelphia. Stephen Cape will display highlights of the Lilly Library Collection at Indiana University. Two scholarly biographies are in preparation: one by Hill, and the first volume of another by me, which will conclude with a second volume in 1994 covering the years 1835–1878.

The essays here reissued have proved a seedbed for subsequent projects. The material in them has not been superseded by later research, but rather put into a more spacious and complex context. These authors worked in the vanguard of revisionary scholarship, sorting out the artist's professional relationships, his contributions to propaganda and illustration, his artistic techniques, and his comic, moral, and humane vision. The articles will best serve their renewed purpose during this bicentenary if they entice another generation of Cruikshankians to explore the craft, humor, ideas, innovations, sympathies, blindnesses, variety, and prodigious energy of nineteenth-century Britain's most celebrated graphic artist.

Houston, Texas
24 December 1991

Foreword

BY ROBERT L. PATTEN

Nearly a century has passed since 1875, when George Cruikshank, aged 83, etched his last frontispiece, this time for Mrs. Octavian Blewitt's *The Rose and the Lily*. After his death three years later, as during his life, he received mixed notices. The hagiography of Victorian novelists whose works he had illustrated commenced even before his death; his claims to have originated *Oliver Twist* and some of Ainsworth's fictions received heated and flat contradictions from John Forster, Dickens' biographer and literary executor, and from Ainsworth himself. Somehow, these unhappy exchanges came to reflect adversely on Cruikshank's whole career, until the artist was reduced to a series of hoary anecdotes about eccentric behavior, and the caricaturist became himself a caricature of frenzied delusions and intemperate advocacies. Reviewing the evidence in an Appendix to her Clarendon Edition of *Oliver Twist*, Mrs. Tillotson pointed out in 1966 that Cruikshank's statement to Robert Shelton Mackenzie asserting that the subject and characters in the novel were all his invention must have been made prior to 1852, when Mackenzie left England for good. She concluded, therefore, that the claim was "not simply a delusion of Cruikshank's old age"; but though such reasoning perhaps modifies our impression of his crabbed senility, it hardly restores his reputation as a man or an artist.

Cruikshank always had his defenders, not least of whom was the artist himself. His ceaseless preoccupation with art, with his own self-image, and with his signature as a projection of that image and a guarantee of its authenticity, is brilliantly caught by Ronald

Searle's sympathetic, original drawing for the striking cover image of this volume. Born in very modest circumstances amidst the tools of his later profession, Cruikshank yearned to elevate himself and his art to the higher status accorded history painters, Royal Academicians, authors, architects, and sculptors. His ambition was not solely personal in origin or purpose; like other nineteenth-century artists, he sought to make his art an effective force for "Good," and an instructive interpreter of the moral, physical, and spiritual condition of the age.

In his declining years and after his death Cruikshank's reputation was conserved by collectors like Cosens, Bruton, Truman, and Douglas, and by bibliographers like Reid and Cohn. By Bloomsbury he was largely ignored, but in 1937 Sacheverell Sitwell boldly joined the ranks of Cruikshank's public supporters with his Northcliffe Lecture at the University of London on Cruikshank as an exemplar of the "English National Genius." The war supervened, however, and though illustrations to some of Dickens' novels provided models for war cartoons, evidently Cruikshank's energetic caricatures of an earlier European cataclysm were thought too particular or too dated to be revised and revived. Afterwards, Ruari McLean's 1948 essay in the Arts and Technics Series seemed a hopeful portent of wide-spread reappreciation; but the series died in mid-career, and the book remains, until this volume, the last published solely on Cruikshank.

Appreciation of his immensely varied output has quickened recently, spurred by Professor Richard A. Vogler's efforts, including his Catalogue for the 1968 exhibition in the J. B. Speed Art Museum at the University of Louisville of the great collection assembled by Mr. David Borowitz, and by Professor Hillis Miller's seminal essay on Cruikshank's drawings for *Sketches by Boz*, first delivered in 1970 as a lecture at the William Andrews Clark Memorial Library. Since Richard Waln Meirs, Princeton '88, gave the collection whose exhibition has inspired this volume, it is hardly too much to say that virtually all defenses of Cruikshank's reputation in the last century have depended on the fierce and loving partisanship of devoted collectors. The academic community has been notably reluctant to come to terms with an artist of Cruikshank's magnitude, force, technical accomplishment, range, and influence: Dr. Jane Cohen's essays provide a possible exception, but even they, significantly enough, found a home in the

Harvard Library Bulletin and depended on the riches of the Harry Elkins Widener Collection.

The present essays signal the beginning of what we hope will be a major and continued revaluation of Cruikshank's vast contributions to the nineteenth century. The causes of his neglect heretofore may be those to which John Fowles alludes in his introductory remarks: "It is as if he made too much fun of too many things; and we've been making him pay for it ever since." If so, then it is high time we put aside ancient combats, to appreciate the matchless skill and penetrating artistry of Cruikshank's work.

The occasion for this revaluation is the exhibition of Cruikshankiana at Princeton mounted by Mr. Robert Fraser, Curator of Rare Books, to display for the first time some of the star items in the Meirs Collection. Professor E.D.H. Johnson, who has scrutinized every item relating to Cruikshank in the Princeton University Library, describes some of its high spots, while at the same time providing a convenient summary of Cruikshank's career, and offering at every point new avenues of approach and interpretation for future students to explore. His article, published separately for the annual Friends dinner in May 1973, is accompanied by four pages illustrating Cruikshank's working drawings.

To place Cruikshank in the tradition of graphic illustration, no one is better qualified than Professor Ronald Paulson, author of four volumes on Hogarth and a recent one on Rowlandson. His essay on the tradition of comic illustration from Hogarth to Cruikshank analyzes the relations between text and picture favored in the eighteenth century, and concludes with some striking observations about nineteenth-century works, especially *Oliver Twist*. The nature of Dickens' collaboration with Cruikshank is then examined by Professor Vogler from different perspectives, those of literary history and biography. His conclusion that Cruikshank's later claims, while exaggerated, were not so utterly without foundation as Dickens' defenders have insisted, may contribute to a redefinition of what "collaboration" meant, especially in the case of serial fiction in which text and illustrations were being coordinated and composed simultaneously.

Mr. Anthony Burton, calling on his familiarity with the extensive resources of the Library at the Victoria and Albert Museum, places the illustrations to *Oliver Twist* in the wider context of all Cruikshank's illustrations to fiction. He adduces example after

example of Cruikshank's psychological penetration and graphic dexterity, showing how proficient Cruikshank became in making his designs sustain a sequential narrative. Dr. John Harvey follows with an evocative description of the development of Cruikshank's line work, his mastery of etching and wood-engraving, his wit, and his generous and inexhaustible humanity.

The purposes to which that wit and humanity were put are discussed by Professor Louis James. He shows how the same means and insights into contemporary life pervade plates propagandizing for very different causes, and at very different periods of Cruikshank's life. Professor David Kunzle surveys the possibilities for sequential narrative art available to Cruikshank through continental models, and elucidates the importance of *Mr. Lambkin* in Cruikshank's campaign for control over his publications and for status as an artist.

The nature of Cruikshank's "characteristic mode," identified by Baudelaire as "the grotesque," is a topic that at least implicitly appears in nearly every essay. Confronting it directly, Professor Michael Steig interprets material, even specific illustrations, discussed elsewhere—notably by Dr. Harvey and Professor James— from a "psychodynamic approach"; drawing on unpublished as well as published works by Cruikshank, he discovers in Cruikshank's grotesque radical graphic solutions to our basic fears and desires. Where Professor James discerns socio-economic myths, Professor Steig exposes psycho-sexual ones.

Professor Stone, like others before him, is interested in Cruikshank's rendering of fairy tales. In his careful discussion of the tortuous relations that developed in the 1850s between Cruikshank and Dickens, as they both redefined their attitudes towards the imagination, he sets forth the reasons why each touched on a particularly sensitive part of the other's most cherished beliefs. That the resulting collision was more damaging to Cruikshank than to Dickens he establishes clearly. Mr. William Feaver, in the concluding essay, argues however that Cruikshank's "whole hog" involvement in the temperance movement gave him new strength and focus at a time when the older modes in which he was so accomplished were dying out. Our last impression, like the first so memorably captured by David Levine's caricature, is of the artist, "At it Again," spying out the world with marvelous

fecundity and virtuosity through the eye of an etching needle and the iris of a printing press.

In the preparation of this volume, we have been assisted by several individuals to whom we are most grateful, and whose names we should like to record here: Mr. F. S. Bradburn, Mr. Henry Chessell, Dr. Jane R. Cohen, Mr. Earle Coleman, Professor Charles Garside, Jr., Professor J. Hillis Miller, Professor Charles Mitchell, Mr. John Podeschi, Dr. Gordon N. Ray, Mr. Ronald Searle, Mr. Peyton Skipwith, Dr. Michael Slater, Mr. Dudley Snelgrove, Professor Margaret Sobel, and Miss Marjorie Wynne. To the following institutions we are also indebted: The British Museum, Cambridge University Library, The Widener Library at Harvard University, The Philpot Museum at Lyme Regis, the Woodson Research Center at Rice University, The Victoria and Albert Museum, and the Beinecke Library at Yale University.

Most especially, I would like to acknowledge the assistance of the American Philosophical Society, by whose grant I was enabled to visit England to confer with contributors and to examine the vast holdings of Cruikshankiana at the British Museum and the Victoria and Albert Museum. In addition, we are grateful to the Annan Fund for a grant to cover the cost of the extra illustrations provided in this volume.

For permission to reproduce drawings and prints, and to print hitherto unpublished correspondence, we wish to thank Professor Richard A. Vogler and the authorities at the British Museum, Free Library of Philadelphia, Greater London Record Office, Harvard University Library, Historical Society of Pennsylvania, Arents and Berg Collections of the New York Public Library, Philpot Museum, Princeton University Library, Victoria and Albert Museum, and Yale University Library.

Two last items may be explained. The first citation in any article to a work illustrated by Cruikshank is followed by the appropriate listing from Albert M. Cohn, *George Cruikshank: A Catalogue Raisonné* (London, 1924), the central authority on Cruikshank's oeuvre. And in the interests of clarifying what is at best a potential source of confusion, the designation "Pl. I" etc. has been used throughout to indicate plates in whatever series of Cruikshank's published works is being discussed; references to the illustrations

in this volume are given as "Figure 1" and so forth. We have pre-
ferred to reproduce less familiar items of Cruikshankiana rather
than to reprint the plates to *Oliver Twist*, easily obtainable in the
Clarendon, and other editions of that novel.

The size and diversity of Cruikshank's output, his long and
often contentious life, the multitude of causes his art served, and
the absence of scholarly aids—any edition of his correspondence,
any *catalogue raisonné* of his drawings, any modern substantial
biography, or even any complete record or public collection of his
works—all combine to render judgments on his life and art con-
tradictory and even combative. Every reader of these essays will find
himself swayed by arguments on both sides of issues, whether the
discussion center on the merits of a single plate or of Cruikshank's
temperance activities. No attempt has been made to impose
uniformity of opinion on the authors here represented. It would
have been impossible and unjust. More than that, it would have
destroyed the lively personal feelings which Cruikshank's line—
political, social, and graphic—was always designed to elicit. Such
an energetic, individual artist deserves no less than an equally
energetic, individual response.

Introduction:
Remembering Cruikshank

BY JOHN FOWLES

C APTAIN Frederick Marryat, the nautical novelist, visited Lyme
Regis in the fall of 1819 and did some sketches that he passed
on for "improvement" to a friend. The friend's name was George
Cruikshank. One of the results was a print that I shamelessly
adapted for my novel *The French Lieutenant's Woman* (Figure
5).[1] It shows a happy gentleman *voyeur* ensconced over a beach, tel-
escope glued to his eye, and deeply absorbed in bird-watching—the
birds in this case consisting of a charming batch of plumply naked
Regency ladies tumbling and disporting themselves in the sea.
Hydromania! reads the legend, *or a Touch of the Sub-Lyme and
Beautiful* (1819)—a horrid pun on Edmund Burke's noble and
unreadable *Philosophical Enquiry into . . . the Sublime and Beau-
tiful* (1756). It shocked the worthy citizens of Lyme at the time and
has gone on shocking them a little ever since; our definitive local
history (published in 1927) feels obliged to pronounce the thing
a tasteless lampoon without any historical basis at all. Yet it is
curious: Lyme likes to boast of its artistic connections. All the
guidebooks proudly parade Henry Fielding, Jane Austen, Tenny-
son, Whistler, and a host of obscurer figures; but never Cruik-
shank. I mention all this because the rancor of Lyme somehow
reflects what has happened to the poor man in the history of British
art. It is as if he made too much fun of too many things; and
we've been making him pay for it ever since.

Of course "illustrations by Cruikshank" still raises the price in
every second-hand bookseller's catalogue, but fashion and taste
seem adamantly to refuse him serious consideration. Bewick's
reputation has done nothing but soar these last fifty years—quite
rightly. He also fits in nicely with the current ecological revolu-
tion and has been helped on his way by the re-evaluation of Blake
and Palmer. In this green-and-gold context of English pastoral

[1] Not in Cohn; only copy traced in The Philpot Museum, Lyme Regis, reproduced
by permission.

mysticism Cruikshank may seem to cut rather a shabby urban figure; and then at the other extreme we have become an age of violent satire, and find Gillray's excesses and savageries more "significant" than Cruikshank's toleration. Current taste in England has also leapt ahead and fallen heavily, a lot too heavily in my opinion, for the camp fancies of Kate Greenaway and Walter Crane. Doré and Gavarni have their claques. There is a new vogue for the artists of the great period of *Punch*; over the last ten years I have watched the prices of drawings by Tenniel, Leech, Keene and du Maurier rise like rockets. Even to Cruikshank's own most immediate rival in the field of book illustration, Hablot K. Browne ("Phiz"), history seems to have dealt a much kinder hand.

I am therefore delighted that the Princeton University Library is doing something to remedy the situation, since to my mind Cruikshank is by far the greatest of the celebrated Victorian illustrators and cartoonists cited above. I suspect the runner-up is John Leech; but Leech never had Cruikshank's social concern, nor a quarter of his technical command—and then he was saddled by his unfortunate mania for the horse and the horsey. I can't consider Phiz as a serious rival. I have here in my study at Lyme a large and spacious watercolor that regularly fools the experts. It shows a farmer on a pony in the Yorkshire moors, quietly chatting with a shepherd: very sweet, open, filled with light. It was done by Phiz and very probably when he went to Yorkshire with Dickens in 1838 to get material for *Nicholas Nickleby*. A very charming and skilled watercolor; but it doesn't square well with the Dotheboys Hall images. Somewhere in Phiz was a soft center; he could never in a thousand years have matched the bitter anger—as Cruikshank did so brilliantly—in the William Hone pamphlets. One has only to compare Phiz's plates for *Nickleby* and *David Copperfield* with Cruikshank's for *Oliver Twist* (Cohn 69, 1837-39) and *Sketches by Boz* (Cohn 232-33, 1836) to see which man had more direct knowledge of reality—and resisted the schmaltz in Dickens more successfully. Try the two plates on rather similar themes by the two artists: "Oliver asking for more" in *Twist* and "The internal economy of Dotheboys Hall" in *Nickleby*. It is like comparing a Goya to a David.

Indeed, I think what is possibly Cruikshank's finest series of book illustrations, those for Maxwell's *History of the Irish Rebellion in 1798* (Cohn 541, 1845), can be compared only to Goya. Of

course they contain unfair propaganda against the Irish and lack the universality of the great Spaniard's rage against human injustice and cruelty. For all that, they still strike savagely off the page. Look at the brilliantly differentiated faces of the two Irish rebels impaling the Loyal Little Drummer in the illustration of that title: the one is an active sadist, the other is a mindless doer of his job (Figure 6a). And then see the child dancing with joy in the background, the blandly watching face of the soldier behind, and the officer seemingly oblivious of what is going on. Ireland 1798—or a certain village in Vietnam a year or two ago?

In his illustrations for another indifferent text—Ainsworth's *Jack Sheppard* (Cohn 13, 1840)—we see a further side of Cruikshank's mastery: his ability to create an indelible image. I never run across Sheppard's name without immediately evoking that white-faced young demon with his bizarrely ferocious eyebrows and jet-black Joan-of-Arc crewcut. Think of Fagin, Bill Sikes, the Artful Dodger: it is Cruikshank who has proved as inimitable as his author.

Needless to say, there were other Cruikshanks: the forerunner of du Maurier, critic of middle-class foibles; the humorous vignettist; the temperance fanatic. All those aspects of his work bring him down to a lower level and perhaps define his essential weakness: too much humor, not enough anger—a very English combination. Chronologically, my genial little joke against Lyme must have been done between work on the cuts for the Hone pamphlets; and something I did not reveal at the beginning—the print copies to the point of plagiarism a previous jibe by Rowlandson against hydromania at Margate. To our authenticity-obsessed modern minds all this may seem a grave criticism of Cruikshank, indeed dangerously near make him guilty of the fault I have already laid at Phiz's door: a soft center. But I don't think so: it simply shows his humanity and his breadth—if you like, the Augustan eighteenth century still triumphing over the narrower nineteenth.

We can see that breadth—of technique as well as of spirit—right down among the trivia: in the distinctly hasty yet vivid little drawings for *Sunday in London* (Cohn 846, 1833; the knacker's cart on page 44 is worthy of Bewick), in the much more elaborate "strip cartoon" series, *The Progress of Mr. Lambkin* (*The Bachelor's Own Book*, Cohn 192, 1844). In both there is a richness of observed

detail and open honesty about the life portrayed. No Dr. Bowdler here, no Victorian prudery; but a full ration of the human heart.

I detect two great figures behind Cruikshank. The first is Hogarth, of course. Cruikshank never mastered oil, and given the age-old European award of primacy to that medium, I suppose he has to be placed on a lower pinnacle. But I suspect that if he and Hogarth had been Japanese, it might well have been the latter who now stood in the shade. Lists of artistic merit are strictly for fools, however, and the important thing is that these two English graphic masters did share, behind their personal neuroses, their particular exaggerations, an identity of spirit. They both attacked hypocrisy and anything that smelt of the complacent Establishment; more interested in man himself than in nature, they had the city in their blood; and for all their ruthless attacks on the stupidity and bestiality of *Homo sapiens,* they never lost faith in his essential humanity.

Behind them again, a greater figure still, and not an artist— that arch-destroyer of the puritanical and the illiberal, that founding father of the open society, that presiding spirit of both the Renaissance and our own century, François Rabelais. To be sure, he and Cruikshank would hardly have seen eye to eye over the divinity of the bottle. But I go back to my little print of Lyme, to the naked girls in the gentle September sea, to the delighted face of the watching man. The basic design may be stolen from Rowlandson, but it is far more than a mere copy. I still see in it the quintessence of Rabelais' smiling humanism, the *substantifique moëlle,* the real marrow of his gigantic comic bone.

Humor ought to be a religion; and Cruikshank, an honored saint of that church.

GEORGE
CRUIKSHANK
A REVALUATION

The George Cruikshank Collection
at Princeton

BY E.D.H. JOHNSON

I

THE nucleus of Princeton's holdings in the work of George
Cruikshank is the great collection formed by Richard Waln
Meirs '88, which came to the University as long ago as 1913.
During more recent years the archive has been steadily aug-
mented by the benefactions of such donors as Gordon A. Block,
Jr. '36 and A. J. Rosenfeld, as well as by purchases from Library
funds. In a brief survey, published in the *Princeton University
Library Chronicle* (1943), Frank Jewett Mather, Jr. estimated
that the Meirs Collection contained about one-half of the 863
illustrated books listed in Albert M. Cohn's *Catalogue Raisonné*;
but, as Professor Mather went on to point out, this figure is mis-
leading, since Mr. Meirs discriminatingly sought out those works
which most amply document Cruikshank's career as a book illus-
trator. Less inclusive are the examples of Cruikshank's political
caricatures and broadsides, although Princeton's collection in this
category, numbering between four and five hundred prints, is
again representative and includes many scarce works. On the
other hand, the Princeton University Library is particularly rich
in trial proofs for illustrations, both before and after lettering
and in colored and black-and-white states. Cruikshank was in the
habit of printing small issues of his etchings and woodcuts on
india or china paper; and as connoisseurs know, the full bril-

1

liance of the plates can be appreciated only when they are seen in this form. Of even greater moment to the student of Cruikshank's technical artistry are the numerous sketchbooks and sheets of pencil and watercolor drawings at Princeton. The subjects often exist in several versions, and it is thus possible to trace the artist's conceptions through the various stages leading to publication. Although without notable success, Cruikshank repeatedly tried his hand at oil painting, and Princeton's nine examples in this medium merit citation as further evidence of the wealth of material from which those responsible for the 1973 exhibition have been able to make their selection.

In 1863 Cruikshank put on view in Wellington Street, Strand, and later at Exeter Hall, a selection of his original works to accompany the *pièce de résistance* of the exhibition, his enormous temperance sermon on canvas, "The Worship of Bacchus; or, the Drinking Customs of Society." Included were several sketches, executed between the artist's sixth and eighth years, 1798-1800, now at Princeton. Reviewing a half century of artistic activity, John Paget wrote in *Blackwood's Magazine* (August 1863): "If we were asked who, through that period, has been the most faithful chronicler of the ways, customs, and habits of the middle and lower classes of England, we should answer without hesitation, George Cruikshank." To Cuthbert Bede the artist said, "I was cradled in caricature." He was doubtless alluding to the youthful apprenticeship which he and his older brother Robert had served in assisting their father, Isaac, in his calling as an engraver; but he might also have had in mind the brutally outspoken Regency world in which he came of age. Not surprisingly his graphic squibs from this period are imitative of that supreme master of the satiric flail, James Gillray, a number of whose final commissions the younger artist is said to have been engaged by Mrs. Humphrey to complete when Gillray became insane. Cruikshank's early caricatures, scurrilous in subject and crude in execution and coloring, are to be found in such scarce, fiercely subversive publications as *The Scourge; or Monthly Expositor of Imposture and Folly* (Cohn 732), 12 vols. (1811-16); *The Satirist, or Monthly Meteor* (Cohn 724), 14 vols. (1808-14; Cruikshank contributed only to the last two volumes); *The Meteor; or, Monthly Censor* (Cohn 553), eight monthly parts (Nov. 1813-July 1814); and *The Caricature Magazine, or Hudibrastic Mir-*

2

ror (Cohn 110), 5 vols. (1807-21).* Like Gillray and their common moral progenitor, Hogarth, Cruikshank had his share of insular prejudice; and in the years preceding Waterloo among his favorite targets were Napoleon and the French. His animosity appears at its most vitriolic in the thirty colored engravings he made for William Combe's *The Life of Napoleon: A Hudibrastic Poem in Fifteen Cantos, by Dr. Syntax* (Cohn 153, 1815).

With the Emperor's overthrow, Cruikshank's burin was enlisted in the radical cause against the self-indulgent Regent, his obscurantist ministry, and his licentious circle in the court. In association with William Hone, the champion of free speech, he helped produce between 1817 and 1823 a series of incendiary pamphlets that established him as the leading caricaturist of the day in succession to Gillray and Rowlandson. One of these, *The Political House that Jack Built* (Cohn 663, 1819), is said to have sold 100,000 copies. The discreditable revelations attending the Monarch's divorce proceedings against Queen Caroline alone elicited nearly 300 caricatures and woodcuts in pamphlets in the artist's most savage mood of raillery. Typical of these are the eighteen engravings and fourteen accompanying woodcut vignettes which illustrated *The Queen's Matrimonial Ladder* (Cohn 680, 1820). The initial cut exhibits the effete sovereign as a monstrous buffoon, slouched in a chair, his clothing in disarray, a shattered glass dangling from his hand. The surrounding floor is littered with empty bottles and other paraphernalia of debauchery. The candles on the table at his side are guttering out. A screen at his back depicts fat dancing nymphs and the drunken Silenus astride his ass. The caption for the drawing, from Solomon, reads: "Give not thy strength unto women, nor thy ways to that which destroyeth kings." Such telling use of incidental detail to comment on the central motif of the composition shows how sedulously Cruikshank had studied Hogarth. As Blanchard Jerrold was to remark of these early successes: ". . . they are remarkable for that power of telling a story, and of concentrating every figure and detail of a picture upon the effect or emotion to be produced, for which Cruikshank in his prime was unrivalled."

Cruikshank's fame as a graphic caricaturist, like Byron's achieve-

* Unless otherwise specified, all the works to which reference is made in this article are in the Princeton University Library.

3

ment in verse satire, rose from the uninhibited license of Regency life. But the temper of society was changing; and the artist's work in the late 1820s begins to reflect the increasing concern for social problems which ushered in the Victorian age. This change in emphasis is apparent in the fine broadside, published by S. Knight with the title, "Salus Populi Suprema Lex" (Cohn 1952), which caustically comments on the pollution by sewage of the Thames waters supplied by the Southwark Water Company, as reported by a Commission of Inquiry in 1828. It takes no great amount of insight to perceive that for all their boldness Cruikshank's caricatures lack the Swiftian *saeva indignatio* which redeems Gillray's drawings even when most deliberately offensive. The artist's political convictions were never fervent enough to stand in the way of his accepting lucrative commissions which might run counter to them. A notable print of 1820, entitled "Coriolanus addressing the Plebeians" (Cohn 1017), portrays George IV in a wholly new guise as the defender of law and order. Clad in Roman attire, he stands before the screen of Carleton House outfacing the mutinous rabble, which includes portraits of many of Cruikshank's political associates. And no trace of his earlier animus against Napoleon is apparent in the designs he executed for the *Life of Napoleon Bonaparte* (Cohn 435), edited by W. H. Ireland, 4 vols. (1823-28). For this magnificent work, of which Princeton possesses three bound sets, one of the original issue and two of the re-issue of 1828, Cruikshank etched twenty-seven plates, twenty-four in color, largely after original designs by such French artists as Vernet. The beauty of their execution, both in line and color, places the artist in the very front rank of masters of the etcher's craft.

After 1823 Cruikshank turned increasingly to recording the social foibles of the day, and such political topics as he treated evidence a growing conservatism. There is at Princeton, for example, a finished watercolor sketch for a broadside, published by David Bogue in 1842, with the title "The Queen and the Union. No Repeal! No O'Connell!" (Cohn 1882), in which the Irish revolutionary leader, labelled a "blustering foul-mouthed Bully," is shown in the act of trying to sever with his axe the harmoniously joined hands of Britannia and Erin. A later etching of 1871, "The Leader of the Parisian Blood Red Republic, or the Infernal Fiend" (Cohn 1312), recalls the Francophobia of two

generations before. More arresting as an example of Cruikshank's highly wrought style in later years is the large engraving of "The British Bee-Hive" (Cohn 957), which, according to the information on the plate, the artist first designed in 1840 (presumably in response to Chartist agitation), but then reworked and published in 1867 to voice opposition to the passage of the Second Reform Bill. This essentially Carlylean conception celebrates the hierarchic structure of British society. The Queen and Royal family surmount an edifice whose foundations rest on the "Bank of the Richest Country in the World," and on the armed services, including, along with the Army and the Navy, the Volunteers (in which Cruikshank proudly held a commission of lieutenant-colonel of the Havelocks or 48th Middlesex Rifle Volunteers). The cells in the great hive descend through the various classes to a bottom row occupied by representatives of those humble callings dear to the artist's democratic heart—the cabman, the ostler, the paviour, the shoeblack, the boatman, the coalheaver, the sweep, the costermonger, the dustman, and the conductor.

II

Cruikshank's turn to book illustration in 1823 liberated inherent faculties both for the purely comic and for the fantastic which lay at the heart of his vision, but which had hitherto been suppressed in the service of political satire. His first excursions in the vein of whimsical drollery which he was to make so peculiarly his own occurred in the forty etchings which appeared in the four volumes of an exceedingly rare publication, *The Humourist: A Collection of Entertaining Tales, Anecdotes, Repartees, Witty Sayings, Epigrams, Bon Mots, Jeu d'Esprits, etc.* (Cohn 419, 1819-20). In addition to the first issue in boards, Princeton has a complete set of undivided proofs in color of Cruikshank's enchanting plates. The shift from political to social commentary is further marked in the illustrations to Pierce Egan's *Life in London* (Cohn 262, 1821); but this famous work, a collaborative undertaking of the Cruikshank brothers, is less significant in George's career than John Fairburn's publication in the following year of David Carey's *Life in Paris* (Cohn 109), for the illustrations of which he was solely responsible. Although there is no evidence that the artist ever visited Paris, the twenty-

one colored plates and twenty-two engravings on wood present an admirably spirited account of high and low life in the French capital, as experienced by those Regency bloods, Dick Wildfire, Squire Jenkins, and Captain O'Shuffleton. In addition to the first issue of the first edition and two sheets of preliminary sketches in pencil, Princeton possesses an unique set of these cuts on large paper, made expressly for George IV.

According to an early eulogist, Rory O'Rourke, writing in the *Dublin and London Magazine* (1828), it was his illustrations for *Points of Humour* (Cohn 176) which "brought Cruikshank fairly before the public." This miscellany of passages, largely humorous, from a variety of sources was issued in two parts in 1823 and 1824 by Charles Baldwyn of Newgate Street. The Preface leaves no doubt that the collection was offered to the public principally on the merits of its illustrations:

> It will be readily perceived that the literary part of this work is of humble pretensions. One object alone has been aimed at and it is hoped with success—to select or invent those incidents which might be interesting or amusing in themselves, while they afforded scope for the peculiar talents of the artist who adorns them with designs. . . . In all this the writer or compiler, or whatever he may be called, claims little merit. That the whole effect is comic, that the persons are ludicrous, and engaged in laughable groups and surrounded with objects that tend to broaden the grin, all this, and a thousand times more, belongs to Mr. Cruikshank;—the writer only claims the merit of having suggested to him the materials.

To the first part Cruikshank contributed ten etchings and eight woodcuts, to the second ten etchings and twelve woodcuts. The illustrations in both colored and uncolored states are of uniformly high quality; but the four which relate to episodes in Robert Burns's "The Jolly Beggars" show Cruikshank's early manner at its best. Their ribald heartiness fully matches the vitality of the accompanying text, as is also true of the cuts for three boisterous episodes from *Peregrine Pickle*. Between the Scottish poet, the Scottish novelist, and the artist there existed deep-seated spiritual affinities.

In 1824 Baldwyn followed the success of *Points of Humour* with

Mornings at Bow Street (Cohn 844), containing twenty-one full-page woodcuts by Cruikshank; and three years later appeared a companion volume, *More Mornings at Bow Street* (Cohn 845), published by James Robins with an etched frontispiece, eight full-page woodcuts, and sixteen vignettes in the text, all by Cruikshank. The contents of these volumes were made up of humorous pieces from the *Morning Herald*, written by John Wight, Bow Street reporter for that newspaper. Cruikshank's illustrations established his graphic sovereignty over the London scene as definitely as a decade later Dickens was to become recognized as its prose chronicler. The originality of the artist's designs for the wood-engravings in these works matched his achievements as an etcher; but their wayward and untrammeled line made severe demands on the engravers responsible for their faithful transfer to the block. The finish of the cuts in the two Bow Street volumes testifies to the skill of such craftsmen as J. Thompson, R. Branston, and S. Williams who stand at the head of the long succession of wood engravers who served Cruikshank so well in this medium.

Cruikshank cherished a particular fondness for nautical subject-matter in which he found an inexhaustible well of mirth. Has anyone ever evoked the ludicrous miseries of seasickness so hilariously? Among his most brilliantly comic treatments of naval life are the twelve colored etchings and sixteen woodcuts which he made in 1826 for *Greenwich Hospital: A Series of Naval Sketches, descriptive of the Life of a Man-of-War's Man. By an Old Sailor* (Cohn 53). In such scenes as "Sailors Carousing," "Sailors on a Cruise" (in a stage coach), and "Crossing the Line," the artist captured with incomparable vivacity the frolics of tars ashore and at sea. The "Old Sailor," who supplied the text, was Captain M. H. Barker, for whom Cruikshank illustrated seven works in all. One of these was *Nights at Sea: or, Sketches of Naval Life during the War*, serialized in *Bentley's Miscellany* (Cohn 69) in 1837-38. Three of Cruikshank's seven etchings exist in admirable watercolor versions at Princeton. One of these, "The Battle of the Nile," depicts a cyclorama of the famous naval engagement as presented at "Bart'lemy Fair." A drunken onlooker is hurling oranges at the spectacle, thus endangering the indignant showman whose head rears up from the middle of the sea. A rough preliminary sketch in pen-and-ink of the scene, identified in Cruikshank's hand as by Captain Barker,

7

suggests the closeness of collaboration between author and illustrator.

As Cruikshank's fame grew, he formed the habit of issuing sets of his illustrations in large proofs on india paper for separate sale. This was the case with the wood engravings for both William Cowper's *The Diverting History of John Gilpin* (Cohn 169) and Thomas Hood's *The Epping Hunt* (Cohn 406), published by Charles Tilt in 1828 and 1829 respectively. The increasingly benign and tolerant humor reflected in the works which he selected for illustration during the 1820s, expressive of the more genial temper of the times which he was helping to define, led in 1830 to one of his most satisfying performances, the fifty-one woodcuts for William Clarke's light-hearted *Three Courses and a Dessert* (Cohn 144). Thackeray recognized the happy wedding of cut and text in this unjustly neglected work: " . . . some of the best designs of our artist and some of the most amusing tales in our language"; but the author, more modest, stated simply that the *plates* were sure to please even if the *dishes* failed to do so. No artist subsequent to Callot and della Bella had succeeded in making the engraving accommodate so great a wealth of narrative implication within so little space—as witness "The Deaf Postillion" or the minute vignette depicting the alternate courses of action confronting the man precariously perched on a fence-post with iron spikes before and behind, a ramping bull on one hand and equally savage watchdogs on the other. In this volume, as well, the illustrator gave free rein to his penchant for endowing inanimate objects with human characteristics, in anticipation of a similar practice in Dickens's early fiction. "Cruikshank never tired of making still life into quick life," Jerrold acutely observed; and no one who has sympathetically studied the colloquy of three sapient lemons or the portrait of a pontifical mushroom in *Three Courses and a Dessert* is ever again likely to take those homely kitchen staples quite so much for granted.

Meanwhile, in that *annus mirabilis* 1823, Cruikshank staked his claim to an even more original and unexplored province of humor. The new departure was announced in the twelve etched designs which he created for a selection of *German Popular Stories. Translated from the "Kinder und Haus Märchen," collected by M. M. Grimm from Oral Tradition* (Cohn 369). This

8

was the first appearance of Grimm's fairy tales in English, translated by John Edward Taylor and "a circle of relatives"; and it was followed in 1826 by a second volume of which Taylor was the sole translator and to which Cruikshank contributed another ten etchings. It is probably not excessive to state that Cruikshank's version once and for all fixed the way that English-speaking peoples think of fairyland. Indeed, the artist's drawings achieved matching popularity in Germany, and so took hold in France that an illustrator, Ambroise Tardieu, in 1830 brazenly passed off lame copies as his own work. "Mr. Cruikshank," wrote Thackeray, "alone has had a true insight into the character of the 'little people.' They are something like men and women, and yet not flesh and blood; they are laughing and mischievous, but why we know not. Mr. Cruikshank, however, has had some dream or the other, or else a natural mysterious instinct . . . , or else some preternatural fairy revelation, which has made him acquainted with the looks and ways of the fantastical subjects of Oberon and Titania." No volumes in the Cruikshank canon are more eagerly sought after by collectors than *German Popular Stories*; and Princeton's holdings are especially extensive in these scarce and costly little books. They include of Volume One, the first issue of the first edition (with the diaeresis omitted from "Märchen" on the title page), and two copies, one in boards, of the second edition, also dated 1823; and of Volume Two, three copies of the first edition, two in boards. In addition, there are a complete set of trial proofs on india paper for both volumes, and four sheets of original pencil sketches with marginal additions. Three of the latter present preliminary drawings for "Cherry, or the Frog-Bride," "The Young Giant inspecting Thumbling," and "The Tailor saving his Life by playing Violin to Bear." The fourth sheet contains a lively drawing of "The Pied Piper of Hamelin," made in 1868 at the request of John Ruskin for a further collection of fairy tales which never materialized. In the same year Grimm's tales were re-issued in a single volume with copies of the plates and an introduction by Ruskin, who, it will be remembered, had claimed that the quality of Cruikshank's etchings for this work in some respects rivalled and even excelled Rembrandt. Two additional sheets of pencil sketches for *German Popular Stories* are in the University Art Museum.

During this period Cruikshank further indulged his fancy in

9

the sixteen full-page woodcuts designed for *Italian Tales. Tales of Humour, Gallantry, and Romance* (Cohn 444, 1824). Princeton has two copies of the first issue of the first edition of this volume, both in original pink paper boards, and one with the substitute plate of "The Elopement" (which in the second issue replaced "The Dead Rider") bound in. The preliminary play of the artist's imagination over his material is recorded in three exquisite pen-and-ink drawings for the illustrations: one for "The Merchant of Venice" and two for "The Sleeping Draught," the latter subject also occurring in a watercolor version.

Akin to the renewed interest in folklore as yet another literary strain emanating from Germany to nourish the Romantic sensibility in England was a fascination with the supernatural. To this influence Cruikshank also showed himself alertly sensitive in the eight etched illustrations which he conceived for a translation of A. von Chamisso's tale of the man who bartered away his shadow to the devil, *Peter Schlemihl* (Cohn 475), published in 1823 (1824). The English version was by a Dr. Bowring; but, like Taylor the translator of Grimm, his name was absent from the title page—mute evidence of the fact that Cruikshank's designs were expected to recommend these works to the public. In addition to copies of the first (Cohn: "utmost rarity") and second (Cohn: "very scarce") issues of the first edition of *Peter Schlemihl*, there exists at Princeton a proof of the front plate, worked on by the illustrator and with three marginal pencil sketches. In 1825 the illustrator further explored this macabre vein in four etched illustrations for Victor Hugo's *Hans of Iceland* (Cohn 382) in an anonymous translation (even the author's name was not given). As well as a set of india proofs of these designs on large paper issued contemporaneously, Princeton has a pencil drawing for the rather fearsome frontispiece, and an early sepia sketch for the second plate, radically different from the final version. The Foreword offers the following apology by the translator: "This single pretension to a favorable consideration [the fact that Hugo's text had been greatly condensed] he feels is considerably strengthened by the four very ingenious and spirited etchings, by Mr. George Cruikshank which his labours have been the occasion of introducing, and which give this volume an attraction wholly unknown to the original."

J. Robins, the publisher of *Hans of Iceland*, also issued in

1830 Cruikshank's *Twelve Sketches illustrative of Sir Walter Scott's Demonology and Witchcraft* (Cohn 188). The artist's greatness as a book illustrator resulted in part from the unerring tact with which he chose scenes congenial to his temperament and skills; and such plates as "The Corps de Ballet" with its use of animistic detail, and "Fairy Revenge," in which there is an element of malice approaching cruelty, present a felicitous blending of humor and uncanniness.

A third realm of make-believe that exercised the same enduring appeal for Cruikshank that it did for Dickens was the theatre; and there was no period in the artist's career which was not productive of cuts inspired by the stage. There are at Princeton two fine watercolors for song-heads from very early dates, one a "Portrait of Fawcett, singing 'Mr. Lobski; or, the River Sprat-Catcher'" (Cohn 1768, 1808), and the other of Grimaldi singing "All the World's in Paris!" (Cohn 880, 1815). Another amusing watercolor (dated 1838, but unpublished) memorializes Grimaldi's apparently bottomless capacity for strong spirits; and, of course, the etchings for Dickens's *Memoirs of Joseph Grimaldi* (Cohn 237), published in the same year, have ensured the immortality of an otherwise fugitive compilation. Among the rarest of the works for which Cruikshank collectors compete is Thomas Kenrick's *The British Stage and Literary Cabinet* (Cohn 461), 6 vols. (1817-22), for the first two volumes of which the illustrator executed twenty-one handsome colored plates of leading actors and actresses of the day costumed for some of their most popular roles.

On all lovers of Punch and Judy, Cruikshank conferred a priceless boon in perpetuating that ancient spectacle through the twenty-four etchings and four woodcuts commissioned by Septimus Prowett for publication in 1828 (Cohn 150). These appeared in a volume with accompanying dialogue and a pioneering account of the origin of puppet plays and their history in England by the drama critic and notorious forger, John Payne Collier. In the interests of fidelity to the source material, Cruikshank and his collaborator during the autumn of 1827 arranged for private performances by an old Italian street entertainer, Piccini, who not only adhered to the traditional mode of presentation, but who owned a set of glove puppets immeasurably superior to any of English make. Piccini moved his portable stage indoors, and stopped the

11

performance on demand to enable the artist to catch the figures in characteristic poses, while Collier made a transcript of the dialogue. Princeton is the fortunate possessor of the splendidly animated watercolors (bound in with india paper proofs) which Cruikshank made on the spot, and which were reproduced for its members by the Limited Editions Club in 1937. Early printings include the French edition of 1836, on the title page of which the illustrator's name appears as Georges Cruishanck. This masterpiece was followed in 1830 by the publication of two burlesques with woodcut illustrations by Cruikshank: Kane O'Hara's adaptation of Fielding's *Tom Thumb* (Cohn 615), and W. B. Rhodes's *Bombastes Furioso* (Cohn 692). The Foreword of the former has these words of praise for Cruikshank: "The pencil of the Artist has in these times the power which in days of yore was ascribed to the wand of the Enchanter Merlin—by it Tom Thumb is again called into an existence, which promises to be lasting as the well-earned fame of his facetious historian, George Cruikshank."

Shakespeare, predictably, inspired a number of Cruikshank's theatrical scenes. At Princeton there are three finished sepia drawings, signed and dated 1833, which take outrageous liberties with famous episodes in the great tragedies: "Macbeth and the Witches," "Othello and Desdemona," and "Hamlet and the Ghost." These drawings were presumably designed for burlesque songheads; but the great nineteenth-century collector of Cruikshank, Edwin Truman, who originally owned them, thought that only the last was ever published. The artist had a particular fondness for *A Midsummer-Night's Dream*. Two of the oil sketches at Princeton show Bottom adorned with the ass's head, and there is, as well, a finished watercolor of the same subject. During the 1860s Cruikshank paid eloquent tribute to Shakespeare's dramatic imagination in an elaborately conceived painting of the playwright as a babe in the cradle surrounded by the creations he was to bring into being. The print is entitled "All the World's a Stage: The First Appearance of William Shakespeare, on the Stage of 'The Globe'" (Cohn 879). Princeton has a large watercolor sketch of the subject in which the figures are very differently disposed. It is dated in the artist's hand 1863, with the notation that this was the second sketch for the final composition.

12

Adroit as he was in parcelling out his talents to suit the varied subject-matter and tonal demands of the books which he illustrated, no work by another could possibly accommodate the full range of Cruikshank's vision. This is why his genius is most fully manifest in the entirely original productions which he began to publish in the mid-1820s. Not even Thackeray, whose spiritual kinship with the artist was in many ways so close, succeeded in isolating the components of the artist's comic style. It derived from an unusually alert sensitivity to all forms of sham. As J. G. Lockhart observed in *Blackwood's Magazine* as early as 1823, Cruikshank was "a total despiser of THAT VENERABLE HUMBUG, which all the artists of the day seem, in one shape or other, to revere as the prime god of their idolatry." Of his controlling motive the artist himself had this to say in the *Comic Almanack*: "While we venerate what is deserving of veneration, let us not forget that quackery, knavery, bigotry, and superstition always merit exposure and castigation." Although he thought of himself as a satirist, Cruikshank's humor is notably impersonal. Its influence on *Punch* in its early days is indubitable; yet, despite the urging of its editor, Mark Lemon, the illustrator refused to join the staff of the periodical because of his dislike of its attacks on individuals. His mirth is the rib-tickling mirth of Puck, mocking, slightly perverse (although without much of Puck's malice), tirelessly alert to man's incorrigible foolishness. For Cruikshank life seems one long spectacle in which the actors are unknowing clowns parading their antic dispositions. His eye, trained in the school of caricature, runs to extremes. The slightest aberration or deviation from the norm calls up gleeful fantasies of the monstrously disproportionate or incommensurate. His natural provinces are parody, travesty, burlesque—to which is added, almost as his own discovery, nonsense.

To elaborate the wildly hilarious spectacle of human existence Cruikshank developed a special format, his designs appearing in oblong folios issued in plain and colored sets, to widen the circulation, usually with several cuts to the page and without supporting text, save for the captions to the pictures. These he himself published for sale by such print-sellers as S. Knight, J. Robins, and Charles Tilt under the titles *Phrenological Illustrations* (Cohn 178, 1826), *Illustrations of Time* (Cohn 179, 1827), *Scraps and*

Sketches (Cohn 180, in four parts, 1828-32), and *My Sketch Book* (Cohn 181, 1834). In their originality of conception these works, as Jerrold was the first to recognize, "may be said to have furnished the pictorial material for the first attempt at illustrated journalism"; and, indeed, the cuts were in short order reproduced in the pages of *Bell's Life in London* without permission or acknowledgment. The theme of mutability or transience is pervasive, so that one has the impression of looking over the artist's shoulder as he records the passing show. Typical sheets group a number of smaller vignettes about a central etching to create a pattern of theme and variations. Any slightest provocation is sufficient to release the artist's virtuosity as an improviser: wooden legs, the season's fashions in bonnets, bellows. There is a constant reliance on visual puns, often elaborate in reference, as in the graphic play on "tails-tales" in the first plate of Part Four of *Scraps and Sketches*. Cruikshank's inventions turn conventional associations topsy-turvy and discover subversive new possibilities of meaning in the willful distortion of familiar and tamely accepted propositions. Dickens was to achieve similar effects through the verbal pyrotechnics of his great comic characterizations, Sam Weller, Pecksniff, Mrs. Gamp, Micawber.

At the same time, commencing with *Scraps and Sketches* and *My Sketch Book*, certain full-page plates are imbued with a more sombre and hortatory mood, symptomatic of the heightened social conscience of the dawning age. There is genuine satiric bite in the etchings devoted to such disputable evidences of "progress" as Brougham's advocacy of the "March of Intellect" and the coming of the railway; and the plate entitled "London going out of Town; or, the March of Bricks and Mortar!" prophetically shows the spoliation of the countryside around the metropolis by factories and jerry-built housing. Cruikshank's eventual espousal of the cause of teetotalism is forecast in three very grim commentaries on the evils of drink: "The GIN Shop" in *Scraps and Sketches*, and "The Pillars of a Gin Shop" and "The Gin Juggernath; or, the Worship of the Great Spirit of the Age" from *My Sketch Book*, the latter a really terrifying evocation of a gigantic gin mill drawn by raving alcoholics and spreading death and destruction in its wake across the darkening land. The disturbingly mordant power of this etching is rivalled by another from *Scraps and Sketches*, "The Fiend's Frying-Pan, or Annual Festival of Tom

14

Foolery and Vice," which castigates the annual outbreak of debauchery and violence fostered by Bartholomew Fair.

IV

In mid-career, from about 1830 to 1845, Cruikshank devoted a major portion of his energies to book illustration. Since many of the contemporary novels which he illustrated first appeared in serial form, this was the period of his association with two of the leading periodicals of the day as their favored artist. To *Bentley's Miscellany*, principally under the successive editorships of Dickens and Ainsworth, he contributed 131 etchings and four woodcuts between 1837 and 1843, deliberately producing poor work towards the end in order to provoke a break with Bentley. Thereafter from 1842 to 1846 he worked for *Ainsworth's Magazine* (Cohn 22), in the pages of which appeared sixty-three etchings and twenty-two woodcuts of his designing. Ainsworth's handsome tribute announcing Cruikshank as the illustrator of his magazine in its first number says a great deal about the foundations on which his reputation rested at this time:

> In securing the co-operation of this admirable artist, the strongest assurance is given, not only of unequalled excellence in tragic and humorous illustration, but of an anxious and thoughtful principle of responsibility in the exercise of that power. No work can need a surer guarantee than that which is conveyed in the association of an artist, who has passed an important portion of his life in satirizing and ridiculing human follies, without giving one moment's pain to a fellow-creature; who has faithfully delineated almost every diversity of character, without creating a single enemy.

Scenes from Washington Irving's *Knickerbocker's New York* and Goldsmith's *Vicar of Wakefield* were among the illustrations which Cruikshank made for Part One of *Illustrations of Popular Works* (Cohn 187, 1830). Princeton's copy, originally owned by H. W. Bruton, is a large paper edition containing india proofs of the plates in two states, presented by the artist to Charles Augustus Howell. Bound in is a sheet of drawings in pencil and sepia for the first plate, "Combat between Roderick and Captain Weazel," of which episode from Smollett's novel there also exists an oil

15

painting at Princeton. From 1831 to 1833 Cruikshank was engaged in decorating seventeen of the nineteen volumes of *Roscoe's Novelist's Library* (Cohn 701-11). He executed in all seventy-four etchings for this popular series of reprints of novels by Smollett, Fielding, Goldsmith, Sterne, Cervantes, and LeSage. There followed a series of thirty-five plates for Scott's Waverley Novels (Cohn 730), for which there are in the Princeton University Library eleven initial watercolor sketches.

These accomplishments were preliminary to the masterpieces which resulted from the artist's short-lived collaboration with Dickens. The Preface to the first series of *Sketches by Boz* (Cohn 232, 1836), later discarded, indicated how eagerly the budding novelist welcomed the support of the established illustrator when Macrone undertook to publish a collection of his journalistic accounts of "Every-Day Life and Every-Day People":

> Entertaining no inconsiderable feeling of trepidation at the idea of making so perilous a voyage in so frail a machine, alone and unaccompanied, the author was naturally desirous to secure the assistance and companionship of some well-known individual, who had frequently contributed to the success, though his well-earned reputation rendered it impossible for him ever to have shared the hazard of similar undertakings. To whom, as possessing this requisite in an eminent degree could he apply but to GEORGE CRUIKSHANK?*

For the First Series of the *Sketches* in two volumes Cruikshank produced sixteen etchings; for the Second Series in one volume (Cohn 233, 1837) an additional ten, increased to twelve in the second edition. This number grew to forty when the *Sketches* were issued in twenty parts (November 1837-June 1839, Cohn 234), of which twenty-seven were rather coarsely re-etched in larger form. With the addition of the holdings in its Parrish Collection Princeton possesses, often in duplicate, all of the rare early issues of this work, the bibliographical history of which is so involved.

Meanwhile, Dickens as editor had inaugurated the monthly numbers of *Bentley's Miscellany* in January 1837 with *Oliver Twist*, which continued to appear with interruptions through the

* To Macrone the writer had proposed as possible titles for the work, "Sketches by Boz and Cuts by Cruikshank," and "Etchings by Boz and Woodcuts by Cruikshank."

first five volumes, adorned by what are probably Cruikshank's most famous illustrations. Before the magazine run was completed, the novel was published in three volumes in 1838 (Cohn 239). A new edition, revised and corrected, came out in ten parts, as well as in a single volume, in 1846 (Cohn 240). For this the majority of the original plates were re-etched and considerably altered. Of extreme interest are the several sheets of pencil sketches at Princeton which supplement the early issues of *Oliver Twist*. As is well-known, Dickens was dissatisfied with the so-called "Fireside Plate" which was published as the final illustration in Volume Three of the first issue of the novel in book form; and Cruikshank substituted for it "Rose Maylie and Oliver at the Tomb." A folded sheet in the Princeton University Library, which shows on its facing halves a version of the suppressed plate along with four rough sketches for the cut which replaced it, would seem to offer evidence that the artist had these alternate designs in mind from the outset. Other drawings in Princeton's collection which vary in suggestive ways from their published versions are: "Oliver claimed by his affectionate Friends," "Oliver waited on by the Bow Street Runners," "Mr. Bumble degraded in the Eyes of the Paupers," "The Meeting," and "Sikes attempting to destroy his Dog." Finally, there is a fine sketch which was never used of Oliver tagging along at the heels of Bumble.

Concurrent with the last installments of *Oliver Twist*, there began to appear in *Bentley's Miscellany* William Harrison Ainsworth's *Jack Sheppard: A Romance*. Although Cruikshank was to illustrate entirely or in part seven novels by Ainsworth, whose popularity at this time rivalled Dickens's, the relationship between the artist and the lesser novelist still awaits the kind of intensive investigation that Cruikshank's partnership with Dickens has received. If it is reasonable to say that the story of *Oliver Twist* is inseparably linked for the majority of readers with the illustrator's rendering of such episodes as Oliver asking for more gruel or Sikes about to leap to his death or Fagin in the cell awaiting execution, how much more justifiable is Thackeray's statement that Ainsworth's story of his unprincipled young scoundrel would be wholly forgotten without the life imparted to it by the illustrator's art: "With regard to the modern romance of 'Jack Sheppard,' " Thackeray wrote, "it seems to us that Mr. Cruikshank really created the tale, and that Mr. Ainsworth, as it were, only

17

put words to it. Let any reader of the novel think over it for a while, now that it is some months since he has perused and laid it down—let him think and tell us what he remembers of the tale? George Cruikshank's pictures—always George Cruikshank's pictures." Indeed, perused separately, these plates not only carry the story-line, but do so with immeasurably greater economy and dramatic force than Ainsworth's wooden narrative. Both in the choice of incidents and in the accumulation of detail within each scene to amplify its significance, Cruikshank shows his debt to Hogarth's "moral progresses." Indeed, Hogarth and his father-in-law, Sir James Thornhill, are pictured among the artists taking a likeness of the condemned protagonist in his cell in the cut entitled "The Portrait." The etcher's change of medium from copper to steel plates at about this time allowed for important technical developments, notably in the treatment of facial expression and in the creation of atmospheric effects through the finer handling of light and shade. And the wealth of original sketches at Princeton shows how carefully Cruikshank worked out his conceptions in advance. There are drawings for nine of the twenty-seven etched illustrations of *Jack Sheppard*, varying from free pencil notations to highly finished watercolors. Since several of these treat the same episode at different stages in its development, it is possible to watch in unusual detail the evolution of the artist's ideas.

In addition to *Jack Sheppard* (Cohn 12, 13), Cruikshank illustrated for Ainsworth: *Rookwood* (Cohn 11, 1836, 4th edn., twelve etchings); *The Tower of London* (Cohn 14, 1840, forty etchings and fifty-eight woodcuts); *Guy Fawkes; or the Gunpowder Treason* (Cohn 16, 1841, twenty-two etchings); *The Miser's Daughter* (Cohn 17, 1842, twenty etchings); *Windsor Castle* (Cohn 19, 1843, fourteen etchings by Cruikshank); *St. James's; or the Court of Queen Anne* (Cohn 21, 1844, fourteen etchings in *Bentley's*, nine in three volumes), and a woodcut design (originally for the unpublished "Lions of London") for the wrappers of *Old St. Paul's* (Cohn 15, 1841). All of these except *Old St. Paul's, Rookwood* and *The Tower of London* (first published in parts) came out as serials in *Bentley's Miscellany* or *Ainsworth's Magazine* prior to publication in book form. The technical excellence of the best of these plates in their fidelity to historical detail suggests that during these years Cruikshank had adopted an altogether more ambitious view

18

of the illustrator's role. He shared Ainsworth's concern for minute accuracy in the rendering of architectural setting, period costume, and so forth; and as their correspondence shows, the two conferred at length about such matters and together conducted a good deal of on-the-spot research. In preparing his designs, Cruikshank clearly found some measure of compensation for the career as an historical painter from which his lack of academic training debarred him. Since Princeton possesses pencil and watercolor sketches too numerous to list, as well as sets of trial proofs and much of the correspondence relating to virtually all of these novels, its holdings offer superlative facilities for assessing the artist's most ambitious and extended collaborative endeavor.

A few additional titles will suggest the extent and varied nature of Cruikshank's commissions as a book illustrator during his later career. In 1845 he achieved one of his most remarkable successes in the twenty-one plates he made to embellish W. H. Maxwell's *History of the Irish Rebellion in 1798* (Cohn 541). There is nothing in the artist's work to prepare one for the brutal savagery of this picturing of the horrors of civil warfare; indeed, to match the stark ferocity of such etchings as "Murder of George Crawford and his Granddaughter," "The Rebels executing their Prisoners, on the Bridge at Wexford," or "Rebels destroying a House and Furniture," one would have to go to Goya's *Los Desastres de la Guerra*. Totally different in character are the artist's thirty etchings on steel for *Frank Fairlegh: or, Scenes from the Life of a Private Pupil* (Cohn 754, 1850), originally published in parts with a woodcut design on the wrappers by Cruikshank. Princeton has his own copy of the parts issue, as well as a number of sheets of preliminary drawings. For the publication in weekly parts of Harriet Beecher Stowe's *Uncle Tom's Cabin* (Cohn 777, 1852) the artist designed twenty-seven woodcuts, as well as the vignette on the title page and a frontispiece portrait of the author. In addition to a sheet of sketches of Eva, there are at Princeton two full-page drawings, as well as a first proof, engraved by John Thompson, for a frontispiece to Mrs. Stowe's novel.

The best examples of Cruikshank's meticulously finished, if somewhat static manner on steel plates are the illustrations which he designed for R. B. Brough's *The Life of Sir John Falstaff* (Cohn

96, 1857-58). Of the care which the artist lavished on the undertaking, the author has this to say in the Preface:

> It may be stated fairly, that no pains have been spared by the artist to make his work conscientiously complete. Every locality indicated by the poet has been carefully studied either from personal observation or reference to the most authentic records— (take, for example, the views of Shrewsbury and Coventry as they appeared in the fifteenth century and the tall spire of "Paul's" before it was struck by lightning). The costumes, weapons, furniture, etc., are from the very best available authorities.

The work first appeared in ten parts, with two plates to each and a woodcut decoration on the wrappers. Princeton has two sets of the parts, one being the first issue. Of the two copies of the publication in book form which it also owns, one has an interesting letter to Planché bound in. In addition to two unpublished pencil portraits of Falstaff and a unique signed proof of the frontispiece worked on by the artist, Princeton also owns a large watercolor sketch for "Sir John Falstaff and the Fairies at Herne's Oak," which differs materially from the final plate. Lastly, there are finished watercolors of "The Prince and Poins driving Falstaff, Gadshill, Peto, and Bardolph from their Plunder at Gadshill" and of "Sir John Falstaff, disguised as 'Mother Prat,' cudgeled and driven out by Mr. Ford." Although the latter are presumably contemporary with the volume, it is impossible to be certain, since Cruikshank sometimes accepted orders to make watercolors from his illustrations, as in the case of the set of drawings from *Oliver Twist*, now at the Morgan Library, which were not executed until 1866.

Cruikshank's comic exuberance persisted in a somewhat muted key in his illustrations for such works as D. M. Moir's *Life of Mansie Waugh, Tailor of Dalkeith* (Cohn 570, 1839) and Charles Lever's *Arthur O'Leary, his Wanderings and Ponderings in Many Lands* (Cohn 483, 1844); but new artists were coming to the fore in response to the changing temper of the public. Towards the end of Cruikshank's association with *Bentley's Miscellany* John Leech emerged as a formidable rival, whose designs first appeared in that periodical in 1840; and in 1844 Hablot K. Browne ("Phiz") took over as principal illustrator of *Ainsworth's Magazine*. The

decade of the 1840s, it will be remembered, marked the rise of *Punch*, for which Cruikshank never worked, as the leading humorous magazine of the day.

V

For the survival of Cruikshank as a comic artist, therefore, one must turn back to the early publications which were largely planned as well as executed by him. To this category belong *The Loving Ballad of Lord Bateman* (Cohn 243, 1839), with serio-comic notes by Dickens, and *The Bachelor's Own Book. Being The Progress of Mr. Lambkin (Gent.) in Pursuit of Pleasure and Amusement, and also, in Search of Health and Happiness* (Cohn 192, 1844), both of which exist at Princeton in their rare first issues. The true indices to Cruikshank's temperamental affinities, however, as well as the most joyous displays of his talents are to be found in the various continuations of the highly personal idiom developed in *Scraps and Sketches* and *My Sketch Book*. Of these the longest lived was the *Comic Almanack* (Cohn 184), first published by Charles Tilt, Fleet Street, and carried on in monthly numbers over a period of nearly two decades from 1835 to 1853. Although the artist was assisted in the text by such friends as Thackeray (whose "Stubbs's Calendar; or the Fatal Boots" and "Cox's Diary" appeared in its pages in 1839 and 1840), Gilbert à Beckett, Albert Smith, Robert Brough, and Horace and Henry Mayhew, the *Almanack* was virtually a showcase for Cruikshank's artistry, including nearly 250 etchings, as well as innumerable woodcut illustrations.

Because of its duration, the *Comic Almanack* offers an unusually rich ground for surveying Cruikshank's mirroring of early Victorian England. Quite as much as Dickens, the artist's depiction of "Every-Day Life and Every-Day People" qualifies him to be regarded as the historian of his society throughout its middle and lower reaches. Like the *Sketches* and *Pickwick Papers*, the early numbers of the *Almanack* record traditional ways of life that were rapidly being superseded. These are inimitably reflected in the introductory etchings to the issues in the opening years of the periodical's career, each of which celebrates some festive occasion appropriate to the month, whether feast-days religious in origin, Twelfth Night, Valentine's Day, St. Patrick's Day, Michaelmas Day, St. Crispin's Day, St. Cecilia's Day, Christmas;

21

or such secular holidays as Lord Mayor's Day, Boxing Day, Guy Fawkes' Day. In their superb vitality and inventiveness these plates rank among Cruikshank's most masterly achievements, even above the similar illustrations for *Sketches by Boz*. The settings, often street scenes, are scrupulously localized to bring out the frolic mood of the occasions. And no stage director ever more carefully disposed his throng of actors to achieve a totality of impression. The artist's skill in discriminating facial expression has often been remarked; but to this should be added his pantomimic sense of the revealing posture or gesture. Note, for example, the varied antics of his urchins and dogs, as they are swept into the whirling vortices of activity. It was this consummate handling of group scenes which led Baudelaire to declare with regard to Cruikshank in "Quelques Caricaturistes Étrangers": "Le grotesque est son habitude. . . . Si l'on pouvait analyser sûrement une chose aussi fugitive et impalpable que le sentiment en art, ce je ne sais quoi qui distingue toujours un artiste d'un autre, quelque intime que soit en apparence leur parenté, je dirais que ce qui constitue surtout le grotesque de Cruikshank, c'est la violence extravagante du geste et du mouvement, et l'explosion dans l'expression. Tous ses petits personnages miment avec fureur et turbulence comme des acteurs de pantomime." And inanimate objects are similarly commandeered to enact their dramatic roles. A somewhat later double plate of 1847, entitled "Born a Genius and Born a Dwarf," contrasts a starving artist in a bare garret sitting despondently before his easel to a dwarf lolling in luxury amidst coffers from which spill money and jewels. The dwarf was Tom Thumb, then at the height of his vogue; the artist, Benjamin Haydon, who was shortly to commit suicide. The picture was inspired by one of the last entries in the painter's diary: "Tom Thumb had 12,000 last week, B. R. Haydon 133½ (a little girl). Exquisite Taste of the English people!" The full irony and poignancy of the situation are enforced by the pairs of boots which Cruikshank has drawn in the lower left corner of each panel. Those of the artist, wrinkled and broken-soled, slump over as if in sympathy with their owner's unhappy state, while the dwarf's are spruce and gleaming, seemingly in anticipation of the swagger with which they will be worn.

While Cruikshank never lost his fondness for subjects designed to excite gusts of laughter, the pages of the *Comic Almanack* show that during the 1840s he was equally capable of a strongly satiric

response to more serious issues. Thus, his drawings acidly comment on such disparate topics as Chartist agitation, the Owenite system of barter, the cartoons submitted for the mural decoration of the new Westminster Hall (a Hogarthian parody of the grand style), the Young England movement, the speculative craze released by the sale of railway shares, Bloomer girls. "Air-um Scare-um Travelling" (1843) ridicules the fad for balloon ascensions with advertisements of express flights to Paris every fifteen minutes and a daily packet service to Pekin and Canton. An etching, entitled "My Wife is a Woman of Mind" (1847), makes fun of the blue-stockings, showing the wife at her desk in the throes of poetic composition, while her distracted husband, babe in arms, attempts to cope with the household chores. Another prophetic picture, "Over Population" (1851), depicts the Thames covered with floating habitations, while in the background rise terraces of dwellings, one piled above the other, the whole surmounted by a topmost tier of edifices suspended from balloons. Yet another, ridiculing the propaganda for female emigration under the caption "Scarcity of Domestic Servants—or Every Family their own Cooks!!!," surveys the chaos reigning in the kitchen as parents and children endeavor to prepare a meal. With a related subject Cruikshank had previously dealt in twelve of his most hilarious illustrations, drawn in 1847 to accompany the Mayhew brothers' text for *The Greatest Plague of Life: or the Adventures of a Lady in Search of a Good Servant* (Cohn 544).

VI

In 1841 Cruikshank acrimoniously broke with the owner of *Bentley's Miscellany*, and established a publication of his own, *George Cruikshank's Omnibus* (Cohn 190), issued in nine monthly parts from May 1841 to January 1842. For this the illustrator made nineteen steel engravings (of which a number were for Bowman Tiller's *Frank Hartwell; or, Fifty Years Ago*, which ran as a serial in *Omnibus*), and seventy-eight woodcuts. Several of the etchings, such as the two sheets satirizing the restrictions of the "Late New Police Act," were in the artist's happiest manner. The principal plate for May 1841, "De Omnibus Rebus et Quibusdam Aliis," was the first of Cruikshank's virtuoso experiments with the type of immensely crowded and detailed com-

23

position on which he exercised his mature skills in the following decade. It represents the world as a kind of dial or clock-face on which are depicted the peoples of the different nations appropriately costumed and engaged in their characteristic forms of diversion. The initial illustration of the last number, "Jack o' Lantern," is one of Cruikshank's most successful excursions into the macabre. Princeton has an extraordinary touched proof of a mezzotint of the same subject (although with variations), "Painted by George Cruikshank. Engraved by John Mills. Published for the Artist by S. Knights, Sweeting's Alley, Royal Exchange, Jan. 1831." This print, which predates the *Omnibus* version by a decade and of the publication of which there is no record, provides significant evidence of the artist's economy in working up designs which had long lain dormant. The verso of the mezzotint carries a very spirited preliminary pen drawing for "Jack o' Lantern."

The Postscript to *Omnibus*, announcing that its monthly publication was being discontinued because of the illustrator's newly formed connection with *Ainsworth's Magazine*, promised that a second volume would appear in the form of an Annual. This promise was never fulfilled; but when Cruikshank fell out in turn with Ainsworth in 1844 after the latter sold his magazine, he founded a publication of his own, *The Table Book* (Cohn 191). Edited by Gilbert à Beckett and published by Bradbury and Evans, it appeared in twelve numbers throughout 1845. With the sense of creative release which independence always seemed to bring, Cruikshank designed for *The Table Book* twelve steel etchings and 116 woodcuts and glyphographs, including two masterpieces which exhibit the opposing horizons of his vision. These were: "The Triumph of Cupid: A Reverie," with its celebration of the blind god's universal sway, and the nightmarish "The Folly of Crime," which portrays as its central subject the descent into the pit of the fiend-haunted murderer clutching his knife. In "The Triumph of Cupid" the artist limned himself as the dominant figure. He sits meditatively before the drawing-room fire; and the smoke curling from his meerschaum materializes into a cloud of exquisitely realized figures, whose differing plights it is a delight to trace. No one is exempt from the gentle passion, whether the blind man, the dustman, the pugilist, or the lamplighter. Cruikshank's full motivation in including so many por-

24

traits of himself throughout his work has yet to be explored, although the materials for such a study have been admirably assembled by George Somes Layard in *George Cruikshank's Portraits of Himself* (1897). The sketchbooks at Princeton are filled with additional examples of self-portraiture. It seems clear that this proclivity on the illustrator's part is not attributable solely to egotism, but that it resulted, at least in part, from a lifelong determination to vindicate the illustrator's claims to be regarded as a creative agent in his own right, quite as much as the authors for whom he worked. Close examination of "The Triumph of Cupid," for example, reveals in miniature a second image of Cruikshank as artist standing before a canvas on which he is sketching yet a third self-portrait, as if to remind the viewer that without his magic brush the fabric of the surrounding vision could never have been embodied. Cruikshank was given to representing himself in company with his collaborators, and always in such a way as to stress their equality in the joint endeavor. Examples are the portraits of himself and William Hone on the title-page of *Facetiae and Miscellanies* (Cohn 405, 1827), of himself and Ainsworth at the head of the section entitled "Our Literary Table" in *Ainsworth's Magazine*, and of himself and Dickens ascending in a balloon on the title-page of *Sketches by Boz*, as well as in the later plate, "Public Dinners." Significant in this respect is Princeton's sheet of excellent pencil likenesses of Sir Walter Scott, dated Sept. 17th, 1833, from the midst of which Cruikshank himself peers out. A conviction that the public was prone to slight the illustrator's role in enhancing the appeal of the works in which he had a hand may help to explain the artist's assertions in later life that he was the true begetter of *Oliver Twist* and of several of Ainsworth's novels.

The Table Book was followed by two short-lived publications of which Cruikshank was the originator: *Our Own Times* (Cohn 193), which appeared in four numbers, April-July 1846, with four etchings, thirty-five glyphographs, and six woodcuts; and *George Cruikshank's Magazine* (Cohn 185), which terminated after only two numbers, January and February 1854. The former opened with an etching illustrative of the mid-Victorian sense of the importance of education. Entitled "An Outline of Society in Our Own Times," it represents the unequal opportunities for schooling and the resultant effect on the behavior of the young down

25

through the various social gradations. For June 1846 the artist designed one of his rare satires on industrial progress. With the caption "Tremendous Sacrifice!" it searingly castigates the evils of mass production, showing a great grinding machine into which starving seamstresses are fed to emerge in the form of cheap goods. In "Passing Events, or the Tail of the Comet of 1853," the initial cut for *George Cruikshank's Magazine*, the artist produced perhaps his most astonishing piece of social reportage on a fold-out etching measuring fifteen and one-quarter by seven inches. In *Personal Recollections of George Cruikshank* Cuthbert Bede summarized as follows some of the year's events to which Cruikshank alluded in this plate:

> It was crammed with hundreds of figures, giving, at one view, an epitome of the leading events of the year—the Peace Conference, the war between Russia and Turkey, the war in China, the Queen's review of the troops at Chobham, the naval review at Portsmouth, Spirit Rapping, Table Turning, the Derby Day, "Betting," the City Corporation Commission, John Gough and the Temperance Demonstration, the Ninevah Bulls, the Zulu Kaffirs and Earthmen, the Anteater, Albert Smith's "Mont Blanc," Charles Keen's "Sardanapalus," Bribery and Corruption, the Australian Gold Discovery, Mrs. Stowe and "Uncle Tom," The New York and Dublin Exhibitions, the Vivarium, Guy Fawkes, Lord Mayor's day, Wyld's Great Globe, Captain McClure and the North-west Passage, Miss Cunningham's Seizure by the Grand Duke of Tuscany, the Ceiling-Walker, Smithfield Cattle Show, Chiswick Flower Show, Christmas Merry-making, and the Pantomimes. . . .

The steel plate for this etching is at Princeton.

For a chronicler of contemporary life as observant as Cruikshank, the Great Exhibition of 1851 provided a matchless opportunity to display his talents. In a serious vein he composed a large etching of "The Opening of the Great Industrial Exhibition of All nations by the Queen and Prince Albert. 1 May 1851" (Cohn 1814), which was issued in three states: plain, india proof, and superbly colored. Amidst the vast throng filling the Crystal Palace the artist himself may be picked out. At the same time he made ten comic etchings to go with Henry Mayhew's text, *1851;*

or, The Adventures of Mr. and Mrs. Sandboys and Family, who came up to London to 'Enjoy Themselves,' and to see the Great Exhibition (Cohn 548), originally published by David Bogue in eight parts. The work includes two illustrations entitled "London in 1851" and "Manchester in 1851," contrasting the two metropolises, the capital with Regent's Circus gorged and choked with sightseers gathered for the occasion, while the streets of the industrial center are wholly depopulated and without signs of life, except for a single seated man reading a newspaper and with a dog curled at his feet.

VII

By 1845 Cruikshank had begun to outlive the popularity which throughout the previous quarter of a century had sustained his reputation as the leading graphic artist of the day. Several factors contributed to this decline from public favor. In its willful eccentricity, its unpredictability, and, on occasion, its fearless candor, his humor belonged to an earlier and more robust age, whereas Leech, Brown, and the later generation of comic artists were content to draw affectionately genial pictures of daily life in which their audience could laugh at its foibles without having its complacency too greatly ruffled by the barbs of satire. In addition, Cruikshank's well-known touchiness of disposition in insisting that he receive recognition as a great original artist made editors and publishers increasingly chary of entering into contracts with him. A further determinant was undoubtedly the apostolic zeal with which the artist excoriated the evils of drink, and later of smoking, once he had forsaken the convivial excesses of his own early years. As far back as *Scraps and Sketches, My Sketch Book,* and *Sunday in London* (Cohn 846, 1833), Cruikshank had begun to inveigh against intemperance as a primary source of social evil, but his method at this time was that of the satirist who lashes a vice out of countenance, rather than the solemnly admonishing tone of the writer of tracts. As late as 1844 in the plate from the *Comic Almanack,* entitled "Father Mathew—An Ice Man for a Small Party," in which an animated pump takes to task a gathering of jovial topers, the emphasis is still primarily comic. Princeton possesses the watercolor drawing for this plate, inscribed as follows in Cruikshank's hand, under the date July 26, 1873: "This

27

sketch was made before I became a 'Pump' myself. But I am now happy to say that I have been a 'Total Abstainer' for twenty-six years up to this date."

The shift in the illustrator's attitude towards alcoholism is forecast in the four very striking drawings he made to adorn *The Drunkard. A Poem* (Cohn 620, 1842) by John O'Neill, who became known as "The Laureate of the Temperance Movement." In their almost surrealist evocation of the excesses to which gin drives its devotees these plates, entitled "The Raving Maniac and the Driv'ling Fool," "The Gin Palace," "The Drunkard's Home," and "The Upas Tree," are far more terrifying than the would-be naturalism of the two famous series, *The Bottle* (Cohn 194, 1847) and *The Drunkard's Children* (Cohn 195, 1848) for which (according to the re-issue of 1876) O'Neill's poem provided the original inspiration. In the latter designs the artist adopted the cruder technique of glyphography to make possible inexpensive reproduction on a mass scale. The eight plates of *The Bottle* are reputed to have sold 100,000 copies at a shilling a print in a few days, and during their brief vogue to have received concurrent dramatic representation at eight theatres. They even inspired Matthew Arnold to write a sonnet, entitled "To George Cruikshank. On seeing in the Country his Picture of 'The Bottle.'" In addition to first editions and large paper presentation copies in both colored and uncolored states of the two series, Princeton owns finished watercolors of two scenes from *The Bottle*. By and large, the numerous illustrations which Cruikshank subsequently made for fugitive pamphlets propagandizing the cause of teetotalism are better overlooked. There are two exceptions, one being the enormous canvas 7'8" by 13'3", now at the Tate Gallery, on which Cruikshank labored for three years before its exhibition in 1863 under the title, "The Worship of Bacchus; or, The Drinking Customs of Society." Of the engraving made from the painting, in which Cruikshank himself etched the vignettes of the countless groups of figures, there is at Princeton a first proof after lettering on india paper. In 1872 appeared *The Trial of Sir Jasper: A Temperance Tale in Verse* (Cohn 379) by S. C. Hall, with plates by many of the leading artists of the day, including Alfred Elmore, Thomas Faed, Noel Paton, Birket Foster, E. M. Wimperis, and Gustave Doré. Cruikshank's contribution was the searingly powerful woodcut, "Ten Thousand Devils haunt him . . . ," engraved

28

by the Dalziel Brothers. Princeton's copy is inscribed by Hall to
Doré, who at this time visited England to make his superb illus-
trations for *London: A Pilgrimage* (1872).

Not even fairyland was immune to Cruikshank's censorial
fervor. The artist's love of whimsy had found recurrent expres-
sion throughout his long career. In 1848, for example, he produced
an enchanting series of twelve etchings on six plates for an ex-
purgated version of Giambattista Basile's *Pentamerone* (Cohn
60), adapted by J. E. Taylor, whose translation of Grimm he had
illustrated twenty-four years earlier. In addition to the first (two
copies) and second issues of the first edition of this work, Prince-
ton owns a fine pencil sketch for "Peruonto astride a Bundle of
Faggots." There followed the seven woodcuts, engraved by J.
Thompson, for E. G. Flight's *The True Legend of St. Dunstan and
the Devil* (Cohn 323, 1852), again in the illustrator's best diabolic
manner. During the ensuing decade Cruikshank illustrated four
children's tales, gathered under the title of the *Fairy Library*
(Cohn 196-99): "Hop o' my Thumb and the Seven League Boots"
(1853), "The History of Jack and the Bean-Stalk" (1854), "Cin-
derella and the Glass Slipper" (1854), and "Puss in Boots" (1864).
There were in all thirty-nine designs on twenty-four plates, and
four wrapper designs. Princeton's holdings of the *Fairy Library*
are virtually complete, including copies of the earliest issues and
sets of china paper proofs of the illustrations for the first three,
inscribed by the artist to the Rev. Thomas Hugo and including
two autograph letters to the recipient. There are also a large
pencil sketch and smaller signed watercolor for "The Pumpkin,
and the Rat, and the Mice, and the Lizards, being changed by the
Fairy into a Coach, Horses, and Servants." The records show that
in 1854 Cruikshank exhibited an oil of the same subject at the
Royal Academy. In furnishing the text for these stories, the artist
took occasion to modify them and to insert cautionary lessons of
his own, including warnings against drink. Such liberties with the
traditional fairy-lore which he so loved moved Dickens to a good-
humored protest, entitled "Frauds on the Fairies," published in
Household Words, October 1853. Cruikshank's rather lame and
unconvincing defence of his action, "A Letter from Hop o' my
Thumb to Charles Dickens, Esq.," first appeared in *George Cruik-
shank's Magazine*, and was incorporated in subsequent addresses
to his public in both "Cinderella" and "Puss in Boots." Happily

the fanciful charm of the illustrations is in no way spoiled by the didactic bias of Cruikshank's textual commentary.

One of the artist's most scintillating imaginative performances was "Puck on Pegasus," the frontispiece of H. Cholmondeley Pennell's collection of verse of the same title (Cohn 633, 1861). This charming volume also contains cuts by Leech, "Phiz," and Tenniel, engraved by the Dalziel Brothers, Joseph and John Swain, and E. Evans. Three other works of fantasy call for particular mention, because Cruikshank's contributions to them are so extensively represented at Princeton. The first of these, *A Discovery concerning Ghosts, with a Rap at "Spirit Rappers"* (Cohn 209, 1863), pokes fun at the current craze for necromancy. In 1871 and 1874 Cruikshank decorated with woodcuts Juliana H. Ewing's *The Brownies and other Tales* (Cohn 277) and *Lob Lie-by-the-Fire, or the Luck of Lingborough* (Cohn 276). All three are worthy of more extensive comment than can here be accorded them, because there are in the Princeton University Library original drawings in differing versions for virtually all of the artist's woodcut illustrations.

In 1840-47 Cruikshank had shared with Leech the illustrations for the three series of the Rev. R. H. Barham's entertaining *The Ingoldsby Legends, by Thomas Ingoldsby, Esquire* (Cohn 50). Barham had been a friend of Cruikshank, as well as of Richard Bentley, in whose magazine a number of his writings first appeared; and a re-issue of *The Ingoldsby Legends* in 1870 (Cohn 52) became the occasion for knitting up an estrangement of many years standing between the illustrator and the publisher. For this volume Cruikshank designed a frontispiece ranked among his most accomplished etchings, and for which there are at Princeton a number of preliminary sketches as well as a full pen-and-ink drawing and the trial proof made from it. Princeton's copy of the latter from the collection of Crawford J. Pocock is accompanied by a letter to the owner, dated January 14, 1870, in which Cruikshank narrates the circumstances leading to his collaboration in the enterprise:

> The etching is entirely done by my own hand, indeed there is not anyone who could assist or "lend a hand" in this operation. . . . And the way in which I came to do the etching was this. You remember meeting the Rev. Mr. Barham, one day

in your town of Brighton—well, he and I are of course, old friends,—and one day I happened to tell him that I thought of publishing a print representing his father surrounded by a number of the characters he has described in his "legends" —the Rev. Mr. B. mentioned this to Bentley—who begged that I would make an etching for this subject for a new edition of the "legends" and to oblige him, but more particularly the Barham family, I consented to do an etching, and then made the drawing, which you now have in your possession.

The frontispiece bears the following engraved inscription: "Designed by George Cruikshank, to represent his highly esteemed and worthy friend, the late Thomas Ingoldsby surrounded by some of his Characters, Good, Bad, & Indifferent which he has so graphically portrayed in his celebrated Legends. 1870. Published by his school-fellow, Richard Bentley."

Such commissions as Cruikshank accepted in his last years were more often than not for works dealing with the supernatural. His last design is supposed to have been the frontispiece for *The Rose and the Lily: How They became the Emblems of England and France* (Cohn 80, 1877) by Mrs. Octavian Blewitt. The artist's inscription on the plate reads: "Designed and Etched by George Cruikshank, age 83, 1875." The subject is "The Demon of Evil," described as follows by the author, as it lurks in the lake: "Grand in his hideousness and patience, all day long he would lie, and never without fatality to some poor silly creature. He was as grand in his treachery as in his hideousness; gathering over his huge head a quantity of weeds, none but the Fairies could discover the evil glaring eyes hidden beneath." The eerie horror of this etching shows that the artist had lost none of the skill in evoking those "vividly terrible images" that had frightened Henry James when as a boy he first saw the illustrations to *Oliver Twist*.

VIII

Cruikshank's artistic achievement is virtually inexhaustible in its surprises; and in so superficial a survey as this much has had to be eliminated that did not fall into readily definable categories. The following brief sampling of other products of the illustrator's hand is intended simply to suggest some of the discoveries that await the investigator of Princeton's collection.

Cruikshank's break with Gillray's stylistic influence to form an independent manner of his own in political satire is apparent in a powerful drawing of 1820, entitled "Venus and Adonis, or Modern Mythology." This caricature, the print from which, if ever made, is unlisted, represents George IV and the Marchioness of Conyngham scantily clad in the garb of their classical counterparts. The caustic caption from Ovid reads:

"Thus Venus school'd her favorite boy
But *youthful heat,* all *caution* will destroy."

Two years later the third edition of Dr. R. J. Thornton's translation of *The Pastorals of Virgil* (Cohn 795) presented Cruikshank in unexpected company. This edition of Thornton's work is primarily prized for its twenty woodcuts by Blake; but Cruikshank made as the frontispiece to the second volume an engraving on wood of the "Assassination in the Senate House of Julius Caesar." A very daintily designed keepsake of 1829, *The Young Lady's Book. A Manual of Elegant Recreations, Exercises, and Pursuits* (Cohn 863) contains a single woodcut on "Archery," deemed by connoisseurs to be Cruikshank's finest accomplishment in this medium. The birth of a more humane spirit in the treatment of dumb animals is reflected in a harrowing plate showing a stable-yard filled with superannuated nags awaiting slaughter. Entitled "The Knacker's Yard or Horses' Last Home!," this appeared first in 1830 in Volume One of *The Voice of Humanity: For the Communication and Discussion of all Subjects relative to the Conduct of Man towards the Inferior Animal Creation* (Cohn 825), and in a second state in Egerton Smith's *The Elysium of Animals: A Dream* (Cohn 758, 1836), as well as elsewhere. In yet another vein Cruikshank produced ten remarkable plates for his friend, T. J. Pettigrew's *A History of Egyptian Mummies* (Cohn 644, 1834). At Princeton there is a preparatory drawing for the frontispiece of this work, "Graeco-Egyptian Mummy unrolled April 6th 1833," and a life-size profile drawing with red chalk and gold leaf of the head of the same mummy. For another friend with botanical interests, James Bateman, the illustrator made two wonderfully funny vignettes. Lovers of beautiful books may be astonished to come on these amidst the magnificent colored lithographs of Bateman's elephant folio. *The Orchidaceae of Mexico & Guatemala* (Cohn 61, 1837-43).

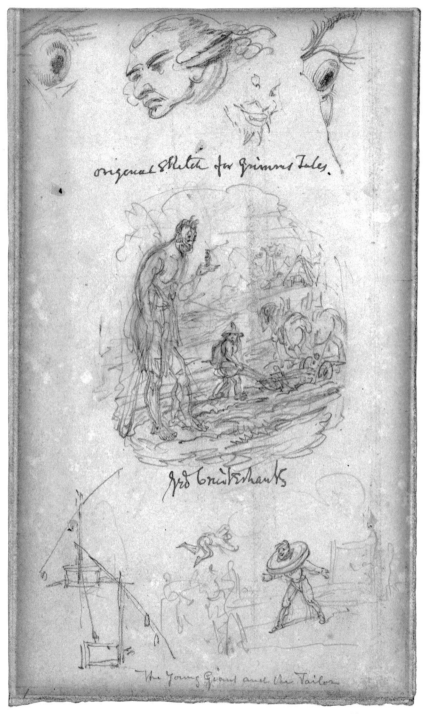

Figure 1. Pencil sketch for etching illustrating "The Young Giant
and the Tailor," from *German Popular Stories*,
Vol. II (1826). See p. 9.
Princeton University Library

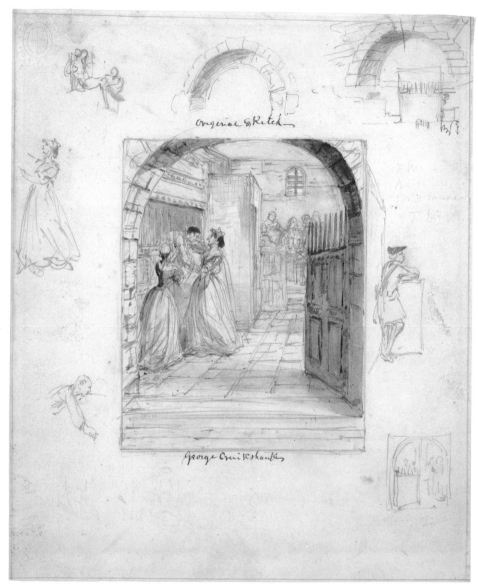

Figure 2. Pencil and wash drawing for etching illustrating
"Jack Sheppard escaping from condemned Hold in
Newgate," from W. H. Ainsworth's *Jack Sheppard: A
Romance*, Vol. II (1839). See p. 18.
Princeton University Library

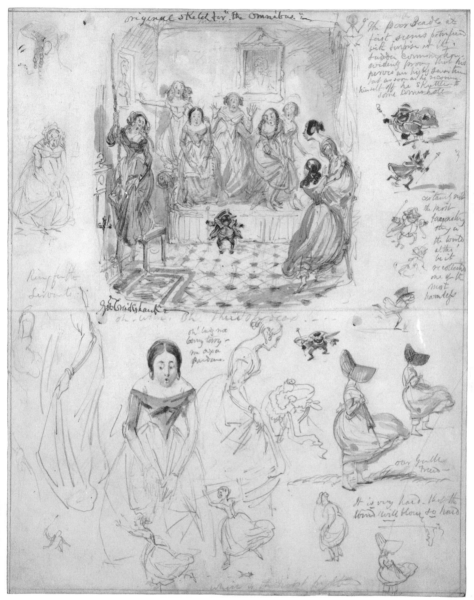

Figure 3. Pencil and watercolor sketch for etching "Oh! my good
gracious! here is a great 'Black Beadle' !!! !!!,"
George Cruikshank's Omnibus, No. IV. (August, 1841)
See p. 23.
Princeton University Library

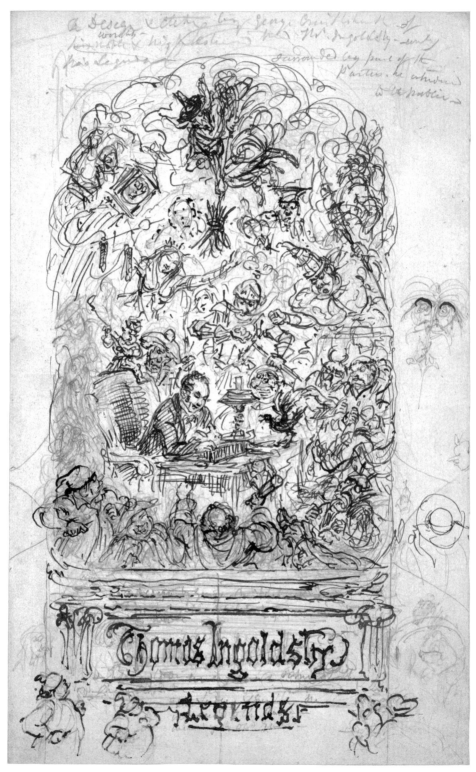

Figure 4. Pen and ink drawing for frontispiece to re-issue of
R. H. Barham's *The Ingoldsby Legends* (1870). See p. 30.
Princeton University Library

Among other drawings at Princeton is a very large sketch, double-folio in size, from which Cruikshank worked for his most famous genre painting in oil, "A Runaway Knock." A woodcut reproduction of this humorous subject appeared in *Illustrated London News* (1855) and two years later in *Illustrated London Almanack*. Finally, attention may be called to the artist's designs for Sir William Augustus Fraser's *Poems of the Knight of Morar* (Cohn 325), privately printed in two formats in 1867. Among the ancillary material at Princeton relating to this work are a water-color drawing with proof etching, dated September 27, 1870, for a frontispiece apparently never published, and three exquisite pencil sketches in different states of completion, along with two trial proofs (dated 1869) of "Some Spirits dancing round a Sundial." This delightfully fanciful composition was designed to accompany further unpublished verses, occurring at the end of one of Princeton's copies of *Poems by the Knight of Morar*. Bound in at the front of the same copy is a finely executed pencil sketch by Cruikshank for Fraser's ornamental bookplate.

The current exhibition at Princeton (1973) should help inaugurate the revaluation of Cruikshank's position as the greatest of English illustrators. And perhaps enough has been said here to suggest that the Princeton University Library offers resources for following up all of the manifold approaches which his astoundingly varied oeuvre invites from art historian and literary scholar alike.

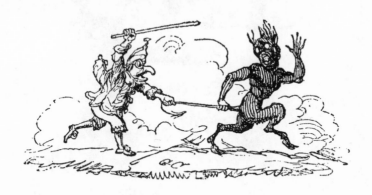

The Tradition of Comic Illustration from Hogarth to Cruikshank

BY RONALD PAULSON

I

S OPHISTICATED analysis of book illustration is a recent develop-
ment, with most attention going to a few special cases like
Blake's dynamic marriage of illustration and text in his printed
works.[1] Another special case, which is my starting point in this
essay, is the illustrations for Dickens' novels. Essays by Michael
Steig, Robert L. Patten, and others have shown that subtle textual
interpretations are contained therein and that the same sort of
analysis that is brought to bear on Dickens' text can be utilized on
the illustrations of Cruikshank and Phiz.[2] These essays acknowl-
edge the source of graphic "readability" to be William Hogarth
but do not go into the question of why he is, as they claim, the
"true father of English book illustration."[3] The question of this

[1] Even with Blake, the best analysis of the relationship of his illustrations to a
text other than his own is Irene Tayler's recent book, *Blake's Illustrations to the
Poems of Gray* (Princeton, 1971). The first indication of what novel uses illustration
might be put to was Ralph Cohen's demonstration that the various eighteenth-
century illustrations for Thomson's *Seasons* could serve as critical commentaries on
the poem (*The Art of Discrimination: Thomson's* The Seasons *and the Language of
Criticism* [Berkeley and Los Angeles, 1964], pp. 248-314). This was followed by
Jeffrey P. Eichholz's sensitive study of Kent's illustrations for Gay and Thomson
("William Kent's Career as Literary Illustrator," *Bulletin of the New York Public
Library*, 70 [1966], 620-46). Scholarly and bibliographical rather than critical, but
equally important, was the work of the late H. A. Hammelmann on Hayman, Van-
derbank, and other illustrators of the St. Martin's Lane group of artists, and of
Marcia R. Pointon on the changing conventions reflected in illustrations of Milton.
In particular, see Hammelmann, "Early English Book Illustrators," *TLS*, 20 June
1968, pp. 652-53; his essays on Hayman, etc., are in *The Book Collector*; for his
essays on Vanderbank, see below, n. 10. For Pointon: *Milton & English Art* (Man-
chester, 1970).

[2] Michael Steig, "Dickens, Hablôt Browne, and the Tradition of English Carica-
ture," *Criticism*, 11 (1969), 219-33; Robert L. Patten, review of the Clarendon
edition of *Oliver Twist*, in *Dickens Studies*, 3 (1967), 165, and "Boz, Phiz, and Pick-
wick in the Pound," *ELH*, 36 (1969), 575-91.

[3] Patten (in *ELH*, p. 590), quoting Frederick Antal's *Hogarth and His Place in
European Art* (London, 1962), p. 175.

tradition has become an issue in the light of two recent essays.

John Harvey's *Victorian Novelists and their Illustrators*[4] shows beyond any doubt the heavy weight of Hogarth on the Victorian illustrators and above all on Dickens himself. Harvey's central insight about the tradition is that it starts from Hogarth's large independent plates, the "modern moral subjects," rather than from his book illustrations, and continues through the satiric prints of Rowlandson, Gillray, and Cruikshank, who returned the independent satiric plate to its text in book illustration but with the addition of all the experience accumulated between Hogarth and Gillray.

The second major contribution to the problem of tradition is J. Hillis Miller's "The Fiction of Realism: *Sketches by Boz, Oliver Twist*, and Cruikshank's Illustrations,"[5] which goes straight to the heart of the matter and asks first about the author and then about the illustrator: what is the "reality" he imitates? To what extent does a given illustrator imitate a literary text (or an author's hidden intentions), the external world, a tradition of graphic representation, or the artist's own earlier work or private sensibility? Is the distortion that separates this representation from ordinary reality in the figure of Mr. Pickwick or Sarah Gamp the author's or the illustrator's own? Or is it determined by the tradition of representation (whose influence Gombrich has discussed at great length),[6] which would include by the time of Phiz's illustrations the work of Cruikshank too as well as Hogarth-Rowlandson-Gillray, and later (with Mrs. Gamp) also the work of Daumier?

Miller insists that these are not merely sources but in every case part of the meaning itself. A Phiz illustration is *about* all of those imitated objects from a Dickens-written scene to a particular kind of figure or sense of space propagated by the graphic tradition of Hogarth. The interdependence of meaning becomes the important issue; for reference moves as well from the text to the illustration as from the illustration to the text. In the case of Dickens at any rate, "Illustrations establish a relation between elements within the work which shortcircuits the apparent reference of the literary

4 (New York, 1971). For another perceptive essay along the same lines, see John Dixon Hunt, "Dickens and the Traditions of Graphic Satire," in *Encounters: Essays on Literature and the Visual Arts*, ed. Hunt (London, 1971), pp. 124-55.

5 In *Charles Dickens and George Cruikshank* (Los Angeles: William Andrews Clark Memorial Library, 1971), pp. 1-69.

6 E. H. Gombrich, *Art and Illusion* (London, 1960).

text to some real world outside."[7] Knowing that an illustration will accompany the text, the author allows his words themselves to bear a certain incompleteness.

Although Miller asked the crucial question for any future study of illustration, he did not attempt to characterize precisely the tradition of illustration which was one source of the imitation—either as to kinds of representation or as to the sort of text-illustration symbiosis he describes. Without knowledge of this tradition it is difficult to say just what part is played by the convention and what by the artist's own sensibility. For example, the spectator outside the central action of many Cruikshank illustrations, connected by Miller with Baudelaire's theory of comedy, is a figure with a long history in the traditions of both illustration and graphic satire.

The present essay will try to clarify the larger issues concerning comic illustration from Hogarth to Cruikshank by answering these questions: what do we mean by illustration, and what are the various possibilities of the relationship between illustration and text (and especially those that led to the situation Miller describes in Dickens)? What do we mean by comic illustration? And how is this different from the moral or satiric tradition of graphic art upon which Harvey places his emphasis?

II

First, let us examine the larger implications of illustration in eighteenth-century England. In Renaissance art as in book illustration the imitated was essentially a written text (assisted of course by objects in the external world, the art tradition of representation, and the artist's own sensibility). The artist's dropping of—or dispensing with, or dissociation from—the "text" is a major development of post-Renaissance art, a part of the larger transition from fidelity to the imitated text to fidelity to nature and ultimately self-expression. With the illustration-painting, as with book illustration, there were always the alternative possibilities of conveying information, merely providing repose or distraction from the labor of reading, developing some aspect of the meaning that was of significance to the artist or his patron, or showing how this particular painter would illustrate this particular text. But

[7] Miller, pp. 45-46.

37

a normative element from the world of imagination rather than the real world always remained: the written text.

Book illustration was one of the ways artists in the eighteenth century made their break from great subject, great style, and great patronage. A Poussin refers to, or imitates, a text of Ovid or Virgil (or a complex composite text), as well as those visual precursors who are themselves illustrators of one of these or some other related text. In the eighteenth century through the agency of book illustration an artist could introduce other, more immediate or contemporary texts; he could shift his attention from Homer, Virgil, or the Bible to Cervantes, Molière, or even Butler, and thence to his real interest, the contemporary scene. And with Cervantes and Butler the artist with satiric inclinations had a text that opened up the possibility of the mock-text, a way of juxtaposing the heroic, the romantic, the plainly fictional with the contemporary commonplace. Illustration is as clear a case as exists of literature influencing art, for as literature broadened and dealt with different and more contemporary subjects, and used new strategies of communication, the artist was drawn to develop, or found a sanction through illustration for developing, the same concerns graphically. Hogarth and his tradition are inconceivable without *Don Quixote, Pilgrim's Progress,* and the works of Defoe, Butler, Swift, and Gay.

Hogarth's own progress was from the actual text on the opposite page in the illustrated book to the large independent illustration for *Don Quixote* and *Hudibras* which assumes the text in the viewer's mind and reminds him via a few lines and references underneath. Then he moved on to the assumed general text, a criminal biography beside the life of a harlot, or beside the life of a rake both spiritual biographies and Hogarth's own progress of a harlot. He might include or imply other kinds of progresses and lives, sometimes using scenes from sources like the Bible or Homer, the paintings of Raphael or Rembrandt, which act as ironic commentaries. Perhaps recalling those imaginary texts projected by Cervantes behind *Don Quixote,* Hogarth supposed a non-existent history painting prior to his "reproductive engraving," where there was, in fact, only a small, colorful genre painting or oil sketch. Or rather, as a traditionalist (as expressed in his format of historical engravings), he implied a pseudo-text behind his illustration; but

38

as a revolutionary artist he may be thought of as discarding the text entirely.

Hogarth turned his engraved image into another form, the best model for which is not the illustration but the emblem. He adapted literally the structure of the emblem, in which the visual and verbal are closely related, the meaning (or reading) only emerging through an interplay of the title, the motto, and the visual image; often he added a prose commentary or verbalization of the meaning of all three. If there is a text prior to the emblem, it is known only to the artist, and the reader's duty is to reconstruct it by inference. In other words, the emblem is not merely illustrating a device (motto), a known adage, or an apothegm; it may use one or more of these topoi as its raw material, both visual and verbal, but it does so in order to produce a total image that is more than the sum of its parts, that is independent, problematical, and to be deciphered.

D. C. Allen has pointed out the relation of the *Emblemata* of Alciati to the *Tabula Cebetis*, "the prototype of that major Renaissance literary-artistic invention, the emblem."[8] Alciati's emblems appear just one generation after the first printing of the *Tabula*, with its simultaneous description and explanation of the visual symbols. In the emblem each viewer is the equivalent of Cebes, the versifier or commentator on the emblematic image, who educes the meaning from the metonymically or metaphorically-related objects in the picture, silently or not so silently supplying the words; in fact, often talking about them in pairs. This meditation is itself materialized for Hogarth's progresses in later printed commentaries like those of Rouquet, Lichtenberg, Steevens, and the Irelands—in each of which there is so close a cooperation between object and reader that the reality of the object is in the transaction rather than strictly speaking in itself.[9]

In short, what emerges as the Hogarthian "comic history" or "modern moral subject" is not an illustration that completes a text but an image that offers a visual substitute, with its own more or less materialized implied verbal text. The one interprets a text, the

[8] *Mysteriously Meant* (Baltimore, 1970), pp. 282-83.

[9] This effect is related to the modern concept of "feedback," for an "articulated reaction of a spectator to a work of art . . . modifies the work, i.e. by conditioning how it is perceived" (G. L. Hersey, "Associationism and Sensibility in Eighteenth-Century Architecture," *Eighteenth-Century Studies*, 4 [1970], 71-89).

other projects its own text. This is not to deny that there is, inevitably, something of a *prefigured* text as complicated in its way, only more fragmented, than the "Virgil" imitated by Poussin. The mock-heroic painting, for example, may presuppose scenes and figures in the *Aeneid* juxtaposed with known contemporaries like Thomas Shadwell and their known plays or poems. In *A Harlot's Progress* the ratio of contemporary reference (Mother Needham, Colonel Charteris, his rape trial of 1730, and other facts of that year) to the heroic past (allusion via composition to a Biblical prototype) is relatively high, which explains Hogarth's heavy reliance on various reading structures—objects of a high denotation, parallels and contrasts between these or between known and unknown figures—in order to make the third element, his own invented text about the life of a harlot in London. When the emphasis falls decidedly on the contemporary prefigurations, it is only a short way to the political satire of Gillray in which current events are seasoned with classical or Biblical myth. Among other differences from ordinary illustrations, the ingredients of the prefiguration— the myths along with the particular people like Pitt the Younger and Charles James Fox—are being satirized, and the projected text produced by the "reader" is Gillray's own satiric statement about them.

III

By the "comic" tradition of illustration, in the largest sense of the term, we do not mean "what makes you laugh," for much of the illustration of comic writing (for example, Cervantes and Molière) was not in itself comic; it merely represented the action described in a comic text. This sense of "comic" is a concern with the low or commonplace, the unheroic or untragic, and ushers in the main concerns of progressive painting in the eighteenth century. But what then is a comic illustration? Obviously it must be amusing either in itself, in its own terms, or in combination with the text.

The Hogarth small illustrations made for Samuel Butler's *Hudibras* (1726) will serve as an introductory example: they were simply copied from an earlier set (1710) but transformed by Hogarth into comic illustrations. The Hudibras of the 1710 edition is a deformed little old man going through the paces indicated by Butler in his verses; Hogarth, by his play with gesture and facial ex-

40

pression, his grotesque exaggeration and his wavering line, turns him into a creature who is funny-*looking*.

But a second person is necessary, for although comic illustration, throughout the century, will be largely indicated through grotesque exaggeration alone, something happens when a contrasting figure is added. In Hudibras' encounter with the lawyer, Hogarth changes the latter from a perfectly normal person (in the 1710 plates) into one as corrupt in a bored way as Hudibras. Two kinds of distortion are related. On the other hand, in "Hudibras wooing the widow" (Figure 7a) the second figure is normative or, perhaps better, a detached observer to Hudibras' deeply involved (passionate, hypocritical, foolish) action. Hudibras' gesture of wooing is expressively comic in itself; but to be understood it needs the patient widow to whom it is made.

One book above all others, *Don Quixote*, served as a vehicle for the development of comic illustration. The illustrator could, to begin with, introduce the contemporary English settings he really wished to represent and the humble events of everyday life; while dealing with a knight in appearance, he could portray a poor old fool in reality amid inns and sheep and windmills. What *Don Quixote* embodied was the essence of comic structure, the incongruous. It was constructed on a combined intellectual and formal incongruity, which was to structure much of eighteenth-century comic writing and art, setting both Hogarth and Fielding on their respective ways. This was an incongruity between the aspiration or illusion of a Don Quixote and the reality of his surroundings, between the image of a knight-errant and his heroic steed and the tall, bony, decrepit old shapes of both Quixote and Rosinante; and in formal terms between these lanky shapes and the short, earthy, well-fed shape of Sancho.

In the 1720s both Hogarth and John Vanderbank made illustrations for the Spanish-language edition of *Don Quixote* sponsored by Lord Carteret, an ambitious piece of book-printing that was trying to live up to parallel editions of Racine and Tasso and emphasize Cervantes' status as classic rather than comic author.[10]

[10] See Hammelmann, "Eighteenth-Century English Illustrators: John Vanderbank," *The Book Collector*, 17 (1968), 285-99; "John Vanderbank's 'Don Quixote,'" *Master Drawings*, 7 (1969), 3-15; and Paulson, *Hogarth: His Life, Art, and Times* (New Haven and London, 1971), I, 161-67, and *Hogarth's Graphic Works* (New Haven, 1965; revised edn., 1970), cat. nos. 146-51, Pls. 158-63. The Vanderbank

Vanderbank, whose obsession with the subject led him to continue painting scenes from *Don Quixote* for the rest of his life, used Cervantes as a way of delineating the congenial subjects denied him by the decorum of history painting. He substitutes an English for a Spanish milieu, but the only comic shape allowed is the figure of Sancho. Both he and Hogarth juxtapose Quixote and Sancho not as comic extremes but as ideal and real; Quixote wears a dignity quite at odds with the reality around him.

Hogarth's images are far more elevated than his small *Hudibras* plates, in which cheap printing and a popular audience allowed him a freer rein. "The Adventure of Mambrino's Helmet" (Figure 8) contrasts the heroic figures of Quixote and Rosinante (a surprisingly well-formed horse) and those of the shaggy donkey and cringing barber, and the effect is pathetic rather than comic. However, Hogarth also introduces a larger contrast between the encounter itself and, at a great distance, the round figure of Sancho on his roundish mule merely watching, quiet observers from another world. Hogarth has not only made the point nicely but suggested something of the difference in shape as well as distance and attitude. One possible element of a comic incongruity then would seem to be an audience or observer of some sort who is set off against the adventure in which the comic hero is caught up. As Miller has put it, referring to Cruikshank's illustrations, the realm of time and memory is contrasted with that of the immediate chaotic moment.[11]

Only in "The Curate and Barber disguising Themselves" (a scene which Vanderbank did not choose to illustrate) did Hogarth find a more congenial subject. The costuming of these unprepossessing figures, and the comedy of juxtaposed objects in the antlers above the inn door, the chamber pot on a shelf, the coat of arms, and the mirror in which the barber regards himself, broach one of Hogarth's own central themes. Decorum seems to have limited the extensive use of such detail to large independent plates like those by C.-A. Coypel imported from France (1724), and Hogarth made only one such independent illustration for *Quixote*,

illustrations first appeared in the 1738 Spanish-language edition and were used thereafter in the Jarvis translation (1742 et seq.). Hogarth's plates were issued only after his death (see *Hogarth's Graphic Works*, I, 176).

11 Miller, p. 61.

which follows the interest of the "Curate and Barber." However, as if unwilling to sully the Don's dignity, he chose a scene involving Sancho's delusion (Figure 9). Here a group of genuinely outlandish characters are participating in a scene of plainly unheroic action. The regally-placed Sancho, who cannot however hide his Sancho-ness, amid regal food and service, in what is clearly a palace, is nevertheless starving. The court physician stays his eager hand from lifting a single morsel to his mouth, the waiters withdraw the plates, and one courtier uses the tablecloth (which is supposed to hold food) to stifle an irreverent laugh. Sancho, who is himself playing a king, is in the midst, unknown to himself, of play-acting. As a witness to the whole charade, a fat woman laughs outright. If Hogarth had continued a set of illustrations on this scale, we can be sure he would have included "Don Quixote and the Puppet Show"; he alludes more than once to Coypel's illustration of the scene, taking from it the figure of the amused bystander to madness.[12] Such scenes carried the authority of Coypel's popular series, but the difference is instructive. Coypel's plates are expressive too, showing a wide variety of comic response, but within the conventions of French art, which means of a fairly rigid decorum. The figures are only as expressive, we might say, as comic actors on a stage; whereas Hogarth's figures exist in a purely graphic realm of the grotesquely comic.

The next stage of development can be seen in Francis Hayman's illustrations for the Smollett translation of 1755.[13] Taking Chapter 16, concerning the adventures in the inn, Hogarth had illustrated the scene of the wounded Quixote being covered with poultices by Maritornes and the innkeeper's wife while Sancho watches. The comedy, such as it is, rests in the almost unpleasantly deformed figures working on Quixote, and perhaps also in the juxtaposition to Sancho's quiet observation, which seems to be Hogarth's version of the Quixotic situation. Hayman, however, has taken the later scene in which Sancho finds Maritornes, who is fleeing from Quixote's deluded embraces, in his bed (Figure 10a). "There was the mule driver [Maritornes' jealous lover] pounding Sancho,

12 The figure of Sancho observing Quixote attacking the puppets from Coypel's "Don Quixote and the Puppet Show" was literally transplanted by Hogarth in *The Mystery of Mock Masonry* (1724) and later in *The Analysis of Beauty*, Pl. 2 (1753).
13 *The History and Adventures of the Renowned Don Quixote* (London, 1755).

Sancho and the wench flaying each other, and the landlord drubbing the girl; and they all laid on most vigorously, without allowing themselves a moment's rest."[14] Hayman has chosen to portray slapstick action, which allows for violent movement, exaggerated postures, and facial distortion that goes beyond a scene of stasis or more formal activity. But it is also noteworthy that he has chosen the moment just prior to the passage quoted: the innkeeper is not yet quite involved in the struggle but only an interested bystander, holding up his candle to observe the combatants. (His figure is complemented by the completely detached figure of the sleeping man on a nearby bed.) Hayman initiates the tradition of comic illustration that goes straight to Rowlandson, who in fact copied his illustration (Figure 10b). Rowlandson has merely simplified (by omitting the sleeper) and exaggerated the violence and put the bed covers over Maritornes in order to make explicit the fact that her place of concealment was in bed with Sancho. This is as much a part of his personal subject matter as the costuming was of Hogarth's.

Hayman as well as Hogarth avoids the central scene of the chapter, in which Quixote himself wrestles with Maritornes, thinking she is Dulcinea (to which the struggle with Sancho is only a postscript).[15] This scene involves a psychological comedy which Hayman is quite incapable of transmitting, but it is the one that Hogarth develops in his large *Hudibras* plates, where he has a less high-minded hero to deal with. *Hudibras* allows him to develop not only the formal contrasts that Cervantes set in motion but also the intellectual and moral ones, which grow into the allusive structures concerning the wit of mingled objects and milieu that lead to the "comic history paintings," and explore comic possibilities far beyond anything in the tradition of comic illustration per se. The play begins with the contrasting shapes of Hudibras and his squire Ralpho but goes off into the juxtaposition of different kinds of reality, different sources of imitation, different texts and interpretations of the text (or of individual words). The plates are all drawn and composed in a heroic style which is a graphic equivalent to the Quixotic situation and the

14 Samuel Putnam translation (New York, 1949), I, 120.

15 Vanderbank does illustrate this scene, but he only shows Quixote taking hold of Maritornes with the mule driver watching suspiciously. Nothing of the Don's confusion of Maritornes with Dulcinea is conveyed.

"Hudibrastic" style of Butler's poem. The exaggeratedly baroque and baroque-classical compositions act as reflections of Hudibras' heroic interpretation of what is in fact commonplace; if Hogarth had chosen to illustrate in the same way the scene in which Quixote embraces Maritornes while thinking she is Dulcinea, he would presumably have conveyed the psychological comedy by embodying the scene in the style of the Carracci. From the emblematic title page onward, he introduces us into a world of illusion and fantasy which is the context or medium of Hudibras' crazy actions. Far beyond the comic situation, this is an exploration of moral illusion and reality. In a way the whole world of the Civil War is an unheroic one seen here in both its gross reality and the illusions of heroism projected by the combatants and those who remembered and sentimentalized it. Hogarth's plates, like the poem they illustrated, were about a specific political situation whose repercussions were still felt in the England of the mid-1720s; and this is one reason the series was to be of particular importance to Gillray when he created his mock-histories, mythologies, and fantasies of the age of the younger Pitt.

These large independent plates also contribute the complex sense, which Hogarth of all his contemporaries grasped best, of a page of engraving versus a page of type and the intricate relationship of words and images, of verbal and visual structures. Each plate is his reconstitution of the poem itself in his own visual terms. In Pl. 2, "Hudibras sallying forth" (Figure 11), the overtones are of a heroic progress, with the knights dominating the picture space, haughtily posing in the middle of a balanced heroic composition (the house to the right was in fact added late to emphasize the balance); and these are contrasted with the grotesque shapes of the quixotic pair. The idea of an admiring crowd has been reduced to a pair of rustics and a dog who respond in their different ways to the heroic progress. Hogarth is literally illustrating only the lines (which he prints beneath his plate) "Then did Sir *Knight* abandon Dwelling, / And out he rode a Colonelling" (I.1.13-14) and the following lines which describe Hudibras and Ralpho, but he includes the general lines (I.1.1-2 and 9-12), which set the scene for the satire, and illustrates them too in his own characteristic way. "When *civil Dudgeon* first grew high, / And Men fell out they knew not why" (I.1.1-2) refers in Butler's poem to upheavals both physical and political, to the King and Parlia-

45

ment, the High Church Anglicans and Puritans, and so forth. But Hogarth transforms "high" into the size and position of the two figures, Hudibras and Ralpho, in relation to the rustic spectators, and "Men fell out they knew not why" is dramatized in the literally falling fruit baskets and the figurative falling out between the two rustics. The latter is a result of the farmer's awe of the heroes; he backs into his wife's table, spilling the produce, for which she blames *him*; and so indeed he will never "know why" they began their quarrel. In a domestic metaphor Hogarth projects a small tableau of the country, its produce, its simple tenants, and its civil war, caused in fact by the grandiloquent gestures of heroic fools.[16]

The next two lines—"When *Gospel-Trumpeter*, surrounded / With long-ear'd Rout, to Battel sounded"—refer of course to the Puritan soldiers (the "Roundheads") and their habit of cutting their hair short, and imply an accompanying bestiality: they are a pack of curs. Hogarth reduces the "Gospel Trumpeter" and the "long-ear'd rout" to a barking dog with extra-long ears, who is trying to "rout" or re-rout the two knights rather than herald or support their advance. "And Pulpit Drum Ecclesiastick, / Was beat with Fist, instead of a Stick" are Butler's own translation of the ecclesiastical podium of the Puritans into a military drum, on which the preacher beats a call to arms. This Hogarth translates into the rustic's liquor keg, suggesting that ecclesiastical words are the ranting of drunkards, the pulpit an intoxicating place, and so on.

The lines are reprinted to allow a comparison between verbal and visual texts, in effect to serve as part of an emblematic riddle to be solved by the reader. The viewer, with Butler's text in mind, goes from the lines quoted to the visualization, each stage producing an incongruity or metamorphosis which should amuse as Hogarth reveals his own interpretation of Butler's words. In linguistic terms, the text begins as *signifier* to Hogarth's illustration as *signified*, but Hogarth's transformation is so thorough that another text is projected forward which is read emblematically out of the constituents of Butler's text, Hogarth's quota-

16 For the insights in this and the next paragraph, I am indebted to a chapter by Laurel Brodsley, "Hogarth's Illustrations to *Hudibras*," in her unpublished doctoral dissertation (UCLA, 1970), pp. 92-102.

tion, title (motto), and image—which is now the signifier to a signified put together by the viewer.

The next stage of dissociation of illustration from text is Hogarth's *The Punishment inflicted on Lemuel Gulliver* (1726, Figure 6b). This is a purely imaginary projection from Swift's text; the scene portrayed appears nowhere in the book, and yet it is true to the spirit of the satire, in fact translating what Swift says by indirection and understatement into an emblematic image of Gulliver's subservient "liberty"-loving folly in a country run by Hanoverian and Walpolian pygmies in the year 1726. *The Punishment inflicted on Lemuel Gulliver* represents the sort of relationship between a text and a visual image that informs much of Gillray's work: he takes a well-known literary source and interprets it in terms of an immediate political situation.

IV

These examples represent Hogarth's greatest contribution to the art of comic illustration. Their experiments are reflected in the huge illustrations for the comedies in Boydell's Shakespeare Gallery but had little or no influence on book illustration per se. Books required a small, simple scene that was not so readable as to divert attention from its text.

The development of comic *book* illustration can be partly at least credited to the St. Martin's Lane group of artists, of whom Hogarth and Hubert Gravelot were the most influential members, who turned to "comic" art in my first sense of a lower, more ordinary and less "literary" or fancy subject and style. These artists used contemporary and non-Biblical or mythological subjects for their wall and stage decorations. Their chief source of income, however, was book illustration and other designs for engraving—and the tastes of booksellers and their middle-class clientele led them to experiment with relatively contemporary subjects.

Gravelot, arriving from France in 1732, brought with him a cultivated sense of the rococo style, which became a trademark of the St. Martin's Lane group and their academy. One form the rococo took for these artists was the fragmentation of an action. Reacting against the elaborate seventeenth-century histories and

illustrations which, like a *Tabula Cebetis,* presented all the events of a story or a chapter in pictorial space (one of Hogarth's own large *Hudibras* plates might be included), they insisted on a highlight, a fleeting moment, a mere detail picked out of a larger fabric. Diminutive size becomes quite literally part of the "comic," and development has to be not from the large but from the small *Hudibras* plates.

The second sense of comic also found nourishment in the rococo style, one aspect of which, accompanying the smaller size, was an emphasis on contrasted shapes, playfully distorted or stylized, expressed in S and C curves. At first embodied in representations of shells, scrolls, and cartouches, these shapes produced a large number of decorative designs that by the mid-1730s were shading off into small "capricci" of grotesque trees, landscapes, and architectural structures. Meissonier and La Joue in France published books of such grotesque designs in 1734 and 1736,[17] and while their main influence was on chapter-heads and -tails, in England their untrammeled grotesque found its way into book illustration.

Hogarth quickly absorbed these ideas and from the late 1730s onward explored the possibilities in contrasting shapes based on serpentine lines versus circles, squares, and other geometrical or "ungraceful" shapes. In his *Analysis of Beauty* (1753) he sums up the comic experience largely in terms of incongruous shapes given to incongruous representations: "When improper, or *incompatible* excesses meet, they always excite laughter the ideas of youth and age [are] jumbled together" to produce such an effect; in all instances, it is the "joining of opposite ideas," "the Inconsistency and mixture of incompatible matter that causes involuntary laughter."[18]

The rococo interest in formal exaggeration and play was fed by the academic tradition of *l'expression des passions.* In a way the door was opened for comic illustration by the French academic

[17] See Juste-Aurèle Meissonier, *Livre d'ornamens* (1734) and Jacques de la Joue, *Livre nouveaux de divers morceaux de fantaisie* (1736), reproduced in Hermann Bauer, *Rocaille: zur Herkunft und zum wesen eines ornament-motivs* (Berlin, 1962), Pls. 34, 48.

[18] *The Analysis of Beauty,* ed. Joseph Burke (Oxford, 1955), pp. 48-49, p. 180; the second from an unused page of Hogarth's manuscript. Although Alexander Gerard calls it "ridicule," he is defining the same effect in *An Essay on Taste* (London, 1759), pp. 66-73. His analysis of Butler's method is particularly relevant.

48

critics of the seventeenth century when they determined that the expression of the participants was more properly the subject of illustration than a mere imitation of the action. The manuals of expression by Le Brun and others doubtless contributed to the development of comic expression, and in the 1830s Hogarth's greatest popular reputation was for his skill at delineating facial expression. It was for this that the novelists invoked his aid in their comic scenes; and this still applied to Cruikshank, who, contemporaries claimed, was "the most perfect master of individual expression that ever handled a pencil or an etching-needle."[19] The more extreme examples in Le Brun's spectra of expressions, their extensions into animal heads, the recollection of the "gothic" figures of Bosch and "Rabelais," and perhaps the imported prints by Teniers and others of animal heads on human bodies, all set the stage for the next development, which was the introduction of caricature.

In the mid-1730s the caricatures of Pier-Leone Ghezzi, the latest fashion from Italy, were introduced to England in Arthur Pond's etchings, and whether one accepts "caricatura" or Hogarth's alternative "character," the result was a much greater concern with facial expression. Indeed Hogarth is "father" of the tradition less by virtue of his large elaborate plates, in which expression in face and gesture is complemented by the use of objects and elements of milieu, than by virtue of the small designs, beginning with the small *Hudibras,* and ending with the illustrations for *Tristram Shandy.*

The first of the *Tristram Shandy* illustrations (1760, Figure 7b) is *the* characteristic Hogarth comic illustration for the tradition, but it is also unique; it could only have been made by Hogarth and only for *Tristram Shandy.* To begin, Sterne is quite unillustratable; he writes in such a way as to preclude the possibility of illustration. He is himself constructing an emblem rather than an illustration, an emblem which must be puzzled out and filled in by his "judicious readers." There is, however, one point in his book where an illustration positively enforces his meaning, and that is where he summons up Hogarth's verbalized theory of the visual in *The Analysis of Beauty* to convey to his reader how Corporal Trim stands as he reads the "Sermon on Conscience."

The comedy of the plate probably begins with the fact that

[19] Blanchard Jerrold, *The Life of George Cruikshank* (London, 1882), I, 14.

it is an illustration by the person whose theory is being verbalized in the text—rather as if Fielding, after writing, "I would attempt to draw [Bridget Allworthy's] picture, but that is done already by a more able master, Mr. Hogarth himself" (in *Morning*), had then recruited Hogarth to draw Bridget. Hogarth's illustration becomes a commentary on his own writing as well as on Sterne's. Following his own visual forms which he had verbalized in the *Analysis*, and which Sterne has verbalized in his novel, Hogarth shows the comic grotesque swelling of Dr. Slop, who is all circles; the long S-curves of Trim, which are less a sign of beauty than of support (as Sterne notes, without them he would simply fall on his face); and, contrasted to these shapes, the geometrical forms of the map and the walls of the room, the "transverse zig-zaggery" of the trenches displayed on the map of fortifications (to which he added in a second state the straight lines and circular face of a clock) and the half-circle of the garland over the fireplace. The faces themselves, of Slop, Toby, Walter, and Trim, offer four different shapes of what Hogarth would have called "character." The drawing is, as it should be, a study in the relationship between different lines and shapes for a comic effect, which also involves the meaningful juxtaposition with a comic text.

Among other things, Hogarth's practice indicates that built into any illustration of a comic text is the slight incongruity which results from going from text to illustration, from verbal to visual version; from comparing your own visualizations with the surprise of the artist's.[20] Even plates as unfunny in themselves as many of the *Don Quixote* illustrations (or as the 1710 plates to Swift's *Tale of a Tub* or early illustrations to *Gulliver's Travels*) produce this simple form of comic incongruity. But beyond this, two general truths about the great comic illustrators of the eighteenth century become clear. One is that the illustration almost invariably followed the text in a subsequent edition, and so the effect was a visualization of a known verbal text.[21] Even the first (though not the second) of Hogarth's illustrations for *Tris-*

[20] This aspect of illustration is connected with what came to be called "novelty" or the pleasant surprise of discovery, versus the Beautiful and the Sublime (in Addison, Gerard, and later in Uvedale Price, who developed it into the Picturesque).

[21] Harrington explained this as the function of the illustrations in his translation of *Orlando Furioso*: "The use of the picture is evident, which is that (having read over the booke) you may reade it (as it were againe) in the very picture" ("An Advertisement to the Reader," 1591 edn.).

tram Shandy was after the fact, added to the second edition. Sterne and Hogarth were saying in effect: this is how this scene will look illustrated by the great Hogarth. Which brings us to the second point, which is that the tradition that flowered in the Dickens illustrations of Cruikshank was to some extent an emblematic rather than an illustrative one, made up of artists whose greatest work was in independent satiric plates. Part of the effect therefore involved the illustrator's prior reputation as a comic artist. A certain amount of the comic effect depends on the knowledge that this is Hogarth illustrating Sterne, Rowlandson illustrating Smollett, or Cruikshank illustrating Dickens—on the sense of one reality seen by two comic artists. The effect is related to the pleasure of hearing a story by Bernard Malamud read by Zero Mostel.

V

Rowlandson is the one comic illustrator of stature in the graphic tradition between Hogarth and Cruikshank.[22] The other great figure, Gillray, was not an illustrator of books. As Harvey has shown, his contribution was strictly through the general tradition of the comic in which Cruikshank was brought up before being subjected to collaboration with an author. We might, simplifying, say that the formal experiments of Hogarth were carried on by Rowlandson while the intellectual ones—the use of allusion, mock-heroic picture frames, animistic surroundings—were carried on by Gillray in his political cartoons. Rowlandson sometimes retained the intellectual tricks, but without much cognitive significance; usually more for their shape than for their refinement of meaning. Though he experimented in his early work with the caricature of Ghezzi and George Townshend, Rowlandson (unlike Gillray) developed his most characteristic figures out of the mode of "character" Hogarth established in the *Four Groups of Heads* and *Simon Lord Lovat*.[23]

[22] Blake was a great comic illustrator in a few instances, but he had no influence whatever on the Victorian illustrators. Outside anything we can call a comic tradition, and yet the only genuinely comic illustrations between Hogarth and Cruikshank—and more complex as illustrations than the work of either—are Blake's drawings for Gray's "Death of a Favourite Cat": if comic means leading to laughter and adding new dimensions or drawing out comic potentials from the source. See Tayler, pp. 55-70.

[23] See Paulson, *Rowlandson: A New Interpretation* (London and New York, 1972), pp. 15-18.

Rowlandson devoted only his left hand to the illustration of other people's texts, and he carries over into his illustration a quite independent comic element of his own, showing how *he* would illustrate a scene from, say, *Joseph Andrews* (1805). Take, for example, the scene in which Lady Booby has summoned Joseph to her bed and is trying to seduce him, with Slipslop a Peeping Tom in the doorway. Unlike his other illustrations for *Joseph Andrews*, this one comes to life, and the reason is that the situation is one Rowlandson has developed independently: a boy and girl having an assignation, with a third party pruriently observing them. The only trouble is that Fielding's text shows an older woman trying to seduce a youth, and Mrs. Slipslop is only eavesdropping. It would not be a Rowlandson scene if Slipslop were not using her eyes. In the hands of Hogarth (or perhaps Gillray) the Biblical parallels Fielding has implied between Joseph and Lady Booby and Joseph and Potiphar's Wife, or the mock-heroic similes surrounding Lady Booby's and Slipslop's passion, would have been conveyed by a picture on the wall or the style of the composition.

In general, Rowlandson simply copies the action the novelist describes, exaggerating where possible the figures and their gestures. When he goes beyond this he projects his own text, creating a kind of Rowlandson mythology concerning old husbands (or teachers or fathers or duennas), young wives (or nieces or charges), and virile young men, with someone watching them (sex enjoyed versus merely looked at or read about).

The Beauties of Sterne (1809) was a collection of the sentimental excerpts from *Tristram Shandy* and *Sentimental Journey*. The latter might have seemed a reasonable book for Rowlandson to illustrate, because it adhered to the basic situation of the sentimental observer confronted with a picturesque scene. In Rowlandson's prints and drawings everything from landscape to sex play is watched by an observer of the sort William Gilpin advocated in his studies of the Picturesque.[24] These observers, however, have usually been grotesque little Rowlandsonian people, as picturesque as the scene observed. Here the observer is Parson Yorick, whom Rowlandson presents as an idealized, attenuated version of Sterne himself, a frail-looking

[24] Ibid., pp. 71 ff., 80 ff.

sentimental figure who is not part of his ordinary repertoire. Some years later he was to develop into the comic figure of Dr. Syntax, but carried more directly into Cruikshank's repertoire he will become the model for the convention of figures like Oliver Twist in a world of Fagins and Bill Sikeses. The scenes, at any rate, call for a rearranging of the usual Rowlandson formula, moving the ideal figures into a position of more prominence than usual.

These designs have for us the further virtue of being invented by another comic artist, Richard Newton, and executed by Rowlandson; which means that Newton interpreted the action and Rowlandson interpreted Newton's sketch. Sterne's text is envisaged in a "comic" way by Newton, and then Newton's idea is transformed by Rowlandson into his own forms and myth.

The typical Newton device seems to be to represent the scene itself, as in "Yorick and the monk at Calais" (Figure 12a), and to add a pair of comic porters carrying a trunk in the background. Rowlandson's delineation then puts the sentimental figures of the monk and Yorick into a comic, and so real world, placing and distancing them. Sterne's scene is itself comic, but in a quite different way: the subtle Sternean undercutting of Yorick's sentiment is probably untranslatable. If Hogarth, on the other hand, had illustrated the scene in one of his large plates, he would have filled it with detail, perhaps including the comic porters, which contributes intellectually to the theme of charity or false charity. Newton-Rowlandson merely present two incongruous worlds, and their meaning has to do with the subsuming of the one—it is not very clear which—within the other.

"Yorick and the grisset" (Figure 12b) is another scene, difficult to convey visually, in which the comedy is psychological. Newton takes the scene at the stage where the grisset's husband has entered, which gives Rowlandson a peculiarly congenial situation to depict: Yorick is still the thin sentimental figure, the milliner is the usual sexy Rowlandson girl, and her husband is the grotesque Rowlandson husband who is always being cuckolded. In the drawing itself the contrast, I suppose, is comic between the grotesque husband and the handsome young couple. However, there is also introduced, with no authority in the text, a fat friar in the distance, out in the street with the traffic, observ-

53

ing this little scene. Once again the scene is made meaningful by the presence of a viewer like us who sets it off as something special from the world of flux in the street.

Rowlandson was, of course, another case of a famous artist who in middle age illustrated novels of half-a-century earlier, already classics in themselves, and the reader is amused to find him developing his own themes in a scene invented by Sterne. His only compromise with an uncongenial text is to restrain his exuberant distortions. But occasionally and perhaps fortuitously illustrator and author meet on the same ground. This happens when he illustrates Smollett. In his drawings for *Roderick Random* and *Humphry Clinker* (and the splendid *Comforts of Bath*, which though independent plates draw on *Clinker*) his own characteristic shapes, actions, and situations, correspond to those described by his author. (But it is of course possible that he learned his form and content from his own earlier reading of Smollett's novels.)

Rowlandson's illustrations for Smollett raise the question of whether the illustration is imitating what the author sees, what a contemporary familiar with the tradition of comic illustration would see, what Rowlandson himself sees, or what a character immersed in the action would see. In *Roderick Random*, a first-person narrative, the exaggeration, the Rowlandsonian-Smollettian grotesque, is due to Roderick's point of view: this is the way these people look to him, under the stress of fear, hatred, and revengefulness; and Rowlandson's illustrations (1805), where a thin, nondescript Roderick appears among swaggering, threatening grotesques, reflects the novel's own epistemology.[25] *Gulliver's Travels* was an earlier book that might have raised the issue: should the illustrator imitate its deadpan style or its horrible reality? should he show us the action the way Gulliver sees it or Swift? Hogarth's mock illustration for *Gulliver* avoided the issue by inventing a new fable which rephrased the deep structure of Swift's fable. Characteristically, he ignored the epistemological problem here and exploited it in his independent prints, where a style of representation as well as of furnishings and decoration represents *his* graphic equivalent of the pro-

25 In subsequent novels, however, where Smollett uses a third-person narrative, the exaggeration becomes again the way these people *are* in the visual vocabulary of a Rowlandson.

tagonist's way of looking at his world. But, with Hogarth at least, this is equally the general context of fashionable assumptions about art and morality in which the poor protagonist, seeking an identity, finds himself trapped; and so can be expressed in furnishings.

Harvey is getting at this distinction when he remarks that Gillray produces poetic metaphor, while "the lucid naturalism of Hogarth's manner frustrates metaphor. If Hogarth paints a wooden leg it must look exactly and only like a firm piece of timber," while Gillray's wooden leg, in *John Bull and his Dog Faithful*, chewed on by a dog, can resemble a bone.[26] One should, however, look at Hogarth's bed curtains turning into a screaming face or horns apparently sprouting from a husband's brows: he is as metaphorical as Gillray but within his naturalistic means. Hogarth's is a kind of higher reality inherent in an ordered universe. The lover sneaking out, sword under his arm, by an accident of perspective does what he has already done symbolically, stabbing the cuckold in the back; the room's wallpaper, if we try to separate figure from ground, proves to consist of antlers (*Harlot*, Pl. 2). In Gillray, Harvey observes, "The lively brevity of [the] notation makes metaphorical transformations easy." But it is the artist's imagination—his insight, as satiric artist, into the situation—that is bringing about the change. Hogarth's scenes have the stability, the solidity of reality; Gillray's are sketchy, unfocused, metamorphosing because the artist's mind is at work on the scene as an active participant.

This reference to the subject-object relationship, whether it involves a character (as with Roderick) or the artist, is perhaps a more meaningful way of describing the transaction in a Rowlandson and a Gillray scene than to enumerate and arrange the sources of imitation. For the larger fiction is the interaction of an artist and his material, a satirist and contemporary folly, or a well-known comic artist and an author's well-known book.

VI

Rowlandson went from illustration of the semi-independent type I have described to a series of collaborations in which the visual image preceded the verbal. He produced the images himself of typical Rowlandson situations, and William Combe

<hr>

26 Harvey, p. 28.

versified them. This was also the way Cruikshank began and, with some of his authors at least, continued, giving them visual ideas to verbalize. He was the last of a series of very special cases of artists who pursued a career of independent emblematic art parallel with one of illustration. Coupled with Cruikshank's compatible versatilities was the popularity in the 1830s of travel books or sporting scenes in which illustration may have priority over text, and in which both text and illustration contribute different perspectives.

Finally, with the advent of the serial publication of the *Pickwick Papers* and *Oliver Twist*, which launched the remarkable Dickens combination of text and illustration, the two became chronologically co-present for the first time. The illustration was usually not based on a written text but either on a few verbal or written hints or on some sort of common agreement between artist and author. The mixed-media effect of monthly serial publication involved the physical priority of the visual image. The reader ordinarily saw first the illustrations, sewn in at the front of the monthly part, and then read the text and related the two versions of the story. The earlier procedure of illustrating a subsequent edition, with "illustration" meaning representation of something in a known text, has now been replaced by a writer-artist collaboration for a visual-verbal effect with more the structure of emblem than illustration. *Punch* was founded in 1841, and the cartoon that was developed in its pages worked in a similar way: one looked at the picture, wondering what it meant, interested and puzzled; then read the caption, which was sometimes quite long; and then returned to the picture, which now meshed with the caption to make a joke.

Thus two independent views were brought together—Dickens and Cruikshank, Dickens and Seymour, Dickens and Phiz—and a kind of marriage was effected between an emblematic writing and an impressionistic, pointed, selective, moment in the illustration.[27] The writer could be as interpretative as he liked, in fact creative in the emblem-reader's sense; the illustration singled out one crucial moment, though the artist might employ in it emblems of his own. In this sort of collaboration the illustrator has access of his own to the emblem tradition and can introduce pigs and donkeys as emblems of sloth and stubbornness that

[27] On the emblematic nature of Dickens' writing, see Harvey, pp. 54-55.

56

do not appear in the text, as Dickens introduces emblems of his own that do not appear in the illustration.[28] One of the elements of the Dickensian comedy is the incongruity of the isolated, frozen moment of fleeting action and expression versus the duration suggested by the pictures on the walls, and even lower levels of transient action by the parallel cavorting of animals. And this is reflected in the style of the text set against that of the illustration, the rhetorical flourish of Dickens' prose style against the austerity, the "meanness," of Cruikshank's line.[29] For it is not, as Chesterton said, as if Fagin drew his own picture, but rather that Cruikshank develops one aspect of the Dickensian whole, which Dickens can fit into the larger formulation of his prose. Even if we include the memories of anti-semitic cartoons in his depiction, a minimalist Fagin appears in Cruikshank's drawings; Dickens' Fagin only begins its onion-like growth from this meager figure.

In *Sketches by Boz*, Miller has noticed, "London was for the young Dickens, in his disguise as Boz, . . . a set of signs, a text to interpret." This is precisely as if Dickens moved from a Hogarth print to the London around him and read it in the same way; both are images of a hidden text, and the writer's task is to interpret it. "What he sees at first are things, human artifacts, streets, buildings, vehicles, objects in a pawnbroker's shop, old clothes in Monmouth Street. These objects are signs, present evidence of something absent. Boz sets himself the task of inferring from these things the life that is lived among them."[30]

This is in general the role Dickens assumes in his early works. But it is also the way a character himself comes to terms with a place and situation. Fagin assumes the role in *Oliver Twist* and projects the stages of analysis the reader follows in "reading" a Hogarth print. His first impression entering a tavern is only of obscurity and confusion:

[28] Cf. Patten, *ELH*, p. 580.

[29] Cf. G. K. Chesterton, *Charles Dickens: A Critical Study* (New York, 1935), p. 112.

[30] Miller, p. 10. Moreover, the form this tends to take as a *point de départ* is the Hogarthian list: "the lists are often the starting point of an act of interpretation which moves beyond them to the hidden ways of life of which they are signs (p. 10). Apparently random lists, they must be "read" by Boz and their meaningful connections discovered. The whole procedure starts with "first the scene, with its inanimate objects, then the people of whose lives these objects are the signs, and finally the continuous narrative of their lives, which may be inferred from the traces of themselves they have left behind" (p. 12).

57

the place was so full of dense tobacco smoke, that at first it was scarcely possible to discern anything more. By degrees, however, as some of it cleared away through the open door, an assemblage of heads, as confused as the noises that greeted the ear, might be made out . . . (Chapter xxvii).

Then, "as the eye grew more accustomed to the scene, the spectator gradually became aware of the presence of a numerous company, male and female, crowded round a long table." The level of Fagin's perception has now reached "male and female"; the next stage is to make out one person from another, and finally to distinguish them in moral terms—by which time Fagin has been replaced by Dickens himself as our interpreter: "countenances, expressive of almost every vice in almost every grade, irresistibly attracted the attention, by their very repulsiveness. Cunning, ferocity, and drunkenness in all its stages, were there, in their strongest aspects."

Fagin's and/or Dickens' perceptual process recreates verbally the visualizing and then verbalizing that is followed by anyone moving about in one of Hogarth's large compositions, which deny the eye stable focusing points around which the rest of the composition can be organized, as opposed to the "good" gestalt with its simple, stable, compact structure. An example is the sixth plate of *A Rake's Progress*, which is almost a visual source for Fagin's account; but Hogarth habitually uses the effect first as an expression of a complex moral disarray, and second as a flickering forest in which the viewer's eye roams discerning an increasing intensity of moral significance without coming to a final rest.

This—the Hogarth way—has become the method of Dickens' written text, while the illustrations focus on one single aspect; the multiplicity of the experience and its meaning, which requires a gradual exploration in time, is interpreted in the text, and the instantaneous immediacy of the bare detail appears in the illustration. Dickens' text, like the commentary of a Rouquet or Lichtenberg, moves from objects to people to a gradual revelation of meaning.[31] A Cruikshank illustration is one detail of a Hogarth

[31] Dickens himself saw the tradition of English graphic humor to culminate in Leech, or at least return in him to the "realism" of Hogarth. This he regarded as a relief from the excess of "grotesque" distortion of the Rowlandson-Gillray tradition. He cannot accept their equation, carried through by Cruikshank and early Phiz, of "personal ugliness" with evil and beauty with good. See his "Leech's 'The Rising Generation,'" *Examiner*, 30 December 1848; see Steig, p. 220.

plate cut away, quite clearly a fragment with its edges circular and hazy, unframed. By contrast Hogarth's viewer saw the picture as itself taking place on a stage, a complete action; Cruikshank's picture is seen as if by a participant who can take in only one thing at a time.

Compression, intensity, and pointed facial-bodily expression are the chief characteristics of Cruikshank's small plates. "Fagin in the condemned Cell" is plainly by a contemporary of Goya rather than of Gillray or Hogarth. Book illustration with its small format was a boon to Cruikshank; with a few exceptions the large rectangular plate was not the most congenial form for him. His tendency was to divide it up into small units of single isolated figures in intense focus, and the over-all effect is diffuse. His proper form is the small vertical rectangle or square with the image growing increasingly clear, dark, and concentrated as the center is approached.

Though the power of "Fagin in the condemned Cell" is exceptional, its intensity is shared by the illustrations that are comic in the sense of laughable. Their comedy relies on the co-presence of dissimilar realities in the text and the illustration, on an intense graphic realization of a figure with a verbal life of his own in the text, and, to a lesser degree, on the simple participation in the tradition of comic illustration. For the conventions of detached observers, pictures on the walls, dog or cat-human parallels were by the time of Cruikshank and Phiz so much a part of the tradition,[32] that for most readers they probably served less their moral or intellectual function of parallelism than to create sheer comic incongruity. Mr. Pickwick and the pigs, Mr. Pickwick and emblems of slothfulness, were doubtless regarded as equally amusing for their own sake, and among Dickens' more learned readers amusing for the added incongruity of moral iconography jostling the world of comic book illustration and nineteenth-century farmyards.

Dickens, like Hogarth, was consciously deserting the texts of contemporary novelists and their conventions, turning back to

[32] See, for example, G. M. Woodward's illustration in *Eccentric Excursions* (London, 1796, facing p. 81) showing justices in an ale house with prints of *Daniel in the Lions' Den* and *The Judgement of Solomon* on the walls. Here, as in Rowlandson, the pictures are only used when occasion demands to make something clear, and are primarily engaging in the comedy of contrasting shapes.

the streets of London, its popular theater, and its popular prints (with a long look back at Hogarth). His particular sort of amalgam of literary and graphic conventions with contemporary sign systems occurs when a writer or artist consciously reacts against old texts and *topoi*. Dickens himself represents the verbal equivalent of the beginning of the comic tradition in Hogarth's *Hudibras* and *A Harlot's Progress*, while Cruikshank represents the end of it, the artist returning from emblem to illustration and putting himself back in the hands of his author.

Cruikshank and Dickens:

A Reassessment of the Role of the Artist and the Author

BY RICHARD A. VOGLER

S EVERAL years ago, before the publication of either the first volume of the Pilgrim Edition of *The Letters of Charles Dickens* or the Clarendon Edition of *Oliver Twist*, I became interested in investigating the claims of George Cruikshank in respect to his role in the conception and execution of the second series of *Sketches by Boz* (Cohn 233, 1836) and of *Oliver Twist* (Cohn 69, 1837-39). I felt, however, that I should wait for the possible contributions to the subject by these two crucial volumes before presenting my views. My original intention was to investigate the Cruikshank-Dickens controversy (long ago settled to the satisfaction of Dickens scholars) with the aim of determining if there might be some fire where there had been so much smoke. Cruikshank's claims, supposedly made during his old age, have usually been regarded as the exaggerations of a senile man subject to delusions about many things. I soon found myself so deeply engaged in a struggle to penetrate the shadow which clouded the reputation of England's foremost illustrator of the nineteenth century that at one time I contemplated titling this paper "The Quest for Cruikshank." Certainly the topic is a complex one, and it has led to many problems that I never anticipated and to discoveries of controversial material I do not relish dealing with in print. For I have discovered that any attempt to justify Cruikshank's admittedly contradictory and exaggerated but, in my opinion, frequently valid claims—most of which have either been scorned or ignored by Dickens scholars—runs the danger of being dismissed (as one friend has suggested) as akin to the Baconian heresy. My involvement in the subject has inevitably led to some defensiveness so that perhaps the right title for this brief survey should be "Cruikshank and Dickens: Portrait of a Scholarly Obsession." Because of the nature of the argument, I feel I have no choice but to write in the first person and thus present myself, as a devil's advocate if you will, for a man who has had many vilifiers and few defenders.

In presenting the "evidence" in the case of George Cruikshank versus his detractors I shall aim to be nonpartisan but, at the same time, I shall make clear that the defenders of Charles Dickens have frequently ignored, or have been ignorant of, important evidence, on the one hand, and, on the other, have misinterpreted the evidence to which they direct attention. I cannot possibly discuss all the visual and verbal documents, published and unpublished, most of which I have located and examined. But I will say here that in all this material I have very seldom found Cruikshank making statements that can be proven false. Indeed, for someone supposed to have delusions, his statements are remarkably lucid and generally consistent with known facts. The evidence adduced for the charges against Cruikshank are his published and unpublished statements and Dickens' letters to him. Beyond that there is nothing else, or at least nothing except hearsay, and if we abide by Anglo-American justice, which says a man is not guilty until proven so, Cruikshank must be found innocent of charges of willful mendacity. To pretend that what I am about to deal with is not controversial would avoid issues that must be dealt with in order to reach a fair evaluation of the facts. But I would remind my readers that, so far as the Dickens-Cruikshank "controversy" is concerned, this is the first time in this century that they have been asked to focus their attention on claims for the artist and not on claims for the novelist. "It must be remembered," Samuel Butler said in his famous apology for the devil, "that we have only heard one side of the case. God has written all the books."[1] In the case of Cruikshank and Dickens, with few exceptions only those interested in Dickens have written the books and thus only his side of the story, mainly through John Forster, has been heard. It would seem time to give the devil his day in court.

George Cruikshank's claims about his assistance to authors must be understood as statements about an artist's view of his relations with those whose works he illustrated. As illustrator he was in the habit of making suggestions to authors, and he frequently saw the effects of his suggestions in their works. This kind of collaborative effort was quite customary at the time, a good example being that of Thomas Rowlandson and William Combe, illustrator and author of the Dr. Syntax books for which, in the

[1] Geoffrey Keynes, ed., *Samuel Butler's Notebooks* (New York, 1951), p. 154.

majority of illustrations, Rowlandson drew his designs before the text was written.[2] Cruikshank himself grew up in an atmosphere of family collaboration and of familiarity with the tradition of the collaborative caricature. He assisted his father and brother in their works, and often, as in the case of Pierce Egan's *Life in London* (Cohn 262, 1821), one is not able to distinguish his work from that of his brother Isaac Robert. Throughout his career of producing caricatures and broadsides for London printsellers, a career which virtually ended after 1826, George Cruikshank frequently etched the designs of others and always gave his collaborators credit for their contributions. The amateur who had the idea for the caricature takes equal credit with the artist who did the etching, although it was in most cases the etcher whose skill determined the success or failure of the caricature, as evidenced by the fact that they are today offered for sale as caricatures "by Gillray," "by Rowlandson," or "by Cruikshank," while the man who had the "idea" is not even mentioned. Literary scholars are generally unaware of the collaborative nature of such work and therefore fail to understand how natural it was for Cruikshank to claim a role in the work of an author whose book he illustrated. A sympathetic understanding of his early artistic training and methods of work in caricature can help us understand Cruikshank's reactions when such claims were scorned and ridiculed in his later years. What most Dickens biographers and critics forget and must be reminded of repeatedly is that Cruikshank did not start a controversy on this subject but merely defended statements published by Robert Shelton Mackenzie four years before Dickens died when, after Dickens' death, these statements were attacked by John Forster. Cruikshank has been charged with having waited till after Dickens died to announce his claims, but the devil's advocate would, in turn, ask why Forster or Dickens did not attack these claims in 1865 when Mackenzie published them. It would seem unlikely that Dickens would not have heard about MacKenzie's controversial statements made in an American journal before the novelist's second visit to the United States. In any event, the burden of proof rests not with Cruikshank but with the challenger John Forster. The controversy would never have become a public matter had Forster

2 Robert Wark, *Rowlandson's Drawings for "The English Dance of Death"* (San Marino, Calif., 1966), p. 6.

not made it public by calling Mackenzie's story an "incredible and monstrous absurdity" and by implying that Mackenzie and Cruikshank were liars.

As Cruikshank's advocate I would begin by quoting what Professor Kathleen Tillotson, the editor of the Clarendon *Oliver Twist*, has said about the controversy, and I would then suggest some ways in which her statements ought to be modified:

> Cruikshank's illustrations, especially those concerned with low life, seem inseparably connected with the text; they are the most vivid of all illustrations to Dickens, and it can be believed that author and artist stimulated each other. But what has been said of their relationship during the progress of the novel sufficiently shows that there are no grounds for Cruikshank's preposterous claim to have been the originator of the story of *Oliver Twist*. This was first brought forward in an article in an American periodical,* by Dr. Robert Shelton MacKenzie, quoted in J. C. Hotten's *Charles Dickens: the story of his life* [1870], and repeated with additions in MacKenzie's *Life of Charles Dickens* (1870); it was emphatically denied by Forster in the first volume of his *Life* (1871); defended by MacKenzie in the *Philadelphia Press* (19 December 1871) and independently by Cruikshank in a letter to *The Times* (30 December 1871);* denied again by Forster in his second volume (1872); and defended by Cruikshank in his pamphlet *The Artist and the Author* (1872). He adds no further evidence, but claims to have told MacKenzie that he was the originator "at the time *Oliver Twist* was in progress," whereas MacKenzie in his *Life* had given the date of the conversation as 1847.* It must have been earlier than 1852, when MacKenzie left England for good, and is therefore not simply a delusion of Cruikshank's old age. But it is none the less a delusion, possibly based on the recollection of some casual suggestion to Dickens, such as the use of Field Lane, and stimulated by the slightly excessive and not unbiased praise of Thackeray, who had written of the 'wonderful assistance' given to Dickens by the artist,

>> who has given us the portraits of his ideal personages, and made them familiar to all the world. Once seen,

these figures remain impressed on the memory, which otherwise would have had no hold upon them . . . *

No contemporary other than MacKenzie appears to have credited Cruikshank's claims, which were weakened by his further claims to have 'originated' several of Ainsworth's novels.[3]

The asterisks stand for four footnotes, two of which require correction. The first states: "Not the American *Round Table,* as stated by Hotten and others after him." A check of *The Round Table,* however, reveals that Mackenzie's statement *was* published in the "Philadelphia column" signed "R.S.M." on 11 November 1865; the only "addition" to this original statement is the date 1847, which appears in Mackenzie's *Life of Charles Dickens* for the first time, a crucial addition because it establishes when Mackenzie first heard Cruikshank's story. The second asterisk refers us to a note on the date 1871: "Cruikshank and MacKenzie were again in touch at this time; see two letters in the Arents Collection, New York Public Library." To my knowledge the Arents Collection owns only one letter, dated 4 January 1872, from R. S. Mackenzie to George Cruikshank, a letter explaining what Mackenzie had done after Forster's attack came to his attention.

Since letters are of great importance in such a controversy (particularly for the neglected Cruikshank side), I would direct attention to two letters dated 15 October and 1 November 1847 from Cruikshank to Mackenzie, now deposited in the Historical Society of Pennsylvania, and unnoted in the Clarendon comment, which deal with Mackenzie's article on Cruikshank in the *London Journal,* the subject of the third asterisk in the above quotation. But even more interesting than these minor letters, showing the friendly but business-like relationship that existed between the two men in 1847, is a third letter, also in the Historical Society of Pennsylvania, from Cruikshank to Mackenzie, dated 22 January 1872, and answering the letter of 4 January from Mackenzie owned by the Arents Collection. This crucially significant unpublished letter, not included in the notes

[3] Charles Dickens, *Oliver Twist,* ed. Kathleen Tillotson (Clarendon Edn., Oxford, 1966), pp. 394-95. Subsequent references from this text will be identified as *OT,* followed by the page number.

of the Clarendon *Oliver Twist*, will be quoted in its entirety and discussed in detail later in this paper.

The Free Library of Philadelphia owns two letters which also pertain to this dispute. The first of these is the original of the letter that was modified by Mackenzie for his published statement in the Philadelphia *Press* which was cited in the Clarendon *Oliver Twist* but without mention of this original. This letter, dated 11 November 1870, and written by Cruikshank to W. J. McClellan, contains Cruikshank's most exaggerated claim in print and will be quoted and dealt with below. The second letter, unnoted by the Clarendon editor, is dated 3 January 1872 and was written by Cruikshank to J. B. Deane, a minister, who was one of the people who remembered from 1836 the interest of Cruikshank and T. J. Pettigrew in orphan children. In this letter Cruikshank thanks Deane for upholding his contention that he and Pettigrew called Dickens' attention to the plight of orphan children in the Parish of St. James. Additional extant letters of some relevance could be cited (and, no doubt others will in time come to light), but the devil's advocate will be content to offer the observation that if the kettle chooses to cite letters in support of its blacking, then the pot can do the same.

The Clarendon editor's summary of the relationship between Dickens and Cruikshank during the progress of the novel has been based entirely on extant letters written by Dickens to the artist. Other than showing that Cruikshank did see portions of the text of the novel, these letters do not make it so clear as the editor assumes that Dickens was dominant and Cruikshank subordinate in their relationship. The only drawing known to have been submitted to the novelist for his approval was the substitute for the "Fireside Plate," and it was Dickens' request to replace the original illustration (a request which may have stemmed from the annoying resemblance of Harry Maylie to the artist himself) which so offended Cruikshank. Cruikshank, probably in his old age, rubbed out Dickens' comment on this substitute drawing although his signature of approval was left untouched.[4] It is, of course, important to make the point that we

4 This drawing, now in the possession of The Henry W. and Albert A. Berg Collection, The New York Public Library, is reproduced by William Glyde Wilkins in "Variations in the Cruikshank Plates to Oliver Twist," published in *The Dickensian*, 15 (1919), 73.

have only the documents that Cruikshank happened to preserve and—even more important—that we have only one side of the Dickens-Cruikshank correspondence. For some hint of what must have happened to Cruikshank's notes to Dickens, of which there must have been some despite the artist's preference for settling matters concerning his illustrations by conference with authors, the devil's advocate would like to offer in evidence the words of K. J. Fielding:

Forster's greatest sin was in destroying all the original papers on which his work was founded. The biography was largely composed of letters, and 'to save him time and trouble', Mrs. Forster told Percy Fitzgerald, 'he would cut out the passages he wanted with a pair of scissors and paste them on his MS.'. It is impossible to verify this story since Forster kept none of his own manuscripts once the work was published. But even if he did mutilate most of the letters he used it made no difference, since he made sure that no one after him should be able to consult any but a few of the least important. He burnt some himself, marked others for destruction, and left instructions that it was his 'express wish that all letters coming under the denomination of private correspondence shall at once be destroyed'. The Rev. Whitwell Elwin, the editor of the *Quarterly*, who acted as his executor, held the same views as Forster about private papers, and spent several months conscientiously examining masses of correspondence and putting them aside to be burnt. Not only hundreds of Dickens's letters, but correspondence from nearly all the famous authors of the day ended thus on a bonfire at Booton Rectory.

It is no justification of Forster to say that the value set on original papers in his day was greatly different from ours: as a practised biographer, historian, and devoted collector of books and manuscripts, he was well aware of the harm he was doing. The only excuse for him is that he was probably carrying out Dickens's own instructions, since he too had burnt all the correspondence he had ever received—as far as he knew—and held strong views about an author's right to keep his private life to himself. Yet there was no need to have destroyed so much; although the manuscripts of the

67

novels were left unharmed, important original papers such as the autobiographical fragments of Dickens's childhood and his initial outline of *The Chimes* were wantonly destroyed. In spite of Forster's generosity in leaving his library and collection of pictures and manuscripts to the Department of Science and Art, he deprived posterity of even more than he bequeathed.[5]

In view of what is known about John Forster's career as a master document shredder, I find it hard to believe that Forster had access only to a draft of a letter dealing with the last six illustrations for *Oliver Twist* (which of course offer no evidence about who originated what in the novel) and to nothing else. Indeed, I would suggest further that perhaps the reliability and accuracy of John Forster as an historian and biographer needs some thorough investigation.

George Cruikshank always preferred personal conferences with the author of a book he was illustrating, and he did not like to select a subject for illustration from the reading of a completed text. Dickens disliked working this way, and he makes clear to Cruikshank at the outset of their work on *Bentley's Miscellany* in a letter of 9 January 1837 that he intended to write his text before he turned it over to Cruikshank for illustrating.[6] However, the pressures of his work as editor and author did not always allow him to do this, and he must frequently have settled upon the illustrations by conference before he wrote his monthly installment; in some cases he may, therefore, have been influenced by what happened during consultations with Cruikshank. As I have suggested elsewhere, how else can we explain the fact that Dickens' description of Sikes fits so exactly Cruikshank's long-standing representation of the street thug as found in many of his published prototypes unless we assume that Dickens saw Cruikshank's designs or adapted the artist's notion of this character.[7] The whole matter of previously published pictorial prototypes for the criminal characters in *Oliver Twist* offers strong collateral

[5] K. J. Fielding, *Charles Dickens* (London, 1953, rev. edn., 1960), pp. 8-9.
[6] *The Letters of Charles Dickens*, ed. Madeline House and Graham Storey (Pilgrim Edn., Oxford, 1965), I, 221. Hereafter cited as Pilgrim followed by volume and page.
[7] See Richard A. Vogler, "*Oliver Twist*: Cruikshank's Pictorial Prototypes," in *Dickens Studies Annual*, II, ed. Robert B. Partlow, Jr. (Carbondale and Edwardsville, 1972), 98-118.

evidence that discussions about characters or events must have taken place during consultations if not through prearranged outright collaboration.

Here I find it best to produce some new evidence to dispel the commonly held notion that Cruikshank's "delusion" about his role in the novels he illustrated for Dickens and Ainsworth dated from his latter years. The devil's advocate can offer in evidence a document in his possession which shows that Cruikshank traditionally looked upon his role as collaborative. This undated document (Figure 13) consists of a rough draft of a letter written to the agent acting for Richard Bentley, publisher of *Bentley's Miscellany*, during the time Cruikshank began to quarrel with Bentley.

> Sir
>
> I cannot help expressing my surprise at the contents of your letter and shall be obliged if you will explain what it is that Mr. Bentley requires of me—the words of the agreement are plain enough and Mr. Bentley for nearly five years has acted up [to] it in the only way I apprehend it can be understood namely—that he has always furnished me with the subject for the design (through the Editor[s?],—and I beg to add that in no one instance has this practice been departed from since the comm[enceme]nt of the work—so far from my having to read for a subject the plates have been almost in every instance etched before the author had written a line—

May I remind the reader that during the *Miscellany*'s five-year existence (January 1837 to 1841) there were two editors: Charles Dickens from January 1837 to February 1839 and William Harrison Ainsworth from that time through 1841. By 1841 Cruikshank had illustrated for the *Miscellany* numerous short works as well as *Oliver Twist* (February 1837 to April 1839), *Jack Sheppard* (beginning January 1839), and *Guy Fawkes* (beginning January 1840).

Clearly this draft shows Cruikshank is irate because he is expected to read text and select a subject for illustration when such a practice had not been customary since the commencement of his association with *Bentley's Miscellany*. The letter was written not in connection with any conflict involving authors but in opposition to a change in what had been a working relationship

among the author-editor, the publisher, and the artist. The letter is unsigned and obviously a rough draft, but the handwriting bears definitive resemblances to known examples of Cruikshank's writing from this period, the date being established by the watermark "J Whatman 1841" clearly visible when held up to the light. This document is of special interest for its revelation of how Cruikshank in 1841 looked upon his role as an illustrator for *Bentley's Miscellany*. Written approximately two years after the conclusion of *Oliver Twist*, the letter even in its fragmentary state supports Cruikshank's claim that throughout the course of that novel he had been supplied with the subject, presumably through consultation (not through seeing the text), of the illustration he was to draw, for he states emphatically that "in no one instance has this practice been departed from." From other correspondence we know that in some instances Cruikshank *was* supplied with the manuscript, but he did not make a practice of reading for a subject any more than Dickens, as we shall see later, necessarily made a practice "of writing up" to a Cruikshank drawing when he was furnished with one before he had written his text. Obviously interpretations of such matters depend on the predisposition one brings to one's analysis; up to now only those with a predisposition in favor of Dickens have written on the subject, and often this one-sided approach has resulted in the most bizarre interpretations. Apparently Cruikshank so disliked settling illustrations by letters that Dickens when writing Cruikshank would refer to this dislike in a kind of private joke: "excuse me for troubling you with a note which I know you abhor," an apology which has led one commentator to assume that Dickens and Cruikshank "rarely corresponded, however, for Cruikshank barely tolerated even short notes."[8] Anyone who knows of the hundreds of letters to and from George Cruikshank in public and private collections in the United States and England will recognize the absurdity of such a conclusion. Misleading judgments of this kind become compounded when uncritically repeated by others.

[8] For the commentary see Jane R. Cohen, "'All-of-a-Twist': the Relationship of George Cruikshank and Charles Dickens," *Harvard Library Bulletin*, 17 (April, July 1969), 323. Hereafter cited as Cohen followed by the page. The author cites two letters from Dickens to Cruikshank dated [?20 April 1837] (Pilgrim, I, 249) and [?17 September 1838] (Pilgrim, I, 434); the quotation cited is from the earlier of these letters.

Most commentators on the extant letters of Dickens to Cruik-shank have been Dickens biographers or scholars using them for support or elucidation of this or that view of Dickens. None has been interpreted by anyone primarily, or even equally, in-terested in Cruikshank. For example, in the last few years a note from Dickens to Cruikshank dated "mid-January 1838" by the Pilgrim editors has been referred to by two Dickens com-mentators as a "detailed précis" for the illustration titled "Mr. Bumble and Mrs. Corney taking tea."[9] The note reads:

> My Dear Cruikshank
> I have described a *small* kettle for one on the fire—a *small* black teapot on the table with a little tray & so forth—and a two ounce tin tea cannister. Also a shawl hanging up—and the cat & kittens before the fire. (Pilgrim, I, 353)

What these commentators fail to mention is that where the shawl is described in Dickens' note as "hanging up" and *is so shown in Cruikshank's etching*, it is not so described in the text of the novel which states only that the matron left the room "muffling herself in a thick shawl which she hastily caught up" (*OT*, p. 151). If the location of the shawl is not the same in the text as in the illustration, this may well be because the text was written after the illustration had been drawn and because Dickens' account in the note of having described the details in the illustration was faulty at one point. Contrariwise, had the artist based his illustra-tion upon Dickens' note alone, he would have had to be clairvoy-ant to have included in it such important details described in the text as the wine bottles, the chairs, the stick, and the hat. There must have been some additional communication between author and artist or the artist would not have included numerous details not mentioned in the note but found in the final text and in the etching. In any event the claim that the note is a "detailed précis" of the illustration is untenable. Since this note is the most detailed reference by Dickens to points in a scene illustrated by Cruikshank, it is evident that the devil's advocate could present very different interpretations of many of the Dickens documents

[9] Cohen, p. 179; *Charles Dickens: An Exhibition to Commemorate the Cen-tenary of His Death; June-September, 1970* (London: Victoria and Albert Museum, 1970), p. 23.

71

that Cruikshank happened to preserve; Cruikshank's half of the correspondence, as all Dickens scholars know, lies in the Gadshill ash heap. No one aside from Frederic G. Kitton in his monumental study, *Dickens and His Illustrators*, has ever called attention to Cruikshank's note to Dickens on the verso of a preliminary drawing for "Oliver amazed at the Dodger's mode of 'going to work'." The note reads:

> Thursday Eg., June 15, '37
>
> MY DEAR SIR,—Can you let me have a subject for the second Plate? The first is in progress. By the way, would you like to see the Drawing? I can spare it for an hour or two if you will send for it.[10]

The devil's advocate can only add that this does not sound like the note of an artist who is required to send his drawings for approval to the writer with whom he is working. It sounds much more like the note of an artist who is in the habit of sending drawings to assist the writer in writing his text. Indeed, the idea that the best known illustrator in England at the age of forty-six, after having illustrated over a hundred and fifty books including the works of Smollett, Fielding, and Sterne, should submit drawings for approval to a twenty-five-year-old author at the beginning of his career seems more unlikely than that he should have taken it upon himself to play mentor to this promising neophyte.

A strong argument can be made from a study of correspondence that "Oliver asking for more," the most famous illustration for an English novel, may have been drawn before the author had written the text.[11] Certainly the use of quotation marks around "asking for more," found at least on more than one of the original drawings for this illustration and dropped in the etching, would seem to indicate that the title of this illustration was Cruik-

10 Frederic G. Kitton, *Dickens and His Illustrators* . . . (London, 1899), p. 14.

11 See two letters, one from Dickens to Cruikshank dated [9 January 1837] (Pilgrim, I, 221) and the second from Dickens to Richard Bentley dated [?18 January 1837] (Pilgrim, I, 223-24). From the first letter it is evident that "I have hit upon a capital notion for myself, and one which will bring Cruikshank out" is not necessarily the case.

shank's.[12] In one instance, "Oliver amazed at the Dodger's mode of 'going to work,'" the quotation marks were retained in the final titling of the illustration. The use of catchy phrases drawn from everyday usage, so apparent in the illustrations for the first half of *Oliver Twist*, was a particular characteristic of Cruikshank and occurs within quotation marks in many of his caricatures as well as in titles of the illustrations in a work like Pierce Egan's *Life in London*, illustrated by Isaac Robert and George Cruikshank.

Admittedly there are several other contradictions and confusing assertions in Cruikshank's accounts and he tends, as is natural for someone who has been publicly labeled a liar, to make extravagant claims, such as "all the characters are mine," etc. The artist never was one to underestimate his own abilities and his natural tendency to be outspoken and to take credit where he felt credit was deserved became more pronounced with age. We must remember that John Forster's attack and Cruikshank's reply occurred when the artist was almost eighty years old. Considering his age and the lapse of thirty years since the Mackenzie meeting, it is amazing that he was as accurate as he was in all major details. The Historical Society of Pennsylvania owns a hitherto unpublished letter in which Cruikshank writes:

Jan. 22nd 1872
Dear Dr. R. Shelton Mackenzie,
 I have to acknowledge the receipt of a copy of "The Press" —of Philadelphia of Dec. 19/71—and also your kind letter of the 4th inst., enclosing a slip from the same paper.

[12] There is an original drawing for this etching with quotation marks around the phrase "asking for more" in the William M. Elkins Collection in the Rare Book Department of The Free Library of Philadelphia. I have seen a photogravure inscribed "with the compliments of F. R. Sabin" and designated E 48—'91 in the Cruikshank collection in the Print Room of the Victoria and Albert Museum. From the photogravure it appears that this drawing has a blindstamp known to date from the time of the composition of the original drawings and the title has quotation marks around asking for more. The Grolier Club 1913 catalogue of an exhibition of the works of Charles Dickens lists a drawing for this etching as item 67a; F. G. Kitton's *Dickens by Pen and Pencil* sometimes contains an extra illustration of a drawing which has quotation marks around asking for more; according to their catalogue entries the Henry W. and Albert A. Berg Collection, The New York Public Library, owns a drawing for this etching. Any or all of the last four items could refer to the same drawing.

In your letter to "The Press"—under the heading of "George Cruikshank—vs.—Charles Dickens"—you entirely clear yourself from any charge in Mr. John Forster's word of *"three* letters"—and in a letter of mine upon this subject, which appeared in "The Times" of Dec. 30th/71 (which of course you have now seen) I fully bear out your statement as to my informing you that the idea and the principal characters of "Oliver Twist" originated from me and not from Mr. Dickens—In this letter, I do state that you had confused the circumstances with respect to what was said and done upon the occasion of the visit you mention, but this does not in any way affect the main question—and considering the lapse of time, and the unimportance of such matters, it is not at all surprising that you should have forgotten some of the particulars of this interview, but whilst writing this letter I may just mention that I have now before me the list which I showed you of the proposed illustrations for "The Life of a London Thief"—with some of the sketches—all of which were done when Charles Dickens was a little boy—some 15 years before I ever saw or heard of him.

As you very properly suggest, Mr. Forster ought to have written to me—to enquire if I really had told you what you had stated as to the origin of "Oliver Twist"—however I am glad that you are now quite cleared from his gross imputation—and in return for the good wishes you express towards me—I beg you to receive the best wishes for your health & happiness from yours truly

GEO CRUIKSHANK

P.S. In a work which I am preparing for publication, I intend to go more fully into this matter.

Upon reading this letter I realized that my previous searches for original visual documentation to support Cruikshank's claims had been misguided since I had been looking for specific drawings rather than notations with slight sketches. To begin again with the idea of finding such a list seemed hopeless, but surmising the most likely place to find such a document was among the enormous Cruikshank holdings in the Print Room of the British Museum or in the Print Room of the Victoria and Albert Museum, I began my search. Ultimately the precious slip of

paper turned up in a miscellaneous group of notes and rough sketches in the Print Room of the Victoria and Albert Museum, presumably part of the great Cruikshank bequest to that institution. Apparently no one had ever recognized that it related to *Oliver Twist*. On one side the artist had added in his old age the ink inscription: "These sketches were intended to illustrate the Life of a Thief [*sic*]—under the Title of Don Cove—The one marked X is a House breaker peeping into a room.—with a "Dark Lantern"—& the men in the corner are Bow St. officers whom he did not see—" (Figure 14). The drawing has been given the Victoria and Albert accession number 9503 B. B as well as I can decipher. The sketches on this side of the slip of paper relate to housebreaking and would seem to be ideas for a possible title page. The notes in pencil on this side of the sheet do not appear to relate to the drawings. Both this side and the verso have signatures added in ink; but the verso, which is otherwise written entirely in pencil, is by far the most interesting part of the document. This side of the sheet bears the inscription CC18B which is presumably a Victoria and Albert box number (Figure 15). At the upper left next to the word "Don Cove," is the word "Don Jewin," suggesting Byron's masterpiece *Don Juan* which first appeared in 1819, when Dickens was seven years old, or as Cruikshank said "when Charles Dickens was a little boy—some 15 years before I ever saw or heard of him," the two men having first met in 1835. This document, so characteristic of the way Cruikshank thinks on paper, reveals a great deal about the kind of work the artist had in mind. Further down the left is the list, "Convicts—& Church/womens side/Beggars Opera/Count Fathom/Col¹ Jack"; the inclusion of works by Gay, Smollett, and Defoe on criminals makes it clear what kind of work Cruikshank had in mind while the woman's side of life with a criminal could be a hint of a character like Nancy.

Beneath the words "Don Cove" there is a sketch, presumably of a thief, with the caption, "Your money." Slightly to the right is a list which begins with the word "Cloister," followed by "Lady Abbess/Nuns" and two words which after much puzzlement I first made out as "chantry bogs," but which I now believe to be "Charity boys." Dictionaries of slang and cant of the period reveal the current meanings of the religious terms; a cloister was a brothel, a Lady Abbess a madam, a nun a prostitute; and the

75

"charity boy" could have been the embryo of Noah Claypole. Next comes a sentence under a sketch of a beggar or thief which reads "You hav'nt [sic] such a thing as half a crown about?" Under this is an ambiguous fragment reading "not coming with grub to the steel" which may mean coming hungry to jail. Under this is a sketch and a caption reading "Bolting with—curly head Poll [?]" which would seem to mean running away with a Nancy or Bet type. These last two inscriptions belong to a kind of ladder that is set up in the next column and this ladder, in terms of George Cruikshank's thinking, must relate to the kind of Hogarthian progress that was featured in the famous "Queen's Matrimonial Ladder" drawn to accompany a pamphlet by William Hone with the same title and with illustrations by George Cruikshank (Cohn 680). This toy ladder (Figure 16a) was first published to accompany Hone's pamphlet in 1820 although the design could have been worked out somewhat earlier, a fact which again could point to 1819. The idea for the "Life of a Thief" reads "Birth / Partners [?] / Education / Juvenile Exploits / Early Employment." The compartmentalized drawings with captions constitute Cruikshank's most detailed account of the kind of work he had in mind. The final column of this page of visual and verbal notations includes a sketch of a handkerchief hanging from a gentleman's back pocket, of a key chain, and of a bottle with the words (apparently applying to all three drawings) "Temptation as." There is also a picture of a woman fruit seller with the words "Swallow Street" written below her, a drawing almost identical in every detail to a figure appearing in a published caricature (Figure 16b) titled *The Piccadilly Nuisance* (Cohn 1841) and dated December 29, 1818, which again points to the year 1819 as the date of this page of notations. The woman in the caricature is holding up her skirt to shelter a young boy, whose nose resembles that of the woman, and who is busy picking a pocket; the action is taking place in front of Hatchett's coffee house on Piccadilly. Swallow Street, mentioned in the notations, connected Piccadilly Street with Regent Street and was presumably a hangout for such types as depicted.

The final notation consists of a picture of a boy with his fists clenched in a fighting posture and the caption "Licking any one in the Nei[ghborhood] of yr own size & some as big again." Just

as one can refer to the dark lantern of Figure 14 and recall that a dark lantern was used during the robbery in Chertsey, so Oliver's fight with Noah Claypole at the house of the undertaker Mr. Sowerberry can be linked to this rough sketch. All this may seem like Sherlockian speculation, but as every lawyer knows, accumulated evidence, however circumstantial, can operate to free a man from charges by a prosecution which offers no such evidence. The date 1819 is tentative but is indicated in the drawing with notations, and thus we have as a part of Cruikshank's grand "delusion," so-called, the bare bones of an idea jotted down not "fifteen" but more likely seventeen years before they were shown to the young author whose imaginative literary genius translated them, according to Cruikshank, into the novel we know as *Oliver Twist*.

Cruikshank's letter of 11 November 1870 to W. J. McClellan, now owned by the Free Library of Philadelphia, differs from the letter used by Mackenzie in his article in the Philadelphia *Press,* cited in the Clarendon *Oliver Twist*. Essentially the differences are typical editorial changes to which a private document would be subjected before it was made public. This letter, written approximately one year before the publication of Forster's denunciation in the first volume of his biography of Dickens, offers the most extreme example of Cruikshank's supposed senile delusions. The text of the letter (underscored as in the original) reads:

Nov. 11th 1870
Dear Sir,

I was the <u>first</u> to illustrate any of the writings of the late Charles Dickens—the <u>first</u> was the <u>first</u> vol<u>e</u> of "Sketches by Boz." The <u>second</u> was the <u>second</u> vol. of "Sketches by Boz." The greater part of this second vol. were written from my suggestions. The next was an illustration of one of his papers in "Bentley's Miscellany" (of which Dickens was the Editor). This subject was <u>my design</u> & he wrote up to it, & this was followed by "Oliver Twist" which was <u>entirely my own idea & suggestion and all the characters are mine.</u>* There were one or two other illustrations to something which he wrote in a vol. [Inserted between two lines of text and apparently in-

77

tended to identify this volume are the words: Pic Nic-papers published for the benefit of the widow of McCrone—the publisher of the "Sketches by Boz."

These are all that I did to illustrate any of Mr. D's works—and I intend to publish as soon as possible an explanation of the reason why I did not illustrate all his other works & to show that he behaved to me in a shabby manner. It was only yesterday Evening that I obtained some of the propectus's [*sic*] for the "Bruce Monument" and forward those by this same post as this letter. With respect to the illustrations in the American edition of Mr. Dickens's books, they may perhaps be copies of some of mine—but not done by the hand of Dear Sir Yours Truly

GEO CRUIKSHANK

P.S. The public at one time supposed that I had adopted the name of "Phiz" to illustrate the works of "Boz"—& the reason why many believed them to be by me was because my style of work was closely imitated.

W.J. McClellan Esqʳ

*It may be observed that "Oliver Twist" differs very much from all his other works.

The assertion here that the greater part of the second series of *Sketches by Boz* was written from suggestions made by Cruikshank to Dickens gave even the devil's advocate some misgivings although a painstaking check of the original publication dates of these sketches in newspapers and periodicals establishes at least the possibility of such an exchange of ideas. The majority of the illustrated sketches (which include some of Boz's best sketches) did first appear in print after the two men met for the first time late in November 1835 and began working together on the first series of *Sketches by Boz*. I identify below each sketch by the exact title of its illustration in its original small version except in the case of the last one which only appeared in the large version done for the parts. The ten illustrated sketches that could have resulted from suggestions made by Cruikshank to Dickens include "The Winglebury Duel" first published in *Sketches by Boz* First

Series; "The Free and Easy" (from "The Streets-Night"), "A Pickpocket in Custody" (from "The Hospital Patient"), "Monmouth Street," "Scotland Yard," "Vauxhall Gardens by Day," and "Our Next-door Neighbours," all published in the first edition of *Sketches by Boz* Second Series; "The last [*sic*] Cabdriver," and "May-Day, in the evening" (retitled: "The First of May"), first published in the second edition of *Sketches by Boz* Second Series; and "The Tuggs at Ramsgate," first illustrated in *Sketches by Boz* when it appeared in parts. *Sketches by Boz* Second Series appeared in the first edition with ten of its twenty sketches illustrated and in the second edition with twelve of its sketches illustrated. Since Dickens did first publish these sketches in newspapers and periodicals after he became personally acquainted with Cruikshank, and since we do not have information about the dates of composition of these sketches, it is possible that the majority of the illustrated sketches in *Sketches by Boz* Second Series *could* have been influenced by Cruikshank, but of course no absolute conclusions can be drawn.

Textual changes in the sketches may offer evidence of passages inserted at Cruikshank's request and later dropped by Dickens. For example, Kathleen Tillotson in *Dickens at Work* cites the following passage which was originally the opening of "Scotland Yard" and which Dickens omitted when he revised this sketch for inclusion in *Sketches by Boz* Second Series:

If our recollection serves us, we have more than once hinted, confidentially, to our readers that we entertain a strong partiality for the queer little old streets which yet remain in some parts of London, and that we infinitely prefer them to the modern innovations, the wide streets with broad pavements, which are every day springing up around us. The old Exeter 'Change, for instance, and the narrow and dirty part of the Strand immediately adjoining, we were warmly attached to. The death of the elephant was a great shock to us; we knew him well; and having enjoyed the honour of his intimate acquaintance for some years, felt grieved—deeply grieved—that in a paroxysm of insanity he should have so far forgotten all his estimable and companionable qualities as to exhibit a sanguinary desire to scrunch his faithful valet, and pulverize even Mrs. Cross herself, who for a long period had

evinced towards him that pure and touching attachment which woman alone can feel.[13]

This passage may have resulted from one of Cruikshank's suggestions, since at the time of the elephant's death on 1 March 1826 the artist had done a broadside caricature, which included four columns of letterpress, titled the *Destruction of the Furious Elephant at Exeter Change* (Cohn 1056). In 1826 Dickens was only fourteen years old; Cruikshank, however, was thirty-four and could well have been acquainted with the elephant for the "some years" mentioned in the passage. The letterpress accompanying Cruikshank's caricature also mentions Mr. Cross as the proprietor of the menagerie at Exeter Change. Dickens, therefore, may have excluded this Cruikshankian anecdote not because it was "too topical" as Mrs. Tillotson suggests but because it was not topical enough.[14]

If "The last Cabdriver" is included among the stories which possibly resulted from collaboration, it might appear that there is a mistake in chronology, for the story that accompanies the etching first appeared in *Bell's Life in London* on 1 November 1835, possibly before Cruikshank met Dickens. This sketch, however, combines two stories and the first about the first omnibus cad appeared on 1 November 1835, but the second, as far as I know, made its debut in the first edition of *Sketches by Boz* Second Series. The general subject matter of "The last Cabdriver" may be Dickens' own but Cruikshank could have told Dickens something about the cabdriver in the story. From their published correspondence it is clear that Cruikshank got permission for Dickens to visit Coldbath Fields Prison a second time; in the sketch the narrator encounters the cabdriver after the latter's incarceration in Coldbath, a prison to which, as far as I know, Dickens never made any further reference in his works (Pilgrim, I, 101). Furthermore, the exact description of the appearance and dress of the cabdriver in Dickens' text could be derived from pictorial prototypes which Cruikshank produced before the text was written. Other influences exerted on Boz by Cruikshank could be Cruikshank's pictorial prototype for Sikes in the pickpocket of his illustration for "The Hospital Patient," a story which also

13 John Butt and Kathleen Tillotson, *Dickens at Work* (London, 1957), p. 55.
14 Idem.

includes the murder of a young woman by a Sikes type, or Cruikshank's first and only plate of Part V of *Scraps and Sketches* (Cohn 180) titled "Anticipated Effects of the Tailors' Strike, etc.," dated 22 May 1834, a design in which one man hands another a card of "Levy—Monmouth Street," presumably the same Moses Levy who appears under his shop sign in Cruikshank's etching for Dickens' "Monmouth Street." All of this evidence is not conclusive but the topic deserves the kind of close study that must wait until further bibliographical research on this complicated work has been done.

Cruikshank claims in his letter to McClellan that he had contributed a drawing to the first issue of *Bentley's Miscellany* (January 1837) before Dickens wrote the text to accompany it. Presumably this drawing is "Tom [*sic*] Twigger in the Kitchen of Mudfog house." This claim is supported by a letter of 26 November 1836 from Dickens to Cruikshank in which, with reference to this particular plate, the author writes: "I will call on you on Monday Evening. I have not written the paper yet, so if anything should occur to you as a good illustration, I shall be happy to adopt it. I will arrange so that next month you may have the MS. by the 5th. and so on for the future" (Pilgrim, I, 198). This etching is, therefore, of particular significance because it offers the only known example of a Cruikshank illustration which, according to Dickens' own evidence, preceded the author's text; in this instance, therefore, the author was "writing up" to a Cruikshank illustration.

The etching shows Ned Twigger dressed in armor seated on the table in the kitchen of Mudfog house with his arm around the cook's shoulder offering a toast with his glass held up. The footman is wearing his helmet and sword and performing for the other people present. The text states:

> While all this was going forward, Ned Twigger had descended into the kitchen of Mudfog Hall for the purpose of indulging the servants with a private view of the curiosity that was to burst upon the town; and, somehow or other, the footman was so companionable, and the housemaid so kind, and the cook so friendly, that he could not resist the offer of the first-mentioned to sit down and take something—just to drink success to master in.

So, down Ned Twigger sat himself in his brass livery on the top of the kitchen-table; and in a mug of something strong, paid for by the unconscious Nicholas Tulrumble, and provided by the companionable footman, drank success to the Major and his procession; and, as Ned laid by his helmet to imbibe the something strong, the companionable footman put it on his own head, to the immeasurable and unrecordable delight of the cook and housemaid. The companionable footman was very facetious to Ned, and Ned was very gallant to the cook and housemaid by turns. They were all very cosy and comfortable; and the something strong went briskly round.[15]

Although Dickens includes most of the important details in the etching, he yet clearly maintains a decided authorial independence. It becomes evident how "writing up" to Cruikshank's illustration could mean one thing to Cruikshank and something entirely different to Dickens. That Monday evening interview mentioned by Dickens undoubtedly consisted of many collaborative suggestions made by both artist and author. A final circumstance of interest is the mistitling of the etching itself. The title appearing on the plate itself is "Tom Twigger in the Kitchen of Mudfog house," but Twigger's name in the text is Ned Twigger—a mistake which would seem to reflect Cruikshank's ignorance of, or indifference to, the text.

The remainder of Cruikshank's letter to McClellan may be an illustration of the elderly artist's characteristic mixture of overstatement and bravado in his assertion that *Oliver Twist* was "entirely my own idea & suggestion and all the characters are mine," but this assertion is not entirely without grounds, just as his statement about Phiz and the differences between *Oliver Twist* and all of Dickens' other works do at least in part ring true. Phiz, along with most other beginning illustrators of the period, did start his career as a Cruikshank imitator, and *Oliver Twist* does stand out as a uniquely different kind of work when compared with Dickens' other works. The letter may contain exaggerations, but not all of its implications can be dismissed as nothing more than the "delusions" of an aged crackpot.

[15] *Bentley's Miscellany* (January 1837, I, 58; rpt. in *Sketches by Boz* [Oxford Illustrated Edn., London, 1957]), p. 618.

For years the Dickens partisans have asserted that Cruikshank weakened his case by making similarly absurd claims about his influence on William Harrison Ainsworth. However, John Harvey in his *Victorian Novelists and Their Illustrators* (London, 1970) has brought forth positive evidence that Cruikshank and Ainsworth did work together in exactly the way Cruikshank said they worked. Harvey cites a letter of 16 September 1840 from Cruikshank to Ainsworth in which the artist details what he wants the writer to put in the text in a scene in *The Tower of London* (see pp. 34-43 and Appendix III). And there are at least a dozen other Cruikshank and Ainsworth letters in private collections and probably twice that number in public collections which, when published, will fill out the story of just how the two men worked together. In some of these letters Ainsworth tells Cruikshank what to put in an illustration, in others the artist does the dictating, as in the example cited by Harvey. But even if there were only the one letter Harvey quotes, the kind of collaborative relationship Cruikshank speaks of is substantiated. Much remains, as Harvey suggests, to be worked out, but since for decades Cruikshank's claims regarding Ainsworth have been used to deride his similar claims in regard to Dickens, I would suggest that the new evidence supporting the Ainsworth claims raises serious doubts about whether the claims in the case of Dickens can be dismissed out of hand. Since so much evidence in the Dickens-Cruikshank controversy must be missing, we shall have to be content with assuming that what we come to learn about Cruikshank and Ainsworth may help us understand at least Cruikshank's grounds for believing that his "suggestions" to Dickens had a similar effect.

Harvey also presents some new information in support of Cruikshank's claim that he and T. J. Pettigrew first called Dickens' attention to the maltreatment of the orphans in the Parish of St. James in Piccadilly, but Harvey weakens his own evidence by stressing that Pettigrew's pamphlet on farming out orphan children (a publication never previously mentioned to this writer's knowledge by any scholar reviewing the Dickens-Cruikshank controversy) was written a year earlier than Cruikshank said that it was written. My own examination of the Parish records of St. James, Piccadilly leads me to believe the troubles in regard to the farming out of children did not stop abruptly in April 1836

when Pettigrew's pamphlet appeared. As mentioned earlier, the Free Library of Philadelphia owns a letter from Cruikshank to J. B. Deane concerning this matter and I have seen a sales catalogue reference to Deane's letter to Cruikshank. Again, the topic deserves more investigation.

Since many Dickens scholars seem to share the view of the editor of the Clarendon *Oliver Twist* that "no contemporary other than Mackenzie appears to have credited Cruikshank's claims," I should like to direct attention to the comments of at least two contemporary reviews. On 9 January 1873 a review of the second volume of Forster's *Life of Charles Dickens* in *The Nation* concludes by saying:

> We may remark, in closing this notice, that Mr. Forster appears to think he has disposed of a charge of inaccuracy brought against his biography by Mr. George Cruikshank, who has asserted certain things in reference to 'Oliver Twist'; and, also, that he has atoned for a piece of bad manners of which he was guilty in substantially calling Dr. Shelton Mackenzie the inventor and promulgator of a lie. In this volume he is compelled to admit that Dr. Mackenzie did not invent a lie; but he seems to have forgotten that, in common decency, he owed that gentleman amends for flinging such an accusation at him. As for the Cruikshank matter, Mr. Forster does not meet the point in issue, but evades it in a fashion which is curious rather than laudable or sagacious. Cruikshank said in substance this: that he was the inventor of 'Oliver Twist'; that Dickens saw in his workroom some pictures of Sykes, Nancy, Fagin, and others of the characters in that story, which caused him to alter the story which he had then begun writing, and to alter it in such a direction that the artist, rather than the author, may be considered the originator of 'Oliver Twist' as we have it. In reply to this, Mr. Forster, some year or so ago, came out in a letter denying that Mr. Cruikshank's claim was at all to be allowed; and this was his argument: Dickens came to town on one occasion when 'Oliver Twist' was far advanced in publication, and seeing that his artist, Mr. Cruikshank, had made two plates which to Mr. Dickens seemed quite unsatisfactory, he wrote Mr. Cruikshank a note saying so, and requesting Mr. Cruikshank to set to work and

84

make two more, which Mr. Cruikshank did. Now, says Mr. Forster, this note decides the controversy; no man who is working subordinately to an artist writes to the artist a note like that. Upon the appearance of this argument of Mr. Forster's, Mr. Cruikshank came to the front again; reiterated his assertion; made it plain as a pikestaff (always supposing that Mr. Cruikshank is a credible witness) that he was not indeed in any admissible sense the originator of 'Oliver Twist,' as we know the novel, and that he was very hasty to make such a claim; but nevertheless that it is perfectly true that he did invent a Fagin, a Sykes, and the general plan of the story (the adventures of a good boy among London thieves); and that Dickens did in fact modify his own plan, and did, to some extent, adopt Cruikshank's notion. Now, how does Mr. Forster meet this? Not, in our judgement, and so far as we know the facts, with candor; and not with cogency and conclusiveness by any means. What he does is to print a facsimile of the letter which the author wrote to the artist about the plates above mentioned, which nobody ever contended were not perfectly under his control, and which Mr. Cruikshank has since said, if we recollect right, were made in accordance with Dickens's wish and against the artist's judgement. If any one had denied the existence of Dickens's letter, Mr. Forster's action in this second volume would have been pertinent. As the case stands, however, we should say it is very like an evasion of a difficulty, or a singular misapprehension of it. (p. 29)

Oddly enough few commentators on this controversy have been fair enough to point out that the letter Forster quotes from Dickens indeed does avoid the basic issue and does not offer concrete evidence to support his case. Carrying the discussion a few steps further the writer of a review, which appeared in February 1873, in *The Atlantic Monthly* says of Dickens:

We are not persuaded, in the matter of Mr. Cruikshank's claim to have suggested the idea of Oliver Twist, that Mr. Forster has all the truth upon his side. Doubtless the artist claims too much in saying that he furnished the principal characters and scenes, and implying that the letter-press

85

merely illustrated his pictures; but it is not at all improbable that Dickens, who was then writing Pickwick and Nicholas Nickleby, as well as Oliver Twist, may really have changed his plot after poring over a series of sketches in the artist's portfolio. The letter of Dickens, which Mr. Forster prints with so much emphasis, he merely declares at the time of writing that he had just seen "a *majority* of the plates for the first time." Nobody will ever believe that Mr. Cruikshank originated Oliver Twist; but Dr. Mackenzie's statement of the matter was so far within the range of possibility, that, after all but calling him a liar, it seems a grudging reparation for Mr. Forster to say that he is not guilty of "the worst part of the fable." But, then, graciousness is not a characteristic of this odd biography, in which the unamiable traits of the biographer combine with the unamiable traits of his subject to give the book as disagreeable a tone as a book ever had. (pp. 238-39)

There were others, of course, who sided with Cruikshank either privately or publicly including the two men, William Bates and Walter Hamilton, who wrote early biographical accounts of the artist shortly after his death, and his lifelong friend William H. Merle who signed collaborative caricatures as "A. Bird." Perhaps because of his close friendship with Charles Dickens, Blanchard Jerrold, Cruikshank's official Victorian biographer, did not take Cruikshank's side and it is Jerrold's version of the Dickens-Cruikshank controversy which is cited in Austin Dobson's account of George Cruikshank in *The Dictionary of National Biography*.

Often I am asked to explain just what someone should believe about Cruikshank's influence on Dickens and I answer that the question of that influence is, as are all questions of influence, resistant to irrefutable "proof" and extremely complex, but certainly deserving of exploration. The question of Cruikshank's influence is as important as the influence upon Dickens of Shakespeare, of Cervantes, of Defoe, of Smollett, of Carlyle, or of Wilkie Collins—to mention only a few of the authors critics have accepted as worth serious study in their search for a full understanding of Dickens' sources. The mystery remains why claims for Cruikshank's influence, unlike the articles and even book-

length studies of other influences, have been received with derision by the "defenders" of Dickens. In the past any hint that the graphic art of George Cruikshank may have influenced as visual-oriented an imagination as that of Dickens has prompted vituperative (and certainly irrelevant) attacks upon the artist's character as well as upon his mental health and professional integrity. Cruikshank's several manuscript versions of his pamphlet *The Artist and the Author* (Cohn 202, 1872), now in the Print Room of the British Museum, reveal little that is not in the published version except perhaps his comment that William Shakespeare would certainly not have denied credit to a friend who had given him suggestions about character and plot for *Macbeth* and *Hamlet*. While this may underscore the literary naïveté of the eighty-year-old artist who felt so slighted, it is nevertheless an indication that he looked upon Dickens as a great writer and that he considered his "suggestions" to Dickens as those of a friend who wanted to be helpful. That Cruikshank at the same time did not seem to differentiate between the works of Dickens and those of Ainsworth may indicate a lack of sophistication in literary matters but cannot refute the artist's claim that he did suggest a story about the life of a young thief to Dickens before he wrote *Oliver Twist* and that a hundred years after John Forster called the whole idea an "incredible and monstrous absurdity," this claim is supported by a rough sketch dating from a period before Cruikshank met Dickens. This sketch, along with the other evidence which we have examined, should offer to any impartial jury strong corroboration of Cruikshank's claims as first put forward by Mackenzie in 1865.

One of the most insidious side-effects of this controversy stems from the fact that Forster's attack on Mackenzie and Cruikshank has so influenced later writers on the subject that such over-defensive language as "preposterous," "absurd," "senile," "delusion," and "liar" has become commonplace. Beyond this, a number of casual anecdotes (among them Dickens' typically humorous remarks in letters about Cruikshank's personality but not about his professional claims) seem after constant repetition and embellishment to constitute what the Dickens supporters "know" about Cruikshank. Cruikshank's name rarely appears in Dickensian criticism or biography without an allusion to him either as a comic drunk or a Temperance fanatic. No one can survive such designa-

87

tions with dignity. Serious consideration of his true stature as a graphic artist has become impossible for the majority of literary critics. Thackeray's complaint about the lack of literary appreciation of graphic art is as true in 1973 as it was in 1840 when he wrote in his famous tribute, *An Essay on the Genius of George Cruikshank*: "How little do we think of the extraordinary power of this man, and how ungrateful we are to him."[16]

It is unfortunate that Blanchard Jerrold's biography of Cruikshank written in 1882 has been accepted as authoritative in all details since it appears to have set in motion an endless repetition of undocumented anecdotes about Cruikshank as a roaring drunk. The passage that has become a favorite with Dickens commentators reads:

"I remember him about 1846," said Mr. W. H. Wills, another old friend. "He was then flirting with Temperance. I wanted him to dine at my house; but he excused himself, saying he should be led into temptation, and he had resolved to be a water-drinker thenceforth." He did not go to dinner, but dropped in later—much excited; and when his host pushed the water-bottle towards him, he gently added brandy. The guests departed, leaving the hilarious George, with two others, to finish the evening; and when the trio got into the street, they found the old difficulty in restraining Cruikshank's boisterous spirits. After trying in vain for something more than an hour to lead him home, they left him—climbing up a lamp-post![17]

In 1911 Stewart Marsh Ellis, the official biographer of William Harrison Ainsworth (who brings no definitive evidence to bear against Cruikshank's claims in respect to Ainsworth) picks up Jerrold's story:

Although as years passed on he overcame the almost chronic intemperance of his early manhood, Cruikshank was

16 William Makepeace Thackeray, *An Essay on the Genius of George Cruikshank* (London, 1840), p. 59. This essay, originally published in June 1840 in *The Westminster Review*, has been reprinted several times.

17 Blanchard Jerrold, *The Life of George Cruikshank, in Two Epochs*, 2 vols. (London, 1882), II, 51.

very convivial in his prime—such as we saw him at Kensal Lodge in the late "Thirties"—and occasionally he would break out and return to the old haunts and low associates of his youth for a night of wild dissipation. His battle with his enemy was a hard one; and as late as 1846, when he had already taken up the Temperance cause, he would be found trying to climb up a lamp-post, or lying in an insensible condition on the pavement—after a jolly evening with his friends and a lapse from his good resolutions. But he conquered at last.[18]

Even more pointed are the words of that most loyal of Dickensians J. W. T. Ley in "Robert Seymour and Mr. Pickwick" (*The Dickensian* for July 1925). Ley is reviewing Lambert's *When Mr. Pickwick Went Fishing*, a book that deals with Seymour's pictorial prototypes of characters who appear in his illustrations for *Pickwick Papers*. Unfortunately, Lambert tried using Cruikshank's claims to bolster his case for Seymour, with the result that Ley repeats the old charges with added embellishments of his own:

> Mr. Lambert, of course, talks about Cruikshank's allegations in regard to *Oliver Twist*, but he is at this disadvantage, that whilst he had to admit that Seymour was in the habit of quarrelling with his literary collaborators, the same is true of Cruikshank. Seymour was a neurotic (as we should say to-day), Cruikshank was a drunkard, till his old age, and then he was a humbug. He had similar disputes with Ainsworth and others. Was Seymour, was Cruikshank in the right in their other disputes? If not, why is it to be assumed that Dickens was necessarily wrong when they brought charges against him? Only prejudice can be the explanation. (p. 126)

Edgar Johnson, author of what is still the definitive biography of Dickens, says nothing about the controversy itself, but in his pages Jerrold's anecdote with its unpleasant overtones lingers on:

[18] Stewart Marsh Ellis, *William Harrison Ainsworth and His Friends*, 2 vols. (London, 1911), II, 81-82.

The artist, once a hilarious climber of lampposts and wallower in gutters, had now become a fanatical teetotaler and was using his etching needle to depict the horrors of alcoholism.[19]

Johnson uses the same language in a footnote (p. 140) in his *The Heart of Charles Dickens* (New York, 1952):

During the earlier part of his career an enthusiastic drinker, climber of lampposts, and wallower in gutters, Cruikshank had by this time turned fanatical temperance reformer and was using the genius of his etching needle to serve that cause.

Even seventeen years later in the *Harvard Library Bulletin* (1969), the author of "All-of-a-Twist" repeats the description without benefit of quotation marks or footnote as if it were a matter of common knowledge:

Overnight the onetime climber of lamp-posts and wallower in gutters became a fanatical teetotaler, adding the force of personal example to his pencil and platform preaching.[20]

This most recent of the circulators of Jerrold's lamppost climbing and gutter wallowing story goes on to observe that "a central concern of any biographer of the artist must be his long relationship with Charles Dickens" as if only his friendship and illustrations for Dickens were of any real importance.[21] According to Albert M. Cohn, Cruikshank's definitive cataloguer, the artist did illustrations for 863 books and produced over 700 caricatures. Of the 863 books, Dickens wrote only two and edited only two. Obviously the "central concern" of any competent historian of Cruikshank's seventy-five-year working career could hardly be his brief working association with Dickens, any more than the central concern of a Dickens biographer would be that association. The genius of both men is so great that neither stands to gain or lose from what has been blown up by Dickensians into the "Dickens-Cruikshank controversy," a dispute which can never be settled definitively unless new documents, especially the pre-

19 Edgar Johnson, *Charles Dickens: His Tragedy and Triumph*, 2 vols. (New York, 1952), II, 619.
20 Cohen, p. 332. 21 Cohen, p. 169.

sumably destroyed letters from Cruikshank to Dickens, come to light, and probably not even then. Certainly, the more I examine the immense corpus of Cruikshank's graphic works the more I have come to realize the insignificance of what should more properly be called the "Forster-Cruikshank controversy" (since Dickens himself wrote not a single word about it). The Dickens authorities who have so readily accepted Forster's version have never taken the trouble to study the visual evidence supporting Cruikshank's claims, preferring to have their laugh at an embellished anecdote and to leave George Cruikshank, the colossus of graphic art of the last century, climbing lampposts and wallowing in gutters for almost a century.

There are signs, however, that there is relief at hand. I note with pleasure the increasing interest of literary scholars in the graphic arts, a field with a tradition older and certainly as much to be respected as that of the study of prose fiction. With the concurrent increasing recognition of the value of "interdisciplinary studies," I would hope that responsible scholars informed in both literary and graphic traditions will bring equal understanding and respect to the work of artist as to that of author. When this happens I predict that George Cruikshank, who was called "inimitable" several years before Dickens' "rocket" began to rise, will be given the long overdue recognition he deserves and that future scholars will look back and wonder how their predecessors could have been so determinedly blind.

Cruikshank as an Illustrator of Fiction

BY ANTHONY BURTON

I

MUCH of Cruikshank's work fell fairly quickly into obscurity. His early political caricatures were ephemeral, and so were most of his early illustrative works, while the books he illustrated in the last thirty years of his life were few, and were seldom reprinted. It was his illustrations for the novels of Dickens and Ainsworth—novels which remained popular and were often reprinted —that kept him in the public eye; and these illustrations have usually been made to stand as representative of his work as a whole. Now that we have an opportunity to reassess his entire output, we may profitably isolate his illustrations of fiction as one distinct part of it, and consider how far they have a special character.

Book illustration in its widest sense is the provision of pictures that relate to the text of a book. The pictures may be purely decorative, simply filling the space on the page which the text does not extend to cover; or, at the other extreme, they may be purely informative. The highest order of illustration is that which attempts to give an imaginative response to a work of imagination: interpretative illustration.

"Successful interpretation," as Philip James says, "implies the need for a reflection of the author's style."[1] Cruikshank's success in matching the style and mood of the novelists whose books he illustrated was often remarkable, and much of this essay is devoted to demonstrating it. Since the demonstration is, after all, a matter of critical judgment, no theoretical advance notice of it is needed here. But one point should be stressed.

It is obvious that, when an artist is illustrating a long and complicated narrative, he is faced, in choosing his subjects, with various problems of selection and emphasis. Usually he comes to the written narrative after the author has finished it, and has the advantage that he sees it whole. Many of the stories that Cruikshank illustrated, however, appeared in monthly installments. This meant that in producing an illustration the artist could not

[1] Philip James, *English Book Illustration 1800-1900* (London, 1947), p. 8.

refer to his memory of the story as a whole, for generally it was still being written; he worked with his knowledge of the story as it had developed up to the point at which his illustration was called for. We might expect that an artist working in such conditions would be more sensitive to changes and developments in the tone and mood of a story, and would feel the movement of a narrative more keenly, than an artist working with a whole book in mind. Furthermore, illustrations to monthly installments occurred frequently and regularly and might well reflect the recurrent emphases which an author would introduce into his monthly parts; hence, the illustrations themselves might well take on a sequential or narrative force.

If Cruikshank's illustrations to fiction prove to have a special character, this is not only the result of his extraordinary sympathy with many of the authors he worked for, but also partly the result of the method of monthly publication, which forced him into a much closer and longer collaboration with his authors than usually exists between a writer and an illustrator.

II

It is important to realize how greatly Cruikshank depended on verbal inspiration. To be sure, the works by which he most endeared himself to his public in the late 1820s and early 1830s, at the time when he established an undisputed pre-eminence among comic draughtsmen, may seem to have as little to do with words as possible. This early work took the form of collections of visual jokes, issued as large oblong etched plates, mostly containing a number of small vignettes, but some bearing a single large caricature. Several sets of such plates appeared: *Phrenological Illustrations* (Cohn 178, 1826), *Illustrations of Time* (Cohn 179, 1827), *Scraps and Sketches* (Cohn 180, 4 parts: 1828-32), and *My Sketch Book* (Cohn 181, 9 parts: 1834-36); one might add to these the miscellanies by William Clarke, *Three Courses and a Dessert* (Cohn 144, 1830) and by W. H. Merle, *Odds and Ends in Verse and Prose* (Cohn 552, 1831), to which Cruikshank contributed in a similar style. Contemporary critics welcomed these with a rapture that was usually content to remain inarticulate: "And now we would willingly dip our pen in laughing gas instead of ink," cried the *Athenaeum*, "that we might convey some notion of the

94

quaint conceits, the sense, the nonsense, which George Cruikshank has etched down in his *Sketch Book*."[2] Thus the critic briefly recommends the book to "all who love a hearty laugh," but even in this passing mention he suggests to us, by his use of the words "conceits," "sense," "nonsense," that Cruikshank's comic art does, after all, have a verbal basis.

At its simplest, his art puns. He was not original in this. Most of the visual jokes in Tom Hood's *Comic Annuals* (1830-42) were, as one might expect, visual puns. Cruikshank (who occasionally contributed to Hood's annuals) was so much livelier a draughts-man than Hood that there is no comparison between their designs; but the two pages of "Tails" in Cruikshank's *Scraps and Sketches* (Pls. 19, 22) are in Hood's idiom. "Curtailing," for instance, shows a dog seizing a man by the seat of his pants. Cruikshank, however, is rarely satisfied with a simple pun. One idea provokes another. And so, on his second page of "Tails," we find "Tell Tale," in which a grimacing sailor with a pigtail is saying to his command-ing officer, "Please your Honor Tom Towzer has tied my tail so tight that I cant shut my eyes." Here the joke is not in the pun but in the grotesque situation it has suggested to the artist. Oddly enough, in *My Sketch Book*, a year or two later, we find (Pl. 9) a "portrait of a remarkable little dog who's tail curled so tight that it lifted him off his hind legs"—an instance of Cruikshank's in-exhaustible ability to produce variations on an idea once it had got into his head.

Another example of verbal inspiration in Cruikshank is his way of taking metaphors literally. In *Illustrations of Time* (Pl. 4) we have a lively vignette of a man whose nose is pressed to a grind-stone by one old lady while another vigorously turns the handle. Or in *Scraps and Sketches* we have (Pl. 2) "The Pursuit of Letters" in which toddlers with highly developed craniums pursue the let-ters "ABC" which are running away on little legs. In the back-ground "LITERATURE" is also making off on legs, followed by hunts-men and hounds. Again, one thing leads to another: "The Pursuit of Letters" is accompanied by "The March of Intellect," which no doubt helped to suggest the later plate (Pl. 10) "London going out of Town—or—the March of Bricks & Mortar." In this unusually mordant plate Cruikshank shows animated shovels, picks and hods

2 *Athenaeum*, 14 September 1833, p. 620.

overrunning the countryside. Animism was one of his constant habits: the lemons with human faces in *Three Courses and a Dessert* (p. 387) are instances; or the anthropomorphic oyster in the same book (p. 197), whom Thackeray characterizes as "cool, gentle, waggish, and yet inexpressibly innocent and winning."[3]

By animism Cruikshank breathes life into objects; by an analogous mental process, he is fond of objectifying abstractions. In *Phrenological Illustrations* we find an expressive embodiment of "Self Love" (Pl. 1), and (Pl. 6) a less penetrating but more quaintly witty depiction of "Veneration"—a grossly fat man admiring a huge carcass of beef. By circumstantial elaboration of this kind Cruikshank imparts great vitality to his sketches: think of the "Toad in the Hole" in *Three Courses and a Dessert*, who squats in a commodious niche with a pipe and a pot of porter (thus catching the mood of the story which Cruikshank is here obliquely illustrating).

It is clear that Cruikshank was a witty man, in the sense that he understood the comic use of words, the interplay of meanings, and the manifold connections of ideas. (His drawing of "Lithography" in *Scraps and Sketches*, Pl. 11, is an exercise in the association of ideas: it shows a pavement artist "drawing on stone.") Often enough his inspiration was a verbal witticism, or simply a word, or an idea, but what gives his designs their special liveliness is his ability to expand a word or an idea into a situation, visualized in all its details. One might instance the plate in *Scraps and Sketches* (Pl. 6) showing seven examples of incidents that could result from the possession of a wooden leg; it is typical of Cruikshank's vivacity that five of them are examples of the absurd advantages of a wooden leg.

My Sketch Book is the only one of the compilations I have mentioned that includes a substantial proportion of material which is directly noted from observation or is an attempt to draw inspiration from traditional satiric motifs (Pls. 14, 20): and this material is weak. What the early collections make clear is the prime importance of words and ideas as inspiration for Cruikshank. One might expect, then, that an artist, so dependent on verbal inspiration where little jokes were concerned, might, if he illustrated fiction, be more than usually responsive to the text he was illustrat-

[3] W. M. Thackeray, "George Cruikshank," *Westminster Review*, 34 (1840), 18.

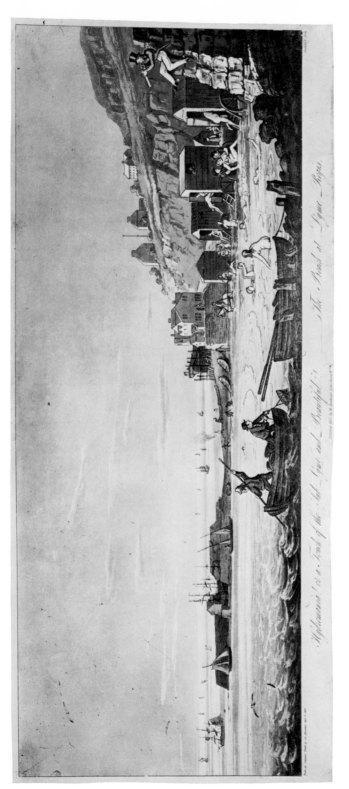

Figure 5. George Cruikshank, *Hydromania!*, 1819. Etching and engraving.
The Philpot Museum.

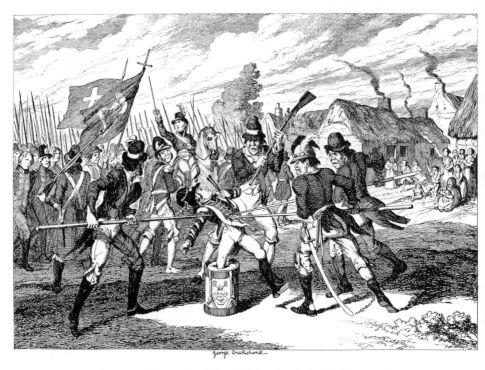

Figure 6a. George Cruikshank, "The Loyal Little Drummer,"
from Maxwell's *Rebellion*, 1845. Etching.
Princeton University Library.

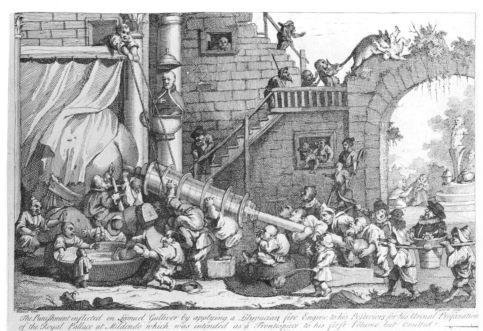

The Punishment inflicted on Lemuel Gulliver by applying a Lilliputian fire Engine to his Posteriors for his Urinal Profanation
of the Royal Pallace at Mildendo which was intended as a Frontispiece to his first Volume but Omitted

Figure 6b. William Hogarth, *The Punishment inflicted on Lemuel
Gulliver*, 1726. Etching and engraving.
British Museum.

W. Hogarth inv.ᵗ Vol. 2, page 148. S. Ravenet Sculp.ᵗ

Figure 7b. William Hogarth, frontispiece to Sterne's
Tristram Shandy, Vol. I, 1760. Engraving.
Princeton University Library.

W. Hogarth Inv.ᵗ et Sculp.

13

Figure 7a. William Hogarth, Hudibras wooing the widow,
from Butler's *Hudibras*, 1726. Etching and engraving.
Princeton University Library.

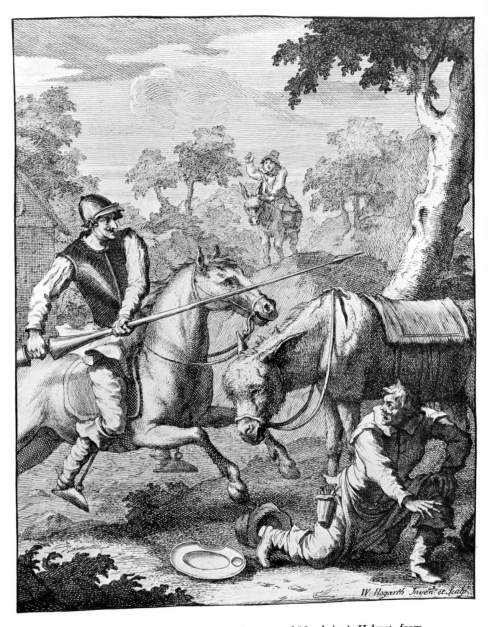

Figure 8. William Hogarth, The Adventure of Mambrino's Helmet, from
Cervantes' *Don Quixote*, 1738. Etching and engraving.
British Museum.

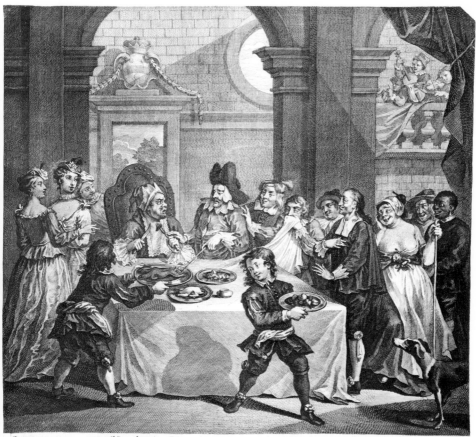

SANCHO at the Magnificent Feast Prepar'd for him at his government of Barataria, is Starved in the midst of Plenty, Pedro Rezzio his Phisician, out of great Care for his health ordering every Dish from the Table before the Governour Tasts it. *Printed for M.Overton & J.Hoole at the White Horse without Newgate* W.Hogarth Inv. et Sculpsit.

Figure 9. William Hogarth, *Sancho at the Magnificent Feast*, before
1732. Etching and engraving.
British Museum.

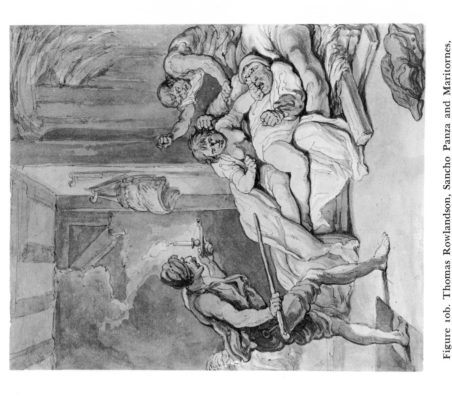

Figure 10b. Thomas Rowlandson, Sancho Panza and Maritornes, after 1755. Pen and ink drawing. Private collection.

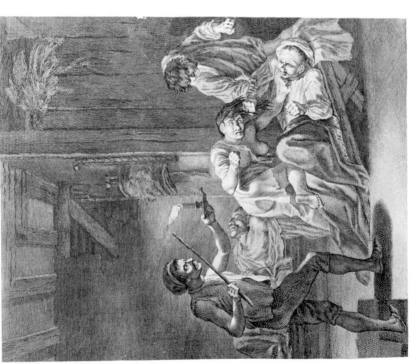

Figure 10a. Francis Hayman, Sancho Panza and Maritornes, from Cervantes' *Don Quixote*, 1755. Etching and engraving. Private collection.

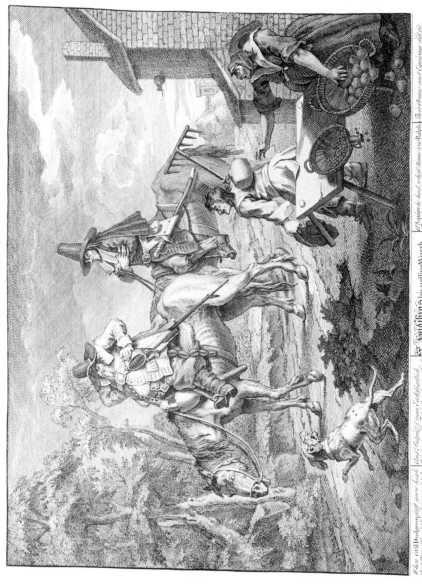

Figure 11. William Hogarth, Hudibras sallying forth, from Butler's
Hudibras, 1725/26. Etching and engraving.
British Museum.

Figure 12a. Richard Newton and Thomas Rowlandson, Yorick and the
monk at Calais, from *The Beauties of Sterne*, 1809. Colored etching.
H. E. Widener Collection, Harvard University Library.

Figure 12b. Richard Newton and Thomas Rowlandson, Yorick and the
grisset, from *The Beauties of Sterne*, 1809. Colored etching.
H. E. Widener Collection, Harvard University Library.

[Page 1]

[Page 2]

Figure 13. George Cruikshank, autograph letter, draft, c. 1841.
Private collection.

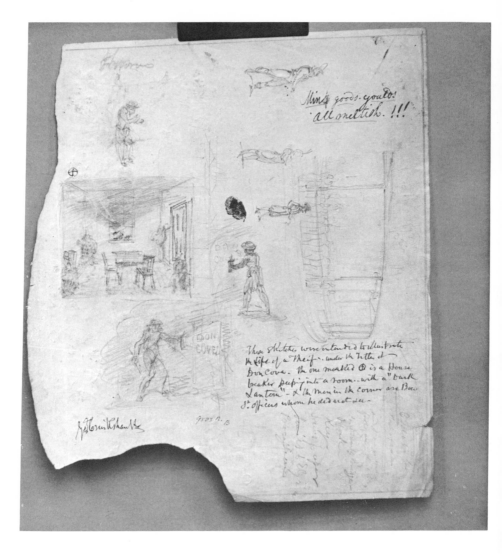

Figure 14. George Cruikshank, notes and sketches, recto, c. 1819. Pencil and ink. Victoria and Albert Museum.

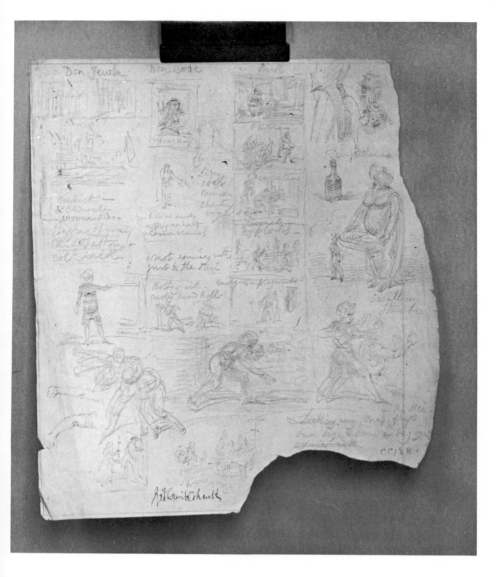

Figure 15. George Cruikshank, notes and sketches, verso, c. 1819. Pencil and ink.
Victoria and Albert Museum.

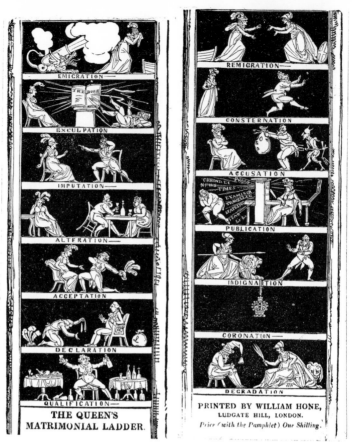

Figure 16a. George Cruikshank, *The Queen's Matrimonial Ladder*, 1820. Woodcut. Princeton University Library.

Figure 16b. George Cruikshank, *The Piccadilly Nuisance*, 1818. Engraving. Princeton University Library.

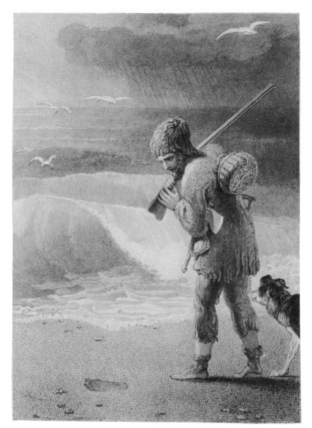

Figure 17a. Thomas Stothard, Robinson Crusoe discovers the print of
a man's naked foot, from Defoe's *Robinson Crusoe*, Cadell and Davies edition, 1820. Engraving.
Victoria and Albert Museum.

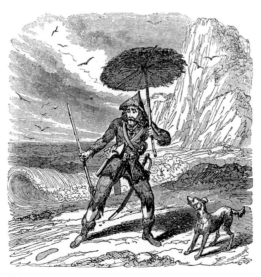

Figure 17b. George Cruikshank, Robinson Crusoe "surprised with the print of a man's naked foot,"
from Defoe's *Robinson Crusoe*, Major edition, 1831. Woodcut.
Princeton University Library.

Figure 18b. George Cruikshank, illustration to
Ainsworth's *The Miser's Daughter*, 1842. Etching.

Figure 18a. George Cruikshank, illustration to
Chamisso's *Peter Schlemihl*, 1823. Etching.

Figure 19b. George Cruikshank, "Humphrey's Disaster," from Smollett's *Humphry Clinker* in Roscoe's Novelist's Library, 1831. Etching. Princeton University Library.

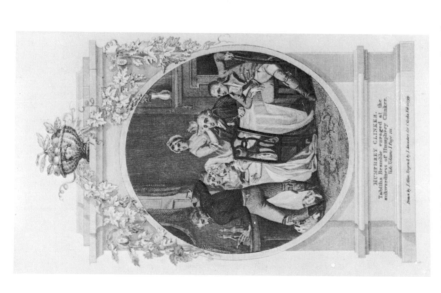

Figure 19a. J. Allan, "Tabitha Bramble enraged at the awkwardness of Humphrey Clinker," from Smollett's *Humphry Clinker* in Cooke's Classics, 1798. Engraving. Victoria and Albert Museum.

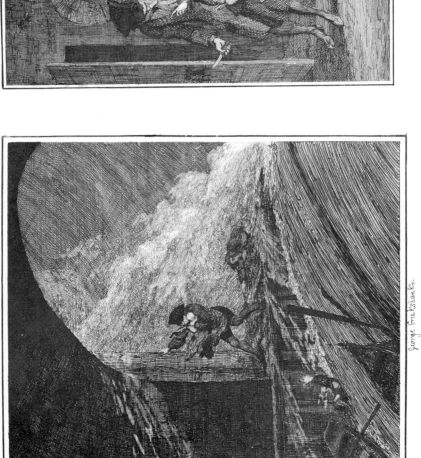

Figure 20a. George Cruikshank, "The Storm," from Ainsworth's *Jack Sheppard*, 1839. Etching. Princeton University Library.

Figure 20b. George Cruikshank, "Jack Sheppard & Blueskin in Mr. Wood's bed-room," from Ainsworth's *Jack Sheppard*, 1839. Etching. Princeton University Library.

Term Time —

Gentlemen — It was a very fine Oyster! the Court awards you a shell each.

Figure 21b. George Cruikshank, from *Illustrations of Time*, 1827. Etching. Princeton University Library.

The Pillars of a GIN-SHOP

Figure 21a. George Cruikshank, from *My Sketch Book*, 1833. Etching. Princeton University Library.

Figure 22b. George Cruikshank, detail from *A Strong proof of the Flourishing state of the Country*, 1819. Etching. Princeton University Library.

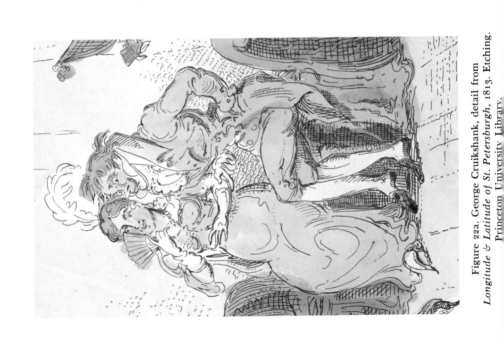

Figure 22a. George Cruikshank, detail from *Longitude & Latitude of St. Petersburgh*, 1813. Etching. Princeton University Library.

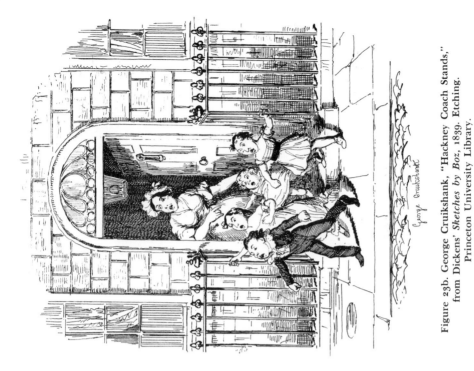

Figure 23a. George Cruikshank, "Hackney Coach stands,"
from Dickens' *Sketches by Boz*, 1836. Etching.
Princeton University Library.

Figure 23b. George Cruikshank, "Hackney Coach Stands,"
from Dickens' *Sketches by Boz*, 1839. Etching.
Princeton University Library.

Figure 24. George Cruikshank, *The Bottle*, Pl. I, 1847. Glyphograph. Princeton University Library.

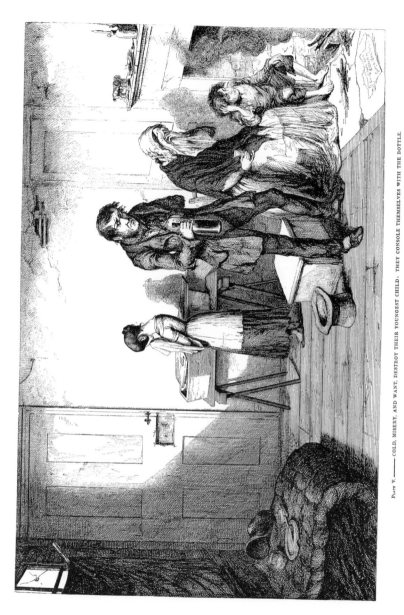

PLATE V. —— COLD, MISERY, AND WANT, DESTROY THEIR YOUNGEST CHILD: THEY CONSOLE THEMSELVES WITH THE BOTTLE.

Figure 25. George Cruikshank, *The Bottle*, Pl. V, 1847. Glyphograph.
Princeton University Library.

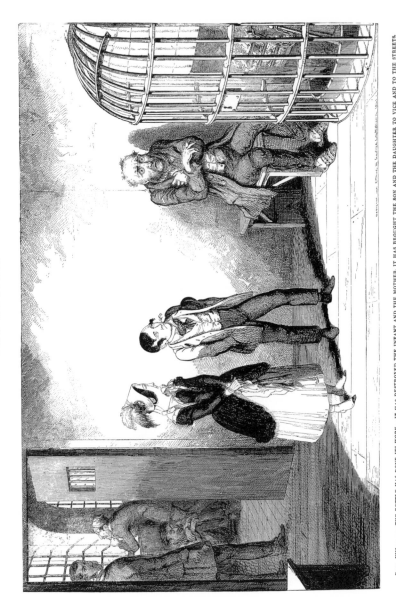

PLATE VIII. ——— THE BOTTLE HAS DONE ITS WORK.—IT HAS DESTROYED THE INFANT AND THE MOTHER, IT HAS BROUGHT THE SON AND THE DAUGHTER TO VICE AND TO THE STREETS, AND HAS LEFT THE FATHER A HOPELESS MANIAC.

Figure 26. George Cruikshank, *The Bottle*, Pl. VIII, 1847. Glyphograph. Princeton University Library.

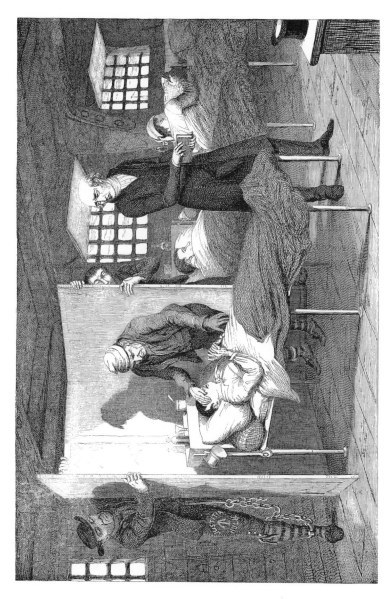

PLATE VII. —— EARLY DISSIPATION HAS DESTROYED THE NEGLECTED BOY. —— THE WRETCHED CONVICT DROOPS AND DIES.

Figure 27. George Cruikshank, *The Drunkard's Children*, Pl. VII, 1848. Glyphograph. Princeton University Library.

PLATE VIII.—— THE MANIAC FATHER AND THE CONVICT BROTHER ARE GONE.—— THE POOR GIRL, HOMELESS, FRIENDLESS, DESERTED, DESTITUTE, AND GIN MAD, COMMITS SELF MURDER.

Figure 28. George Cruikshank, *The Drunkard's Children*, Pl. VIII, 1848. Glyphograph.
Princeton University Library.

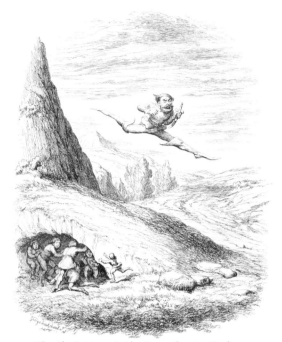

The Giant Ogre in his Seven League Boots
pursuing Hop o'my Thumb & his Brothers, who hide in a Cave

**Figure 29a. George Cruikshank, "The Giant Ogre in his
Seven League Boots," from *Hop-o'-my-Thumb*, 1853. Etching.
Princeton University Library.**

MAY, —— "All a-growing!"

**Figure 29b. George Cruikshank, "All a-growing!"
from *The Comic Almanack*, 1838. Etching.
Princeton University Library.**

THE

POLITICAL SHOWMAN—AT HOME!

EXHIBITING HIS CABINET OF CURIOSITIES AND

Creatures—All Alive!

BY THE AUTHOR OF THE

POLITICAL HOUSE THAT JACK BUILT.

" I lighted on a certain place where was a *Den*." *Bunyan.*

WITH TWENTY-FOUR CUTS.

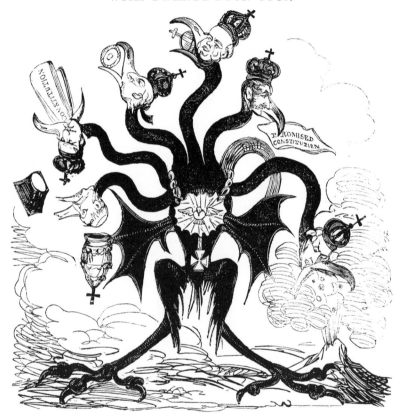

" The putrid and mouldering carcase of exploded Legitimacy."

Mr. Lambton.

LONDON:

PRINTED FOR WILLIAM HONE, 45, LUDGATE-HILL.

1821.

ONE SHILLING.

Figure 30. George Cruikshank, illustrated title page
for Hone's *The Political Showman—At Home!*, 1821. Woodcut.
Princeton University Library.

Figure 31a. Thomas Rowlandson, "The Dram Shop," from Combe's
The English Dance of Death, 1815. Colored aquatint.
Princeton University Library.

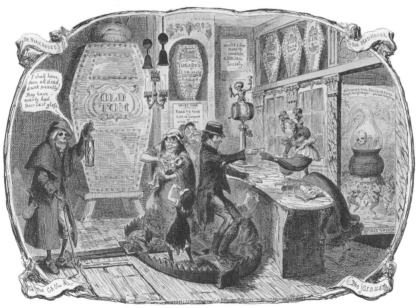

Figure 31b. George Cruikshank, from *Scraps and Sketches*, 1829. Etching.
Princeton University Library.

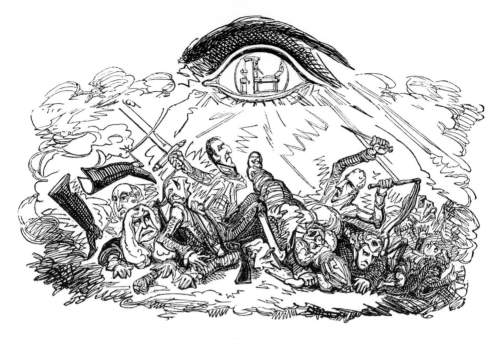

Figure 32a. George Cruikshank, tailpiece from Hone's
The Political Showman—At Home!, 1821. Woodcut.
Princeton University Library.

[Plate 3]

[Plate 4]

Figure 32b. Daniel Chodowiecki, *Progress of Virtue and Vice*, 1778. Engraving.
Princeton University Library.

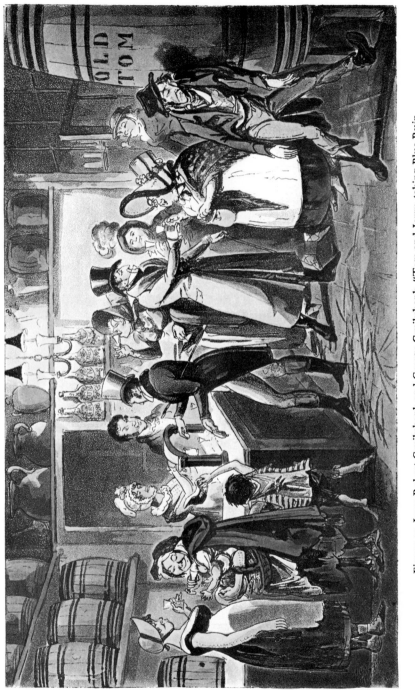

Figure 33. Isaac Robert Cruikshank and George Cruikshank, "Tom and Jerry, taking Blue Ruin, after the Spell is broke up," from Egan's *Life in London*, 1821. Colored etching. Princeton University Library.

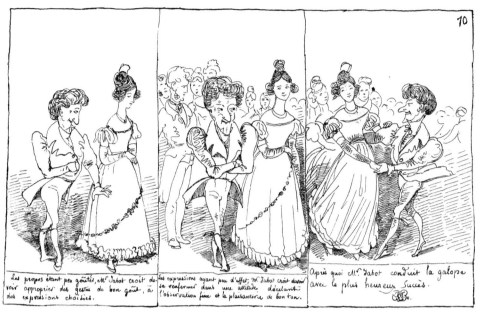

Figure 34a. Rodolphe Töpffer, Mr. Jabot meets Mlle. du Bocage,
from the *Histoire de Mr. Jabot*, Pl. 10, 1835. Etching.
Princeton University Library.

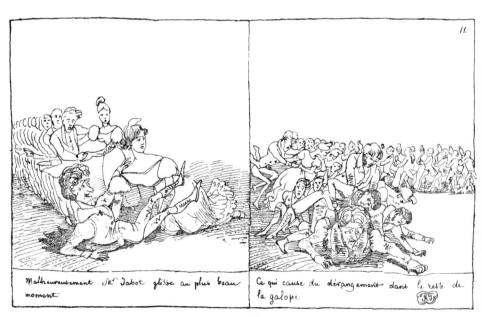

Figure 34b. Rodolphe Töpffer, Mr. Jabot slips,
from the *Histoire de Mr. Jabot*, Pl. 11, 1835. Etching.
Princeton University Library.

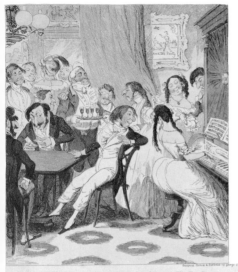

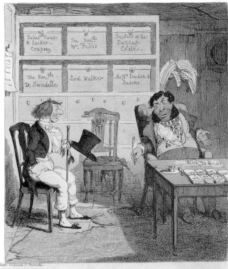

Mʳ Lambkin makes some most delightful acquaintance.- The Hon. D.
Swindelle and his delightful family, his Ma, such a delightful lady!- and
his Sisters, such delightful girls!!- Such delightful musical parties,-such
delightful soirées, and such delightful card parties,- and what makes
it all still more delightful is that they are all so highly delighted
with Mʳ Lambkin -

Mʳ Lambkin in a moment of delightful delirium puts his name to some
little bits of paper to oblige his very delightful friend the Hon. D.
Swindelle, whom he afterwards discovers to be nothing more than
a rascally Black-leg.- He is invited to visit some chambers in one of
the small Inns of Court, where he finds himself completely at the *mercy*
of Messʳˢ Ogre and Nippers. whose demands make an awful hole in his
Cheque-book.

Figure 35a. George Cruikshank, Mr. Lambkin meets the Swindelles
and Messrs. Ogre and Nippers, from *The Bachelor's Own Book*,
Pl. 7, 1844. Colored etching.
Princeton University Library.

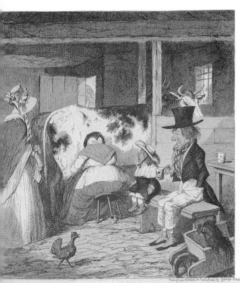

Mʳ Lambkin's confidence in the curative powers of Hydropathy being very
much damped, and being himself quite soaked through, in fact almost wash-
-ed away, he takes to the good old—fashioned practice of walking early
in the morning, and drinking "New Milk from the Cow."

Mʳ Lambkin being quite recovered, with the aid of new milk and Sea
Breezes, determines to reform his habits, but feels buried alive in the
Grand Mausoleum Club; and, contemplating an old bachelor member
who sits poring over the newspapers all day, he feels horrorstruck
at the probability of such a fate becoming his own, and determines
to seek a reconciliation with the Lady of his Affections.

Figure 35b. George Cruikshank, Mr. Lambkin drinking "New Milk from the Cow" and
resolving to reform, from *The Bachelor's Own Book*, Pl. 11, 1844. Colored etching.
Princeton University Library.

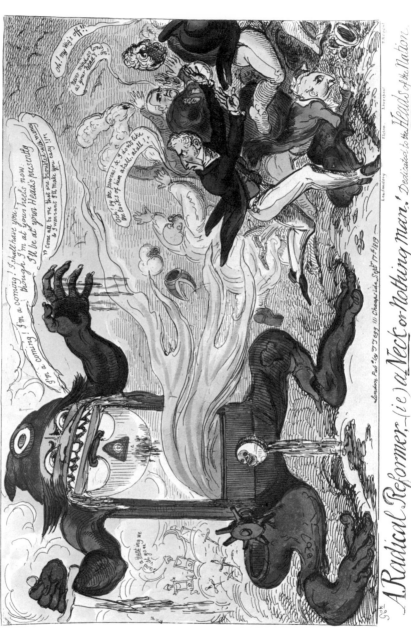

Figure 36. George Cruikshank, *A Radical Reformer*, 1819. Colored etching. Princeton University Library.

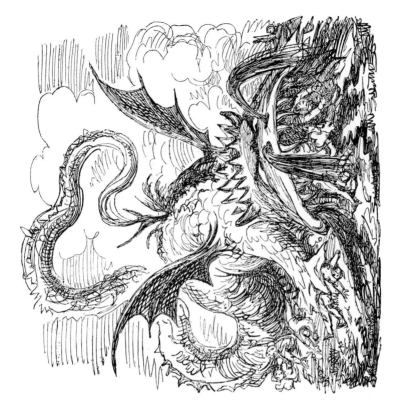

Figure 37b. George Cruikshank, "The Legitimate Vampire," from Hone's *The Political Showman—At Home!*, 1821. Woodcut. Princeton University Library.

Figure 37a. George Cruikshank, pencil drawing, no date. British Museum.

Figure 38b. George Cruikshank, "Commentary upon the 'New Police Act' (No. 2)," from *George Cruikshank's Omnibus*, 1841. Etching. Princeton University Library.

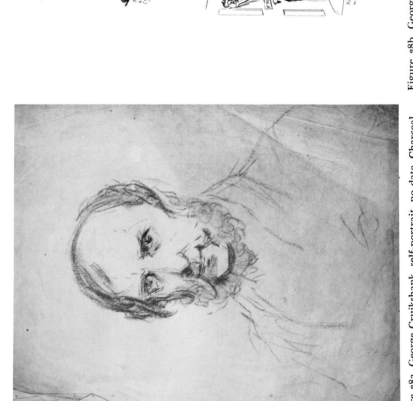

Figure 38a. George Cruikshank, self-portrait, no date. Charcoal. British Museum.

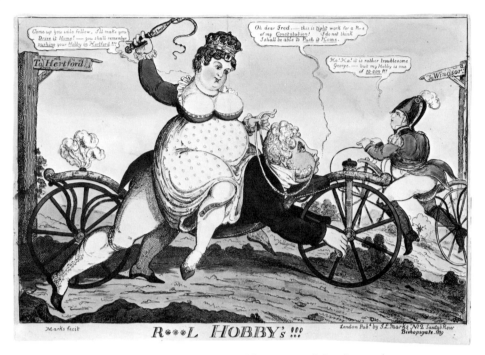

Figure 39a. J. L. Marks, *R***l Hobby's!!!*, 1819. Colored engraving.
British Museum.

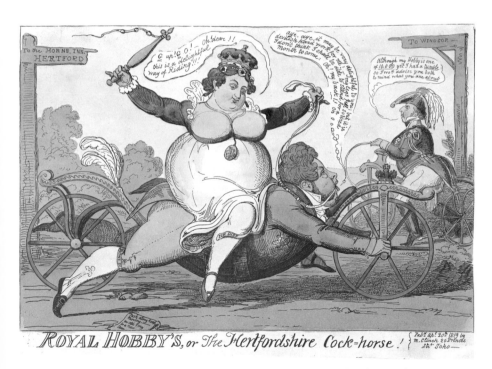

Figure 39b. George Cruikshank's *Royal Hobby's*, 1819. Colored engraving.
Princeton University Library.

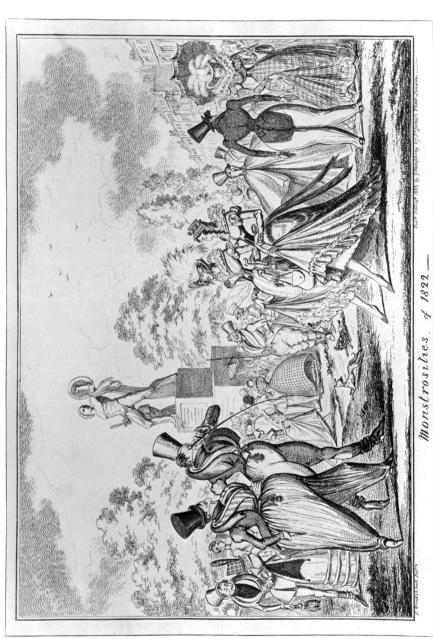

Monstrosities of 1822

Figure 40. George Cruikshank, *Monstrosities of 1822*, 1822. Engraving. British Museum.

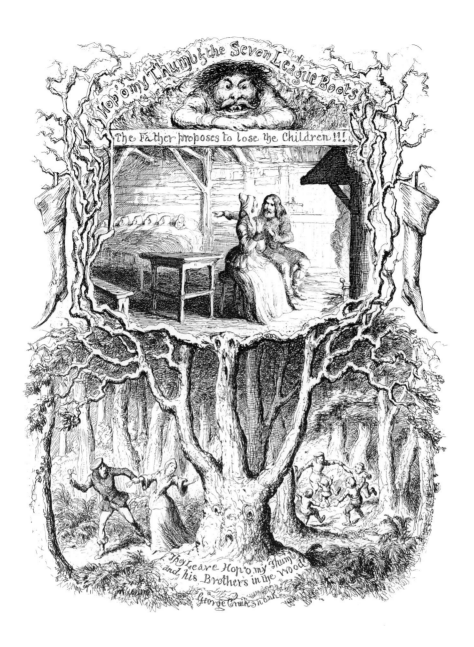

Within the illustration, the following text appears:

Hop'o'my Thumb & the Seven League Boots

The Father proposes to lose the Children !!!

They leave Hop-o'-my Thumb and his Brothers in the Wood

George Cruikshank

Figure 41. George Cruikshank, illustrated title page for
Hop-o'-my-Thumb, 1853. Etching.
Princeton University Library.

such libellous slander against any family, noble by birth or otherwise; nor would you, now that I have pointed out the objectionable parts of the old editions, place them in the hands of any of your little ones, nor desire that they should fall into the hands of any other children. Feeling and knowing all this, and with the highest admiration for your great talents, and esteem for your personal worth,

 I have the honour to be, Sir, your most obedient servant,

<div align="right">HOP-O'-MY-THUMB.</div>

P.S.—I had almost forgotten to notice your "Whole Hogs," in which, it appears to me, you have made another great mistake—in using that term in connexion with the Vegetarians, the Peace Society, and the Temperance people. You are generally most happy in your titles; but, in this instance, the application seems singularly inappropriate. The "whole hog" should, by rights, belong to those parties who patronize pork-butchers; and the term as applied to the Peace people would be better used in regard to the Great Bear, or any other war party; and surely, as to any allusion to the "unclean animal," in connexion with total abstinence, the term would more properly attach to those who wallow in the mire, and destroy their intellects by the use of intoxicating liquors, until they debase themselves to the level of the porcine quadruped! And, as far as my editor is concerned, I consider it a great act of injustice to mix him up with other questions, and with which, *you know*, he has nothing whatever to do. I have therefore to beg, that in future you will not drive your "whole hogs" against us, but take them to some other market, or keep them to yourself if you like; but we'll none of 'em, and therefore I take this opportunity of driving them back.

Figure 42. George Cruikshank, last page of *George Cruikshank's Magazine*, 1854. Woodcut.
Princeton University Library.

Figure 43a. George Cruikshank, "Quarter Day,"
from *The Comic Almanack*, 1844. Etching.
Princeton University Library.

Figure 43b. George Cruikshank, "Guy Fawkes treated
Classically," from *The Comic Almanack*, 1844. Etching.
Princeton University Library.

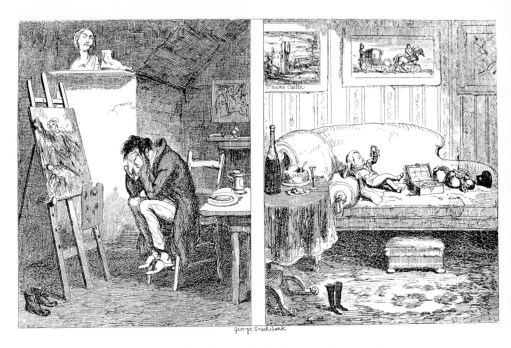

Figure 44a. George Cruikshank, "Born a Genius and
Born a Dwarf," from *The Comic Almanack*, 1847. Etching.
Princeton University Library.

Figure 44b. George Cruikshank, subscriber's ticket to
purchase fund for *The Worship of Bacchus*, c. 1868. Etching.
Victoria and Albert Museum.

ing. Certainly Cruikshank's work shows that he can be counted among those artists whom Edward Ardizzone ranks as born illustrators, for Cruikshank has the two characteristics necessary for such beings: "The first is that their creative imagination is fired by the written word rather than the thing seen; the second is that when it comes to their illustrations, they would rather make them up than have recourse to life."[4] For such illustrators, Ardizzone recommends copying as a source of inspiration, so it may be as well to consider at this point whether, in his illustrations to fiction, Cruikshank copied, and what there was to copy from.

III

Many of his earliest illustrations for fiction—mere bread and butter work—were done in the second and third decades of the nineteenth century for children's books and cheap chapbooks. Often enough he contributed only a crudely etched frontispiece which would later be blotched with color by hand; there is seldom much to be learned from a frontispiece about an artist's comprehension of a work. Or, sometimes, he would provide designs for a set of woodcuts, as in the case of Wallis's *Juvenile Tales* (Cohn 826, 15 vols., 1822-23) or in the series of story books by William Gardiner (Cohn 336-45). His illustrations for Gardiner's oeuvre were re-used from one little volume to another, for each volume consisted of a number of separate stories, and the possibilities of permutation were endless. If these illustrations really are, as the title-pages claim, by Cruikshank, they are quite uninspired. Indeed, there is little in Gardiner's tales to inspire. Although they are dressed up in Oriental trappings, so as to fascinate the juvenile mind, and although they are granted the additional allurement of illustrations, their clear aim is to convince the child that he must suppress his imagination. In tale after tale, this subversive force (symbolized in "The History of Prince Iris" as a Purple Horse) drives unfortunate youths into wild and visionary courses which only lead to disillusion, or perhaps to the depressing appearance of "an old man with a long white beard, leaning on a staff." " 'My name is Experience,' said the aged Sire; 'Rise, and follow me, for thou art now cured of thy folly . . .' "[5] It is hard to

[4] E. Ardizzone, "The Born Illustrator," *Motif*, 1 (November 1958), 37.
[5] In "The Folly of Extravagant Riches" in *Original Tales from my Landlord* (c. 1821). "The History of Prince Iris" is also included in this volume.

imagine Cruikshank responding enthusiastically to this kind of thing, and it is no surprise that his illustrations are untouched by his peculiar genius and are no better than run-of-the-mill chapbook cuts.

A much more interesting case is *Robinson Crusoe*. By the beginning of the nineteenth century this work was firmly established in chapbook literature (where it rubbed shoulders with such tales as *The History of Tom Thumb* and *The Life of Jack Sprat*), and many sets of crude illustrations to it were in circulation. One set of seven woodcuts is, indeed, attributed to "Cruikshank."[6] They are livelier than some, but not noticeably better than, for instance, the set of six in William Davison of Alnwick's *New Specimen of cast-metal ornaments* (c. 1815; nos. 263-68). These are worth noting: the fact that a printer's supplier included cuts for *Robinson Crusoe* among the ships, royal arms, blocks for tea-packet labels, and other miscellaneous illustrations that he offered for sale in his specimen,[7] tells us something of the great popularity of *Robinson Crusoe* in cheap illustrated editions.

The subjects depicted in the chapbook cuts are a fairly standard selection. Crusoe on his raft, at home in his hut, and discovering Friday's footprint, are perhaps the commonest, while other frequent subjects are Crusoe threatening to shoot the swimming Moor, Xury shooting the lion, Crusoe finding the goat in the cave, and the savages dancing round their fire. The last is especially interesting. Cruikshank used it in his 1831 edition, and Ruari McLean singles it out for praise because of the profound impression the black dancing figures and their curving canoes made on his mind when he read the book in the nursery.[8] But this subject was not Cruikshank's invention. It dates from the first (1719) edition of *Robinson Crusoe*, where, on the engraved map of the island, the dancing savages are to be seen along with their canoes. The first edition also, in its frontispiece, established the style of Crusoe's suit of skins.[9] There was, then, a popular tradition

6 See Edwin Pearson, *Banbury Chap Books* (London, 1890), p. 40; also reproduced in *1000 Quaint Cuts from Books of Other Days . . . from Original Blocks Belonging to the Leadenhall Press* (London, 1886), p. 14.

7 There are more *Robinson Crusoe* cuts on later pages: nos. 845-46, 849-54.

8 Ruari McLean, *George Cruikshank, His Life and Work as a Book Illustrator* (London, 1948), p. 19.

9 See G. S. Layard, "Robinson Crusoe and Its Illustrators," *Bibliographica*, 2 (1896), 181-203.

of *Robinson Crusoe* illustration, and it continued: two other un-dated illustrated chapbook versions I have seen were printed by Evans of Smithfield (c. 1820-30?) and the Yorkshire J. S. Publishing and Stationery Co. of Otley (c. 1840?).[10]

Cruikshank, whether or not it was he who made the series of chapbook cuts attributed to him, must have been well acquainted with such popular illustrations to *Robinson Crusoe*; and I think that they must have been in his mind when he designed the wood-engraved illustrations for Major's 1831 edition of Defoe's story (Cohn 229, cf. Cohn 227-28, Figure 17b).[11] Although Cruikshank withholds none of his skill and understanding from these, they relate in scale and composition (and, of course, technique) to the chapbook cuts.

To judge from his Preface, the publisher John Major hoped, so far as possible, to reach both a popular and a cultivated audience with this edition. He seems to think of the book pre-eminently as a children's story, but emphasizes in a footnote that "it has also been pronounced to deserve a place in the library of every scholar and man of taste": therefore, he claims, "the TEXT . . . is restored in this edition by a careful collation with the early copies." Furthermore, the book, although modest in format, is excellently printed by William Nichol; and Major, when he compares its illustrations with "the celebrated Series by the admirable Stothard," implies that his book will hold its own against the ample Cadell and Davies edition of 1820 in which Stothard's illustrations made their second appearance (Figure 17a).[12] The comparison of Stothard's and Cruikshank's illustrations will help us to perceive the special virtues of the latter.

They are, above all, more spirited than Stothard's, which are like most of his work in taking refinement to the edge of enfeeblement. In Stothard's plates, Crusoe looks listless, even when he comes upon the footprint: he looks askance at it, morosely, not at all "like one thunderstruck." Cruikshank's Crusoe, more like a

[10] The dates I give are based on the list of publishers' working dates in Judith St. John, *The Osborne Collection of Early Children's Books 1566-1910: A Catalogue* (2nd edn., Toronto: Toronto Public Library, 1966).

[11] According to Cohn, Cruikshank had provided six etched illustrations for an earlier edition published by Fairburn, undated.

[12] Engraved by Charles Heath; they had previously appeared, engraved by Medland, in Stockdale's 1790 edition. An earlier set had appeared in 1781 in the edition in Harrison's *Novelist's Magazine*.

chapbook mannikin, recoils melodramatically, with tense limbs. But besides this somewhat naive vigor, there is in Cruikshank's illustration a characteristic touch of psychological penetration, which distinguishes his treatment of this incident from Stothard's and from the chapbook tradition. Crusoe is accompanied by his dog. In many illustrations the dog, like Crusoe, looks anxiously at the footprint. In Stothard's plate the dog is not taking notice at all, and seems to be looking through Crusoe's legs at the sea. But in Cruikshank's illustration, the dog, recoiling, looks anxiously at Crusoe as Crusoe looks anxiously at the footprint: and this, surely, is right and natural.

Stothard's illustrations give the impression that Crusoe's life on the island was an idyll. We see him strolling about in what seems to be beautiful English parkland. Even in his illustration of Crusoe on his raft, Stothard introduces a "lovely and inviting sylvan scene in the background." This he put in because he had dreamed it, and "therefore, endeavoured to throw his vision upon paper."[13] Cruikshank's illustrations suggest a different view of Crusoe's condition. There are more of them than of Stothard's illustrations:[14] this means that Cruikshank, as well as using traditional subjects, had the opportunity to choose some fresh ones. The new subjects that he chooses emphasize Crusoe's loneliness, and tend to show him at moments of psychological drama. In Cruikshank's set, as in Stothard's, we begin with Crusoe shipwrecked and Crusoe on his raft. Stothard's next illustration shows us Crusoe at home in his hut, comfortable and serene. Cruikshank does not give us this subject until much later, in Crusoe's eleventh year on the island, and it is placed (intentionally, no doubt, for the cuts are carefully dropped into the text at the precisely appropriate point) so that Crusoe's ironic description of the scene ("It would have made a stoic smile, to have seen me and my little family sit down to dinner") keeps at bay the sentimentality that enfolds Stothard's illustration. Stothard does not depict Crusoe's initial struggle for survival, but Cruikshank does. He shows us Crusoe shooting his first wild goat (p. 87), Crusoe setting up the cross on which he notched the passage of days (p. 91), Crusoe thanking God for deliverance from sickness (p. 135), Crusoe making his first unsuccessful attempt to construct a boat (p. 180—

13 Mrs. Bray, *Life of Thomas Stothard, R.A.* (London, 1851), p. 120.
14 Stothard: 22 engraved plates; Cruikshank: 38 woodcuts and 2 engraved plates.

Stothard has a plate showing Crusoe making a later boat with Friday's assistance, but Friday does not figure much in Cruikshank's illustrations; Cruikshank does, however, depict the tame kid which mitigates Crusoe's loneliness, p. 158), Crusoe sailing round the island in the canoe that he later successfully completed (p. 195). Apart from the illustrations of Crusoe discovering the footprint, and the savages dancing round their fire (a subject not attempted by Stothard), the rest of Cruikshank's illustrations are less striking, and no conclusions readily offer themselves in connection with the illustrations to Part II. But the series of designs I have picked out seems to demonstrate that Cruikshank responded eagerly to the text he was illustrating—notwithstanding that he might have contented himself with reproducing subjects already well-known through chapbook cuts—and that he responded most intensely to moments of crisis in Crusoe's solitary struggle for survival. We may suppose that Cruikshank was like any good reader in identifying himself with Crusoe. But he went beyond mental identification: for according to Major's Preface, he used himself as a model for Crusoe. "Those who are personally acquainted with him," says Major, "will be not a little pleased to recognize *his own Portrait* in the earlier scenes." Cruikshank's impersonation of Crusoe can symbolize for us his close involvement in the story, an involvement that led him to select for representation a series of psychological crises.

IV

After *Robinson Crusoe* Cruikshank did not further draw on or develop the popular tradition of illustration by small wood-engravings. For by 1831 he had found his own style of illustrating fiction: by full-page etchings. His adoption of this style can be dated to 1823, when he produced his etchings for *Points of Humour* (Cohn 176). "It is remarkable," Cornelis Veth observes, "that in these he almost suddenly found his own style, a style wholly different from that shown in his political prints His own manner manifests itself not only in a more sober form of caricature, but in the handling of the lights and shadows, in which he at once attained excellence."[15] Added force is given to this remark if one recalls that 1823 also saw the appearance of Cruikshank's

[15] Cornelis Veth, *Comic Art in England* (London, 1930), p. 72.

eight etched illustrations to Chamisso's *Peter Schlemihl* (Cohn 475). These are outstanding among his book illustrations, although they are among the earliest. Peter Schlemihl, it will be remembered, sells his shadow to a grey gentleman in return for a magical purse which provides an inexhaustible supply of money. Riches do not, however, protect him from the horrified rebuffs of his fellow men when they discover his lack of a shadow; and the grey gentleman dogs him in pursuit of his soul. Shadows and lights, then, play an important part in the story, and in his etchings Cruikshank renders them both brilliantly and subtly, achieving effects which would be impossible with wood-engraving. Outstanding is his illustration to chapter iv, showing Peter awaiting the return of the grey gentleman after a year and a day (Figure 18a). Peter sits eyeing his clock (as midnight approaches) in front of a flaring lamp; all the furniture casts deep shadows but Peter sits shadowless in the full glare; arms folded and one hand raised to his mouth in a gesture of fear. The upper half of his body is in an attitude not unlike that of Fagin in the condemned cell; that later etching is a much grimmer study of terror, but the comparison is permissible, perhaps, in order to emphasize how well Cruikshank has caught the uncanny, frightening, sometimes desperate tone of the German tale.

As we have seen, he responded keenly to the parts of *Robinson Crusoe* in which the hero was alone and fighting for life. In *Peter Schlemihl* the hero is in some sense an outcast like Crusoe, and in Cruikshank's illustrations he is shown either solitary (like Robinson Crusoe in the illustrations to which I particularly drew attention), or accompanied by a single figure. There are crowd scenes in the novel but not in Cruikshank's illustrations. In all of these Peter is dominant, and the illustrations, studied apart from the book, tell a good deal of the story by themselves. Here Cruikshank has succeeded in giving something of the force of narrative to his illustrations. Perhaps it is not too fanciful to add that, in the strangely elongated and spidery forms of Peter and the other characters, he expresses in visual terms the jerky, feverish narrative style of the novel. Another noteworthy feature of the *Schlemihl* illustrations is the sympathetic rendering of German landscape: Cruikshank's sympathy was nourished, no doubt, by his reading of Grimm's tales, for which he provided brilliant illustrations—again in 1823, a wonderful year for him.

Peter Schlemihl was an exceptional achievement; *Points of Humour* established a style that was to be typical of Cruikshank. It appeared in two parts in 1823 and 1824. Of the ten "Points" in the first part, four illustrate Burns's "Jolly Beggars" and three of those are no more than caricatures. The rest of the etchings illustrate short anecdotes and are subtler, fuller productions. The Preface remarks upon the difficulty of selecting subjects for illustration. "No artist can embody a point of wit," the writer observes. We have seen that this is not true of Cruikshank, but still, it is reasonable to argue that "those ludicrous subjects only which are rich in the humour of *situation* are calculated for graphic illustration," and it is to situations that Cruikshank accordingly applies himself. He proves to be very good at conveying the differing feelings that activate the various persons brought together in a situation, and at indicating how the persons are interacting with each other. Any artist could draw a procession of priests falling downstairs (Point IX), but Cruikshank's special skill is revealed in, for example, Point X in his depiction of the baffled resentment of Cardinal Bernis, the sarcastic courtesy of Prince B, and the surprise, glee, and expectation of the watching attendants.

In the second part of *Points of Humour*, the Preface observes that "it has been said that it is a pity Mr. Cruikshank should waste his talents upon ephemeral anecdotes, and not hand down his name by illustrating the works of our great Novelists." For this set of Points, therefore, recourse has been had to one of the English novelists: Smollett. The Preface explains that Smollett has been preferred to Fielding because he "is rich in that which is uncommon and eccentric. His field is among oddities, hobby-horses, foibles and singularities." As a result we find several rather poor plates by Cruikshank in which there is far more of grotesquerie than of the humor of situation. By way of explaining why Fielding was unsuitable for illustration, the Preface says: "Fielding is a master in the power of laying open all the springs which regulate the motion of that curious piece of mechanism, the human heart." One would have thought that it was just this which would make his works abound in good subjects for Cruikshank.

Cruikshank did illustrate Fielding's novels—and Smollett's, and Sterne's *Tristram Shandy*, Goldsmith's *Vicar of Wakefield*, Cervantes' *Don Quixote* and Le Sage's *Gil Blas*—for Roscoe's Novelist's Library in 1831 (Cohn 701-11). His illustrations again

103

take the form of an unframed etching filling an upright full page, and showing three or four figures, each two or three inches high. This was the style Cruikshank had adopted as his own in *Points of Humour*; moreover it is the style that precedent would have dictated for illustrations to the classic English novels.

Few of the great English novels were illustrated on their first appearance. As we have seen, *Robinson Crusoe* was; and a later set of illustrations was much reprinted.[16] But this book, like *Pilgrim's Progress* (first illustrated in 1680, and in 1728 illustrated with a set of engravings by John Sturt which remained current through the eighteenth century[17]), did not achieve the status of a classic English novel. Fielding's *Joseph Andrews* was disappointingly illustrated by J. Hulett in 1743. *Tom Jones* was well illustrated by Gravelot in the French edition of 1750; but Gravelot's rococo elegance is too French for Fielding, who ought to have been illustrated by Hogarth. Hogarth did illustrate Sterne's *Tristram Shandy*—at least he provided frontispieces for the second edition (first London edition) of volumes I and II (1760)—but he is too downright to match the devious moods of that book. Smollett's *Peregrine Pickle* was given an interesting, odd set of illustrations in 1769 by Henry Fuseli: very early and quite uncharacteristic work. For the 1748 edition of *Roderick Random* two frontispieces were designed by Francis Hayman, who, along with Gravelot, provided illustrations for the 1742 edition of Richardson's *Pamela*. This can claim to be the first well-illustrated English novel, and Richardson was luckier in his illustrators than the other novelists. The sixth edition of *Clarissa* (1768) was illustrated by Samuel Wale, and the seventh edition of *Grandison* in 1778 by Isaac Taylor. In addition, of course, there were engravings after Highmore's paintings illustrating *Pamela*. Richardson suited the illustrators best, perhaps, because his works were not humorous or satirical, and were adequately illustrated by pretty and rather sentimental scenes of middle-class life, which was what the illustrators were good at. All the illustrations to which I have referred have a common format: the upright oblong shape, filled with a group of two or three figures. And apart from Highmore's engravings, they have the same scale, the duodecimo or small

16 Layard, p. 188.
17 See Frank Mott Harrison, "Some Illustrators of *The Pilgrim's Progress* (Part One): John Bunyan," *Library*, 4th ser., 17 (1936), 241-63.

octavo page, which was to be the scale of Cruikshank's etchings.

Later in the eighteenth century Rowlandson illustrated several eighteenth-century novels,[18] with colored aquatints of a flat oblong shape. They are undeniably lively but have more of Rowlandson's characteristic spirit than of the spirit of the authors they illustrate. Rowlandson's aquatint illustrations to the Dr. Syntax books and to the *English Dance of Death* were to exert their influence on Cruikshank when he helped to illustrate Pierce Egan's *Life in London* (Cohn 262, 1821) and David Carey's *Life in Paris* (Cohn 109, 1822); but Rowlandson cannot be counted an important influence in the illustration of fiction.

In the late eighteenth century, while the caricaturists apart from Rowlandson concentrated on political satire—Gillray did only two rather good fiction illustrations, for *Tom Jones*[19]—the illustration of fiction remained in the hands of Thomas Stothard and his school. Around the turn of the century these illustrators were much in demand to decorate the numerous cheap series of reprints of the classics of English literature, poetry and essays as well as fiction.[20] Stothard did a great deal of work for Harrison's *Novelist's Magazine* and John Bell's *British Theatre* and *British Poets*, Richard Westall contributed extensively to John Sharpe's British Classics, Henry Corbauld illustrated many of Cooke's Classics. Their style hardly rose above the decorative, and indeed in their illustrations the elaborate frames by which the figure subjects are surrounded are as attractive as the subjects themselves. Cruikshank did not waste labor on frames: there are only three framed illustrations among those he did for Roscoe's Novelist's Library, and these have quite simple rococo cartouches, not the elaborately symbolic surrounds of the earlier series. The illustrations to these series are never less than pretty; those for poetry are often no more than pretty, but the artists seem to have been stimulated to their rather nerveless best by the novels they illustrated. Even so, when Cruikshank came to novel illustration from political satire, he brought some much needed spirit, and greater competence in the depiction of human passions. An illustrator like Stothard would instinctively prefer elegant poses

18 See Edward C. J. Wolf, *Rowlandson and His Illustrations of Eighteenth Century English Literature* (Copenhagen, 1945).
19 See Draper Hill, *Mr. Gillray The Caricaturist* (London, 1965), Pls. 21, 22.
20 See "The Cheap Movement in Literature," *Book-lore*, 4 (1886), 10-12.

and balanced compositions to intense depictions of feeling. But a caricaturist must learn above all how to suggest by expression and attitude all the seething passions which he wishes to impute to his quarry. Furthermore, the political caricaturist usually carries on a long campaign against his antagonists, and learns how to throw their figures into all kinds of attitudes, how to give them a sustained and varied individuality, while the illustrator may not need to bother with such variation if he only has to depict his hero once or twice.

Cruikshank, then, had not a great deal to learn from earlier illustrators of fiction, but he was, we may suggest, familiar with their work. For example, his illustration (for Roscoe's *Peregrine Pickle*) of "Hatchway's Experiment to rouse Peregrine" seems to have been copied from Corbauld's illustration of this incident ("Peregrine's agitation on the news of his succession to his father's fortune considered as a delirium by Hatchway who discharges a pitcher of water at him") in Cooke's Classics. There are one or two other similarities: "The Magician" (*Peregrine Pickle*) and "Humphrey's [*sic*] Disaster" (*Humphry Clinker*) are close to illustrations for Cooke's Classics also (Figures 19a and 19b).

Cruikshank's illustrations have pronounced characteristics of their own. They almost all depict moments of tension and crisis, often moments of intense emotional engagement for a group of figures. There are some grotesques, such as Lismahago in *Humphry Clinker* or Parson Trulliber in *Joseph Andrews*, but Cruikshank does not exhibit them for the sake of their external oddity alone. He depicts them in situations that enhance the oddity of their characters: thus Lismahago capers because he is relishing his retaliation upon Sir Thomas Bulford, and Trulliber swells because he is triumphing over Adams who has fallen into the pigsty. Cruikshank's figures, grotesque or not, reveal themselves most fully in encounters, and encounters are accordingly the principal feature of the illustrations to Roscoe's Novelists. There are fights: "Roderick Random threatening to execute justice on Gawky," "The Battle Royal in the Church Yard" (*Tom Jones*), "Squire Western's Rage with Tom Jones." And mishaps: "Humphrey's Disaster" (*Humphry Clinker*), "Strap's misfortune in the Dining Cellar" (*Roderick Random*). Cruikshank vividly expresses the tensions that quiver between the tightly grouped figures in these encounters: their faces are distorted with passion

106

and their limbs fly out in angular, uninhibited gestures of aggression. Less violent but equally intense are the illustrations in which Cruikshank depicts frights: "Strap's fright at the Raven" (*Roderick Random*), "Davy Jones" (*Peregrine Pickle*), "The Affrighted Sentinel" (*Tom Jones*). Or discoveries: "Roderick Random & the Bumpkins," "Square discovered in Molly Seagrim's apartment" (*Tom Jones*), "Booth discovered in the Hamper" (*Amelia*). Here staring eyes and open mouths make visible the alarm of the protagonists, and their conflicting impulses to attack and retreat, which root them to the spot, are well caught by a trick Cruikshank has of jack-knifing his figures at the joints so that their limbs and bodies are physically bending both forward and back.

Having achieved these excellent and lively illustrations to the English classics, Cruikshank was ready to illustrate the fiction of his own day. We shall see that here also he was to record some memorable moments of encounter.

V

John Harvey has shown how fiction in the later 1830s customarily appeared with illustrations.[21] After the success of *Pickwick*, publishers were keen to issue novels either in monthly illustrated parts or through monthly illustrated magazines. As it turned out, much of the fiction that Cruikshank illustrated was serialized in magazines.

This was the case with *Oliver Twist*, the first serial novel in *Bentley's Miscellany* (Cohn 69), a magazine for which Cruikshank acted as resident artist from 1837, when it began, until 1841, when he broke with Bentley. The illustrations to *Oliver Twist* seem to me to be such an exceptional example of all that is interesting and original in Cruikshank's work that I propose to leave them until last. Cruikshank usually etched two plates for each issue of *Bentley's* (though other artists contributed occasionally), one for the serial novel then in progress, and the other for a shorter contribution. He executed, therefore, a good many single illustrations which are of little concern to us here. Some have remained well known, as for instance those he did for the *Ingoldsby Legends*,

21 John Harvey, *Victorian Novelists and their Illustrators* (London, 1970), chapter i.

107

which are in a rather hearty and slick style. Most of the others have sunk into oblivion, though some are full of brio, such as those for M. H. Barker's *Nights at Sea*. This was not quite a novel, being a series of nautical tall stories held together by a narrative of life on board a man-of-war. Nobility and sentiment on the quarter-deck, quaint backchat among the jolly tars, purple passages on storms and sunsets, and dashing descriptions of sea-battles make up the linking narrative. The tall stories are told with a gusto which Cruikshank (who always liked to draw sailors) matched in his lively illustrations. One of the most spirited shows the brave sailor Bob Martingal rescuing a lovely damsel from Davy Jones, who has rather ineffectually disguised himself as a ship's captain: a cocked hat hides his horns, a black patch covers one eye " 'cause it was a ball o' fire as looked like a glowing cinder in a fresh breeze" and only a rustling in his trousers betrays

". . . a tail as long—"
"Almost as long as your'n, I suppose," said old Jack Sheave-hole; "a precious yarn you've been spinning us, Mister Bob!"

In this illustration Cruikshank recalled and improved upon his earlier Davy Jones in the Roscoe *Peregrine Pickle*.

Between 1826 and 1844 he illustrated several other books by M. H. Barker, the earliest being *Greenwich Hospital* (Cohn 53, 1826), which had twelve hand-colored etchings. These large compositions stand between the colored etchings of *Life in London* and Cruikshank's later etched illustrations in black and white, such as those for *Bentley's*. The racy ebullience of the plates for *Greenwich Hospital* is not lost in the illustrations for *Nights at Sea*, while these show a great gain in tonal expressiveness.

Cruikshank's main work for *Bentley's*, apart from the plates for *Oliver Twist*, was the series of illustrations for Ainsworth's *Jack Sheppard*, which was serialized from January 1839 to February 1840, overlapping for a time with Dickens's novel. Cruikshank had already contributed illustrations to the fourth (1836) edition of Ainsworth's *Rookwood* (Cohn 11), but *Jack Sheppard* is the first novel upon which they collaborated over an extended period. Their collaboration was to continue with *Guy Fawkes*, which also appeared in *Bentley's* from January 1840 to November 1841: by this time Cruikshank was trying to sever his connection with Bentley, and his illustrations for this work were

purposely poor.[22] Their next work, *The Tower of London* (Cohn 14), was issued in twelve parts from January to December 1840. Cruikshank did not illustrate *Old St. Paul's* (which came out in monthly parts in 1841), but rejoined Ainsworth when the latter, having resigned the editorship of *Bentley's Miscellany* in 1841, started his own miscellany, *Ainsworth's Magazine* (Cohn 22), of which the first number appeared in February 1842. In this Cruikshank illustrated *The Miser's Daughter* (February to November 1842), *Windsor Castle* (July 1842 to June 1843; the first few parts were illustrated by Tony Johannot) and *St. James's, or the Court of Queen Anne* (January to December 1844).

The *Jack Sheppard* illustrations are foremost in interest. They show a slight development from the *Oliver Twist* designs in that they are framed, and somewhat more elaborate both in detail of subject matter and in technical finish. Probably Ainsworth is responsible for this. Cruikshank's designs for *Rookwood* did not satisfy him and he complained to his publisher that they were "sketchy." Cruikshank, he thought, "has evidently two styles, and one can hardly recognize in some of his '*Bozzes*' [i.e. illustrations for *Sketches by Boz*] the hand of the designer of the *Comic Almanack*."[23] Perhaps, then, Ainsworth insisted that the illustrations to *Jack Sheppard* should be highly wrought in the style of the *Comic Almanack* (Cohn 184, 19 vols., 1835-53). It was not necessarily a wise choice, for Cruikshank's economical habit of omitting inessentials had its positive side: many of his illustrations impress us so deeply just because of their simplicity. And his technical polish was achieved only at the eventual cost of vitality.

In *Jack Sheppard*, however, the greater finish of the plates brings no loss of strength. A plate such as "The Storm" will demonstrate this (Figure 20a). It is as near to abstract composition as Cruikshank came, for the three small figures in it hardly count, and it is the contrasting areas of tone that give it its impact. Technically these are a brilliant representation of the turbulent mingling of air and water, light and shadow at the height of a storm. And formally they make a strong pattern of shapes: the rounded archivolt of the bridge, the curving rush of the water

[22] In *Bentley's* he also began to illustrate Charles Hooton's *Colin Clink* and Henry Cockton's *Stanley Thorn*, but he lapsed before these serializations were completed.

[23] S. M. Ellis, *William Harrison Ainsworth and His Friends*, 2 vols. (London, 1911), I, 278.

and the counter-curve of the driving rain, the conflicting diagonal courses of the flying spray, and the rectangular frame of the etching which keeps the whole surface pattern taut. This is a plate that could not have been achieved but for the more finished style that Cruikshank adopted for this book.

Most of the *Jack Sheppard* plates, in contrast, are heavily loaded with accessories; the reader is intended to miss none of them, and Ainsworth conscientiously details them in the text. No doubt readers felt they were getting Hogarthian value for money from plates crowded with detail, but it was easy to make fun of them. *Punch* did so, in 1842,[24] in "Our Library Table," which was a parody of the opening announcement of *Ainsworth's Magazine.* The artist is praised both for his comic designs and for his somber subjects:

> The picture of a public-house assassination stands before us in appalling black and white. A prostrate figure occupies the *avant-scène*, with the toes upwards, and skilfully foreshortened. The murderer stands horror-stricken over his fearful work; the knife, with the maker's name distinctly and picturesquely put in, occupies his reeking hand! But it is the accessories which demand the highest praise, for they impart a terrible truthfulness and actuality to the scene. It is the bar-parlour and bar; barrels are ranged around exhibiting numerous X's, from 'single' to 'four-ble.' The sides of the apartment are covered with advertisements inscribed respectively with 'Stout, 4d.;' 'Ale, 6d.;' 'Rum, 4d.'

Despite their elaboration, the plates for *Jack Sheppard* are an uncommonly powerful series; and they may rightly be described as a series. After the first four plates which illustrate "Epoch the First. 1703," every plate save one ("Jonathan Wild throwing Sir Rowland Trenchard down the well-hole") features the easily recognizable figure of Jack Sheppard. Each is linked to the last and to the next by his presence, and (like the illustrations to *Peter Schlemihl* and *Robinson Crusoe* where the hero is also constantly present) they thus take on a narrative force.

Any contemporary reader, absorbing the serial part by part at monthly intervals, would have been more on the alert for the sequential element in the plates than a modern reader. For the

24 Ibid., II, 127.

latter, they are occasional interruptions to his steady progress through a book; for the former they were milestones in a necessarily interrupted progress; they helped to mark his position month by month and to point the way ahead. Furthermore, the illustrations to *Jack Sheppard* took on a life of their own apart from the novel: on the stage. Philip Collins reminds us that "contemporary reviewers and moralists, when deploring the social effects of the 'Newgate Novels' and other forms of popular fiction, were referring at least as much to the debased theatrical versions as to the novels themselves."[25] For the audiences of these plays, *Jack Sheppard* and *Oliver Twist* would linger in the mind as visual spectacles as much as verbal narratives, and in some at least of the adaptations the visual side of the production was closely modelled on Cruikshank's illustrations. I. T. Haines's adaptation of *Jack Sheppard* (1839), for instance, contains a commendatory letter from Ainsworth which remarks: "The fact of the whole of the Scenery having been superintended by Mr. George Cruikshank, must be a sufficient guarantee to the Public for its excellence and accuracy." And the list of scenes gives cross-references to Cruikshank's plates in *Bentley's*.[26] Cruikshank could, then, reasonably expect his audience to regard his illustrations as a sequence rather than as isolated entities.

They are an exceptionally interesting sequence because Cruikshank is not content at achieving a narrative with a regular pace —one incident coming after another—but on two occasions quickens the pace to accompany a climax in the story. The first occasion is Jack's escape from Newgate, which Cruikshank illustrates with three plates, two of them subdivided into four and the last into two. In effect he draws a strip cartoon of ten frames, showing each stage of Jack's escape. As in the case of Schlemihl and Crusoe he is depicting a man in extremity and on his own, and so he puts no figure but Jack's in these little designs, and emphasizes the desperate nature of his single-handed feat by the starkly simple backgrounds. Thackeray might well observe in these illustrations "the extreme *loneliness* of them all."[27] In this, and in the fact that they are about imprisonment and escape,

25 Philip Collins, *Dickens and Crime* (London, 1962), p. 265.
26 And see the frontispiece to G. Almar's "serio-comic burletta" *Oliver Twist*: it shows how "The Last Chance" was staged. Both are in the Forster Collection, Pamphlets, No. 111.
27 Thackeray, p. 57.

a theme that always fascinated Cruikshank, they are superior to the second example of acceleration in his *Jack Sheppard* illustrations. This comes at the very end, when Jack's progress to the gallows is shown in two plates each divided into three tiny strips, crowded with figures.

The illustrations to *Jack Sheppard* are on the whole high-spirited. Ainsworth presents his irrepressibly criminal hero in a sympathetic light, and Cruikshank does not fail to match this sympathy. But there is one plate, not often commented upon, with which Cruikshank contrives, as only he can, to stir a deeply inward fear. This is the illustration of "Jack Sheppard & Blueskin in Mr. Woods bed-room": Mr. and Mrs. Wood lie asleep as the two thieves tiptoe in (Figure 20b). The plate combines Cruikshank's early linear style with the later tonal virtuosity that he repeatedly shows in the *Jack Sheppard* plates. Mr. and Mrs. Wood, lying in the light of the candle, are drawn with something of the easy, open, looping line of Cruikshank's work in the 1820s. They are depicted by line only, without shading. Their plump faces, their bodies swelling beneath the blankets, the bulging pillows, even the little bags hanging at their heads, are all comfortable, rounded forms, emblematic of contentment and happiness. The image of a sleeping couple is one readily adopted by comic draughtsmen, and usually viewed with affection or amusement. One can instance Rowlandson's "The Trumpet and the Bassoon,"[28] or, in Cruikshank's *Scraps and Sketches,* "A Comfortable Nap" (Pl. 13). So the right-hand part of Cruikshank's illustration is open and easy both in its subject and in its manner of representation. On the left, however, are two other figures, darkly shadowed, thin and angular. They wear crepe masks, and Cruikshank's rendering of their faces behind the hanging crepe is a triumph of delicacy. Jack stands in front of Blueskin, and while the former bends to his left, the latter turns to his right, so that we read the two figures as a single figure, bending at the waist and turning his upper body around, as if peering carefully and short-sightedly. Or, to make a more far-fetched comparison, we may be reminded of a snake, rearing up and swaying its head from side to side before striking. At any rate, the plate is an uncanny representation of evil silently menacing

[28] See Thomas Wright, *A History of Caricature and Grotesque in Literature and Art* (London, 1865), p. 485.

112

unprotected innocence. It stands comparison even with "Monks and the Jew" in *Oliver Twist,* which is an emblem of the same menace, and it shows how subtly Cruikshank can play on our morbid feelings.

He can also embody morbid psychology in images just as compelling as those he finds to represent normal psychology in extreme circumstances. An example (which will almost stand comparison with "Fagin in the condemned Cell") is "The Miser discovering the loss of the mortgage-money" in *The Miser's Daughter* (Figure 18b). The miser stands "transfixed, with his hands stretched out, his mouth wide open, his eyes almost starting from their sockets." The gestures could easily be made grotesque. But Cruikshank throws the miser into a pose in which he appears to be rooted to the ground by conflicting impulses. (We have noted several such postures in the illustrations for Roscoe's Novelist's Library.) His right leg seems to carry him away from his coffer, but his left arm and tilted head reveal a contrary movement. His head seems to have sunk on his chest, suggesting that he is collapsing in despair; or else his shoulders are hunching up round his ears as horror stiffens him. The ambiguous posture conveys an unresolved tension. His horror and despair are thrown into relief by the dull emptiness of his surroundings. Cruikshank never surpassed the mastery of tonal gradation that he shows here. Light enters from the window on the miser's right and has to force its way through the dusky gloom before it can fall on his pallid cheek and brow. Behind him, through the door, we see receding rooms also filled with a strange dusty light that suggests emptiness and disuse. The gaping apertures of window and door mock at the gaping emptiness of the miser's money-chest.[29]

Apart from this plate, *The Miser's Daughter* is of little interest. The illustration which shows the miser dead in his cellar, in the hole he has been digging to find his treasure, somehow fails to inspire the macabre thrill that it was meant to. Ainsworth writes up this incident somewhat perfunctorily. It is only in passing that Thomasine, the mercer's daughter, remarks that the miser "has been found dead in his cellar . . . where he had digged his own grave, and tried to bury himself, to save funeral expenses."

[29] Cruikshank has tried a few highlights: the bottle, the keys, the nails in the hanging shoes give a gleaming reflection of the light from the window; he tried this effect again in the frontispiece to *Clement Lorimer* (Cohn 687, 1849).

One can imagine what black comedy Dickens might have extracted from this gruesome notion.

As for the rest of the illustrations, in which Cruikshank aimed to "let the public of the present day have a peep at the places of public amusement"[30] of the eighteenth century, one need only compare them with Rowlandson's exuberantly lovely drawings of the same scenes to see how pinched and forced they are.

These, and Cruikshank's other historical illustrations for *The Tower of London* and *Windsor Castle*, fail to carry conviction, although it is difficult to be sure quite why they do not work. True, these plates are carefully and conscientiously executed; nothing is skimped technically. But the subjects are meanly designed; the more serious and elevated subjects seem to be the meanest. The most obvious objection is that Cruikshank seems to have attempted, but has certainly failed to achieve, academic naturalism. Reviewing *The Tower of London*, the *Athenaeum* observed: "the figures are sad caricatures. Some bony, spider-waisted phantom must stand between our artist and the sun, whenever he wishes to sketch youth and grace in woman."[31] There is no reason to think that men and women of the past are any more truthfully rendered by the naturalism of, say, Maclise than by Cruikshank's idiosyncratic style. But naturalism seems the lesser evil. At least it appears not to distort, whereas Cruikshank's style, formed by caricature, always carries a satiric bite and cannot avoid mocking its subjects. The mockery is as much in Cruikshank's line as in the distortions that his training as a caricaturist taught him to make. A very few of Cruikshank's designs were engraved on steel plates by an engraver used to interpreting the work of academically correct artists: these were his illustrations for Defoe's *Journal of the Plague Year* (Cohn 226, 1833) and Irving's *Knickerbocker's History of New York* (Cohn 440, 1834), both published in Murray's Family Library. Here Cruikshank's distortions seem sadly weak, for the smooth technique of the engraver Davenport has removed their vitality. They will only come alive if rendered by Cruikshank's own restless line. Conversely, anything etched by his own hand, however correct in form, willfully evades academic smoothness. It is odd that he

30 Letter to *The Times*, 8 April 1872, reprinted in his *The Artist and the Author* (London, [1872]), p. 1.
31 *Athenaeum*, 2 January 1841, p. 13.

was later to make a fetish of academic naturalism. When G. A. Sala met him,

> I remember that he gave me very good advice, counselling me to take the earliest opportunity to begin the study of artistic anatomy; for that, he said, "will set you all right with your pelvis; and what are you, and what can you do, if your pelvis is wrong?"[32]

The pelvis, unfortunately, was one of Cruikshank's particularly weak points, and there is no doubt that he had much to learn about it when he began to attend the Royal Academy Life Class in his seventies.

On the whole, then, Cruikshank's illustrations to *The Tower of London* and *Windsor Castle* fail.[33] The set for *St. James's, or the Court of Queen Anne* succeed better because here scenes of high life are intermingled with scenes below stairs. The contrast between the two causes Cruikshank's serious style to stand out for once as identifiably serious, while his unserious style seems the more captivatingly jolly. He was later to do good historical illustrations for R. B. Brough's *Life of Sir John Falstaff* (Cohn 96, 1857-58): there is no doubt that Falstaff is a comic character, and so Cruikshank does not try to inhibit his comic style.

Presumably it was Cruikshank's association with Ainsworth, a historical novelist, that led him to attempt historical illustration. One cannot think why, otherwise, he should have thought he would be good at it. The idioms of successful historical illustration were well established, and pre-eminently exemplified in the numerous illustrated editions of Scott's works. Stothard, Westall, and other artists of their school in the early years of the century had provided elegant designs, engraved with polished accomplishment by craftsmen such as the Heaths and the Findens, and their illustrations were often reissued in collections such as the *Waverley Album* of 1833 and the *Book of Waverley Gems* of 1846.

[32] G. A. Sala, *The Life and Adventures of George Augustus Sala*, 2 vols. (London, 1895), I, 206.

[33] His woodcuts of various features of the Tower, as they looked in the nineteenth century, are very dull, although they are neatly dropped into the text at appropriate points and make their intended effect. W. A. Delamotte, who executed the architectural and topographical woodcuts for *Windsor Castle*, was an artist of more experience and accomplishment in this field: he executed the vignette drawings, engraved on wood by Orlando Jewitt, for Ingram's *Memorials of Oxford* (London, 1837).

Turner provided illustrations for Lockhart's editions of Scott's *Poetical Works* (12 vols., 1833-34) and *Prose Works* (28 vols., 1834-36), and Cattermole produced his *Illustrations to the Poetical and Prose Works of Sir Walter Scott* in 1833. From 1842-46, while Cruikshank was doing his historical illustrations for Ainsworth, the Abbotsford edition of the Waverley novels was appearing: it contained woodcuts and steel engravings with much the same effect as Ainsworth and Cruikshank achieved in *The Tower of London* and *Windsor Castle*. Cruikshank must have been aware of all this, not least because he himself contributed to a series illustrating Scott's novels that was published in London and Paris in 1836-38 by Fisher, Son and Co. (Cohn 730). But in this project he was *not* asked to attempt serious historical subjects: these were the preserve of Turner, Henry Melville, Alexander Chisholm, William Harvey, and others. Cruikshank was commissioned to provide the specifically comic illustrations, which he did extremely well. His illustrations to Scott are full of his characteristic vigor, and would be worth fuller consideration here if it were not that, jumbled up with the work of other artists and issued as a series of plates without text, they do not constitute sufficiently full evidence of Cruikshank's response to any whole work of fiction by Scott. At any rate, Cruikshank here made the contribution that he was best equipped to make in the illustration of historical fiction; it is a pity that he expended so much effort with less success in illustrating Ainsworth's novels.

VI

Among the other serialized fiction that Cruikshank illustrated for *Ainsworth's Magazine* was Mrs. Gore's *Modern Chivalry: or the New Orlando Furioso* (July to December 1843). This was a novel of high life; shrewd, cynical, brittle, mannered. Its analysis of the personal relationships of sophisticated and selfish people was not, perhaps, likely to appeal to Cruikshank, and its tone was not one with which he would naturally be in accord. Furthermore, while Mrs. Gore spreads herself on feelings and motives, she is sparing with action, and there are not many good subjects for Cruikshank to illustrate. The first plate is the most attractive: it shows two young men conversing over breakfast. Cruikshank manages to convey something of the amiable persistence of Tom

116

Mauley and of the patronizing boredom of Howardson, but the secret of the plate's charm is the fact that it recalls "Our Library Table" or "Sir Lionel Flamstead and his friends," in which Cruikshank depicted himself and his fashionable author friends.

Modern Chivalry appeared in *Ainsworth's* concurrently with a more down-to-earth novel by William Maginn, *John Manesty: the Liverpool Merchant* (July 1843-September 1844). It is a tale of a highly respected merchant, a Dissenter who conscientiously eschews the slave trade—a prominent feature of Liverpool's economic life in the 1760s, when the story takes place—but who is eventually discovered to have been for many years secretly in business as a pirate. His misdeeds catch up with him. Romantic interest is provided by the courtship of his nephew Hugh (later revealed to be his son, and still later to be no relation at all but the rightful Sir Hugh Wolsterholme). Cruikshank illustrated the first six instalments in a rather plain, modest style, appropriate to the subject of the book and contrasting with the style of the *Modern Chivalry* plates. After the sixth instalment, however, *John Manesty* was allowed to peter out unillustrated, for Ainsworth's *St. James's* began and engrossed Cruikshank's attention.

If Cruikshank found it hard to catch Mrs. Gore's upper-class tone, one would not expect him to be at home with the class-consciousness of the *Punch* circle. He did not, of course, contribute to that magazine, but he did illustrate fictional works by some *Punch* authors, and very well. For the Mayhew brothers he illustrated *The Greatest Plague of Life* (Cohn 544, 1847) and *Whom to Marry* (Cohn 545, 1848). These stories, told in the first person by foolish females, are book-length treatments of two regular *Punch* jokes: "Servantgalism" and the marriage joke. They are tales of ludicrous misfortunes which befall stupid and gullible people. The clever, knowing sneer of *Punch* is not altogether absent from the narrative: but there is no trace of it in Cruikshank's illustrations, which are a joyful celebration of the absurdities of the servant problem and the marriage question. Instead of feeling a rankling disapproval (even if disguised by jocularity) of servant maids who gossip instead of working, Cruikshank depicts them as a charming sight (*Plague*, facing p. 182). One of his subjects in *The Greatest Plague of Life* ("It's my Cousin M'am!") was given the compliment of imitation by Leech, who copied it in "Domestic Bliss" (*Punch*, 31 August 1850). A

117

comparison is instructive. In Cruikshank's plate the housewife, discovering the maid entertaining a follower, seems to glory in her (rather precarious) dignity, the maid glories in her pertness and the guardsman in his splendid punctilio. In Leech's version they all have the most disagreeable expressions of spite and resentment, and the maid is saying "It's only my cousin who has called just to show me how to boil a potato," thus infusing the situation with the petty deceit that Cruikshank's treatment excluded. Cruikshank is expansively good-natured, Leech urbane but malicious.

The Mayhew brothers edited *The Comic Almanack*, which Cruikshank illustrated, and it was in this ephemeris that two early and minor fictions of Thackeray appeared, each in twelve portions (one per month) illustrated with twelve etched plates. In the 1839 *Comic Almanack* appeared "Stubbs's Calendar; or the Fatal Boots," and in the following year came "Barber Cox and the Cutting of his Comb." The first is the more interesting. It is an exercise in ironical first-person narrative. Stubbs, a knave and sneak, tells the story of his life of steady, and, as he supposes, undeserved decline into indigence and ostracism. What he reveals of himself makes it clear that the decline is only too richly deserved. His first-person narration is a precursive attempt at what Thackeray was to do more forcefully in *Barry Lyndon*, whose hero "narrates his own adventures and rascalities with the artless *naïveté* of a man troubled by no scruples of conscience or misgivings of the moral sense," as Theodore Martin said, adding: "a conception as daring as the execution is admirable."[34] Thackeray carries off the ironic narrative of "Stubbs's Calendar" without lapsing, with a consistency that seemed relentless to his contemporaries, who, when faced with Thackeray's villains, tended to "gasp for a more liberal alternation of refreshing breezes of unsophisticated honesty."[35] Even Thackeray came to feel that Stubbs's "adventures were somewhat of too tragical a description to provoke pure laughter."[36] But the tone of Thackeray's narrative was evidently not lost on Cruikshank, who, although he could not achieve an ironic effect, could and did main-

[34] In the *Westminster Review*, April 1853; quoted in. G. Tillotson and D. Hawes, eds., *Thackeray: The Critical Heritage* (London, 1968), p. 174.
[35] John Forster in the *Examiner*, 22 July 1848; quoted in ibid., p. 57.
[36] Thackeray, p. 48.

tain a consistency of treatment in his plates. Stubbs is always at the center, and his irritable self-satisfaction is well hit off. In "Barber Cox" both Thackeray and Cruikshank allowed themselves to diversify their effects, and so dissipate their satiric force.

Having become disaffected with *Bentley's Miscellany*, Cruikshank himself launched a periodical in 1841: *George Cruikshank's Omnibus* (Cohn 190). This lasted for nine numbers and included a serialized work of fiction, *Frank Heartwell; or Fifty Years Ago* by Bowman Tiller. It is a rather perfunctory story, for it had to fit into nine episodes, and is poorly written. Lieutenant Heartwell comes into a fortune. He receives it from his lawyer in bags and sets off for home in a cab. He is abducted by the villainous lawyer (who later turns out to be mixed up in French Revolutionary politics) and cannot be traced. His son Frank, therefore, has to rise in the world by his own unaided efforts. He has a successful naval career, and twice saves the life of the girl he eventually marries. Later, his mother chances to be living in a country cottage that was once the hideout of the gang which abducted her husband. Frank finds a secret room containing the stolen treasure. Lieutenant Heartwell turns up, imprisoned in a lunatic asylum but alive and well. Cruikshank's illustrations to this rather silly story do not speak very loudly as a sequence, but some of them are powerful in themselves: there is a shipwreck, which is his best version of this favorite subject, and there is a fine illustration of Frank breaking into the secret room. It is an impressive and suggestive image, recalling the plates that show Jack Sheppard breaking out of Newgate, and witnessing to Cruikshank's fascination with the idea of imprisonment and escape.

Cruikshank's best illustrations had been done for highly melodramatic tales by Dickens and Ainsworth. But he never let himself go so recklessly as in his illustrations for the sensation novel *Clement Lorimer; or, The Book with the Iron Clasps* (Cohn 687, 1849) by Angus B. Reach, a diligent hack writer who devoted himself chiefly to comic work (including some for *Punch*), but produced this one lurid novel before his early death. It is a story of a vendetta between the houses of Benosa and Vanderstein, which begins in Antwerp in 1610: Cruikshank's frontispiece, which achieves fine tonal effects, shows the originator of the vendetta laying upon his son the responsibility of prosecuting it until no Vanderstein remains alive. The story proper opens in

119

1833. By this time, the last surviving Benosa (taking the name Werwold) has married the last surviving Vanderstein and killed her. But not before she has given birth to a son; and he, with Vanderstein blood in his veins (albeit mingled with the blood of the Benosas), is now to be hunted down by his father, whom he has never known. Reach handles the development of this wildly improbable plot well: at first, Clement Lorimer (as the hero is called) is baffled by the machinations of his unknown persecutor, but gradually the mystery is unraveled. Reach had a flair for atmospheric writing, and almost every chapter opens invitingly with a piece of crisply written description. He is not so good on psychology and motivation: indeed his most sensational moments are well on the way to absurdity.

> Benosa's face was distorted with something scarcely human, his gaunt frame had ceased to tremble—it shook. He pointed, with his long, skinny fingers, to the spectres of his diseased imagination, gibbered and mouthed at them; and at length, after one or two convulsive gasps for breath, uttered one of those hideous bursts of hysterical laughter which form so terrible a symptom of acute mania. (p. 205)

Perhaps the most engaging parts of the book are those concerned with a group of young journalists who launch a satirical paper, *The Flail*: here Reach was evidently writing of what he knew.

Cruikshank's plates show that he responded to this book with gusto. Some, however, are recollections of his earlier work. "The Ship Owner & the Ship Captain" and "The Wreck on the Goodwin Sands" are in his familiar nautical idiom. "Miss Eske carried away during her trance," which shows a storm on the Thames, is a revised version of the two plates in *Jack Sheppard* depicting a storm on the Thames; and "The Escape" reminds one of "Jack Sheppard in company with Edgeworth Bess escaping from Clerkenwell Prison." Some of the plates show discrepancies from the text: in "The Escape" the windows are wrongly shown as forced open, and in the final plate Werwold should already have fallen dead, killed by a poisonous vapor from the book, before the book goes up in flames. Still, the plates also include some ripe examples of Cruikshank's knack of choosing the odd, inexplicably sinister gesture or circumstance to illustrate: "Making the favourite safe for the Derby" shows Werwold and a jockey doping a horse

while regarded by that animal and another with huge, staring eyes; "The Opera Box" shows a bad baronet, Sir Harrowby Trumps, being suborned by Werwold, who hides his face, grotesquely, behind a bouquet; and "Making Circumstantial Evidence" depicts Werwold touching the lips of the insensible Miss Eske with a feather—she has been drugged, but Werwold wishes to suggest, by depositing a little poison on her lips, that she has taken her life. These illustrations lack the power of Cruikshank's best, for he relishes the melodrama rather too openly; but they are a pronounced example of one of his idioms.

Another idiom is to be seen in his twenty-eight etchings for *Frank Fairlegh, or Scenes from the Life of a Private Pupil*, by Frank Smedley (Cohn 754).[37] It was issued in fifteen parts from January 1849 to March 1850, the earlier portions having appeared in *Sharpe's Magazine*. It is basically a series of anecdotes concerning the hero's life at a private school and at university. The plot interest turns on the identity of the mysterious benefactor who pays to send Frank to Oxford after his father has died, leaving the family in reduced circumstances. The benefactor turns out to be a lovable misanthrope, a distant relation to Matthew Bramble and other such humorous characters. It is uncommonly fortunate that this benefactor also proves to be the rightful guardian of the girl Frank loves; he sends packing an evil guardian who has usurped his position and who refuses to permit Frank to marry his ward.

The illustrations are Cruikshank's most extended celebration of the trim vigor and cheerful adventure of young men. They are full of charm, but seem a little pastel-colored when compared with his more florid early work.

[37] Readers familiar with the controversy over Cruikshank's claim to have been the originator of *Oliver Twist* will recall that in a letter to *The Times* of 30 December 1871 (reprinted in F. G. Kitton, *Dickens and his Illustrators* [London, 1899], pp. 19-22) Cruikshank outlines the story which, he says, he suggested to Dickens. It was to be a tale of the rise from rags to respectability of a poor but honest and industrious boy. Cruikshank had intended that the hero should be "a nice pretty little boy," and, disliking the name Oliver Twist, he "wanted the boy to have a very different name, such as Frank Foundling or Frank Steadfast." The fact that Cruikshank was later to illustrate stories entitled *Frank Heartwell* and *Frank Fairlegh* may indicate that, when in 1871 he was looking back over his work, his memories of what he had intended for one author and what he had actually done for others became confused; or it may indicate that he stuck to his idea of a hero called Frank and got other authors to use it after Dickens had declined to do so.

Cruikshank illustrated a wide range of fiction. He produced exceptionally good illustrations of the great eighteenth-century English novels. And the literature of his own day offered him a variety of subjects: sensation and melodrama, costume drama, high life, low life, middle-class life, commercial life, nautical life. For several of the works he illustrated, his etchings are much more than occasional embellishments: by virtue sometimes of his choice of subjects and sometimes of his manner of composition, they link up with each other so as to form a sequence alongside the written narrative. Cruikshank seems to have responded with special intensity to descriptions of certain situations, themes and states of mind: extremes of adversity, imprisonment, escape, moments of encounter, and opposing passions whether in a group or an individual, inspire some of his best designs. All these qualities are most vividly seen in his illustrations to *Oliver Twist*.

VII

If any single illustration has secured immortality for Cruikshank, it is his etching of "Fagin in the condemned Cell." It is an extremely simple image: a single seated figure against a background which is hardly more than two areas of dark tone, one being covered with cross-hatching and the other with a stippled effect. As we have seen in *Peter Schlemihl, Robinson Crusoe*, and *Jack Sheppard*, Cruikshank provided some of his most powerful designs when he was given the opportunity to illustrate loneliness, and the fears and struggles that accompany extreme adversity. The intensity of his feeling for such subjects suggests that he readily identified himself with fictional characters in such circumstances. We know that he identified himself with Fagin. There is no need here to repeat the anecdotes collected in Blanchard Jerrold's biography;[38] they fall into two classes, some telling how Cruikshank, for years after the appearance of *Oliver Twist*, liked to act the part of Fagin, others telling how he settled on Fagin's pose in the condemned cell by himself assuming it before a mirror. On this evidence we may venture to conclude that some of Cruikshank's illustrations were the result of a kind of dramatic re-enactment by the artist of the incident he was illustrating, and that they

[38] Blanchard Jerrold, *The Life of George Cruikshank*, 2 vols. (London, 1882), I, 226 ff.

are, therefore, in a specially intimate way, disclosures of aspects of his personality. Chesterton put this point in rather overblown terms: in his eyes, Cruikshank's drawings

> have a dark strength: yet he does not only draw morbidly, he draws meanly. In the doubled-up figure and frightful eyes of Fagin in the condemned cell there is not only a baseness of subject; there is a kind of baseness in the very technique of it. It is not drawn with the free lines of a free man; it has the half-witted secrecies of a hunted thief. It does not look merely like a picture of Fagin; it looks like a picture by Fagin.[39]

This certainly testifies to Chesterton's sense of Cruikshank's close identification with his subject. It was Chesterton also who produced a phrase which seems to me to be quite the most suggestive description of Cruikshank's peculiar talent, and which hints at the qualities in his personality that shaped his talent and that are disclosed in his work. "There was about Cruikshank's art," said Chesterton, "a kind of cramped energy"

This is indeed to be found in "Fagin in the condemned Cell." Fagin had made his last previous appearance in the *Oliver Twist* illustrations in the nineteenth plate, "The Jew & Morris Bolter begin to understand each other," where he was to be seen grinning hugely and stretching his crooked legs wide apart in luxurious enjoyment of his cunning. In the condemned cell he has snatched himself together and crouches abjectly on his bed. His knees are bent and his body bends over them in that foetus-like posture to which a man will sometimes revert in acute terror. His shackled legs are held close together and his arms are clutched tight to his body. All his muscular power seems to be exerted in holding himself rigidly still, in cramping himself. And yet energy glares from his face; in his piercing eyes and bared teeth an animal fierceness seems to spring out to the attack. There is nothing to attack save his own raised hand, so his fierceness is turned on himself.

Sir Joshua Reynolds (in his Fifth Discourse) told his students that the expression of mixed passions was a difficult problem for an academic painter, since all such mixtures derogate from perfect beauty. For the caricaturist this is no problem: the more passions he can mix the better. Cruikshank had a special gift, as we have

[39] G. K. Chesterton, *Charles Dickens* (London, 1906), p. 111.

repeatedly seen, for expressing not just mixed but conflicting and even counteracting passions. So Fagin embodies the conflict of cramped energy. And in "Oliver asking for more" the master of the workhouse seems to be both bursting with rage and deflated by shock. Of these, and of many other figures in Cruikshank's illustrations, one might say (borrowing another phrase from Chesterton): "His whole attitude was suggestive of a sort of paralysis, that was both rigidity and collapse."[40]

For anyone coming nowadays to Cruikshank's illustrations to *Oliver Twist*, the earlier plates are quite overshadowed by "Fagin in the condemned Cell" and "The Last Chance." The reader of Dickens' *Oliver Twist* may also find that the deaths of Sikes and Fagin are the incidents which make the most immediate impact. But perhaps he may feel, with Graham Greene, that the essence of the book is not here, but in Oliver himself:

> Oliver's predicament, the nightmare fight between the darkness where the demons walk and the sunlight where ineffective goodness makes its last stand in a condemned world, will remain part of our imaginations forever. We read of the defeat of Monks, and of Fagin screaming in the condemned cell, and of Sikes dangling from his self-made noose, but we don't believe. We have witnessed Oliver's temporary escapes too often and his inevitable recapture: *there* is the truth and the creative experience.[41]

However this may be for the modern reader, it must have been true for Cruikshank and his contemporaries, who began to read about Oliver in February 1837 and did not reach the climactic death scenes until two years later. During these two years it was the alternating light and dark of Oliver's life that constituted the essential character of the book. This is the theme that Cruikshank has emphasized.

The earlier *Oliver Twist* illustrations form a sequence.[42] Fur-

40 From his story "The Dagger with Wings" in *The Incredulity of Father Brown*.
41 Graham Greene, "The Young Dickens," in his *The Lost Childhood and Other Essays* (Harmondsworth, 1966), p. 61.
42 These illustrations, more than any other of Cruikshank's illustrations to works of fiction, constitute "a series of drawings . . . in which, without a single line of letter-press, the story [is] strikingly and clearly told." These words are from R. S. Mackenzie's account (in *The Round Table*, 11 November 1865) of the origin of *Oliver Twist*: Cruikshank claimed that he had produced an independ-

thermore, there are close similarities between some plates and others, and there is a formal pattern in the disposition of the figures in several successive plates; these features seem too meaningful to be fortuitous, although Cruikshank may have introduced them unconsciously. Admittedly, some illustrations cannot be fitted into the main sequence—notably Pl. 11, "Mr. Bumble and Mrs. Corney taking tea," Pl. 12, "Mr. Claypole as he appeared when his master was out," and Pl. 16, "Mr. Bumble degraded in the eyes of the Paupers"—but it is not hard to see similarities that link these too. It is as if Cruikshank, in his work for *Oliver Twist*, could hardly avoid making his illustrations match and interpret each other.

In the main sequence the connecting link is the figure of Oliver: a lonely figure, one against the world, like Schlemihl and Crusoe —or more like Jack Sheppard, for the world in the *Oliver Twist* plates, as in the *Jack Sheppard* plates, is other people who form groups from which Oliver stands excluded. The theme of the sequence is the repeated captivity and escape of Oliver, and when Dickens' plot thickens to such an extent that Cruikshank cannot illustrate incidents that bring this out, he keeps the theme lurking in his illustrations by exploiting the symbolism of apertures.

The first illustration ("Oliver asking for more") sets the pattern. Oliver is at the center in a posture of supplication: slightly bent at the knees, holding out a bowl and spoon, his arms crooked at different angles. He faces the workhouse master, and behind him are bunched the heads of the other boys. All eyes look at Oliver in stupefaction or hostility: there is no friendly gaze. The pattern is followed in the second plate ("Oliver escapes being bound apprentice to the Sweep"): Oliver is now on his knees facing the magistrate, and behind him, again, is a bunch of indifferent and hostile faces; on the right Bumble, with raised hand and open mouth, echoes the master's wife, similarly posed, in the previous plate. Oliver's figure reappears in each of the first ten plates, and then, after a gap, in Pls. 13 to 15. Defenseless and unattached he faces one group of people after another, who mock, repudiate, persecute and attack him, or sometimes accept him with

ent series of etchings, described by Mackenzie in the words above, which Dickens took as the basis for *Oliver Twist* and wrote up to. In demonstrating the sequential element in the *Oliver Twist* plates I am not intending to back up Cruikshank's claims to have originated *Oliver Twist*.

a certain reserve. It is not until the final plate that he feels a friendly hand. There is no room here to analyze the sequence plate by plate, but anyone who will look through the illustrations, mentally blotting out all but Oliver's figure, will find that his varying attitudes tell a story of their own. And in each case his figure stands over against a group of others. He reacts to them and they to him, and in the placing of Oliver and the group in relation to each other a pattern may be seen to subsist throughout the sequence.

Two further instances of formal patterning must also be noted. We have seen that the second illustration closely follows the first in construction; the fourth ("Oliver introduced to the respectable Old Gentleman") follows the first even more closely. Oliver stands almost in the same posture, but in the fourth plate holds his hat and stick instead of a bowl and spoon; behind him, where in the first plate the workhouse boys were seated at a table with spoons in their mouths, is a group of Fagin's boys seated at a table with pipes in their mouths; in front of Oliver, instead of the workhouse master at his copper, is Fagin by his fire. Here, then, one design deliberately repeats the construction of another in order to make a point.

In another case, several plates combine to make a point. The fourth to eighth plates, if laid out side by side, make a kind of ironical strip cartoon. On the left of Pl. 4 stands Fagin; Oliver is led towards him from the right, from the outside world. In Pl. 5 Oliver recoils from the Dodger and Charley Bates who are picking Mr. Brownlow's pocket: Oliver's movement of flight will take him off the right-hand side of the plate, into the world again, away from Fagin. In Pl. 6, Oliver has come to rest in a chair at Mr. Brownlow's fireside, and that benevolent gentleman has interposed his ample frame between Oliver and the left-hand edge of the plate, where, somewhere beyond, Fagin still waits. Oliver is recaptured in Pl. 7, and is dragged on to Pl. 8 from the left, to be confronted at the right-hand side of the plate by the Jew, blocking his escape. Cruikshank could hardly have conveyed more pointedly the sickening inevitability of Oliver's progress. The repeated formal pattern in the first and fourth plates tells us that wherever Oliver seeks help, he finds himself in the same plight. And the strip cartoon formed by the later plates reminds us that

126

however hard he flees from evil, it is there waiting ahead of him when he turns the next corner.[43]

Doors and windows, and all apertures between one space and another, are potent symbols of exclusion and inclusion, and Cruikshank is eager to play on "all that mystery which is alternately veiled and revealed in the symbol of windows and of doors."[44] The mystery is most uncanny in "The evidence destroyed," where we see Monks pointing gloomily down an open trap door. If a door can be an eerie reminder of the unknown outside, how much more dismaying is a trap door which opens a pit beneath the feet and threatens imbalance and helpless descent. The other doors and windows in the *Oliver Twist* illustrations are seen as inlets for danger. In the third plate a door is flung open upon Oliver to admit an angry virago; in "The Burglary" the door opens on him and emits a puff of smoke and a bullet; in "Monks and the Jew" a window opens to reveal the two villains waiting outside Oliver's little enclave of security; in "The Last Chance" Sikes, seeking the security of the rooftops, the inaccessible secrecy of the open sky, is menaced by little figures who thrust themselves out of windows. Fagin in the condemned cell sits beneath a barred window; ironically it admits only the peaceful light of day and no danger from outside, for Fagin, heedless of the light, has evil deep within him.

Cruikshank, then, has told the story of *Oliver Twist* by composing the figures in his designs so that certain patterns of grouping and gesture recur. These patterns express Oliver's relations with the adult world, relations which are crucially a matter of captivity and liberation, of exclusion and inclusion. These themes Cruikshank treats not only by representing them in human terms, but also by reiterating details that cumulatively gather symbolic force.

VIII

I have tried to show that there is much more in the *Oliver Twist* illustrations than the frantic gloom of "Fagin in the condemned

[43] Maybe it is unlikely that in this instance Cruikshank consciously disposed the figures on his plates so as to make this strip narrative; but he was soon— in *Jack Sheppard*—to make deliberate experiments in strip lay-out.

[44] Another phrase of Chesterton's, again from "The Dagger with Wings."

Cell." Among Cruikshank's illustrations to works of fiction, the *Oliver Twist* plates are the prime example of his ability to make his designs sustain a narrative. They are not merely visualizations of disconnected moments in the author's story; they are themselves connected by various means, so as to form a sequence. A sequential element is to be seen also in the illustrations to *Peter Schlemihl, Robinson Crusoe,* and *Jack Sheppard.* In the last, Cruikshank experiments with variation of pace in his visual narrative, and in the *Oliver Twist* plates he seeks, by repetition, a cumulative effect and an effect of dramatic irony. In the case of *Jack Sheppard* and *Oliver Twist,* it was no doubt the conditions of monthly publication that disposed Cruikshank towards the creation of visual narratives; he absorbed the verbal narrative little by little, never seeing it whole, and so his illustrations reflect his developing understanding of it.

He has extremely well conveyed the dominant mood of *Oliver Twist,* the mood of anxious expectation that is generated by a story of subjection and liberation, of oppression and compassion, of exclusion and inclusion. It is such themes as these that have inspired Cruikshank to his most compelling illustrations for other works. In *Jack Sheppard* there is the frank thrill of physical confinement and escape. In *Peter Schlemihl* there is Peter's spiritual enthrallment to the grey gentleman, his consequent repudiation by his fellow men, and the strange deliverance offered by the seven-league boots. In *Robinson Crusoe* there are the psychological constraints and exertions of the hero's struggle for survival. If there is a single phrase that will cover this complex of feelings which Cruikshank represents and evokes so powerfully, it is Chesterton's phrase, "cramped energy."

Surely also, Cruikshank's line—so delicately precise, so forcefully restless—is aptly described by this phrase. And may it not be applied to his personality as well as his works? Since no good biography of him has yet been written, it would be rash to develop this notion; but the man who shines through the anecdotes of his contemporaries is characterized by an effervescent good nature strangely curbed by eccentricity and obsession. The phrase "cramped energy," then, evokes the personality; and more particularly denotes the special, distinguishing quality of his best illustrations of fiction.

128

George Cruikshank:
A Master of the Poetic Use of Line

BY JOHN HARVEY

CERTAINLY Cruikshank survives, and not only in galleries and libraries. Last year a good trade was driven by a Cambridge stallholder who was ripping the illustrations from first editions, and selling them individually (packaged in polythene bags) as *objets d'art*; and presumably if, for the sharks, Cruikshank still is money, for a large public he still is art. But Cruikshank's illustrations have always been popular, and again and again reprinted and sold in their own right. Yet it is not precisely as a great artist that he survives. He was a propagandist, first a Regency caricaturist, against the Prince but *risqué* (and a buck) himself, later a teetotal fanatic. And he was a book-illustrator, mostly of bad books, with a bent for stage-villains, and goblins. He did not draw from the life, and he painted in oils almost not at all, and then mainly in his dotage. He could hardly be called a master of art in a large sense, and since Chesterton's description of "Fagin in the condemned Cell"—"It is not drawn with the free lines of a free man; it has the half-witted secrecies of a hunted thief"[1] (which is not true, as anyone may see who looks at the drawing)—the idea has stuck that the phenomenon Cruikshank leaves for posterity is that of genius diverted into the oddest of tight, crooked channels. Jane Cohen showed the tenacity of Chesterton's idea, when she claimed recently, in her extended account of Cruikshank's career and his relations with Dickens, that if we want to understand Cruikshank's development in his later years, we should understand that he came more and more to identify with Fagin. She gives two other such helps, Lord Bateman and "No-body"—a witless dandy and a facetious freak Cruikshank had drawn—the three together composing her basic characterization of Cruikshank.[2] This tradition of Cruikshank criticism does seem to me facile and ignoble. Again

[1] *Charles Dickens* (London, 1906), p. 111.
[2] " 'All-of-a-Twist': The Relationship of George Cruikshank and Charles Dickens," *Harvard Library Bulletin*, 17 (1969), 169-94, 320-42.

129

and again we see in Cruikshank, governing both his life and the habitual minute observation of his art, humanity and the vigorous play of a large, free, fertile imagination.

<center>I</center>

Cruikshank was a major artist, and though his case is complicated, and one needs to select carefully, he left behind a body of etchings and wood-engravings (not to mention pencil drawings) that are superlative in their media; works where we don't need to wrestle with the problem of how the distorted, the pixilated, or the grotesque can be great. That problem does await us, of course, in a sizable proportion of his work; Baudelaire acclaimed such inexhaustible abundance in the grotesque as Cruikshank's "mérite special."[3] One may object to Baudelaire's nimble way of leapfrogging over a row of artists by equating a frequent idiosyncrasy of each with his best genius (Goya's *oeuvre* is conveniently picked up by the handle of "le fantastique," as Cruikshank's by "le grotesque," and the two are interchangeable), but he has picked out, with his confident French deftness, a characteristic. Though I believe Cruikshank did many varied pictures where Baudelaire's emphasis is not right, and which are better than the generic Cruikshank illustration that Baudelaire evokes, it should not be forgotten that by the grotesque, Baudelaire did not mean merely the bizarrely or inanely ugly: he describes Cruikshank's endlessly fresh spectacle of "la violence extravagante du geste et du mouvement, et l'explosion dans l'expression" as something that needed genius to produce it, and inconceivable energy. I believe Cruikshank's pictures that are less explosive show no less genius than the ones Baudelaire has in mind, and that they show him working to much less restricted and repetitive ends: that they show he has the powers of a poet.

There are many kinds of poet, of course. When Thackeray called Cruikshank "a poet, a maker," he spoke out of his awe at Cruikshank's richness, in the easy endless production of vital characterizations. But a "poet" should be more than a maker in that sense: surely the pictures where it is really useful to call a painter a poet are those where an artist with this dramatic, characterizing gift has in his line or brushwork a wonderful fertility in visual metaphor, and where his whole picture is a metaphor, a

<hr/>

[3] *Charles Baudelaire: Critique d'Art*, ed. Claude Pichois (Paris, 1965), pp. 258-60.

<center>130</center>

vehicle of emotion and meaning—pictures like those of Brueghel, Hogarth, Blake, Goya, Daumier. It may be felt one does not add anything to a description of these artists' *art*, by hanging the label "poet" round their necks. I have done so because often art criticism will divide poetic art down the middle, putting meanings and feelings on one side, and aesthetic delicacies and sensitivities on the other—and will do this in practice, aiming alternate sentences to either side, even when the main purpose is to appreciate the whole. Whereas, if one sees visual art as one form of human poetry, that kind of distinction breaks down, since it is normally understood that in anything we would call "poetry," the way the thing is said, and the beauty of the saying, cannot be separated from what it is that is said. And in, say, an etching by Goya, how could one separate the buttonholing emphases of black and white, the crossed tensions in the composition, the irresistible floods and sucks of movement, from the subject, the meaning, the emotion? What is so clear in his etchings is only more subtly true in his oil paintings, and in many oil paintings. At all events, it has more and more come home to me, with seeing, reading, and comparing, that Brueghel, Blake, Goya are the same species, the same animal, as the memorable dramatic poets: that, for all the obvious differences, they have more in common with Shakespeare, Dante, Tolstoy, than they have with the visual artists who are all eye. Energy from deep sources, and the tragic discrepancies of experience, press them hard, so that their born gift cannot but expand beyond the special development of a sense, and inevitably becomes a language for something that has to be said because it is important. Of course, the poetic idea will not be an indispensable help in approaching every great painter: there are many kinds of painter. But confirmation can come from unexpected quarters: when Picasso describes what he does in his painting, he frankly says that the resources he uses are the same resources that the poet has always used: comparison, metaphor, animism—even rhythm and rhyme—serving characterization in depth and tragic vision.[4]

[4] For example, from the passages in Françoise Gilot's memoir describing the painting of *La Femme-fleur* (originally, she says, "a fairly realistic portrait of a seated woman"):

"I'd been wondering how I could get across the idea that you belong to the vegetable kingdom rather than the animal." (p. 111)
"Painting is poetry and is always written in verse with plastic rhymes, never in prose. Plastic rhymes are forms that rhyme with one another or supply asso-

131

Though Cruikshank was not Goya or Picasso, we can quickly meet the artist-poet he was in his etching "The Pillars of a Gin Shop" (Figure 21a). This comes from *My Sketch Book*, the crop of pictorial doodles, puns, and squibs he collected in 1833 (Cohn 181). Most of the sketches are casual; but in this one, we can see he has been moved out of himself, and driven to realize in line a vivid succinct metaphor for a widespread plight that appalled him: though, since he is a satirist of the Hogarth-Gillray school, his chief tool is a serious wit. An example is the play with pillars: one refers to people who "support" an institution as pillars of it, but these human pillars are incapable, physically, of supporting even themselves, and in fact are propped up by two genuine pillars which, with their elaborate capitals, call to mind the irony of the Gin "Palace"—the sleazy ornate Pandemonium that had in its patrons' lives that dominance, and association of enlarged life. This young couple are of course man and wife, and the effect of gin addiction on marriage and family—what always mattered most for the humane Cruikshank—is read in their obliviousness of each other, and in the way they sag apart, separated by the swollen booby face of the still, flourishing its spout like a blundering elephant. We will be more impressed by the drowned couple when we see how old they are: the woman is hardly more than a girl, and —for the pen of this poetry is the etching needle—the brief touches of black that make up her face, bruised and deformed on one side, with the mouth sagged out to the left in a stroke of the needle that is the visual equivalent of her besotted slang, describe a face that has been pretty, and is hideous, young, and true.

The man, too, is drawn with some grace. If one thinks the rapid line runs the risk of breaking down into scribble, one has only to look at his relaxed left hand hanging down, or at the perfect

nances either with other forms or with the space that surrounds them; also, sometimes, through their symbolism, but their symbolism mustn't be too apparent." (p. 117)

"An artist isn't as free as he sometimes appears. It's the same with portraits I've done of Dora Maar. I couldn't make a portrait of her laughing. For me she's the weeping woman. For years I've painted her in tortured forms, not through sadism, and not with pleasure, either; just obeying a vision that forced itself on me." (p. 121)

"My tree is one that doesn't exist, and I use my own psychophysiological dynamism in my movement towards its branches. It's not really an aesthetic attitude at all." (p. 122)

All from *Life with Picasso* (Harmondsworth, 1965).

knowledge, in control, in the brisk drawing of his legs. Where the line is scrabbled and confused in his front, it gives well the crumple of tatters of his neglected, worn-out clothing. But chiefly, with the man, one sees that he is not an obese sot, he is a young man, and well-made; yet he is the epitome of sodden debility, above all in the handsome, corrupt face.

The artist's experienced irony makes the children of the marriage more conscious than their parents. The little girl on the left feels the situation and sits down crying, but if this seems a maudlin Victorian invitation to join in crying, we should note the sardonic way in which Cruikshank brings out the futility of her sadness by placing a black imp on the far side of the mother, echoing the girl's posture, but taut with malicious vitality. The small boy beside his father is also conscious—"awake" is more the word— with the narrow canny vigilance of an urchin who has had entirely to fend for himself. While Cruikshank's line jerks, twists, and scratches to give the filthy threadbare mess of his clothing, it simultaneously brings out his indomitable toughness in the planted, upright way he stands, hands in pockets, head firmly set. The life-history is horribly scrawled across his face: he almost has no face, it is battered and shrunk out of childhood. Yet there is some tender drawing by Cruikshank of his feet, and his young sensitive toes (i.e. no shoes). Throughout, the vigor of the line-work is not exuberant *brio* but passion communicated, and the irony that contains the passion is not destructive, it is sympathetic and generous.

Despite the family likeness to *The Bottle* (Cohn 194, 1847) and *The Drunkard's Children* (Cohn 195, 1848), and to earlier works such as "The GIN Shop" (in *Scraps and Sketches*, Cohn 180, 1829), "Pillars" is not propaganda. "The GIN Shop" (Figure 31b) shows the difference: there, the family stands in the jaws of a vicious man-trap; the father is gulping from a glass, the mother is pouring gin down a deformed baby's throat, the little girl is tossing back a glass, and the younger child is clamoring for one. The idea is simply repeated, not developed, and there is no power of contrast, while Cruikshank redraws and multiplies his lines, like a man who nervously keeps on talking because he has not yet convinced even himself. The success of "The Pillars of a Gin Shop" is that of an artist finding the right, perfect expression of material that had weighed hotly on his imagination for some time; though

it is not the diagram to a thesis, and so is not compromised by the fault Dickens found with *The Drunkard's Children,* that of mistaking gin for the cause of misery, when it was the result of it; and in any case it is a picture not only of the tragedy of drink, but of the tragedy of young life wasted and perverted.

It will probably still be thought, however, that to say such things of a drawing does not make the draughtsman a remarkable *artist*: it does not give enough evidence of the lifelong intense interest in what we see, and in what the hand can make for the eye. Though it seems undeniable to me, and always worth saying, that an artist cannot be great if the developed interests of the eye do not cooperate with the deepest interests of the man; without the interests of the eye one does not have an artist of any kind. And the art of Cruikshank, though he himself is not the greatest kind of artist, expresses not only the deep concern of the man, but intense visual interests that make him, specifically, the most versatile genius in the use of line that English art has seen. It is above all his power of line that makes him a major etcher and draughtsman for wood; it is a power that makes the range of things Beardsley can do with his pen seem impoverished, and frigidly deliberate and hard even in his complicated sensualities. However, because Cruikshank's line changed so much in character and quality through his long working life, an attempted account of its strength needs to be also a chronological account.

II

Speaking of his line in this way could imply that his visual genius was something separate from the poet in him, for linear draughtsmanship can seem the most literal of arts, where the artist has the clear, unmetaphorical and unpoetic duty of just making his line correspond closely to the contour of the thing seen. But no good drawing is ever quite that, and in Cruikshank's case, assisted by his practice of always inventing, not copying, what he drew, we see the non-literal and poetic priorities operating in the most basic habits of his draughtsmanship: we see them in his early work, and the first unfolding of his talent.

This last does not apply to his very earliest published work, but that was done in his early teens, and by 1811 even (Cruikshank, it may be useful to remember, was eight years older than

134

the century), in such a print as "Princely Piety," he has virtually found his style: the few lines that do the right leg of death are all mobile rapid moulding, running together in one swift ripple of rhythmic movement. By 1814, the artist is formed, learning much from Gillray, and a little from Rowlandson, but an independent master of spirited caricature, with a fluidity and impetus in the line that does away with any idea that drawing depends on a literal, one-to-one correspondence between the lie of the lines on the paper, and the angles and contour of the subject. Even Cruikshank's cross-hatching is all sweeping movement, currents and cross-currents of concerted lines, that not only plump and round out the three-dimensional convexity of the form, but enact muscular tautness or relaxation, and physical and mental movement. And the characteristic of the line is the characteristic of the whole figure the lines compose: the joyous facility expresses itself in extravagant posture, and carries into every finger and hair. One should perhaps add marginally that in these early caricatures, the drawing is so bold partly because it has to show up through the watercolors, and at the same time that because the figures are marked off from each other by color, they are not so clearly distinguished by tonal emphases as they would be in a black and white drawing.

Cruikshank's economy at this stage can be seen in the pictures he hangs on the walls, themselves small narratives, or in the posture and clothing of background figures in repose: for instance, in the couple sitting out the dance in *Longitude & Latitude of St. Petersburgh* (Cohn 1329, 1813, Figure 22a). The crossed starts and ripples of line convey the movements and tensions in the dandified torso: not only the extravagant ascent of lapel and collar, or the push from within of the padding about the shoulder, but the inflation and swell of the little round rib-cage, comically set, as on a stalk, on the throttled constriction at the waist. One can observe here, what always applies, that the character of the line works like the tone of a piece of writing to communicate the artist's attitude to his subject: the relaxed curling flow shows that the acuteness of the vigilant satirical eye is here devoted only to the genial amused enjoyment of the figures and the convivial scene. The satiric point here is slight; and often in these early prints, the satiric message has not a great deal to do with his energy, though there are occasions of concentration and serious

135

purpose. The study of the starving boy in the print *A Strong proof of the Flourishing state of the Country* (Cohn 2010, 1819, Figure 22b) is one of Cruikshank's strongest drawings: the whole body is shriveled, sharpened and devoured by an agony of hunger. His mouth is a vertical slit of pain among the sharp arrowing lines of his pointed jaw. The drawing of his eyes does not copy any normal formation of head, but it does represent the movement of hollow eyes turned upwards in blind pain. The face is utterly unchildlike, and hardly like any human face; it is the pure statement of anguished starvation, and a moving sign of genius in the artist.

Intensity of this kind is, however, rare in the caricatures. Normally they show an undisciplined flow of joyous creative power and fancy in the young man. It happens often to be expressed in anti-Napoleonic propaganda, but the question it might at the time have left one anxious to answer is where, into what, will this free energy go, in maturity?

III

In the event, it went into book illustration. As it seems to me, the move into illustration was in the long term frustrating and harmful to Cruikshank, but immediately it brought a new incentive and focus to his drawing, while in the caricatures themselves, after 1814, his style was not maturing, but rather running to seed. There is slackening and indecision in the individual line, and a tendency to repetitive and inert line-work merely to fill in and darken certain areas. There are, of course, exceptions, and the best prints after 1814 do show development, but in the direction of a more closely worked style less distinct from Gillray's. But Cruikshank had already learned all he had to learn from Gillray for his own individual manner, and his stylistic convergence with Gillray now, though immediately it means an improvement, suggests a faltering and loss of bearings in his own talent. It would be more than understandable if the long-drawn-out pathetic extinction of Gillray—the leading and guiding light in English caricature—preoccupied and demoralized his apprentice; and the decline in the print trade after the Napoleonic wars must have disheartened a young man beginning the art. At all events, there is nothing corresponding to the faltering of the prints in Cruik-

shank's first book illustrations; it is in them that we see his draw-
ing rapidly evolve and sharpen. The marked change of style in
his illustrations was of course a metamorphosis, not a break, as
we can see from the copies of Gillray's etchings that he was com-
missioned to make: the prints had to be scaled down to fit the
page of a book, and in a plate like *New Morality* (Cohn 1784,
c. 1819) the miniaturized version of Gillray's style is near kin
to Cruikshank's style in his book illustrations. This is not to say,
though, that his book illustration is merely the shrunken head of
Gillray's caricature: as the imitations show, reduction was not a
matter of copying each line smaller, but of making one line do the
work of three or four. The result is a new economy and strength.

Similarly, in his illustrations to Combe's *Life of Napoleon*
(Cohn 153, 1815), he tackles subjects that he had already used in
his full-scale caricatures, and if the Combe Napoleon is more like
a comic puppet than before, that suits the general purpose of
cutting Napoleon down to size, while the actual drawing is
markedly more spare, so that each energetic line means more. This
could be demonstrated simply from the wooden palings in the
foreground of the illustration "Pursued by Cossacks": the thick,
rough-and-ready lines give beautifully the rough texture of
dehydrated wood, while in the tree growing up the side of the
building, they enact the graceful rhythmic movement of the
growing stem, with its turns, re-turns, knobbly involutions and
twiggy dispersals of tree growth; the drawing is stylized, and Cruik-
shank has not so much imitated appearances, as used, like Picasso,
his "own psychophysiological dynamism in his movement towards
its branches," but this is what makes it like a real tree.

Time and again, although he was no countryman, Cruikshank's
trees have a vegetable vitality of their own. In the trees in the
background of many plates, for instance in the Trulliber plate
for *Joseph Andrews* (Cohn 706, 1832), the foliage is rendered
in runs of fine lines which are both curved, with a suggestion of
individual leaf-forms and also of clumps of leafage, and yet sweep
up and round with the felt springing of the trunk from the ground
and the leaf from the trunk. They normally tend in one direction
more than another, as it were with the push of wind through
them, and these small strokes sometimes also sweep up with the
toss of a branch in the wind; the wind-motion and wind-direction
being confirmed by the flow in the outline of the clouds, and the

rush of small flecks across the sky. One does not normally elicit separately these subtle and subliminal communications of the line, but close inspection of many illustrations in his best period will show the ink-mark on the paper to have a controlled and used ambiguity that enables it to assume simultaneously a variety of the characteristics of what it draws, not just the shape and tone. This ability, used with the richness and delicacy with which Cruik-shank uses it at his best, gives his line-work an incalculable, magical suggestiveness. A small instance in the Trulliber plate is the way the ivy leaves are drawn on the wall, in a recoiling, crinkling line, so that as one looks at them, the eye is constantly rerouted and interrupted, and they seem to flutter on the walls as though a breeze were ruffling through them.

Line that works in this way has a different kind of power from that of an acknowledged master of line like Goya; he, by contrast, shows both his passionate strength, and how near to madness his passion brought him, not so much in his subjects, as in his way of drawing them, where the tiny swarming strokes tend to run all one way, to pour across the plate in narrow jets that seem the graphic definition of mania. Cruikshank's line is elastic and freely suggestive; and what is especially remarkable is that the kinds of effect that have been discussed are just as apparent, if not more so, in his best wood-engravings, where his drawing was in fact mediated by another man's knife. In innumerable extraordinary engravings, his delicate individuality proves unexpectedly robust, and comes through barely diminished—Thackeray noted how well the engraver had caught Cruikshank's "own particular lines, which are queer, free, fantastical, and must be followed in all their infinite twists and vagaries by the careful tool of the engraver." But the character of Cruikshank's drawing for the wood—"little dots and specks, and fantastical quirks of the pencil," as Thackeray puts it—amounts to more than quaint idiosyncrasy. The curious twisting line, which is so versatile when one looks closely at what it does, now spiky, thorny; now meandering exploratively like fibres of root; now coiled or curving like a strong spring; runs back and forth, over and through itself, and makes a kind of broken shimmering web, in which one sees figures, faces, landscapes as one sees them in knotted wood or mottled linoleum. His dots and specks always provoke some play in the realizing eye, evoke or half-evoke not just some

138

material reality, but its quality: the new-laundered crispness and brilliance of an apron, the corrugation of rough, lichen-crusted tiles across a roof.

Several of the engravings do have spaces where the engraver has felt not equal to the exhausting challenge of Cruikshank's line, and has substituted normal, mechanical shading. But the majority of the illustrations for *Italian Tales* (Cohn 444, 1824), *Mornings at Bow Street* (Cohn 844, 1824), *More Mornings at Bow Street* (Cohn 845, 1827), and *Three Courses and a Dessert* (Cohn 144, 1830), are remarkable for this electric charge in the line. The little illustrations in *Italian Tales* are wonderful for it, and in particular they make it clear both that Cruikshank knew just what he was doing in drawing for the wood—knew that he was drawing for a particular range of possible effects—and that he was an innovator in his sense of what wood-engraving could do. As it seems to me, Cruikshank's drawing on the wood-block led to wood-engraving as remarkable and fine as Bewick's, though quite different in character, and original.

However, it would be easy in discussion of these effects to lose sight of the line that does not flexibly crumple and mold itself to the character of its subject, the line that stands clear in its single slender sweep. This, of course, belongs to his etchings, where the stroke that Cruikshank made with his needle can be bitten and printed direct: the slow wood-carving of such a line would change its character. It should be said, though, that the kinds of effect in the wood-engraving just referred to could not be equalled in etching, since they depend on a constant marked variation in the thickness of the line, and no laborious elaboration in biting the etched plate to different depths could quite equal this.

In the early illustrations, one of Cruikshank's refinements on his caricaturing practice is to give his figures one fine, clear, fluid outline running down their brightly-lit side. I don't know why Lawrence commented, "it is not what we call drawing," of the Etruscan murals he describes (with his ignored genius for art-criticism):

> The subtlety of Etruscan painting, as of Chinese and Hindu, lies in the wonderfully suggestive edge of the figures. It is not outlined It is the flowing contour where the body suddenly leaves off, upon the atmosphere. The Etruscan

artist seems to have seen living things surging from their own centre to their own surface. And the curving and contour of the silhouette-edge suggests the whole movement of the modelling within.[5]

But though Cruikshank uses outline, his outline has this quality (as do many artists' outlines)—even in so vulgar a piece as the etching "The Awkward Squad" for *Mansie Waugh* (Cohn 570, 1839). The line that flows down the outside of the leg of the man on the left is just the sort of contour Lawrence describes, as also is the line defining his hand. (It is worth remarking that Cruikshank's comic figures often have good legs; though a master of comic posture, he has no facetious obsession with spindle shanks.) It is a small drawing, it is not an anatomical diagram, and it is obviously related to certain artistic conventions in rendering the leg: but the mobile hair-line expresses a sense of the well-formed limb full and rounded about its center, and has the advantage over the mere stopping of flat color along the place where the line would be—as in the Etruscan paintings— that the line itself has a character in its "touch," its "feeling" and movement. The danger with outline is that it can implement a determination in the artist to arrest, pin down, and "possess" his subject—then the subject usually escapes, and one is left with the motionless chilly line like a piece of bent wire on the paper. But the "touch" in the scrap of line here expresses not the imposing will of the delineating artist, but his intuitive feeling for the grace in the firm flow of surface in a fit working body. It expresses a delight in the functional beauty of the body's contour that Hogarth expresses:

> To enforce this still further, if a line was to be drawn by a pencil exactly where these wires have been supposed to pass, the point of the pencil, in the muscular leg and thigh, would perpetually meet with stops and rubs, whilst in the others it would flow from muscle to muscle along the elastic skin, as pleasantly as the lightest skiff dances over the gentlest wave.[6]

I believe one could collect a hundred pictures by Cruikshank where the human contour is done unpretentiously, in vulgar

[5] *Mornings in Mexico and Etruscan Places* (Harmondsworth, 1960), pp. 166-67.
[6] *The Analysis of Beauty*, ed. Joseph Burke (Oxford, 1955), p. 76.

contexts, and, as it were, offhand—and yet has this warm beauty, and has it, in fact, in a greater degree than the official Outline School that flourished in these years. Flaxman's contours seem by contrast hard, frozen to the paper; Cruikshank's have a combination of delicacy and energy that makes them more like Blake's.

Mention of Blake will recall that even genius in line can amount only to a part of the powers making great art, and in particular that Cruikshank, unlike Blake, does not exist as a colorist. Yet the comparison, or contrasting, of Blake and Cruikshank is not so straightforward as it might appear. For they could seem simple opposites, the noble versus the low: Blake despised caricature—he told Trusler, "your Eye is perverted by Caricature Prints"[7]—and his use of his own "wiry bounding line" is controlled by a reverence for ideal beauty. Though (like Cruikshank) he prided himself on not drawing from the life, in his case it was because, he insisted, the forms he drew were spirit-forms seen in vision; moreover, such copying as he did do, and utilized in his own compositions, was not from the life, but from engravings of Old Masters who had themselves idealized. Even so, unless there really are such spirits that have such bodies, these removes can only be developments and refinements of the beauty of the actual human body; and, positively, it is noticeable that though his male spirits have an oddly stylized musculature, they are athletic and fit, and that the full lovely curves in the female forms draw on his immediate sensuous and sensual familiarity with the down-to-earth human form: if one called their beauty ideal, it would not mean that they belong to another world, but only that the art that creates them selects and emphasizes in relation to distinct interests. One might still think these interests the opposite of those informing the caricature school. But the sentence from Hogarth corresponds to a quality in Hogarth's painting; and the beauty of Rowlandson's better line is not an abstract beauty either, but a beauty of human contour felt with tender sensuality. It is not surprising that comparable feeling is to be found in Cruikshank's art, and when we return to the question of energy, Cruikshank and Blake are clearly akin in their chief characteristic. We also find that in dramatic and passionate situa-

[7] Letter to the Rev. Dr. Trusler, 23 August 1799, in Geoffrey Keynes, ed., *The Letters of William Blake* (London, 1956), p. 35.

141

tions they will use the same stylizations of posture, and Cruikshank's energy transcends caricature, while Blake is in fact not less extreme in his expressive distortions of the body than is Cruikshank. It would be wrong, however, to leave the parting stress on distortion, expressive or not: the energy that characterizes both artists is human energy, purposive, and poetic, and, for instance, Cruikshank's "Pillars of a Gin Shop" could serve as a better visual analogue for a Song of Experience like "London" than the illustration Blake provided.

In the convention used in the *Mansie* illustration, while one side of the figure is drawn slenderly, the other side is marked by a thickened line which we accept not as literal observation so much as a stylization of shadow which we allow to suggest the brightness of the light illuminating the scene, and also the roundness, solidity, and foreground prominence and importance of the figure. Similarly, when a figure wears colored clothing, an even grey tone is laid across it, and rather than deepen this gradually as the form curves and recedes, Cruikshank again suggests the round mass with the same dark edge down one side. The convention does in fact correspond to facts of observation, for shadow seldom increases round a clothed figure in an even gradation, and often appears to concentrate darkly to one side. The weight of the black edge also enables it to work as a sculptural accentuation, as if it were forcefully pushing back, in malleable material, the form's curve away from us and out of sight; nonetheless, though varied, it is also standardized and recurrent, and though it is not one of Cruikshank's most vital characteristics, it can illustrate how details of Cruikshank's drawing operate like a complex onomatopoeic, denotative, and metaphorical language or poetry: so that his basic technique and *quality* as an artist, what makes him a master of line, is continuous with, not separate from, the qualities of a whole composition that would make us call him a visual poet.

IV

I hope at the same time that this discussion makes clear that to call him a visual poet in his use of line is not a way of easing pressure on the artistic side. To speak of his lines being suggestive is not to license vagueness, an unchecked rambling of lines

142

in which one can see anything; on the contrary, the suggestiveness is a matter of realizing much with little, and the appreciation of it should make one more exacting. For there is undeniably a great need for distinctions, not only as to date, to be made in Cruikshank's work: I think for instance of the great difference in quality between the two versions Cruikshank made of his plates for *Sketches by Boz* (Cohn 232-33, 1836-37; Cohn 234, 1839). The two sets were done within a couple of years, both fall within his best period, and the later series follows the earlier closely, but the difference in quality is immense; and this needs to be pointed out because it is the larger, more elaborate plates that are the worse, yet it is they that are most often reproduced and discussed as *the* illustrations to *Sketches by Boz*. It is not surprising they are inferior, for they are the later versions: copying normally deadens, and these plates show that copying even one's own recent work can kill it. In confirmation that the lethal factor was the copying, one can note that the illustrations for the later series that were new subjects for the new occasion, such as "The Streets, Morning," are on quite a different level, and the latter has a just reputation as a masterpiece. But the revised version of, for instance, "Hackney Coach Stands" is not a masterpiece, though the first version had been one (Figures 23a and 23b). The children, then, were done simply and rapidly, but with a freshness and truth sufficient to dispose forever of the idea that Cruikshank could draw children only as diminutive adults; in the face of the right-hand child, each short curving line models the face physically and brings out the fresh and wholly childlike excitement. But in the later version, the face is not a child's, the line is insensitive, the expression is ambiguous shading to imbecilic. This is an extreme example of deterioration, but the general feature of the revised version is a mechanical overworking: there are many more bricks to the wall, drawn more carefully, and more window-panes too, while the cross-hatching of clothes and indoor shadow is heavier and darker. These features draw attention to themselves, though they are inexpressive and mean nothing, and they weigh down and smother the original freshness.

Similarly, in the two versions of "The Pawnbroker's Shop," the general change can be represented by the feeble sketching of the carpenter's face, compared to the intensity of shrewd, bat-

143

tered disgruntlement in the clenched lines of his earlier face. Other items for comparison are the faces of the two brawling women in "Seven Dials," or the children, the dog, the clothes— really, every detail—of "Monmouth Street."

V

Nonetheless, though the admirer of Cruikshank is kept on the alert, critically, by the large fluctuations in quality at every stage of his career (inevitable when the genius was also a hard-pressed professional), the principal distinctions are still the chronological ones. In particular, there is the radical change in his work in the years around 1840. It is evidently associated with his illustration of Harrison Ainsworth, and with the idea of fineness of execution which seemed to him appropriate for such high-class fiction (for Ainsworth was always the gentleman, though much given to New-gate slumming): he regularly honors Ainsworth with a careful minuteness and polish of execution he had accorded to no earlier author, certainly not Dickens. And the results of this prolonged careful devotion to "effect" can be very fine in the richly dense gatherings of shadow, and the glimmerings and percolations of light that break out here and there in clear gleams. But one is always hearing these plates admired for their "Rembrandtesque" qualities (though the hatching is actually not as bold and deci-sive as Rembrandt's; and surely Rembrandt, too, could overwork his plates, and often did), and this admiration does harm when it implies that these are among Cruikshank's best things, or that they are nearly on a par with his best things (for it has been observed that in order to get these fine effects, he did have to sacrifice some of his wonted boldness and vigor). It is not only the boldness that has gone out of his drawing, however, but also its poetic range, its infinitely varied and variable energy of sug-gestion. The fine lines ruled across the sky mean certain tones of azure and nothing else; the fine hatching across the walls means —scarcely masonry, but just deep shadow. Surely it is time to ask whether the appeal of an art resting on the management of shadow from somber to jet black, or of light from veiled glow to flaring incandescence, is a relatively superficial attraction? This could be borne out by observing that in this style, Cruikshank had chosen to enter into competition with the steel-engravers of

144

his time: enormously practiced and dexterous, they had become expert in the minute scratching and roughing of a metal plate so as to convey the subtlest, or the harshest, or the deepest, modulations of light and shadow. And Cruikshank's achievement is to do something similar in etching; indeed, he does so with extraordinary finesse: in the sky of "The Duel in Tothill Fields," he uses a combination of light biting and stopping out to portray a soft luminescence of dawn spreading through layers and rolls of light fleecy cloud. And yet he does not, I think, achieve more than a number of steel-engravers could have achieved. This is not to belittle either Cruikshank's achievement, or theirs, which was the product of years of industry and refined skill. But Cruikshank only equals their work, he does not better it, and though he shows himself a most polished and expert master of the craft of etching, he ceases to be a genius with a unique gift.

This new mode, which is first indisputably present in the illustrations to *Jack Sheppard*, becomes the style of his work for Ainsworth, and, after 1840, of most of the serious illustration that he did. It is then not a matter only of hitting the right note for Ainsworth, but also of a general change at about 1840 in Cruikshank's priorities and ambitions. Charles Lever's *Arthur O'Leary* (Cohn 483, 1844) is in quite a different style of fiction, picaresque Irish Pickwickism, but Cruikshank brings to it the same minute industry of execution that he brought to Ainsworth; the *O'Leary* illustrations are personal favorites in this phase of Cruikshank's career—their clarity and brilliance is marvelous, and in "A Night in the Forest of Arden" there is some expert navigation among the many different tones of clothing, grass, and near and distant foliage and bark.

Of the work of the 1840s, we can say that Cruikshank has in a sense become more ambitious; he is trying for effects he had not attempted before, but he seems to have become more ambitious in this way because he had lost faith in the gift that he had; his line has lost the reckless assurance that it had before, and justified. Whether the loss of impetus was the cause or the result of his new self-consciousness as a Fine Artist, he certainly shows, in his now habitual determination on "effect," a most destructive kind of self-consciousness for an artist to have. Possibly a certain hesitancy should not be surprising, seeing that, though barely half-way through his career as a book-illustrator,

145

he was by now nearly 50; it may also be that his deference to the proprieties of the Victorian bourgeoisie, which had become prescriptive only after his formative years, perhaps focused by his close collaboration with Ainsworth, made him embarrassedly conscious of the vulgarity of his earlier work, and led him to think that not merely his subjects and his humor, but his powerful line, was vulgar. Certainly his faith in himself, as an independent artist who, though an illustrator, could stand alone by the intrinsic strength of his art, received its first drastic blow with the failure —it foundered within a year—of his *Omnibus* (Cohn 190, 1842), the magazine where all other contributions were to be strictly subordinate to his drawing. That suggested that he could now *not* be independent as he had been in his youth, and the ensuing disillusionment would be likely to sap the indispensable confidence of his talent, and to cause his line to lose its nerve.

At any rate, loss of nerve was the result, and the dense thickening of the cross-hatching in the illustrations of the forties seems to me camouflage. In the illustrations to *Clement Lorrimer* (Cohn 687, 1849) his line is lost in the smoke of cob-webby shadows he has drawn. But in the large, near figures in the foreground, he is exposed. His genius had never been for the meticulous, detailed modeling of form: he had no practice at that, since he did not draw from the life, and the inevitable result is that when, in this period, with his subdued and broken-up line, he painstakingly tries to realize human figures in static, close-up solidity, they tend to be stiff, wooden even, and the fine shading on the form can make it go flat rather than round. The same could be said of the many figure studies in the *Frank Fairlegh* illustrations, done the following year (Cohn 754).

By the time Cruikshank illustrates Henry Mayhew's *1851* (Cohn 548), his drawing, when it comes into the open, is loose and free in a sketchy, unrealizing, negligent way—the first plate could be mistaken for late work by "Phiz"—and one bad sign, also reminiscent of the late "Phiz," is the obtrusive use of the roulette, run back and forth across the plate to darken the tones. The sameness of the regular, mechanical punctures jars against the expressive individuality of a line from the artist's hand; worse, Cruikshank has moved the roulette in a straightforward zigzag, so that the dots on each successive line come just under, line up with, and touch, those in the line above: the result is not a shadowy

146

cloud of dots, but a run of ragged striations. The last illustration is slipshod in a more revealing way: in "The Dispersion of the Works of all Nations . . ." Cruikshank's lines multiply shakily, and do not know what precise form they are hovering over; and this may be because the economy of his better work depended not merely on his having seen, but on his having known for years, the people and things he drew (though they might be rearranged in fantastical combinations). The new objects swarmed round him at the exhibition and filled his imagination like the weird creatures assailing St. Anthony, yet he could not realize with his needle what he had not repeatedly noticed, absorbed, and realized in his experience.

The frontispiece to *1851* is, however, in a different class from the other illustrations. "All the World going to see the Great Exhibition of 1851" is one of those prints he liked to do in his later years, in which the whole globe is seen as an anthill, crammed with tiny figures drawn with meticulous care and compulsory economy. In some of these prints, his inclusive ambition can seem like a cooped-up megalomania, showing his state of mind when his ambition as an artist was undiminished, but had lost the sense that its fulfillment lay more in a single figure vigorously realized, than in a thousand people minutely hinted at. This particular plate is not, however, quite so ominous: the picture of the thronged world is wittily right for the convergence of the world's population on the Crystal Palace in that year, and there is much wit in the drawing, as in the American steamer curving round a sector of the world, and representing prodigious innovations with its twelve paddle-wheels one after the other down its side.

I have dwelt on the latter novels as representing different aspects of the direction Cruikshank's development took in his later years, but certainly there are better illustrations done later; those to the *Life of Sir John Falstaff* (Cohn 96, 1857-58) stand out. Though the line runs too much to a repetitive fretwork filling-in of areas, it is a pleasantly relaxed version of the drawing for Ainsworth, and is adroit in unifying in a single integral picture, with a distinctive atmosphere, groups of active figures, crowded streets, and distant landscapes and skies. The gables, overhangs, beams, gargoyles, mullioned windows, and all the little ins and outs of Old English houses are drawn with affectionate expertise. But

147

after this, there is no further significant development in Cruik-
shank's use of line to be recorded: change is decay, and the last
stage, the stage of *The Brownies* (Cohn 277, 1871), is miserable.

VI

If, now, one turns back to, say, an illustration of *Mansie Waugh*,
one sees not only that the later illustrations are weaker in line,
but also that they are not comparable in clarity and force of design.
"Curse-cowl and the Apprentices" shows a mass of bodies thrown
backwards, but on inspecting the plate, one notices that the lines
of heavy shadow mostly run one way, giving a unified movement
and lean to the confused mass of figures. The brightly lit corner
of table on the left edge makes a sharp arrow pointing into this
angle of movement; Curse-cowl's stick is parallel to it, so too is
the leaning roll of material on the shelf, top left. The tones on the
wall consist of two sets of lines crossed, vertical and diagonal, and
while they give the wall its shadowed solidity, at the same time
they give the figures an unobtrusive acceleration: the vertical
lines corresponding to the erstwhile uprightness of the people
and giving a stable frame of reference, the diagonals parallel to
and assisting the present leaning-falling departure from the
vertical.

"Curse-cowl and the Apprentices" illustrates in a simple way
how it is, in Cruikshank's work, that considerations of line be-
come considerations of composition: for in his good work, the
design does not simply set the subject out to good advantage in
terms of lighting, proportion, and perspective, but is itself func-
tional, and extends the metaphor. This control does not apply only
to ambitious projects, it is as true of a representative small
satirical drawing like "Term Time" (from the *Hard Times* plate
in *Illustrations of Time*, Cohn 179, 1827, Figure 21b). Probably
what first strikes one in "Term Time" is the easy nicety of touch
in the drawing, concentrating decisively where the darker forms
are to be, or becoming nervously sensitive in suggesting, without
fuss, tight corrugations about buttons and breeches. But the brisk-
ness of the draughtsman's hand does not mean that the picture
was a perfunctory squib: after a few moments of looking at it,
one realizes that it is beautifully composed. It has a clear, sym-

metrical basis in the three figures, with their mass, shape, and the emphatic shading of their forms, balanced with the negative space between and around them. The formal principle linking the separate figures is that of two squares: on each side, the horizontal arm of the lawyer, the horizontal shading below, and the upright inner profiles of the bodies, make a rough invisible square which the mind unconsciously recognizes, with the consequence that it feels the spacing to be right. And though the squares are rough, the irregularities help to relate the figures; the curves in the lawyer's outline are repeated, slightly accentuated, in the litigants' bodies. The three figures are thus associated across intervening space with an appropriate irony: the swell of the lawyer's firm stomach answers to the hollow bellies of the litigants.

The space between the figures should not in fact be called "negative": on the right, for instance, it is used in a well-proportioned way to frame a study of a debtor being arrested by a bailiff, eloquent in the sagged vertical of the caught man, and the tilt and momentum forward to grab him of the captor. The little scene is marked off by the prison wall and the fall of shadow across the ground, to make it a smaller square within the large square, and it is tied to the foreground group both in composition and in meaning by the similarity in posture between the debtor and the litigant. The satirical-serious purpose that ties the two figures also sets the litigant himself against the prison wall, so that he is surrounded by the shadow of it. It is a debtors' prison, and behind the litigant's back, balancing the vignette of the debtor caught, is the not caricatured realization of the grill of the prison: a further square, if we let the notice "Pray Remember the Poor Debtors" rule off the arch of the window, and filled with tiny squares that burst with jostling faces, a sufficient evocation of the poignancy and enormity of a debtors' prison, though Cruikshank's communication of this is complimented by the inscription lying, easily neglected, on the ground, and corresponding to the sign displayed above, "Pray Remember the Poor Creditors." The touch throughout is light, but this, if not before, is the point at which one acknowledges that Cruikshank's satire is not shallow or simple, it is intelligent.

To the left of the lawyer, we look under his arm to an echoing vignette of discontented litigants arguing with a barrister, while

149

his colleagues sweep into Westminster Hall with bulging blue-bags, eager for business. This study is not so tight and pithy as that on the right—for the left-hand side of the composition is definitely the looser—but the figures are further away, and make the right background. The receding perspective of Westminster Hall, paralleled in the cloud shape, makes an arrowing or funneling movement across the picture, accelerated by the sweep along the lawyer's spread arms, into the debtors' prison: the two very different edifices are related both in composition and in point, for composition in this picture, though elaborate, is the servant of meaning.

Such a protraction of analysis is, I know, something to apologize for, but it does make a critical point. Formal analysis is readily elaborated in homage to an Old Master, but is not normally bestowed on a caricaturist or book-illustrator, on a Cruikshank. It should be, sometimes, for it serves to show, not that Cruikshank was a deliberate calculator of formal patterns—which would not be a recommendation—but that his day-to-day graphic satire has the subtle internal coherence, and the fine balance of co-operating energies, that one finds in a large masterpiece in oils, or in poetry.

I have been wanting to show that not merely line, but composition too, makes a significant contribution to the visual poetry; and Cruikshank's strength in significant design outlasts his strength in line, as, for example, the last plate of *The Drunkard's Children* shows (Figure 28). It comes in a late work (1848), a series in which, generally, his art has stiffened and gone hard and dull with propagandist zeal. The industrious drawing is defective, so that feet do not rest on the floor but hover indeterminately above it, and he is so bent on suppressing vulgar caricature in the faces, that he suppresses character and life, and the figures are mostly dummies. Plate V is crowded with lawyers, a traditional gorgeous subject for caricaturists, and earlier for Cruikshank, but here there is no memorable variety of type and passion in the massed legal faces. (It should be said, though, that the face of the lodging-house keeper woken up in the night, Plate IV, is the essence of bleary stupor.) Nonetheless, many of the designs are well-composed as to balance, space, and proportion, and in the plate showing the Dancing Room (Plate III), the rhythm and movement of the dance undulates from figure to figure, animating

150

the whole design (a lovely characteristic of all Cruikshank's dance scenes). There is a largeness and relaxation in the picture that is not habitual to Cruikshank: clothes, for instance, sweep energetically round, not with all their actual ripples and flutters, but in bold expressive simplifications of the way clothes move in dancing. And the last plate is unforgettable.

The subject is the suicidal jump of the Drunkard's daughter into the Thames. The stone bridge fills our sight, and down its blind wall the girl is falling, a sharp white shape against the general grey; her dress streams up above her, and her coat-tails tug back, in the speed of her fall. Cramped up in the top right corner two figures show their alarm, but are tiny, dimmed, and she is as far from their sympathetic horror as she could be. In the lower part of the picture, the wall opens backwards into the enormous cavernous underside of the bridge; this, I think, plays on our sense of death as a hollow dark cavern into which one *falls*. But the drawing of the arch is ambiguous. The lines across it run parallel, rather than converge, and it is so little darker in one place than another, that it effectively lies there on the paper as a flat shape. Its great curve is a key feature of the plate, drawing the eye, and imagination pushes it back as the underside of the bridge, but the drawing is ambiguous and so unstable, and if one looks at it for any length of time, it takes a life of its own, and now recedes, and now advances as a kind of black rainbow or shadowy wheel sweeping down, accelerating the girl's fall. *Beneath* the bridge is a cold moon obscured by smoky cloud, and along the bottom of the plate is a line of ship's masts, sharply sticking up like spikes. The powerful, simple, intense design uses an unexpected diversity of means, and the Temperance rhetoric transcends itself: one has only to consider what Cruikshank makes of Waterloo Bridge. For the Temperance melodrama, it is just the convenient property straddling the Thames from which the girl can dramatically drop. But it is drawn with an unexpected attentiveness, especially as to the massive regularity of its stones, and the regularity of the plain decorative pattern under the parapet. It calls attention to itself as something man-made and as something heartlessly colossal, hard and cold, with an implication about the world out of which the girl is falling.

151

Design of this kind has a suggestiveness analogous to that of Cruikshank's line in individual passages. One might say that in both the "poetry," in the economy, consists of the multiplicity of things unobtrusively and concertedly shadowed forth; but that would leave out the sense suggestiveness should carry of the burrowing of deep roots. I have in mind the immediate leap so many of Cruikshank's pictures make into our dream-life. This is most apparent in, though it is not peculiar to, his illustrations to fairy tales: above all in the illustrations to Grimm (Cohn 369, 1823-26), for Ruskin's discrimination in favor of them, against the *Fairy Library* (Cohn 196-99, 1853-64), would be difficult to refute. Nonetheless the Grimm illustrations are well appreciated (even in poor reproductions—the original proofs are worth looking out, where the fine lines are perfectly clean and sharp, and the blacks are like caked soot); and there are plates in the *Fairy Library* that deserve emancipation. "The Giant Ogre in his Seven League Boots" is one (Figure 29a). The lightness of the etching, which elsewhere in the *Fairy Library* indicates weakening grasp, is here functional, since it assimilates the Giant to the sky, which is drawn all in straight lines going the same way that he is, so that he rushes forward in an accompanying rush of wind. In the Giant's legs, Cruikshank has borrowed a distortion from the artists of the turf, using it, as they do, not to educate our anatomical sense, but to evoke rapid flight: the Giant's legs are stretched out and elongated in one line of motion. It is the ideal visualization of the fairy-tale conceit of the seven-league boots, but is more than that. The Giant seems himself a creature of the rapid pursuing gale, and calls up our ancient sense that there is in the rushing wind something alive, weird, and fearful. The little human figures are right by a deep instinct to hide themselves in a tight rocky hole in the protective ground, at the bottom of the picture. The heavy shading of the rock to the left, and the hillside in the center, thicken the wall of sheltering earth, and at the same time, in their diagonal sweep across the picture, speed his movement; the line-work of the landscape beyond is also in sweeping motion, and both creates a still countryside, and yet is like a turbid river. With such depth of implication the picture goes beyond being, what it also is, the perfect illustration to its fairy tale; it shows that

whatever Dickens thought, and with whatever Teetotal moralizings Cruikshank encumbered his text, the artist in him did still know what fairy tales are, knew from what they draw their power.

The assimilation of the Giant to the air is an instance of the part played in Cruikshank's work by his animism, which in more developed form comes out in those drawings of corks, pumps, houses so that a face forms in them with a nearly human personality. These drawings in particular could be cited to show the metaphorical tendency, the pregnant ambiguity, of his visual imagination and line-work; for he does not crudely draw a human face on the inanimate object, he draws the object, his coiling line marvelously recreating the texture and feel of it, and accentuating certain marks and bulges on its surface, so that we imaginatively see into the area of lines the face that he sees there. The object retains something of the strangeness and ambiguity of the inanimate thing it is: the animated oyster shows in its shape and expression that it is compounded of the soft, colorless flesh of an oyster, and we almost hear the sweet slushy voice. It is not quite humanized, not quite reconciled with our species, it remains a weird oyster-personality. These pictures, which Cruikshank produced in great numbers, embody an idiosyncratic kind of genius, a genius that is a curious combination of visionary imagination and lively wit, and they draw remarkably on childish and primitive levels of perception, on our intuitive inclination to see the world as a mystery, populous with foreign active presences, each aglow with its queer, different spirit of life. Yet decidedly they are also evidence of his genius for the grotesque, and in view of this what perhaps needs most to be said about their place in his work, is not that they are a memorable specific division of it, but that we see the same animating power in the *Comic Almanack*'s series of scenes from London life (Cohn 184, 1835-53). Both genres evince the rare power that Cruikshank shared with Dickens, which is a "quickness" of eye to see the distinct life in all the diverse crowding events that surrounded him and made up his world: life that he sees so vividly because his own imagination actively goes out to it, equipped to do so by the richness of his own inner life. The pictures of "The Seasons" that record innumerable true manifestations of street-life in London add up to one serial *opus* that is much more than invaluable anthropology

153

of the London folk. In the etching, Cruikshank recreates what he has observed with intense participating and enjoying imagination, so that the vitality and character of the figures is felt in the starts and curves of his line, and especially in his countless vital physiognomical studies. This does not apply only, where it applies most clearly, in the many festive scenes: to give a detail, there is the mobility, weight, and character in the spare line-drawing of the three brawny, energetically shoveling men, in their coarse work-clothes, in the background of the February plate "Changes of Weather." In general, the characteristics of the scenes—the lively sway of crowd or dance movement, or the jostling and threshing, the dustiness, shabbiness, fogginess; the playfulness, color, and merriment—seem not so much to be depicted, as to embody themselves in the vibration, the coiling and breaking, the ragged or taut weave, of the drawn line.

The plates speak for themselves and analysis is redundant, but because there is much in them that, in being real, is rough, and because the life in many of them could seem tied to the crowdedness, the dense packing, there is a case for pausing to discuss the different—but representative—quality of the most beautiful print in the series, "All a-growing!" (Figure 29b, very rightly picked out by Philip James for reproduction in his King Penguin *English Book Illustration*). It is a marvel of "atmosphere," of the management of tone and space to give the airy freshness, the bright sunlight and warmth of the May morning. But though also full of particular observation—witness posture, costume, the donkey-cart (and the donkey)—the visual poet is evident. Like the other prints in the series, it has a theme—given in the street-call of the flower-sellers, "All a-growing!"—but there is nothing obtrusive or crude in the way the theme is repeated through the composition: it waits to be discovered in the gradual natural taking-in of the picture. Then one notices that it is not only the plants being hawked that are all a-growing, but that there are trees, bushes, and wall-plants all round, and that the trees —in their pointed contrast with the rigidity of the lamp-standard —are drawn in light brisk upward strokes that give their free push and flow of upward growth. (Each of the three main trees is in fact placed behind and above a particular flowerpot to mark the family association—so also, ironically, is the street-lamp.) But the main point of Cruikshank's wit here is that the terrace

154

is rife with active children in every phase of growing; and they *are* children, perfectly done, not shrunk adults. The poetic wit here is gentle, but it is in the real (as all the faces show) and substantial.

The complete series makes one extended visual poem about London life, unified by its cycle of the human seasons: surely Cruikshank's masterpiece. One could not say of this artist, that his distinctive power is in the grotesque: on the contrary, when one thinks of the tendency in visual artists to lump crowds hectically together *as* crowds, with aversion, and to see in city life mainly what is nightmarish, Cruikshank stands out for a quality that seems the opposite of grotesque. He is endlessly observant of the multifarious play of life in the metropolis, and his seeing and his drawing, his nervous line of sharp perception, is not governed by an eye hungry for the bizzare, but by a generous humor, a sense of the natural relatedness of people and things, and an inexhaustible imaginative humanity.

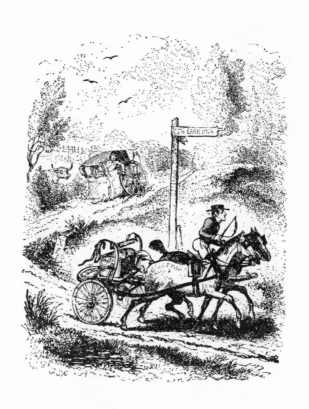

An Artist in Time:
George Cruikshank in Three Eras

BY LOUIS JAMES

B LANCHARD Jerrold, in his revised *Life of George Cruikshank* (1883), thought it necessary to remind his readers that "the present generation are familiar merely with the George Cruikshank of the last thirty years. But his course stretched through three generations of his fellow-men."[1] He had lived through the Regency, through the era of the Reform Bill agitation and the dawn of the Victorian period, and he was still active in the middle decades of the century. Not only had he been alive, but he had helped to create the graphic art through which each era had become aware of itself.

He had been associated with the social and political satire of the Regency, and with his brother Isaac Robert, he had illustrated Pierce Egan's *Life in London* (Cohn 262, 1820-21), a seminal work of nineteenth-century urban literature. Through the twenties and thirties, his prolific designs commented on the tensions of an era of transition, ranging from urban pollution to the coming of the railways, from commercial exploitation to the vanities of fashion. Later still, *The Bottle* (Cohn 194, 1847) and his painting *The Triumph of Bacchus* (1863) reflected the high earnestness of the mid-Victorian period.

This brief essay will not attempt to characterize George Cruikshank's place in even one of these three eras. Rather, by considering one polemical work from each, it will attempt to suggest some of the graphic conventions within which Cruikshank worked, and which he made his own.

I

The Political Showman—At Home! (1821)

'*Tip us your flipper,*'[2] said Harry—'then I see you are a true

[1] Blanchard Jerrold, *The Life of George Cruikshank* (new edn., London, 1883), p. 3.

[2] Invitation to shake hands: an interest in urban slang was an important feature of such lightly fictionalized travel books as *Real Life in London*.

bit of the *bull* breed—one of us, as I may say. Well, now you see the spot of earth [William Hone] inhabits—zounds, man, in his shop you will find amusement for a month—see here is *The House that Jack Built*—there is the Queen's *Matrimonial Ladder*, do you mark?' [And] they approached towards St. Paul's, chiefly occupied in conversation on the great merit displayed in the excellent designs of Mr. Cruikshank, which embellish the work they had just being viewing [*sic*][3]

Hone's shop on Ludgate Hill was one of the sights of London in 1821, when this passage in *Real Life in London* was written. *The Political House that Jack Built* (Cohn 663, 1819) alone sold an estimated 100,000 copies between 1819 and 1820, and inspired a minor subliterature of imitation and riposte.[4]

Such a circulation indicated the new era of political journalism opening up at this time. The etchings of Gillray and Rowlandson were drawn on soft copper and hand colored for comparatively small impressions. From 1791 the wide dissemination of Paine's *Rights of Man* indicated a rapidly increasing reading public.[5] At the turn of the century the iron frame press made printing faster and less expensive, and Bewick's development of wood engraving allowed the use of woodcuts which were cheap, robust, and easily set in a form of type.

In 1816 William Cobbett's *Address to Journeymen and Labourers,* printed on an open sheet at 2d., sold 200,000 copies, and fear of the new power of the cheap press this indicated led to repressive taxation of newspapers in Six Acts of 1819.[6] William Hone, thrice tried and acquitted for publishing political parodies of religious forms in 1817, himself was a hero of a battle for the freedom of the press that was to continue into the thirties.[7] In the publications that followed he explored the possibilities that were opened up by the expanding reading public and new printing techniques. In this work he was intimately associated with George Cruikshank.

3 Anon., *Real Life in London* (London, 1821-22), pp. 415-16.
4 F. W. Hackwood, *William Hone, His Life and Times* (London, 1912); see also Edgell Rickword, ed., *Radical Squibs and Loyal Ripostes* (Bath, 1971).
5 Richard D. Altick, *The English Common Reader* (Chicago, 1957), pp. 357-90.
6 Ibid., p. 381.
7 James Routledge, *Chapters in the History of Popular Progress* (London, 1876).

Their approach was highly inventive. They used the format of bank-notes, a child's printed toy, a newspaper—parodied right to the advertisements.[8] In *The Political House that Jack Built* they exploited the chapbook genre that provided the major form of reading for children over a wide social range—and for many adults. The pamphlet parodies the popular nursery rhyme. The house is the shrine of the British constitution, resting on the three pillars of King, Lords, and Commons, and containing the Englishman's civil rights. The vermin infesting the house include the corrupt Church, Law, and Military, a venal king, oppressive taxation, and a reactionary government. They will be destroyed by the organ of free expression, the printing press.

Cruikshank's designs are perfectly adapted to Hone's text. They are simple to the point of crudity, in the chapbook tradition. The satire is muted—the work lies in the shadow of the Peterloo tragedy—making the villains vain or inhuman, but not absurd. The cut of the Prince Regent is a minor masterpiece, a masterpiece because it is minor. The jacket is only just too tight, the boots slightly too large, and the symbols are offered unobtrusively: the royal crest of ostrich feathers replaced by three peacock plumes, bedraggled; the plethora of decorations including a coronetted corkscrew. It is only in the penultimate cut—added to a postscript filling the pamphlet to a duodecimo gathering— that Cruikshank allows himself the extravagance of full political allegory in his virulent (and less successful) image of a Janus-like priest, offering at one aspect a cross, at the other, gibbet, gun, and irons.

Because it has received less attention than *The Political House that Jack Built*, I wish to consider in greater detail the Hone-Cruikshank pamphlet *The Political Showman—At Home!* (Cohn 668), which William Bates has considered "one of the most curious . . . I happen to know."[9] The origins lay in a painting on glass executed by Cruikshank to celebrate the acquittal of Queen Caroline on 10 November 1820, and further illuminated with colored lamps in the words "Knowledge is Power" for the benefit of the Queen herself when she passed Hone's shop on her way to worship in St. Paul's on 30 November. It showed the Queen's portrait, surrounded by laurels, held by a figure of Liberty, in

8 See my forthcoming book on print and popular culture, 1819-53.
9 William Bates, *George Cruikshank* (2nd edn., London, 1879).

front of a printing press radiating light from which the Queen's enemies flee in every direction. In the pamphlet each of these malignant figures is enlarged and commented upon by a showman in the form of the animated printing press.

The stance of "Showman" would have certain associations for the early nineteenth century. Shortly before reaching Hone's shop, the heroes of *Real Life in London* were stopped in the Strand by men dressed as Yeomen of the Guard urging passers-by to view "the Bonassus," a "newly discovered animal from the Apalachian Mountains of America," seventeen months old, five feet ten inches high.[10] Strange exhibitions were a common feature of life in town and country, in particular through the popularity of the great fairs of the nineteenth century. Some had a genuine educational interest—the "Bonassus" was probably a buffalo. Many were fraudulent wonders, mermaids, pig-faced women (David Prince Miller toured with one that was a shaved bear, strapped to a stout seat), Amazon giants with burnt cork and stilts, and the like.[11] When Hone began his pamphlet, "Walk *up*! Walk up! and see the CURIOSITIES and CREATURES—all alive! alive O!" he was associating his exhibits with both wonder and fraud.

The title page (Figure 30) has a quotation from Bunyan, "I lighted on a certain place where was a *Den*," and the satire also has associations with the religious and political allegory of *Pilgrim's Progress*. It opens with the figure of a latter-day Apollyon. It is a bird-monster based on Charlemagne's emblem of the two-headed eagle, and shared by the three countries of the Holy Alliance, Russia, Austria, and Prussia, a pact looked on in England as a treaty for oppression, linking armed force with the Beast of Catholicism. Tzar Alexander I, who initiated the Alliance, dominates the creature, which however has not two heads but seven.

The allegory is carefully worked out. From left to right, Pius VI has lost his papal crown (having been deposed by Napoleon); King Ferdinand of Spain is also inverted, indicating his acceptance of a constitution from the Cortes in 1820, which is seen thrust down his throat. Louis XVIII clings to the tricolor. Frederick William II of Prussia and Francis I of Austria make up the left

10 *Real Life in London*, pp. 154-55.
11 See David Prince Miller, *The Life of a Showman* (2nd edn., London, 1849), *passim*.

flank, while a ghost neck, with head as yet invisible, represents England, since the design was made immediately before the coronation of William IV on 19 July 1821. The Beast straddles a desert landscape, with the volcano to the right presaging revolutions to come.

Throughout, Cruikshank and Hone link general with particular. The snapping boiled lobsters of the military look across the page to the scorpion figure of the Duke of Wellington; the Prime Minister Liverpool, an idiot's head on a broken crutch, faces the "Opposum," the Rotten Borough member swinging uselessly on the tree of State. The images build up to the savage satire on Castlereagh as "Dirkpatrick," a pale head on a bleeding dagger, faced in the text by the "BLOODHOUND," its spiked collar indicating the crown of England, that savages the helpless figure of Ireland crippled by the irons of "Union." In the background the wheel and hoist of the Spanish conquistadors stand beside the gibbet and triangle of Castlereagh's terror, underlining the point of the text: "there is scarcely any difference between the transatlantic *Spanish* blood-hound and the *Irish* wolf-dog"

At this point terror collapses into laughter. Sidmouth is introduced, his sick body reduced to an anal douche, "inflated and astrut with self-conceit." He is paired by a similar sac, deprived even of a face, peering erect at the world with complacent vacuity —the "Booby" or sinecurist, that can at best be stuck on a stand and ignited for bad gas to burn as a light. Cruikshank next introduces himself as the artist, emptying Hone's prime enemy Dr. Stoddard, editor of the reactionary *New Times,* like dirty water into an upturned coronet. This is followed by the remarkable image of the figures of evil reduced to a dislocated heap by the rays of a giant eye, with a printing press in its iris (Figure 32a).

The pamphlet ends with a recapitulation of the image with which it began—the great Beast of political repression. It is now seen as "The Boa Desolator, or Legitimate Vampire" (Figure 37b). Hone's text, which is one of his wittiest and most effective, is outside our concern here: it is matched with a crude but powerful cut from Cruikshank. This dragon is not erect, but sprawling across the earth. Only one foot is visible, and this is amorphous, almost a root; the whole body appears an extension of the swampy ground. It is curiously mechanical, a robot bulldozing into piles of human victims. Blood jets from the nostrils and

belches down from the mouth, as from a machine broken and malfunctioning. Its tail swings clumsily into its own back, as the text tells of its destruction by "a Black Dose consisting of the four and twenty letters of the alphabet . . . well worked in a Colombian press."

The Political Showman—At Home! shows Cruikshank as a central part of the Regency scene, yet in many ways standing apart. As a political cartoonist he cannot take comparison with Gillray, or even Rowlandson. Gillray's genius lay both in the direction of the Romantic movement, which inspired his great satiric panoramas, and of intimate invective. Peering through his window above St. James's, he observed every idiosyncrasy of his victims, and published his prints for the comparatively small circle of eighteenth-century political London. With the opening up of the reading public, the great growth in urban population, and the increasing concern after the French Revolution with the politics of ideas, this genre had to pass.

Cruikshank's figure of the animated printing press, and even more of the eye with a press as its iris, indicated the new element in political satire. Previously the satirist took the stance of correcting folly and vice through ridicule. In taking the emblem of the eye, Cruikshank was using a figure in constant use from the middle ages. It was traditionally the emblem of divine power and virtue, linked to universal vision, often emphasized, as in Cruikshank's cut, by rays of light proceeding from the eye itself. In France at the time of the Revolution it became associated with the people's State, appearing as such on assignats; in England it was sometimes identified with the "fourth estate" of the Press, and was printed at the head of such papers as *The Manchester Observer*. Cruikshank therefore saw political satire working through its very ability to make folly and vice in high places known to the people. Whatever its artistic limitations, his work with Hone has an important place in the democratization of political polemic in the years surrounding Peterloo.

II

"The GIN Shop" (1829)

"We rejoice," declared *Fraser's Magazine*'s reviewer in 1830, "to see this eminent artist at last finally emerging from the

slough of politics, in which it was his original fate to be plunged."[12] The reviewer was by implication rejecting not only Cruikshank's cartoons for Hone, but the moral tone of the Regency political scene itself. Cruikshank had been "ridiculing and caricaturing a husband . . . for trying to get rid of a wife whose guilt was notorious, and whose conduct was disgraceful . . ." In dabbling in such matters Cruikshank had been covered in "sable stains" (the echo of the *Dunciad* is deliberate) which he had now "shaken off" by his comic fantasies illustrating William Clarke's *Three Courses and a Dessert* (Cohn 144, 1830). Yet the transformation was not as complete as the reviewer may have thought: Cruikshank was reacting to a changing social milieu. In this, his most creative period, the genius was the same: fantasy, humor, and an ability to create myth.

Cruikshank's design, published first in *Scraps and Sketches* (Cohn 180, 1828-32, Figure 31b), can be compared with Hogarth's "Gin Lane" (1751), and "The Dram Shop" in Rowlandson's *The English Dance of Death* (1815-16, Figure 31a). In both cases the differences are more important than the similarities. Hogarth's design, often taken loosely as realism, is a complex allegory on the effects of drunkenness on trade, manners, religion, the family, and the whole web of eighteenth-century social relationships. In the foreground a man and a dog dispute a bone, indicating man reduced to the level of the animal. Rowlandson's engraving is much closer to Cruikshank's, and was almost certainly in his mind when etching "The GIN Shop." The layout of the scene with the counter to the left, Death and the server behind it, and gin being prepared by Death are the same: both even use the same brand names, Old Tom and Deady's Cordial, placed side by side. At this point the comparison ends. Rowlandson's drinkers are both sad and merry, ragged and well-dressed; Cruikshank's show stylized poverty. Rowlandson is full of a sense of the flesh; even his Death is real because it is more physically alive than the carousers, its backbone lithe, its shoulders strong, its skull expressing huge pleasure. Rowlandson portrays a Catholic horror of Death in Life; Cruikshank's dark scene, the Puritan nightmare of Life in Death.

"The GIN Shop" is an elaboration of the concept of Death as

12 Review of William Clarke, *Three Courses and a Dessert*, *Fraser's Magazine*, 1 (June 1830), 549-54.

a trap. This begins at the heavily indicated borders, with pennants apparently showing ways out, but indicating "dead-ends." (The design throughout invites such verbal punning. Death the watchman points to the "trap"-door by his feet, where "spirits" are stored, and his statement "they have nearly had their last glass" refers as much to the hour-glass he holds up as the glasses of gin.) The drunkards have death to the right, death to the left. Mortality is reflected in the death's head Bacchus above the gin-taps, in the posters on the wall, and in the five coffins, also gin-vats, on the walls around them. The central "gin" is drawn so that it will spring shut the moment one of the group loses physical control and so falls, hitting the spring-plate. It is a perfect ambiguity. The sense of dangerous poise that animates the design of the swaying carousers is carried through to the skeleton serving maid, pirouetting to keep her skeletal balance as she hunches up behind the fashionable mask.

To the extreme right the devil's brew surrounded by dancing demons is at once an image of the disordered imagination of the gin-addict, and a pointer to the imaginative roots of Cruikshank's design, executed not only before Cruikshank had turned teetotaller, but before the Teetotal movement in England had properly begun. It is not so much about drink, as about the fear of ghouls and devils Cruikshank felt profoundly in his Scottish Calvinist blood, which made him perhaps the finest artist of the supernatural in the British tradition. It is a scene from Scott's *Lectures on Demonology and Witchcraft* (Cohn 731, 1830), so brilliantly illustrated by Cruikshank, modified to a social intention and an urban setting.

Yet it has also another level. On the counter is a book—"Open a gin shop—the way to wealth." The accurately observed marble, glass, and elaborate gas-light are all part of the image presented by the smart early nineteenth-century gin-shops in their attempt to get away from the "Gin Lane" image, and are also an indication of the ready profits they were earning. It is important too that the marble fronting is shown to be thin, the pediments almost two-dimensional, and that the frieze of a grapevine, like the vine-crowned death's head Bacchus, attempts to give associations of wine. The glitter is fraudulent. Even the girl's fashion, its bonnet, bustle, and wasp-waist, is in the very latest style, linking the exploitation of the poor with the fashionable world.

164

"The GIN Shop" draws then on two elements of the imaginative resources of its period. It shows a strong residual sense of myth, coming from an earlier era, but to be increasingly eroded before rational education and the materialism of the Victorian period. This sense of myth lies strongly behind the earlier work of Dickens. It also shows, in the year before the agitation surrounding the first Reform Bill, the growing awareness of the economic factors in social predicaments. That awareness was entirely absent from the Hone-Cruikshank polemics. But it was to become increasingly evident in the decades that followed.

III

The Bottle (1847)

The Bottle (Cohn 149), Cruikshank's series of eight plates showing the progress from prosperity to murder and ruin of a respectable workman, was thought by William Bates to be "somewhat unsatisfactory, whether as a work of art, or as a moral lesson."[13] Most critics have shared this evaluation. Dickens wrote to Forster, "the philosophy of the thing, as a great lesson, I think all wrong," for "the drinking should have begun in sorrow, or poverty, or ignorance."[14] Matthew Arnold's remarkable sonnet "To George Cruikshank, Esq. on seeing for the first time his picture of 'The Bottle', in the country," is appreciative, but gives the series a pessimistic significance that would surely have dismayed Cruikshank himself:

> man can control
> To pain, to death, the bent of his own days.
> Know thou the worst! So much, not more, he *can*.

Critics have regretted the use of "glyphography," a process by which engraved lines lose their definition, distance its graduation, and the whole effect is rendered flat and lifeless. Nevertheless both The Bottle and its sequel, The Drunkard's Children (Cohn 195, 1848) were hugely popular, particularly at the lower middle class and working class level. The Bottle was made into a penny issue novel by Gabriel Alexander (1848), and in its various

[13] Bates, p. 36.
[14] John Forster, The Life of Charles Dickens, ed. J.W.T. Ley (London, 1928), p. 464.

dramatized forms it became a standby of mid-Victorian repertory theater. Within a few days 100,000 copies of the shilling folio were said to have been sold. Again, an understanding of the reasons for its success will give clues to the way it should be scanned.

The design of the series owes much to the theatrical "box set" introduced into England a few years previously (1841) by Madame Vestris. In all but one of the scenes the setting remains the same, the cleverest effect of all coming in the final act, where the mad cell is shown to have exactly the same lay-out as the sitting-room in which the story opened, but denuded of all human meaning (Figures 24 and 26). Within this set framework, Cruikshank was able to chronicle minutely the degradation of the group, physically and symbolically.

The few symbols are easily distinguished. In Plate I, on the mantlepiece stand an idealized cottage, and miniatures and statuettes representing the family itself. Little by little these break and disappear, the figurine of the man being the first to be knocked over. In Plate VII, the domestic objects have been replaced by the sinister form of the bottle. The picture of the church dominating the back wall, the Bible on the chest of drawers, the miniatures and the casket of (presumably) the family treasures, showing continuity, all are significant.

The iconography of the everyday objects, while equally clear, perhaps needs emphasizing today. In reviewing Holman Hunt's "The Awakening Conscience" in 1854, Ruskin wrote:

> There is not a single object in all that room—common, modern, vulgar (in the vulgar sense, as it may be), but it becomes tragical, if rightly read. That furniture so carefully painted, even to the last vein of the rosewood—is there nothing to be learnt from that terrible lustre of it, from its fatal newness; nothing there that has the old thoughts of home upon it, or that is ever to become a part of home? Those embossed books, vain and useless—they also new—marked with no happy wearing of beloved leaves[15]

Ruskin's comments are relevant in that they describe a scene the exact opposite to that of Cruikshank's opening scene. Every-

[15] John Ruskin, Letter to *The Times*, 25 May 1854, in E. T. Cook and Alexander Wedderburn, eds., *The Works of John Ruskin*, 39 vols. (London, 1904), XII, 334-35.

thing here indicates frugality, domesticity, order, and love. From the neatly stacked cupboard to the carefully washed and mended clothes the family wear, all is well kept. Although it is an urban scene the housewife has procured flowers, and lavender gives fragrance to the room from behind the mirror. The lavender is like (a Victorian reader would have savored this comparison) an offering to the household gods of the hearth, over which it is placed. The design of the grate is itself significant. An early nine-teenth-century pattern still to be found in working-class houses built at this period, it was practical, economical, and graceful, re-flecting the family morality and taste. It is ripped out by Plate V (Figure 25), and the fire becomes ineffectual save as menace, as when in the next scene clothes catch alight from it. The grate in the final madhouse scene is angular and forbidding, shut off from the man by bars and by lock, as he is shut out from the warmth of a family hearth.

The series shows a home becoming a room. In Plate I the door with its prominent lock is a protective delimitation of the family circle. Two plates later it hangs open, and flat light drains the room of intimacy. By Plate V the lock has been taken off, and in the two following scenes the room is increasingly invaded by the outside world. The walls themselves flake and crumble, reveal-ing a skeleton of lath and plaster. One is reminded that *Dombey and Son*, with its even more complex use of house symbolism, was completed shortly after *The Bottle* appeared.

As in "The GIN Shop," the series is not simply about the evils of drink. (For what it is worth, one may note that Cruikshank became a teetotaller *after The Bottle* was published.) It is a com-panion piece, by antithesis, to the literature of working-class endeavor also closely linked to teetotalism in such periodicals as John Cassell's *Working Man's Friend* (1850-53). Drink was evil because it threatened the economic ethic of self-help, with its ancillaries of self-respect and the ordered family unit.

In this essentially materialistic world, the objects of respect-ability and domestic security took on potent significance. By entering into it and using it Cruikshank showed his profound sense of a central area of Victorian culture at a time when it was moving towards the celebration of industrial artifact in the Great Exhibition of 1851. *The Bottle* also shows his extraordinary versatility. His imagination was essentially that of the visionary.

167

More characteristically Cruikshank's machines and objects take on human or inhuman life. In *The Bottle* this impulse was completely restrained. Even the bottle itself remains solid, dark glass, throughout. Its weight breaks the wife's skull.

While acknowledging that Cruikshank worked in "three generations," Jerrold as a Victorian arranged the artist's biography in two epochs: from birth to 1847; and from the year that he decided that "it was no use preaching without an example" to his death.[16] For Jerrold the decision to be socially active was the crucial one, and he misleadingly puts *The Bottle* in Cruikshank's Teetotal phase, although it was designed immediately before. It was only the comment of William Cash, Chairman of the National Temperance Society, on the completed series that led Cruikshank to sign the pledge. All his most effective polemical work was created outside specific social or political commitment. Even when closely associated with Hone, he occasionally lent his pen to the opposite party. His emergence as a public figure on the lecture platform coincided with the rapid decline of his art—partly for reasons of age.

It would be wrong to see this as moral weakness on the part of the younger Cruikshank. Intimately involved with social and even political issues as it was, his art was primarily the creative work of the poet, a poet as Keats saw Shakespeare, with the genius of negative capability. He "is the most unpoetical of any thing in existence; because he has no Identity—he is continually in for—and filling some other Body"[17] This to some extent explains his claims to works he illustrated, such as *Oliver Twist*: he became what he drew. But he was also instinctively in touch with the wider modality and convention of each age in which he worked, its sensibilities, mental structures, and iconography. Cruikshank tells us so much about the nineteenth century because he shows us not only what it experienced, but also the ways in which it felt and communicated.

[16] Jerrold, p. 3.
[17] John Keats, Letter to Richard Woodhouse (27 October 1818), in Hyder Edward Rollins, ed., *The Letters of John Keats*, 2 vols. (Cambridge, Mass., 1958), I, 389.

Mr. Lambkin:
Cruikshank's Strike for Independence

BY DAVID KUNZLE

THROUGHOUT his long career, George Cruikshank lived in the shadow of Hogarth, whose status as artist-author he envied. This status seemed to promise an artistic independence and an economic security that always eluded Cruikshank. His life and oeuvre were divided by his principal biographer, Blanchard Jerrold, into two distinct epochs: Before Temperance (through 1847) and After Temperance (1848 to his death in 1878), the second being judged at that time and since as incomparably less fertile than the first. At the junction of these two periods stands his most Hogarthian work, *The Bottle* (Cohn 194, 1847), with its sequel, *The Drunkard's Children* (Cohn 195, 1848), perhaps the artist's last truly creative performance, and his only truly successful attempt to combine the coveted dual role of artist-as-author. *The Bottle* has, however, a close chronological predecessor which is the only other example in Cruikshank's immense oeuvre of independent pictorial narrative. This work, which is called *Mr. Lambkin* (Cohn 192, 1844) for short, has been little regarded, probably because it is graphically not very striking, nor does it share the particular biographical or controversial interest of the book-illustrations which preceded it. The importance of Cruikshank's first experiment in independent narrative lies principally in the light it sheds on problems transcending those of the artist's personal career in particular and touching upon the art of caricature in general as it adapted to new conditions and evolved new alternatives.

I

The development of the "independent pictorial narrative," or picture story, or comic strip, however we choose to term it, is a phenomenon which poses at various points problems of collaboration between artist and author that are sometimes resolved by

169

combining the roles in one man.[1] Cruikshank, in his ambition to become artist and author, was working in a genre clearly defined by the example of Hogarth, but lacking in a continuous tradition. The international impact of Hogarth's example, as a highly moralistic artist-author, was such that critics in France and Germany were constantly on the lookout for second Hogarths among their countrymen. Continuities scarcely intended by the artist were "read into" the Salon paintings of Jean-Baptiste Greuze, who was exhorted to raise Hogarth's new genre of "romans muets" (dumb novels) to a more decent social and moral level. Greuze did not, however, get further than an extensive written scenario, inspired by Hogarth's *Idle and Industrious Apprentice*.

In Germany, where enthusiasm for Hogarth was unreserved, the writer Georg Christoph Lichtenberg, who was engaged upon his brilliant, free commentaries on the English artist, undertook the task of converting the Berlin engraver Daniel Chodowiecki into a second Hogarth. Having already identified himself closely with the Hogarthian Progress in a sequence of very small but very moral calendar illustrations (*Life of a Rake*, 1774), Chodowiecki found himself earmarked by Lichtenberg for more of the same kind. Artist and writer worked harmoniously in a *Progress of Virtue and Vice* (1778, Figure 32b), but the collaboration was short-lived. Chodowiecki's no less Hogarthian *Life of an Ill-educated Girl* (1780) appeared without the expected witty commentary by Lichtenberg. The artist, always suspicious of what he considered the doubtful compliment of the "German Hogarth," resented Lichtenberg's importunate proddings to align himself closer still with his English model, whose independent narrative mode he thenceforth abandoned.

A comparison between Chodowiecki and Cruikshank is cogent for several reasons. Although separated by two generations (Cruikshank was nine years old when Chodowiecki died at age 75 in 1801), both artists were the outstanding illustrators of their respective national literatures. Both came to literary illustration relatively late, in middle-age, after being forced by the demands of the market to abandon the craft which they had exercised in

[1] Cf. my *The Early Comic Strip, c. 1450-1825* (Berkeley, 1973), from which the material presented here on Cruikshank's predecessors is drawn. The article as a whole has benefited from various editorial improvements kindly suggested by Deena Metzger.

their youth—Chodowiecki, miniature portrait painting; Cruik-shank, broadsheet caricature. Both fought the domination of an outstanding literary figure and tried to shore up the waning prestige of etching at a time when it was becoming engulfed in literature. Both were famous, meticulously collected and cata-logued during their lifetimes; the reputation of both has declined markedly in our own century.

Chodowiecki and Cruikshank were both forced to become etchers in miniature—"Kleinmeister"—having to contend with a marked reduction in scale vis-à-vis the traditional broadsheet. Since there was no longer a market, in Germany of the later eighteenth century, for the large comic engraving, Chodowiecki found himself trying to preserve on the tiny scale of the almanac illustration (measuring about two and a half by one and a half inches) something of the physiognomic realism of Hogarth. Cruik-shank, trained in the larger scale of the broadsheet caricature for which the market had declined by the mid eighteen-twenties, was subjected in his book illustrations to a comparably severe degree of reduction (whereas a plate from the *Progress of a Mid-shipman* (Cohn 1874, 1820) measures about seven by ten inches, an *Oliver Twist* (Cohn 239, 1838) illustration measures around four by three and a half inches). He thereby sacrificed much of the grandeur—the sublime grotesque element—he had inherited from Gillray, and developed a form of bizzare comedy lacking in that *outré* quality which separates true caricature from mere illustration (and which is also an important characteristic of Dickens' writing). The bizarre *Mr. Lambkin* is still, in spirit and scale, comic book illustration; while the scale of *The Bottle*, which is that of the artist's broadsheet caricatures and nearer to that of a Hogarthian Progress, permitted Cruikshank to unfold a Hogarthian moral dignity. *The Bottle* stands in relation to the rest of Cruikshank's oeuvre of the period as the *Farewell of Calas* (an exceptionally large etching of 1768) does to Chodowiecki's: both were responses to a burning social issue, permitting them to be executed on a scale which the market did not normally allow.

The fate of the Hogarthian Progress during the period between Chodowiecki and Cruikshank as illustrator is a curious one. In England certain important artists, John Hamilton Mortimer, James Northcote, and George Morland (a history, portrait, and genre painter respectively) each tried his hand at the mode,

171

preserving something of Hogarth's scale, but with a success in-different both commercially and artistically. The caricaturists, in their transposition of Hogarth, did not attempt as the painters did to break into the "High Art" market with large multi-plate sequences. Instead they returned to the older format of pictorial narrative, one rendered obsolete by Hogarth although common in seventeenth-century Germany and Holland: the single engraved sheet, compartmentalized into strips of small designs. The little-known Richard Newton, in an intense flourish of activity before his death in 1796 at the age of twenty-one, scored a series of minor successes in this vein, lightening the heavier Hogarthian Progress both in style and content. Gillray tried both the sub-divided strip and the multi-plate sequence, but only fitfully. He must have found that the tiny format of each scene in the first category of print cramped the natural exuberance of his style, and a major independent project for a multi-plate sequence failed (like Greuze's) to advance beyond a written scenario. It is signifi-cant that the *Rake's Progress at the University* (1806), with its Hogarthian title, was not of his own devising, but was dictated by an amateur, and is of no moral and little graphic interest. The young George Cruikshank himself produced no variations on the Hogarthian Progress except at dictation: the *Sailor's Progress* (six scenes on one plate, Cohn 1945, 1819) is largely by Lieutenant John Sheringham, and the *Progress of a Midshipman* (eight plates) is more Marryat than Cruikshank. Both are mildly amus-ing, neither of particular originality. The *Stroller's Progress* (six plates, Cohn 2009, 1809) may contain more of Cruikshank's own design than the others, but it has little intrinsic narrative continuity.

We may draw another lesson in the fate of the Hogarthian Progress by returning to Germany. Johann Heinrich Ramberg had been sent as a boy, on the recommendation of Lichtenberg, to England where, coming under the influence of Rowlandson, he developed a natural gift for caricature. This he was unable to exploit in his native Hanover. Rather than becoming a second Hogarth, as Jean Paul had cast him, he was condemned (as he woefully admitted) to being a second Chodowiecki, specializing in calendar illustration. Nothing came of Jean Paul's proposals to tie a dozen of these illustrations together in the form of a Hogarthian Progress, with his own commentary, although Goethe

172

had commented on an earlier series of Ramberg calendar etchings. In the early 1820s, however, Ramberg did try to break new ground with a series of twenty-six drawings which he titled *The Life of Strunk the Upstart*, and to which he himself wrote a pungent commentary. He got as far as engraving three designs, but stopped, probably in the knowledge that, whatever the commercial prospects of so big an independent venture (albums similar in scale humorously illustrating Till Eulenspiegel and Reinecke Fuchs had failed), its aggressive tone and barbed allusions to corruption in church and state could not have survived the censorship.

II

In England, censorship was much less of a problem, but Cruikshank had to contend with an important change in the market, away from expensive caricature albums towards a series of small etchings published to accompany either comic verse (prototype *The Tour of Doctor Syntax, in search of the Picturesque*, 1813) or humorous prose impressions of urban life (prototype *Life in London*, Cohn 262, 1821). In comparing these two best-selling works, which provoked a quantity of sequels and imitations, one may observe a highly significant shift in the relationship between artist and writer. In *Dr. Syntax* the artist was given the leading edge, for Rowlandson was entirely free to choose his own designs (although Combe might suggest modifications), and he never saw the verse ahead of time. Combe was freely "writing up" to Rowlandson, as Lichtenberg had freely "written up" to Hogarth. In *Life in London* (Figure 33), the initiative lay with the writer, for although Pierce Egan in his text consciously made the most of the Cruikshanks' illustrations, to which he specifically directed the reader, and without which the book would be, commercially speaking, worthless, the collaboration was of a kind which permitted the artist no leeway in the direction of the narrative. Here, in fact, lies Cruikshank's first direct "defeat" at the hands of his literary collaborators: he wanted those Regency rakes Tom and Jerry to come to an untimely end, like the heroes of Hogarth (and Richard Newton); but Egan, more sensitive to public taste and not wishing to foreclose the possibility of a sequel, married them off. Cruikshank even proposed to execute a larger version

173

of the *Tom and Jerry* illustrations, in oil,[2] in the manner of Hogarth, which he would presumably have turned into large "art-engravings" in order to tap the higher reaches of patronage.

As is indicated by the proposed title "Sketches by Boz and Cuts by Cruikshank," Dickens' original intention was to market his first writings as free literary exercises, drawing some of their inspiration from Cruikshank. From the start, however, he knew that his writing must have absolute priority, and conscious as he was of the need in writing new sketches to include picturesque subjects attractive to the famous artist, he was determined at the outset to establish his supremacy. He immediately contested Cruikshank's right of "suggesting any little alteration to suit the Pencil,"[3] and to refuse subjects uncongenial to it. It is evident that Cruikshank continued "excessively troublesome and obtrusive in his suggestions"[4] when artist and writer came to discuss illustrations to *Oliver Twist*.

Oliver Twist offered George Cruikshank an opportunity denied him by the very format of *Sketches by Boz*. He saw his chance to collaborate upon a continuous story, instead of unconnected literary "Scraps and Sketches" (to borrow the title used by Cruikshank himself for his miscellanies), and to develop designs of a moral and narrative coherence far superior to that of *Tom and Jerry*. We are not concerned here with an assessment of his exact share in the story of *Oliver Twist*, nor with the extent to which history (managed chiefly, it seems, by Dickensians) has maligned the artist for his "claim to authorship" of this novel,[5] but only with an explanation of why Cruikshank should have been particularly anxious during the late eighteen-thirties and early eighteen-forties to play a role greater than that which an illustrator was then permitted. If it is demonstrable that Cruikshank had very concrete reasons for aspiring to "authorship" at this moment, then it is easier to understand that he should develop a very particular

[2] Blanchard Jerrold, *The Life of George Cruikshank*, 2 vols. (London, 1882), I, 124.

[3] *The Letters of Charles Dickens*, ed. Madeline House and Graham Storey (Pilgrim Edn., Oxford, 1965, 1969), I, 183 *fn.* 1.

[4] Jerrold, I, 185, quoting Ainsworth on Cruikshank.

[5] The injustice of Dickensian historiography, jealous of any apparent diminution of the novelist's monumental reputation, is dealt with in Richard Vogler's article *supra*. I take this opportunity of expressing my deep gratitude to Dr. Vogler, who generously opened to me his magnificent collection of Cruikshank, and his store of knowledge on the subject.

sense of proprietorship over any literary ideas which he may have given to the writer, or which may have been identical to those already held by the writer. It was in order to avenge his "defeat" by Dickens, who either refused his ideas or used them without giving proper credit for them (or both), and in order to justify his claim to "authorship" (which, though not made public until much later, was vented privately at the time), that Cruikshank devised his first truly independent narrative, *Mr. Lambkin.*

As long as he had been bound to broadsheet caricatures, dealing with social farce and the topicalities of the day, Cruikshank had been unable to widen the ground for that flattering comparison with Hogarth which had been made as early as 1823, when he was urged to raise his sights by developing his literary gifts.[6] For Cruikshank was an artist, but not yet an author like Hogarth, and it was becoming increasingly important to be a Hogarth rather than a Gillray. The reputation of the relatively simple, decent, and unpolitical satire of Hogarth had been rising in the twenties and thirties, even as that of the relatively sophisticated, coarse, and politically partisan Gillray and his contemporaries declined. Hogarth was applauded unreservedly by noted critics of the day, such as Lamb and Hazlitt,[7] who thus established his respectability among the bourgeoisie at large: Hogarth became popular among the English as no artist or writer had ever been before. Heath's complete edition of Hogarth's *Works* from the original plates[8] brought the artist into thousands more homes. Hogarth was available at the highest and lowest levels of patronage. *Marriage A-la-mode*, one of his most popular stories, and among his very best paintings, was now permanently on view amidst choice Old Masters in the new National Gallery. A full-page "Gallery of Comicalities" was inaugurated by the weekly newspaper *Bell's Life in London* with small wood-cut versions

[6] George Somes Layard, "Lectures on the Fine Arts, No. 1, George Cruikshank," *Blackwood's Edinburgh Magazine*, 14 (July 1823), 18-26.
[7] Charles Lamb's essay "On the Genius and Character of Hogarth" (*Works*, ed. E. V. Lucas, 5 vols. (New York, 1913) ends with the analogy of Hogarth's work to "the best novels of Smollett or Fielding" (I, 101). William Hazlitt's most extensive appreciation of Hogarth was included in his series of *Lectures on the English Comic Writers*, No. VII, of which a third one-volume edition appeared in 1841 (*Collected Works*, ed. A. R. Waller and Arnold Glover, 12 vols. (London, 1902-04), VIII, [2]).
[8] Published 1835-37. There were various editions with re-engraved plates, the cheapest being T. Clerk's, first published in 1810.

of the *Harlot's Progress* (22 June 1828). Not only Dickens, but other novelists as well (notably Ainsworth, whom Cruikshank also illustrated) drew on Hogarth for inspiration, referring to him specifically and trying to emulate his realism and moral fervor.

III

Since the Hogarthian format—several large plates sold only as a set—was no longer commercially viable for caricatures, the question arises as to what other formats and vehicles were available. In France caricature had developed, from the English example of the Great Age, in new directions. Having found a home in the independent satirical magazines of Philipon, French caricature had preserved some of the physical and political autonomy of the old broadsheet, even as it gained massively in circulation, and actually increased both in social and artistic effect. The situation in Paris was the contrary of that prevailing in London. The new caricature magazines of the 1830s, *Le Charivari* and *La Caricature*, did not restrict illustration to a crude woodcut engulfed by letterpress, like *Bell's Life* and other cheap newspapers, but allowed for considerable artistic scope. The superior power and dignity of the *comédie humaine* in Daumier, Grandville, and Raffet, as well as the potential of the lithograph as a medium (not considered commercial in England) was recognized by Thackeray, an art student in Paris in 1833-34, when the government prosecution of opposition press and caricature magazines was at its height. Back in England, Thackeray published his views in the *London and Westminster Review*,[9] while Cruikshank was still smarting under his "defeat" by Dickens. Thackeray must have shown his article to his friend George, who had taught him etching, and on whom he wrote a highly laudatory article in the same magazine the following year. Through Thackeray, then, Cruikshank's attention was drawn to the example of French caricature. If it was the young H. K. Browne ("Phiz," destined to become Dickens' more permanent illustrator) rather than Cruikshank whom Thackeray summoned to learn from the French, we must understand that it would hardly have been tactful for a novice

[9] 32 (April 1839), 282-305.

176

writer like Thackeray to deliver public instruction to an older, established artist like Cruikshank.

Presumably Thackeray and Cruikshank also discussed artists and initiatives not covered in the article, including perhaps picture stories such as Victor Adam's *Vie d'un jeune homme*, originally published in 1824, but still being sold in 1839, a "bitter, Balzacian comedy" of fashionable life.[10] Henry Monnier, a much more important satiric illustrator, also a writer, who is cited approvingly by Thackeray, had planned a pictorial "Vie d'un Jeune Homme à Paris." He may well have had occasion to discuss this project personally with Cruikshank, whom he met during his stay in London 1822 (?)-25, and whom he visited again in 1828. It was to Cruikshank that Monnier dedicated his *Distractions*, and it was Cruikshank who inspired his *Esquisses Parisiennes* (1827) and *Vues de Paris* (1829). (Baudelaire was later to testify how strongly Cruikshank's work appealed to French caricaturists.)[11] Monnier's project for a pictorial "Life of a Young Man in Paris," evidently planned as a kind of dandified Rake's Progress, and expected by Balzac to establish the artist's fame as a satirist and as the equal of Hogarth,[12] did not materialize as such; but it was to be taken up conceptually, at some remove in time, by Cruikshank in his *Lambkin*.

IV

A more immediate stimulus to Cruikshank's ambition to write his own picture story came from another quarter. With political caricature crushed by the censors of Louis-Philippe, and with a consequent shift of emphasis to social comedy, Paris in 1835 was ready for the introduction of new modes of graphic humor. A truly revolutionary style of draftsmanship, and an entirely novel narrative format, had been invented by the Genevese writer-artist Rodolphe Töpffer, who had been informally drawing "histoires

[10] Seventeen plates, unpublished, mentioned in M. Mespoulet, *Images et Romans* (Paris, 1939), p. 30.

[11] *The Painter of Modern Life and other essays*, trans. and ed. Jonathan Mayne (London, 1964), p. 190.

[12] *Oeuvres complètes*, ed. Marcel Bouteron and Henri Longnon, 40 vols. (Paris, 1912-40), XXXIX, 144-45; passage originally published in *La Mode*, 2 October 1830.

en estampes," as he termed them, since 1827, but who did not dare offer them to the Parisian public until 1835.[13]

Töpffer's caricature albums were sold in Paris by Philipon's publisher Aubert, whose shop is mentioned by Thackeray in his *London and Westminster Review* article. The first published work of Töpffer was the *Histoire de Monsieur Jabot* (1835, Figures 34a and 34b), followed two years later by the stories of *Monsieur Crépin* and *Monsieur Vieux-Bois*. Various plagiarized versions of the latter, under the title *Adventures of Mr. Obadiah Oldbuck*, with English captions and no acknowledgement of origin or authorship, were launched by two different publishers in the United States, and in England by Cruikshank's own publisher, Tilt and Bogue. The latter surely sold all the other Töpffer albums as well, either in the original (the terse captions would have presented no problem to an Englishman with an elementary knowledge of French), or in English copies.[14] Töpffer was also available, no doubt, at Aubert's authorized agent, Delaporte's in the Burlington Arcade.

Interest in the caricature of Töpffer, who died in 1846, reached new heights around the mid-forties. His theoretical treatise on the art of caricature, *Essai sur la physiognomonie*, was published in 1845, the same year that his seventh and last completed story, *Monsieur Cryptogame*, was translated into woodcut by Cham for mass distribution in *L'Illustration*; Franco-German editions of his collected caricatural works were published in 1846 by J. Kessman in conjunction with B. Herrmann in Leipzig (with an introduction by Friedrich Vischer), and the following year by C. T. Heyne, also in Leipzig. By 1848 three of Töpffer's prose stories had been translated into English.

Meanwhile, by 1843 the number of Töpfferian picture stories by Cham, similar in general character although original in specific content, had grown to nine. These firmly established an important

[13] He had been emboldened in his decision by the approval of the aged Goethe, whose classicist principles in art had been undermined by Lichtenberg's commentaries on Hogarth. Goethe had encouraged the young Ramberg's caricatural improvisations, and had expressed amusement at Thackeray's gifts in this same direction, manifested on behalf of the children in the Goethe circle at Weimar (cf. Lewis Melville [Lewis S. Benjamin], *William Makepeace Thackeray* [London, 1909], pp. 78 ff.).

[14] Töpffer piracies and imitations, which were usually published anonymously, and in which the British Museum Library appears to be remarkably deficient, offer a considerable bibliographical puzzle.

new vehicle for the caricaturist, one which promised both more artistic freedom and more personal financial gain, than could be had by working for the publishers of satirical magazines or novels. To Cruikshank, as to any English caricaturist seeking new outlets, a Töpfferian picture story must have appeared more tempting than a contract with a humorous journal such as *Punch*, "The London Charivari" (as it was subtitled), founded in 1841 on the French model, where an artist was tied to the policies of an editorial committee composed chiefly of literary men. When Cruikshank refused to work for *Punch*, he did so not only because he objected to personal satire and radical politics, but also because he knew that to leave novel illustration for the journal of Mark Lemon and Henry Mayhew would have been to cast himself from a literary frying pan into a literary fire. Cruikshank tried in 1841 to launch a humorous magazine of his own, and its failure must have strengthened his resolve to seek his luck another way.

V

The international success of Töpffer probably acted as a powerful incentive, but Cruikshank was far too heavily established in his own style to consider actually imitating him. On 1 August 1844 there appeared in the bookshop of David Bogue "*The Bachelor's Own Book, being the Progress of Mr. Lambkin, (Gent.) in the Pursuit of Pleasure and Amusement. And also in Search of Health and Happiness*. Designed, Etched and Published by George Cruikshank" (Figures 35a and 35b). The twenty-four plates are arranged in the traditional album format, two almost square scenes to a page, so that one double-scene plate of *Lambkin* corresponds in size and shape to one oblong page of a Töpffer album, with its two-to-four scenes also printed on the facing pages only. There is no general and little particular resemblance between *Lambkin* and the Töpffer story best known in England, the *Adventures of Obadiah Oldbuck*, for which Cruikshank may have been asked by Bogue to design a frontispiece.[15] *Mr. Lambkin* bears a closer resemblance to *Monsieur Jabot*, Töpffer's first publication. Cruikshank's hero Lambkin is, like Jabot, squat, barrel-chested, and big-

[15] A manuscript note on the fly-leaf of the New York Public Library copy of this work (placed at 3 MDY) reads: "The drawing for this frontispiece (title-page) was among George Cruikshank's things sold at Sotheby's, 1879."

nosed, a physical type expressive of a clumsy social vanity. Both represent the same social type placed in the same basic story-line: the social climber whose aspirations are frustrated in various ways until the very end, when he achieves a happy marriage. Beyond this simple traditional framework, however, the differences are far greater than the similarities. Jabot's social foray is merely the pretext for some extraordinary flights of fantasy. Lambkin moves entirely within the tradition, engaging in those raffish activities and visiting those picturesque locales in which he had been preceded by Tom and Jerry. Courtship, gastronomic excesses, gambling, indebtedness, the fight with the police, sickness and cures—all these motifs derive from a picaresque tradition of the picture story which goes back beyond Hogarth to Dutch and Italian tales of harlots, rakes, and Prodigal Sons.

In Töpffer, the whole narrative mode is transformed. Each drawing is a link in a causal chain, a phase in a larger movement rushing the reader from page to page. In Cruikshank the scenes plod along episodically, with only an occasional inherent connection of a stereotyped kind. The most original episodes are placed towards the end (17-21, Pls. 9-11) when Mr. Lambkin undertakes to cure his general debilitation by means of various remedies, one of which (21, Pl. 11) gives us perhaps the only genuinely comic and novel scene in the whole sequence. The sight of the big-city trencherman sitting forlorn in a cowshed sipping "New Milk from the Cow" (Figure 35b) lies on an imaginative level one would wish to have seen maintained elsewhere. (A resemblance here with Töpffer's *Vieux-Bois/Oldbuck* may be entirely fortuitous: as a remedy for his sickness, Oldbuck drinks ass's milk and, like Lambkin, takes exercise on horseback.)

Lambkin, like Jabot, is literally a poseur; wherever he goes, he strikes an appropriate pose, rendered by Cruikshank with characteristic assurance. But whereas the English caricaturist shows his hero as having struck the pose, the Swiss shows him actually practicing it. The more conscious poseur is obviously the more ridiculous. Jabot's posturing is emphasized by a stylistic reduction which Cruikshank cannot afford to make. By eliminating most of the background detail, Töpffer is able to isolate attitudes, arrange them in telling sequences, and permit the reader, as it were, actually to follow the hero around the drawing room. Cruikshank

180

clings to the significant background accessory of the Hogarth tradition, particularly in the symbolic pictures on the walls.

Töpffer explodes the conventional realism of scenario which limits so drastically Lambkin's range of manoeuvre. To take two specific points of momentary convergence, which immediately become points of maximum divergence: first, both heroes achieve entrée into what they believe to be high-class society, Lambkin at Swindelle's (Figure 35a) and Jabot at Madame du Bocage's (Figures 34a and 34b). Lambkin foolishly allows himself to fall into the clutches of a confidence trickster, and thence into those of a rascally lawyer; Jabot, whose carelessness was quite trivial and relatively innocent, finds himself faced with much worse: no less than seven duels. In Töpffer's topsy-turvy world, the smaller and slighter the cause, the greater the cumulative effect. And the effect is always cumulative. In Cruikshank's world there is a rigid pairing of cause and effect, which chokes off development of new directions in the narrative. The second point of convergence lies in the marriage which, after much hardship, awaits both. The divergence here is even more extreme. Whereas Lambkin's marriage is the logical result and just reward for so many painful social lessons, Jabot's is the outcome of the absurdest chain of accidents.

In draftsmanship as in story-line, we may contrast the relative realism of the Englishman with the deliberate anti-realism of the Swiss. Cruikshank preserves Gillray's exaggerated and simplified, but still basically naturalistic contour, complete with three-dimensional interior hatching. Töpffer has systematically abandoned all pretense to anatomical correctness and three-dimensional reality, having made the significant discovery (explained in his *Essai sur la physiognomonie*) that the imagination supplies more freely what the hand leaves unstated. Töpffer's revolutionary method of graphic doodling, his development of a shorthand code, facilitates a breathless narrative pace to which Cruikshank does not aspire.

Technically, imitation of Töpffer would have presented no problem to Cruikshank. The latter's facility with a childish-looking, parodistic, medievalizing style relying, like Töpffer's, on a relatively crude outline in the figures, is evident enough in *The Loving Ballad of Lord Bateman* (Cohn 243, 1839), which was particularly admired by Dickens. But to pursue this childlike

181

style consistently and extensively rather than as an occasional exercise appropriate to a "medieval" text would have required a complete change in attitude towards the art of representation. Töpffer's use of lithography also lies outside the scope of Cruikshank's intermittent experiments with the medium. The casual effect of Töpffer's line is unobtainable in any other reproductive medium, and his ability to draw directly, without preparation, on the stone, offers an immediacy which the more laborious process of etching from preparatory drawings could never rival.

The success of Töpffer in England was somewhat limited by the strangeness of the content. This much is clear from a review of the *Adventures of Mr. Obadiah Oldbuck*, which was found inferior to the French original (Töpffer's original lithographs were evidently known to the reviewer) and in its new guise "not suit[ed to] the English name."[16] This form of adventure story is deemed "chiefly peculiar to continental habits." The reviewer suggests that "the New Munchausen" would have been a more appropriate title. While Cruikshank was of course a highly popular illustrator of German fairy tales,[17] and even set about adapting them to his own Temperance morality later, he never attempted to generate one of his own.

Cruikshank was not a writer of stories. His literary gifts were much more limited than those of Gillray, who could write captions of considerable verbal wit; indeed, these captions were considered a major attraction. The captions to *Lambkin* are slightly pompous, as they are probably meant to be, but they are also repetitive and flat. They have none of Gillray's sardonic emphasis, nor, for that matter, the delicate, faintly parodistic irony of Töpffer. Cruikshank's unwillingness to write the captions for his broadsheet caricatures was regretted by a verse satirist who accuses the publisher Hone of cheating the artist of his due, and exhorts the latter to develop his literary potential: "Were Cruikshank wise, he might with trouble small, / Write his own captions and eclipse you all."[18] It was, doubtless, partly in order to make a virtue out of necessity that Cruikshank proposed to tell his "Life of a Thief"

16 *Gentleman's Magazine*, N. S. 17 (January 1842), 73.

17 William Bates, *George Cruikshank: The Artist, the Humorist, and the Man* (Birmingham and London, 1878), p. 49, where his gifts in rendering the supernatural are deemed superior to those of Callot and Fuseli.

18 Quoted by Bates, p. 16.

"without a single line of letterpress."[19] He could write a scene as he did on several occasions for Ainsworth, but not a story, as Ainsworth himself points out in his rebuttal to Cruikshank's claims to have "invented" much of *The Miser's Daughter* (Cohn 17, 1842): "Had Cruikshank been capable of constructing a story, why did he not exercise his talent when he had no connection with Mr. Dickens and myself?"[20]

VI

Like Hogarth, Cruikshank had definite material objectives in his determination to rise from the rank of illustrator to that of author. As Hogarth had sought through his famous Copyright Act to prevent the exploitation of his engravings by dealers and booksellers, so Cruikshank wanted to secure to himself some of the profits which normally went to the author and publisher of a book he illustrated, and to escape "the thraldom of the bookseller, whose slave I have been nearly all my life."[21] Knowing that the success of a Dickens or Ainsworth novel depended in no small degree upon his collaboration as illustrator, he naturally resented having no more than his poor original fee to show for it. Unlike Dickens, he was in no position to drive a hard bargain.

Cruikshank was overtaken by changes in public taste and publishing procedures, and, perhaps worst of all, felt threatened by a number of younger artists whom he promptly suspected of deliberately imitating, plagiarizing his style. It was in a way inevitable that, once identified as Dickens' illustrator, Cruikshank should find people supposing that he was Phiz; and he was in no position to welcome a follower, as Töpffer had Cham.

Defrauded by the plagiarists who converted his delicate designs into the crude wood-engraved headpieces and vignettes in *Bell's Life*, Cruikshank had more reason than most artists of the day to regard his designs and ideas as inalienable personal property. Eventually he felt compelled to appeal to the public for his rightful share as the co-inventor of certain novels. The Dickens-Cruikshank controversy crystallizes an essentially bourgeois and typically nineteenth-century conception of art, of artistic idea as a species of commercial property.

The conception of Töpffer was diametrically opposed to all this.

[19] Jerrold, I, 216. [20] Jerrold, I, 263. [21] Jerrold, I, 216.

Considering himself an amateur, he believed in art as a kind of useful amusement, a necessary distraction of the mind. His personal circumstances favored a non-professional attitude, for denied by poor eyesight the career in art for which he had been trained, he had married a wealthy wife, founded a profitable boys' school, and obtained a lectureship at the Academy of Geneva. Even without his novels and travel stories, not to speak of his caricature albums, he was financially secure. His "histoires en estampes" were originally drawn to amuse schoolchildren, not as commercial ventures like *Lambkin*; when they became so, he took little apparent interest in their sales, having permitted them to be thrown anonymously on the Parisian market. He encouraged Cham to make imitations which were sold by Aubert as the work of the author of *Jabot, Vieux-Bois*, and so forth.

Cruikshank, on the other hand, was in acute material need for all the artistic credit he could get. Thus his "defeat" over *Oliver Twist* was dual. In public, and later, he complained about being denied the co-authorship which was rightfully his; privately, and at the time, he must have felt that the publication of this novel had foreclosed the artist's plans for his own "Life of a London Thief" which dated back to the 1820s. In a hitherto unpublished letter to Robert Shelton Mackenzie discovered by Richard Vogler,[22] the artist refers to a "list which I showed you of the proposed illustrations for 'The Life of a London Thief'—with some of the sketches—all of which were done when Charles Dickens was a little boy—some 15 years before I ever saw or heard of him." Many of the motifs from this project must have been absorbed into *Oliver Twist*, and the project as such was never resumed.

VII

While any "Life of a London Thief," however handled, cannot have failed to be serious in spirit, *Mr. Lambkin* was deliberately non-serious. Since it was also lacking in comic novelty, we need not be surprised that the public paid little attention to it, and that it was the relative failure of *Mr. Lambkin* which convinced the artist that he needed more serious, socially useful subject matter, and a more serious style to go with it. He found both, within three years, in *The Bottle* and *The Drunkard's Chil-*

22 See Vogler, *supra*.

dren, which were resounding successes, chiefly because their themes were so very timely, as was the dignity with which they were treated. There is no evidence that *Mr. Lambkin* failed completely, but it was surely not so successful as the artist had hoped. A second edition appeared in the artist's lifetime,[23] but no contemporary took note of the publication, and the early biographers have little to say about it. The judgment of a Cruikshank contemporary, Blanchard Jerrold, in 1882 may well reflect a more general attitude. Noting in passing that *Mr. Lambkin* was "entirely Cruikshank's own," Jerrold dismisses it as "the least successful, and deservedly so, of his works." Elsewhere, in a footnote, he carelessly assigns the work to that limbo of little-known works done in the last years of the artist's life, ignoring the fact that in reality it precedes by four years the date set by the author himself as the beginning of the artist's decline.[24] Bates, writing in the year the artist died, reveals the extent to which *Lambkin* and the unique character of the work had been forgotten, by merely listing it "among the innumerable books he has illustrated."[25]

Cruikshank seems to have planned the story of a young lady,[26] as a sequel in the traditional manner of such sequels; it did not materialize, surely because of the disappointing reception accorded *Mr. Lambkin*. But he used the example of *Mr. Lambkin* as proof of his capacities as "independent author" in order to propose a form of collaboration in which he, as illustrator, would have the upper hand and decide the character of all the etchings, to which the literary portion would be subordinate. Cuthbert Bede, on the occasion of his first visit to Cruikshank's home in 1853, was requested by the artist to

[23] In the preface to the Routledge edition of *Mr. Lambkin* (apparently the second, entering the British Museum in 1865) Cruikshank observes that, in respect to the saying "out of sight," the book was not "out of mind," as many inquiries testified. David Bryce in Glasgow published a third edition in 1883.

The second edition has a variant title which has passed into some Cruikshank catalogues: . . . *The Adventures of Mr. Lambkin* . . . An apparently slight change, but one which may reflect Cruikshank's instinct to "update" the Hogarthian title to conform with a Töpfferian one.

An edition, presumably plagiarized, published by Carey and Hart in Philadelphia (1845) is entitled *The Bachelor's Own Book, Being Twenty-four Passages in the Life of Mr. Lambkin, (Gent.).*

[24] Jerrold, I, 226 and II, 219, fn.

[25] Bates, p. 47.

[26] According to unpublished evidence kindly passed on to me by Dr. Vogler.

write a humorous story of modern life, to be illustrated by himself, with a series of designs, something after the style of his 'Adventures of Mr. Lambkin,' and he jotted down some rough memoranda and sketches (in pencil) embodying his own ideas on the subject. . . . As a matter of course, I gave my best consideration to Mr. Cruikshank's suggestions and ideas, but submitted to him that I could not see my way to carry them out to our mutual satisfaction; I also raised objections to the somewhat hackneyed nature of the themes he suggested, and stated my preference for writing a story that should be wholly and entirely my own original composition.[27]

Cruikshank acceded; the themes he had proposed, described by Bede as "somewhat hackneyed," were presumably not very different in kind from those of *Mr. Lambkin.*

One may take it as a tacit recognition on the artist's part of the sterility of the *Lambkin* experiment, that its successor as an independent picture story should be a work so vastly different as *The Bottle.* From the perspective of the Temperance worker which he became within three years of *Mr. Lambkin,* that gentleman's bibulousness (depicted in no less than five different scenes) must have appeared as deserving more serious treatment than gentle mockery, and as conducive to a different fate from the happiness of the wine-decked wedding table. We have noted that it was the seriousness of subject and style which insured the success of *The Bottle;* we may add that this seriousness anticipated the tendency of Victorian illustration around mid-century towards the classical, the dignified, and the tragic.

The brisk comedy of Leech was superseded, in *Punch,* by the gravity of du Maurier, in whose art the caricatural spark of Victorian illustration was finally extinguished. The impulse towards the childlike and farcical, given by Töpffer, survived in England in the cheap magazines like *Man in the Moon* (1847-49), to which Cham and others contributed Töpfferian pull-outs, and in the illustrations to children's books, such as Thackeray's *The Rose and the Ring* (1853). But Thackeray, whose *Mrs. Perkins's Ball*

[27] Jerrold, I, 220. Cuthbert Bede's project was published by Nathaniel Cooke that year under the title *The Adventures of Mr. Verdant Green, an Oxford Freshman.* This contains some amateurish illustrations by the author, whose crude but legible outlines may possibly betray the influence of Töpffer.

(1847) had indicated some interest in a predominantly pictorial narrative mode, thenceforth abandoned all pretense to the title "the second Hogarth"[28] and dedicated himself to novels in which his illustrations play a very modest role. Thackeray, in whom literary and artistic gifts were much better balanced than in Cruikshank, and who might have attained that fine equilibrium between writer and artist manifested in Töpffer and his German successor Wilhelm Busch, was not willing to risk the kind of neglect suffered by Cruikshank. The ultimate successor of Mr. Lambkin in England was Ally Sloper, whose adventures lay near to half a century in the future.

[28] W. E. Church, *An Essay on the Genius of George Cruikshank by William Makepeace Thackeray . . . edited with a prefatory note on Thackeray as an Artist and Art Critic* (London, 1884), p. ii.

George Cruikshank and the Grotesque:
A Psychodynamic Approach

BY MICHAEL STEIG

A DISAPPOINTMENT of early childhood that I recall vividly had to do with a reprint of the collected issues of *The Comic Almanack* (Cohn 184, 1835-53). The book belonged to my Uncle Bill, whose possession of it was a source of as great an envy as I was capable of feeling at the age of six or seven. In the summers, when we lived three minutes' walk from my uncle's house, I would often spend a morning looking at various cartoon and picture-books of his, including the *Almanack*, but for some reason I seem to have been half-consciously saving up for a really long and careful enjoyment of the hundreds of etchings and cuts in the volume, and had spent more time with colorful Rackhams and Dulacs. But one day, when I had (or so it seems to me now at a distance of three decades) resolved to have a good long read, I discovered that the volume was missing from its customary place. Where was it, I asked my uncle, and he replied that he had given it to his brother Irwin. But *why?* Because Irwin liked Cruikshank so much, was the explanation offered. My Uncle Irwin lived in another town; we visited him only once or twice a year, and there was rarely time during those visits to look at many of his books. I will not say that I shed tears or mourned my loss for the rest of that day, but it *was* felt as a loss, and not forgotten; I believe my feeling at the time was that Bill (who in fact had probably never even seen me open the book) should somehow have known that this book was of special importance to a child—certainly more so than to Uncle Irwin!

This anecdote seems to me a useful starting point for a discussion of Cruikshank and the grotesque, for it conveys something of the extent to which a strong response to Cruikshank is a childhood trait. "He is the friend of the young especially," says Thackeray, who gave up confections to be able to buy Cruikshank's prints. And secondly, it hints at elements in this artist's appeal that go beyond the stimulus to "laugh outright" which Thackeray

189

speaks of.[1] For I am fairly certain that my "saving up" the *Comic Almanack* by only dipping into it briefly and intermittently was a response to the fact that his art is disturbing as well as amusing. But perhaps the one thing that most directly accounts for George Cruikshank's hold upon us—which is lifelong if we have first encountered him in childhood—and which ties the other qualities together, is that his work is beautiful, at times sensuously so. It is with the coalescence of seemingly disparate elements in Cruikshank's grotesque vision, and thence into its fascination for us, that I shall be concerned in this essay.

I

A passage from a recent study of Dickens provides a way of entering directly into the central problems:

> The strange impression one gets in looking at the work of Cruikshank or Tenniel, that somehow realism and fantasy have been clamped together in a single style, without being integrated, comes from their elaborate use of detail, their strict definition of line, light, and shadow, and their careful filling in of background—all in order to convey an emotion, a settled disposition of feeling, a "human" quality, which is conceived abstractly, indeed fantasized, and thus is strangely at odds with the very medium. Everything seems exaggerated and distorted because there is a gap between the means (realistic, scientific, factual) and the message (moralistic, emotional, fantastic).[2]

Taylor Stoehr's remarks seem to pinpoint in Cruikshank's art a peculiar relationship between content and form, which creates for the viewer a sense of conflict; but conflict does not necessarily mean lack of integration, and I shall argue that the "means" cited by Stoehr are essential to Cruikshank's grotesque vision and not at odds with it, although as one might expect, artistic integration is not always achieved.

First, the concept of the "grotesque." Few past writers on Cruikshank have avoided the term entirely, but few, if any, provide

[1] "An Essay on the Genius of George Cruikshank," in Thackeray, *Works*, 13 vols. (Biographical Edn., London, 1899), XIII, 286.

[2] Taylor Stoehr, *Dickens: The Dreamer's Stance* (Ithaca, N.Y., 1965), p. 276.

either a definition or the example of a perspicuously consistent usage. My own working definition is based upon several theorists' discussions of the literary grotesque.[3] In grotesque literature or art, content which might produce anxiety through its appeal to childhood fantasies of desire, aggression or fear, is modified in the direction of acceptability to consciousness by techniques of comedy, caricature and form, including the sensuous surface of the medium, whether words, or line, composition and color. But these formal defenses against anxiety (analogous to the defense mechanisms described by psychoanalytic ego-psychology) are imperfect, either because they are simply too weak, or because there is a feedback of anxiety owing to the nature of the defense itself —as when the use of a childhood technique such as word-play or the simplifications and distortions of caricature is, despite its seeming triviality, also redolent of primary thought processes, infantile fantasies of aggression, omnipotence and the forbidden.

It is necessary to make a further distinction in regard to caricature, which has been usefully defined as the ridicule and degradation of a feared or hated entity by visual distortion and childlike techniques which may take a number of forms: overemphasis of certain traits, animalization, transformation into the inanimate. Such degradation and ridicule are analogous to magic used upon the effigy of an enemy.[4] A simple example is George Cruikshank's treatment of Bonaparte throughout his illustrations to *The Life of Napoleon* by "Dr. Syntax" (Cohn 153, 1815), where Bonaparte appears in nearly every etching as a virtual midget in relation to the other figures portrayed. His childish stature is the main caricatural thing about him, in contrast with the gross and deformed heads of the French soldiers; and the overall effect is only weakly grotesque in the sense in which I am using the term, for Napoleon is simply the artist's victim, reduced to utter powerlessness, and retaining little of menace or malevolence. The caricature, in other words, too thoroughly controls the anxiety, and there remains little feeling of the artist's own aggression—as there is, by contrast, in the satire of 3 March 1813, *Anticipation for* BONEY, *or, A Court Martial on the Cowardly Deserter from the* GRAND ARMY! *(British*

[3] In particular, Lee Byron Jennings, *The Ludicrous Demon* (Berkeley and Los Angeles, 1963), and my own, "Defining the Grotesque: An Attempt at Synthesis," *JAAC*, 29 (1970), 253-60, which contains further references.

[4] Ernst Kris, "The Psychology of Caricature," in *Psychoanalytic Explorations in Art* (London, 1953), pp. 173-88.

Museum Catalogue of Political and Personal Satires, No. 12023; Cohn 890), in which the Emperor is a thin, pitiful, weeping figure with a rope around his neck.

In this latter instance caricature seems almost to defeat its purpose by making the viewer sympathize with the object of attack, against the aggression of the artist; but a more typically grotesque quality does appear in the Republican judge and executioner, who are given distorted faces, grimacing mouths and threatening eyes, so that they seem at once frightening and ridiculous. Here we move from the primarily reassuring humor of *The Life of Napoleon* to the terrors of Cruikshank's graphic assaults upon political forces, characterized as horrible monsters, ludicrous to a greater or lesser degree, but unquestionably dangerous. In the satire of 17 July 1819, *Universal Suffrage, or—the Scum Uppermost——!!!!! allegory to demonstrate the fatal consequences of 'Radical Reform' | in plain English[,] Revolution* (B.M. Cat. 13248; Cohn 2065), we see a hell-cat breathing fire, with bat wings, four dragon heads, eagle claws and a serpent's tail with a liberty cap on its end, surmounting in triumph a pile of crowns, sceptres, and symbols of British law, culture and commerce. The contemporaneous *A Radical Reformer,——(i.e.) a* Neck *or nothing man! Dedicated to the* Heads *of the Nation* (17 September 1819, *B.M. Cat.* 13271; Cohn 1886, Figure 36) shows a horrifying anthropomorphized guillotine putting to rout royalty, politicians and clergy.

The contrast between these anti-radical satires and those of Napoleon suggests that the further the object of caricature is from a real person, or even a national people, and the closer to an abstract force, the more difficult it is to use reassuring ridicule as a main tactic. Napoleon can be made into a midget, put on a chamber pot (*Little Boney Gone to Pot*, 1814, *B.M. Cat.* 12261; Cohn 1322), or have his fingers, ears and nose removed (*The Hero's Return*, 1813, *B.M. Cat.* 12012; Cohn 1197), but what can one do with the force of *Radical Reform?* In most of the Napoleonic satires there is something of a balance between hatred and comedy, but the two satires I have cited from 1819 are dominated by hatred and fear, to the extent that one might expect their effect to be closer to the purely horrific than to the grotesque. But the differences in Cruikshank's artistic strategy in the two plates are instructive. In *Universal Suffrage* . . . the horror of the

192

hellish symbol of "revolution" is balanced not by the slightest touch of comedy, but by purely abstract, visual means: the entire composition is symmetrical, with the demon itself having almost perfect bilateral symmetry, while the pile of symbols is precisely centered; even the background clouds contribute to the general symmetry. Further, the etched lines are clear, precise and pleasing to the eye (compare Taylor Stoehr's remarks on Cruikshank's artistic "means"). The result is that disturbing emotions are kept under control, and a tension, typical of the grotesque, is set up.

Indeed, one may feel that the stylistic control in this satire overcomes the fear almost entirely, by translating the image—rather remote anyway as a symbol of universal suffrage!—into something like an allegorical device. This over-control may be due partly to the fact that Cruikshank is here working from the design or verbal suggestion of an amateur, and thus is perhaps un-involved emotionally and imaginatively. Nothing of this sort could be said about our other example, designed by Cruikshank him-self, *A Radical Reformer* . . . , which is not symmetrical (although the design is balanced), and where the guillotine-man-monster is etched in such a way that its lines are loose and flowing—more like a Cruikshank drawing than an etching. The effect is that the guillotine is dynamic, seeming to move toward the scurrying men, while the allegorical monster of *Universal Suffrage* is compara-tively static. Further, the anthropomorphic guillotine is given a full range of "Freudian" symbols: glaring eyes, biting mouth, fiery bowels. But most amazing is the pelvic location of the hole where the victim's neck would be placed, almost explicitly equating decapitation with castration, but also implying fantasies about childbirth and the differences between men and women. This is perhaps the most extreme example one could find, but Cruik-shank's work throughout his career is full of material that recalls the Freudian concept of primary-process thought—associative, a-logical, emotional, as opposed to rational, logical, "realistic" mental processes. In a paradox that is more apparent than real, Cruikshank's relative freedom from explicit scatology or bawd-iness, compared with his contemporaries among the satirists, is directly related to the preponderance of unconscious, fantasy material in his work.

The element that makes *A Radical Reformer* grotesque rather than merely horrible is not line or composition, but comedy,

partly in the unseemly haste with which the "heads of the nation" stumble over one another trying to get out of the way, but more directly in the tiny guillotine-monsters shown far in the distance. These figures, by being wholly ridiculous and unthreatening in appearance (although their intellectual message is that more monsters are coming in the future), one of them singing, "And a-Hunting we vill go," undercut the seriousness of the main subject by implying that such forces are, after all, easily kept under control. But they do not *negate* the primary message of the satire, they only help to make it supportable emotionally. One of Ernst Kris's remarks on the psychology of caricature is relevant here: "Things which simply arouse anxiety or unpleasure cannot be adapted to comic expression—to attempt to do so may produce an uncanny effect—until they have been reduced in intensity and undergone some degree of working over."[5] But in *A Radical Reformer* the reduction of intensity is just enough to hold dangerous emotions in a precarious balance.

The relatively uncontrolled line is found much less often in Cruikshank's etchings than in his wood engravings, which are sometimes closer in character to drawings. We may see examples of such a line in some of the cuts for William Hone's pamphlets of the period 1820-22. There is no evidence of any change in personal political convictions on the part of the artist between 1819 and 1820, and thus the use of similar methods for seemingly opposite political positions is remarkable. The cut which comes closest in feeling to *A Radical Reformer* is that for "The Boa Desolator, or Legitimate Vampire" (*B.M. Cat.* 14169; from *The Political Showman—At Home!* [Cohn 668, 1821], Figure 37b). This combination of crocodilian, bat and other charming creatures, its nostrils spouting blood, crushes and devours masses of human beings, and is plausibly comic only in its crossed eyes. The cut on the whole is about as close to the purely horrible as Cruikshank's fantasy ever gets, and it is noteworthy that this beast, in total contrast to the guillotine-monster, represents the repressive elements in Royalty and government, which are to be destroyed only by forcible feeding with the products of a free press.

The similarities of method, and contradictions in political ideology, suggest that the sources of emotion in Cruikshank's art

5 Ibid., p. 185.

194

lie much deeper than politics (again, a similar monster to the "Boa Desolator" appears in yet a third context—*The Red Dragon* [Cohn 2028, 1859], which represents the evils of brewers and distillers). And further, in retaining his artistic power when the political events are long forgotten, Cruikshank must be drawing upon more basic, only partly conscious psychic material in himself and his audience. A prime factor in the Cruikshankian grotesque is the fragmentation of the human body, and the exaggeration and distortion of certain parts. This may sound commonplace as far as graphic satire is concerned, but Cruikshank's artistic treatment of the body is qualitatively different from that of his predecessors and contemporaries.

The three satires discussed in detail thus far have in common a preoccupation with the mouth, as a voracious, destructive thing, threatening to maim and devour. Most obviously, this expresses and evokes fears of being devoured by the rage of others, fears of the animality implicit in human rage. But we comprehend this animality through the experience of our own rage, and its connection with clenched or gnashing teeth and the desire to bite. One need not follow the Kleinian psychoanalytic school, which finds the origin of all fear of the mother in a projection of the infant's biting urges at the breast, to see that Cruikshank's use of frightening mouths in his satires expresses both fear of others' aggression, and fear at one's own aggressive impulses. The idea of biting as a representation of something threatening comes, after all, not from the object of satire, but from the artist's own imagination. As Gombrich and Kris remark, "Willingly we may yield to the caricaturist's temptation to us to share his aggressive impulses, to see the world with him, distorted."[6]

Another example of the threatening mouth is an unpublished pencil drawing (Figure 37a, British Museum Cruikshank Collection, bearing neither date nor accession number) which shows a quasi-human demon, who is mostly legs, arms and head, striding off the top of the Royal Exchange, and threatening with fork and knife the Royal procession below. Here, the idea of oral aggression is reinforced by the utensils, and it is mainly the idea of a cannibalistic monster using civilized eating-tools that prevents this freely-drawn figure from being solely horrible. This drawing, like the three published satires discussed above, contains another body

[6] E. Gombrich and E. Kris, *Caricature* (Harmondsworth, 1940), p. 26.

195

feature prevalent in Cruikshank's work, of all periods: the star-
ing, penetrating, mad and threatening pair of eyes. The contexts
in which such eyes occur are various, and frequently there may be
no evident connection between the subject and the expression of
the eyes; yet these eyes are often simultaneously fascinating and
terrifying, without any immediately apparent reason. The facial
expression is notable for its rigidity; typically, the eyes are wide
open, but not in surprise, since the mouth is usually either turned
up in a grin, or is gaping open with the threat of biting. That
Cruikshank could consciously associate such eyes with murder and
madness is to be seen in his use of them in the "Portrait (from
memory) of a gentleman after he had taken some refreshment,
Now sentenced to twenty years' penal servitude for attempting to
murder a lady."[7] This gentleman's face is horribly wrinkled up
with the exertion of sticking out his tongue as far as it will go. But
equally fascinating and fearsome are the eyes of Grimaldi in
All the World's in Paris! (1 February 1815, *B.M. Cat.* 12698; Cohn
880)—a reproduction of which was one of the pleasurable terrors
of my childhood—and those of the comet in "The Comet of 1853,"
an etching for *George Cruikshank's Magazine* (Cohn 185). Note
that neither the clown nor the comet is actually supposed to be
malevolent.

The peculiar effect of such eyes can be interpreted on various
levels, and surely has its roots deep in the unconscious. At a con-
scious level, they may represent the enraged adult, beyond—or
so it seems—the reach of emotional influence, unchangeable in his
expression by any appeal to affection or pity. But the extreme
rigidity, combined with the frequent association with a devouring
mouth, suggests that psychoanalysis may give some clues here. Otto
Fenichel has written that a rigidly fixed gaze is, to the unconscious,
a combination of sadistic aggression and passive fascination, deriv-
ing from the child's combined role as witness of and identifier with
the parents in sexual intercourse (the "primal scene").[8] According
to Fenichel, the rigidity of fascination "represents the child's help-
lessness in face of the enormous masses of excitation experi-

[7] Sir B. Ward Richardson, *Drawings by George Cruikshank, Prepared by him to
Illustrate an Intended Autobiography* (London, 1895), Pl. XXXVI (Cohn 694).

[8] "The Scoptophilic Instinct and Identification" (1935), *Collected Papers, First
Series* (London, 1954), pp. 373-94.

enced."[9] Further, the rigid, fixed eye itself, in this connection, comes to symbolize in the unconscious at once a devouring mouth, through fear of one's own aggression, and, through identification, the sexual organ in a state of arousal.

Fenichel's whole argument is much more complex than I can indicate here, but I have cited it to suggest how deep may lie the sources of certain aspects of Cruikshank's art. It is surely to our purpose that the penetrating stare is an attribute of Cruikshank himself, which he sometimes recorded in his self-portraits, and is usually evident in photographic portraits of him. It was certainly noticed by others: Blanchard Jerrold, his biographer, says, "His was a handsome face, with steely blue eyes that struck through you. They flashed as brightly as the eyes of Mr. Dickens, but they had no merriment—only keenness, and a certain fierceness in them."[10] And the artist himself, when ridiculing a description by a journalist of his eyes, chose a rather surprising metaphor for his ostensible facetiousness: he is able, he says, to see through a millstone, "upon merely applying the single optic, right or left, to the centrical orifice perforated therein." And he agrees with the journalist that he is himself "unconscious" of the power of his penetrating gaze.[11]

The notion that Cruikshank's work deals obsessively with certain aspects of the body is interestingly complemented by the quantity and nature of his casual self-portraits, scribbled on letters, etched as remarques in the margins of plates, and drawn and painted, over and over[12] (Figure 38a); for these self-portraits are remarkably stereotyped, as to both pose and expression, throughout his career, being divisible into two basic types, the profile (which are, in the hundreds, to be found in the British Museum and Victoria and Albert Museum Cruikshank collections), and the three-quarters or full face. In the latter, usually only the eyes seem expressive at all. Another interesting preoccupation, in view of his own prominent nasal member, is with noses. The plate in *My Sketch Book* (Cohn 181, 1834), "A Chapter of Noses," may by itself impress as an amusing physiognomical tour de force, but taken in conjunction with the later version of the central subject,

9 Ibid., p. 390.
10 *The Life of George Cruikshank*, 2 vols. (London, 1882), I, 164.
11 "My Portrait," *George Cruikshank's Omnibus* (London, 1842), pp. 2, 5.
12 See George Somes Layard, *George Cruikshank's Portraits of Himself* (London, 1897).

197

the author's lifting up of an offending bookseller by his nose with a pair of tongs,[13] and the painful example of nose-pulling in the *Table Book* (Cohn 191, 1845; "Relieving a Gentleman from a State of Coma," p. 21), it becomes something more. An automatic equating of noses with penes is perhaps to be avoided, but Cruikshank's interest in the nose (like Gogol's and Edward Lear's) cannot simply be explained in terms of, say, chronic rhinitis. In these and other designs he is in effect saying that the nose is at once the most important and the most vulnerable of organs; the possession of a fine nose (like the artist's) is a proof of character, and one will further prove oneself by pulling or hurting the nose of any other gentleman who gives offense. It is perhaps not unimportant that both booksellers offended Cruikshank by, so to speak, calling his identity into question (passing off other Cruikshanks' work as his); but I defer here to the reader's inclination and ability to interpret these matters psychologically.

The interest in certain bodily features and the tendency to stereotype are related to each other, and to the strengths and some of the weaknesses of Cruikshank's art. Among weaknesses I have in mind particularly his increasing tendency to stereotype the figures and faces of women, particularly young and respectable ones. On the whole, however, the preoccupation with flesh leads to an achievement in the grotesque very different from Thomas Rowlandson's, but equally impressive. Rowlandson is, even in his most squalid caricatures, a celebrator of human flesh. It has been said that etching is an inappropriate medium for Rowlandson, who is really a watercolorist; and in a way this is no doubt true, for while Cruikshank's watercolors usually look like either sketches for or copies of etchings, Rowlandson's etchings often resemble unnaturally stiff versions of watercolor drawings, with little or no advantage being taken of the special possibilities afforded by the etching technique. Yet paradoxically Rowlandson's grotesqueness derives primarily from a fascination with the varieties of flesh which receives its most striking incarnation in the fine, precise lines of etching. Rowlandson's etchings celebrate the capacities of flesh for taking wildly varied forms—its defiance of symmetry, its shaping into endless masses and folds, its incredible range of expressiveness. And there is a constant artistic tension between this unruliness of flesh and its depiction in precise, mechanically re-

13 *A Pop Gun Fired Off* (London, 1860; Cohn 186), p. 38.

produced lines. Flesh in Rowlandson's watercolors is delightful, but in his etchings it is also disturbing.

In Cruikshank's etchings, flesh is seldom if ever allowed the kind of freedom of line it has in Rowlandson's; instead, in the early work, while Cruikshank is still primarily a graphic satirist rather than an illustrator—and in some non-illustrative later works—the human figure is conceived largely in terms of controlled curves, which may be used to represent fat—huge bottoms, bellies and breasts—or lean—the inward curve of a woman's corsetted waist or a man's slender leg. To a degree, Cruikshank is employing the conventional linear vocabulary of the graphic satirist of his time, but an example of his direct imitation of another artist will help to demonstrate his special place among his contemporaries.

In 1819, a great many satires appeared which featured the velocipede or "hobby," either in direct social commentary upon the fad, or as a metaphor of one kind or another. A series of these was devoted centrally to the Prince Regent's relationship with Lady Hertford, and secondarily to a financial scandal involving the Duke of York. What is apparently the first of this series, *Exercising a Hobby from Wales to Hertford* (*B.M. Cat.* 13213, attributed to Marks), is dated March 30, and shows a grossly fat Prince Regent seated upon a velocipede with an equally fat Lady Hertford upon his lap—her globular breasts become a hallmark of the entire series. On April 9, again unsigned but probably by Marks, appeared *A P****E, Driving His Hobby, in Herdford* (*B.M. Cat.* 13216); this now shows the couple facing one another upon the contraption. What is presumably the third of the series is dated only 1819, but signed, "Marks fecit"; the title is *R***l Hobby's* (Figure 39a; a George Cruikshank print of April 9 had been called *Royal Hobby's* [Cohn 1920], but it bore no resemblance to this series), and it shows Lady Hertford now in the dominant position, seated upon the Regent's back, while his stomach rests on the machine, which is decorated with the three feathers of the Prince of Wales (*B.M. Cat.* 13221). Although Dr. George gives this a higher catalogue number, she conjectures that it is probably the source, rather than a copy, of Cruikshank's *Royal Hobby's, or the Hertfordshire Cock-Horse* (dated April 20, 1819, *B.M. Cat.* 13220; Cohn 1921; Figure 39b).

It is plausible that Cruikshank is the plagiarist here (if such a word is appropriate to the mutually piratical traditions of the

199

graphic satirists of the period), since his print is a good deal more elaborate than Marks's, and one would not expect a copier to reduce and simplify his model. He has followed Marks's treatment rather closely, but changes enough details to make a genuinely new print: the Regent is now strapped to the machine, and instead of pushing with his feet, one leg is straight out in back, while the toe of the other foot barely touches the ground; the feathers are altered so as to resemble a cock's comb. Further, Lady Hertford's eyes have a much more demonic gleam, and she wears spurs. The effect is greatly to magnify the effect of Lady Hertford as a forerunner of Leopold Bloom's fantasies of the transvestite Bella-Bello Cohen, and to reduce the Regent much more to a thing, a part of the machine, as well as a "cock-horse"—implicitly also a coxcomb and perhaps a cuckold, while the slang use of "cock" for penis may also be here (as it is in Robert Cruikshank's *Boarding School Hobbies! or Female Amusement* of the same year—*B.M. Cat.* 13416). The allusion to a nursery-rhyme adds, as well, to the quality of a childhood fantasy. However, simultaneously one must notice Cruikshank's superior artistry in the much more careful molding of the lady's flesh, so that it appears taut and sensual, and his much more perfect use of symmetry, resulting in a composition of curves and circles which is stylized and abstract enough to temper the anxieties aroused by the image of the domineering bitch-queen and the identification of the Regent with a machine. While Marks's variations on his (?) original theme are clever, Cruikshank's are brilliant; where Marks depicts two fat, funny people, Cruikshank creates a comic nightmare.

Such a balance between the fascinations of the human body and the creation of controlling design seems to have been something Cruikshank was striving for as he developed as a caricaturist. The progression between the earliest of the fashion satires, the *Monstrosities* plates in 1816 (Cohn 1747), and "A Scene in Kensington Gardens—or—Fashions and Frights of 1829" (January 11, 1829, in *Scraps and Sketches*; *B.M. Cat.* 15981; Cohn 180) is noteworthy. The earliest of these etchings are mere random collections of Dandies and women fashionably over-dressed, and posed in various odd ways; only in 1822 and 1825-26 do the assorted figures begin to coalesce into an ordered composition. In the *Montrosities of 1822* (*B.M. Cat.* 14438; Cohn 1752, Figure 40), beyond

the satirical comments upon current fashions, Cruikshank seems clearly to be drawing upon and appealing to unconscious fantasies and repressed childhood confusions about pregnancy and the differences between the sexes, in the strangely contorted and sexually inappropriate shapes of the men and women. By 1829, the overall design dominates, and something of the inventive vigor of the earlier work is lost. However, in *Inconveniences of a Crowded Drawing Room* (*B.M. Cat.* 13046, May 6, 1818; Cohn 1229), design absorbs flesh, but flesh is still there in all its emotional ambiguity. The satire centers upon a horribly fat and ugly man and woman bumping bellies in the doorway, while to their left, a man steps upon a lady's train. The ravishing sweep of the lines, and the coalescence of all the disparate figures into a whole without subordination of grotesque distortion to design, contribute to what is possibly George Cruikshank's greatest early work. Even color, so often a distraction, here works, as the bright red in the coat of the man at far left, the one at left center, and the open door, aid the unification of the design.[14]

Something of what I have called a preoccupation with the body is to be seen in later works. In a minor etching, the "L" of *The Comic Alphabet* (Cohn 189, 1836), "Latitude and Longitude" is the idea that becomes an excuse for playing, artistically, with the body—the woman's huge breasts and implication of pregnancy, contrasted with the pencil-like figure of the man (surely there is a phallic implication in this way of depicting men?). And in the quasi-sketchbooks of the 1820s and 1830s (*Phrenological Illustrations*, Cohn 178, 1826; *Illustrations of Time*, Cohn 179, 1827; *Scraps and Sketches*, Cohn 180, 1828-32; and *My Sketch Book*, Cohn 181, 1834-36) there are frequent improvisations on such a theme as fatness or legs, which, though delightful, and of permanent interest as part of Cruikshank's oeuvre, seem tame compared to the earlier satires. But on the whole, Cruikshank gives up this kind of playing, and women in particular become more and more stereotyped. And with the shift to book illustration, with its limitations upon size and general restriction to black and white, new techniques are required.

As an illustrator of books in the 1820s, Cruikshank developed

[14] This has been reproduced in color in M. Dorothy George, *From Hogarth to Cruikshank* (London, 1967).

as an etcher of the grotesque in new directions. Since, as with almost any other decade, his subjects and techniques at this time are exceedingly varied, generalizations are chancy; but I should like to mention one etching, from 1825, as epitomizing the potentialities of what was, in effect if not by definition, a new medium. While the quasi-sketchbooks are largely refinements of the earlier caricature style, the illustration of non-satiric books imposes different requirements. In the 1820s, many of these are collections of folk or fairy tales, but one of the most striking illustrations is the small title page to *Hans of Iceland* (Cohn 382, 1825; a translation and abridgment of a work by Hugo): it shows Hans, the Quilpish monster, in his cave. He is as ugly as anything in the social and political satires, but the relation between fearsomeness and style is quite different. The shape and size of the subject help to give a feeling of constriction and suffocation, but equally, the use of heavy crosshatching for the interior of the cave and for Hans himself, and of multiple jagged lines for the exterior of the cave contribute to both fear and reassurance. That is, the lines, unlike so many of Cruikshank's, are not curved and sensuous, and produce instead a sense of harshness and hardness; but at the same time, there is a concentration upon the lines for their own sake that reduces anxiety, for its reduces the feeling of strict representation, reminding the viewer that these are, after all, lines, not reality. In later years, the artist will become more and more engrossed with the possibilities of crosshatch—not always to good effect.

Most of the supernatural grotesques of this period are executed in lines so firm and controlled that one is reminded of Stoehr's views on the incompatibility of Cruikshank's style and subjects. One instance where this is certainly not true, and where comedy and terror balance perfectly, is the first plate of the *Twelve Sketches Illustrative of . . . Scott's Demonology and Witchcraft* (Cohn 188, 1830), entitled "The 'Corps de Ballet.' " At the left, a man stands nervously by his fire, looking out of the corner of his eye at the animated chairs and the jolly ghosts dancing with them. Chairs and ghosts are given an ambiguous status by being etched in thin, scrawly lines, to the extent that the ghosts seem to merge with the equally scrawly shading upon the wall—a very different, but equally effective, technique from that in *Hans of Iceland*.

202

II

Before turning to George Cruikshank's later phases, I should like to offer a restatement and amplification of the ideas developed so far. In his grotesque work Cruikshank draws upon fantasies of one's own and others' aggression, of chaos, engulfment, being devoured, and of childhood sexual confusion and desire, and in particular childhood ideas about the body. There is no direct correlation of political views with these uses of fantasy material, although Cruikshank's later statements about his youthful radicalism and growing conservatism, though of questionable accuracy, are probably not irrelevant to his development as an artist. In various ways, he employs comedy, ridicule, symmetry and line to manage (or, in psychoanalytic terms, defend against) the various anxieties aroused.

Although it is doubtful that anything short of a full-scale, critical psycho-biography could relate these features of Cruikshank's art to the artist, it seems worth mentioning the published illustrations for his unwritten autobiography (a few pages of notes for this projected work survive in the collection of David Borowitz, but I have not seen them). In 1864, in the process of trying out Charles Hancock's invention of etching on glass, the artist did a number of miscellaneous sketches, three of which depict scenes in his earliest life. The first shows his mother, feeding chickens, while the nurse holds him (he is perhaps one to two years old), and brother Robert stands nearby. In the second, the scene is the same, except the mother falls back upon the fence because Georgy has startled her, and according to Hancock she fell into the pond, the result of which was the premature birth of a baby sister. The third plate shows George, at the age of four or five, held by his father out of a window; according to Hancock, George told him that his father, annoyed at his misbehavior, said, "I will throw you out of window, you naughty boy," and pretended to carry out this threat. In the picture, the father looks gentle and amused, not angry, while the child looks up at his parent quite fearfully.[15]

Although one should not try to infer too much from this material, it is not insignificant that George Cruikshank, at the age of

[15] Hancock writes in the Preface to *A Handbook for Posterity: or Recollections of "Twiddle Twaddle" by George Cruikshank* (London, 1896; Cohn 815), in which these etchings on glass are reproduced (as they had been the year before in a slimmer volume—see note 7, above).

seventy-two, should choose these two incidents to illustrate for his projected autobiography. The first surely expresses the artist's sense of having committed an act of aggression against his mother —who is depicted as a typically idealized Cruikshank woman, and who does not seem pregnant—connected in Cruikshank's memory with his mother's pregnancy and the birth of his sister (itself both a painful and mysterious event for a very young child). And then this is followed by the father's threat, taking place some years later, but recalled, as it were, in the same breath. A full study would have to gather whatever evidence exists about Cruikshank's relation to his parents, or at least conjecture on the basis of much more material than I can present here. But the existence of these three "etchings on glass" seems to indicate the extent to which the artist was imaginatively in touch with his childhood, and thus has important implications for the various grotesque themes and techniques that run through his work.

III

While *The Comic Almanack* (appearing yearly from 1835 until 1853) may be seen as George Cruikshank's continuation of his earlier caricature mode in a more polished and somewhat subdued form, it is his book illustrations of the late 1830s and early 1840s that represent the new developments of his middle period. J. Hillis Miller has recently written of the feeling of constriction conveyed by the plates for *Sketches by Boz*; this feeling comes, he says, from their "centripetal," circular compositions, the focus "of all energy on a central point," which "is reinforced by the fact that Cruikshank's plates are not only usually dark but are also overshadowed by ponderous architectural overhangings."[16] Yet the "claustrophobia" of this world seems to me more noticeable in the original, smaller and more circular etchings than in the larger re-etchings of 1838, which Miller is using as his plates of reference; and the whole question is complicated by the fact that it was typical of Cruikshank's illustrations of the 1820s and 1830s to be of approximately the size and shape of those in the original *Sketches*, and to a degree size and shape in themselves may con-

16 "The Fiction of Realism: *Sketches by Boz, Oliver Twist*, and Cruikshank's Illustrations," in *Charles Dickens and George Cruikshank* (Los Angeles: William Andrews Clark Memorial Library, 1971), p. 55.

tribute to a constrictive effect. One should also note Cruikshank's having, in certain proofs for *Sketches by Boz* now in the British Museum, shaded out the subject at the edges so as to convert a nearly circular design into a rectangular one, as though the original shape seemed incomplete to him; and with this change a certain amount of the "centripetal" effect disappears.

Miller also contrasts Cruikshank's "centripetal" tendency with Gillray's "centrifugal" one, a point which has important implications for us. For although there is an immensely greater amount of explicit sex and scatology in Gillray's satires, Cruikshank's compositional habits call greater attention to the body and to the relations of various figures, shapes and masses than do Gillray's, which tend to diffuse attention to particulars. Thus, the kinds of exaggeration and linear tension that Cruikshank uses may frequently be more unsettling to the viewer than is Gillray's overt presentation of urination, defecation and copulation.

The constrictive effects noted by Miller are emphasized in Cruikshank's illustrations to Ainsworth's novels. Blanchard Jerrold praises the plates to *The Tower of London* (Cohn 14, 1840), *The Miser's Daughter* (Cohn 17, 1842), and *Windsor Castle* (Cohn 18, 1843) for "effects which Rembrandt would not have disdained," and their "technical skill in rendering infinite varieties of light and shade, of emotion, of scenery."[17] Truly, Cruikshank is trying his hand at something new, in particular the use of heavy crosshatching and shading to convey degrees of dark and light in backgrounds; but without detracting from his skill, one may be permitted to feel that many of such "Rembrandtesque" etchings are stiff and stereotyped in their depiction of human beings, and that after a while the shading becomes a somewhat tedious stylistic mannerism, rarely as interesting as some of Hablot Browne's "dark" plates (where light and shade are manipulated by means of mechanical ruling, biting in and stopping out). It seems odd that Jerrold should omit *Jack Sheppard* (Cohn 12, 1839) from his list, but it may be because the subjects are "low" compared to the later novels, though today one may feel that their caricature style in the depiction of characters has much more life than the neutrality of the royal and noble characters in *The Tower of London* and *Windsor Castle*.

It is in *Jack Sheppard* too that Cruikshank achieves some of his

17 Jerrold, I, 241.

most moving effects through shading. The water in "The Storm" (Figure 20a) is, by means of crosshatching and highlights, made motile, while the human figures are dwarfed by it; and this and other etchings convey—more vividly than Ainsworth's text—the helplessness of human beings by contrasting them with massive, threatening buildings. Architectural atmosphere becomes more and more of a technical gimmick in the novels to follow, but in some of the *Jack Sheppard* plates Cruikshank achieves a type of grotesque without comedy, in which the main anxiety is suffocation, relieved only by the careful compositional balance and the pleasure afforded by the artist's precise lines. A later, splendid example is one plate for Ainsworth's novella, *Modern Chivalry*, "The Béguines of Ghent" (*Ainsworth's Magazine* [Cohn 22], 4 [1843], 283); it is a perfectly ordered composition, but the effect is not really one of serenity, for the human figures seem helpless in the huge cathedral, and the row of faceless, praying nuns become horribly dehumanized objects.

Some of these techniques, especially "centripetal" structure, operate in *Oliver Twist*, for example with "Fagin in the condemned Cell." But what is perhaps the most intense example of Cruikshank's comic-grotesque vision, "Oliver asking for more," depends partly on a different stylistic principle. It has always seemed to me that in Dickens' text it is not the moment of Oliver asking for more, but the violent reaction of the workhouse bureaucracy immediately following, that expresses Dickens' special vision. It is the illustrator, rather, who has fixed the moment of "asking for more" in the readers' imaginations. The means by which he accomplishes this is to combine an extremely careful composition with a bare, almost childlike rendering of facial features, particularly of the children with their hollow, staring eyes (something similar is evident in "Oliver introduced to the respectable Old Gentleman"). The startling thing about this etching is that its method resembles that of two of the last plates Cruikshank did for *Bentley's Miscellany* (Cohn 69) which he drew as badly as he could out of pique with the editor.[18] In the latter cases, the result is that the figures are simply drawn as though by an incompetent artist; in *Oliver Twist* it is a successful presentation

18 "The unexpected recognition," *Bentley's Miscellany*, 13 (1843), 614; and "Regular Habits," *Bentley's Miscellany*, 14 (1843), 400.

of the author's intentions, and indeed embodies those intentions more thoroughly than does the author himself. There are few Cruikshank designs which employ quite so tellingly what is normally thought of as "distortion" to create feelings of pity and horror, as well as comedy in the two absurdly horrified adults.

As Cruikshank's career progresses from the early 1840s, his technique becomes ever more controlled, and the main fascination of the illustrations to a work like Smedley's *Frank Fairlegh* (Cohn 754, 1850) comes to reside in the perfection of design and etching, and the sensuous appeal of something much like Hogarth's "line of beauty." In the myriad tiny figures in some of the folding plates for Cruikshank and Henry Mayhew's *1851* (Cohn 548), the primary appeal comes from the amazing virtuosity—though there may be something as well of a disturbing quality of virtuoso technique pushed to the point of insanity. As late as 1871, the old themes of the century's first two decades could exercise the aged artist, but although *The Leader of the Parisian Blood Red Republic, or the Infernal Fiend* (Cohn 1312) is astonishing for a man of 79, it carries little of the force of its counterparts of 1819, so fully controlled is the technique.

It is not, however, my purpose here to present an evaluation of Cruikshank's career, and in pursuit of further varieties of his achievement in the grotesque, I turn now to certain works of his middle life. When Cruikshank had become primarily a book illustrator (apart from the *Almanack*), as opposed to relatively independent graphic satirist, some of his most imaginative work appeared sporadically in his own abortive journals. It is difficult, at this distance in time, to grasp fully that *George Cruikshank's Omnibus* (Cohn 190, 1841-42) and *George Cruikshank's Table Book* (Cohn 191, 1845) were intended to be regularly established monthly periodicals with many contributors, so totally does the artist's work dominate. The most celebrated illustrations (if that is really the proper word) are probably the large etchings, such as the "Preface" to the *Omnibus* (with its globe and tiny figures a precursor of "All the World Going to see the Great Exhibition" in Cruikshank and Mayhew's *1851*), and "The Triumph of Cupid" (frontispiece) and "The Folly of Crime" (p. 45) in the *Table Book*. Of these, only the last comes close to the grotesque, and that only, I think, in the toothy demons of the center vignette,

207

for the plate as a whole is as preachy and stilted as the artist's most parochial temperance designs, however high its level of technical merit.

Many of the etchings in these two periodicals in fact seem studied and over-controlled, in contrast with the wood-engravings and glyphographs (a quick process developed about this time) scattered profusely throughout. Those etchings which risk most, both technically and emotionally, are a pair in the *Omnibus*, "COMMENTARY upon the late—'New Police Act,' " 1 and 2 (pp. 33 and 34), which consist of sets of small figures, reminiscent of small cuts, with no backgrounds and no obvious technical bravura (Figure 38b). The topic is not far from what one might find in a political caricature of earlier decades, but the whole conception is very different. Cruikshank has drawn figures much as a child would, only with greater detail and finish: they have tiny bodies, large heads, and immensely long legs. They are highly ambiguous in age, and are all involved in defiant, rebellious behavior, including the mangling—literally, putting him through a mangle—of a policeman. No real child could execute drawings, much less etchings, of this quality, but the effect is like what George Orwell reported of his own childhood response to Dickens: the impression that the books were written *by a child*. The stylistic risk I have adverted to lies in the thinness of the boundary between such figure-drawing and the mere technical incompetence of a child; the emotional risk lies in dallying with infantile fantasies of omnipotence and aggression. From our present standpoint, the childlike technique acts at once as defense, by trivializing the lawlessness of the behavior depicted, and as a source of anxiety in itself, since it utilizes a normally repressed childhood mode of seeing. The effect is that the artist's intention seems ambiguous, and the viewer's ability to maintain emotional distance remains unstable.

Among the small cuts in these volumes, the fears, aggression and fantasies of childhood are similarly evoked, as in the wood-engraving of nose-pulling in the *Table Book* (mentioned above in connection with Cruikshank's nasal aggression and eroticism), where the man doing the pulling bares his teeth in an animalistic way without becoming any specific animal, and his victim takes on a vaguely *fishy* look—something more disquieting, I think, than overt metamorphosis into an animal, which in Cruikshank's

work is usually handled in a playful and fairly reassuring way. In the four tiny cuts of "window phenomena" (pp. 56 and 57 of the *Table Book*), the preoccupation with bodily distortion is given one of its most extreme expressions, but with the comic rationalization that these are merely distortions produced by window glass (fairly improbable). A different, but possibly related fear, that of supernatural creatures, is given unflamboyant but telling graphic expression in "O! meet me by moonlight alone," again from the *Table Book* (p. 223). It derives from a humorous passing reference to the Cock Lane Ghost singing this song, in the essay, "Poetical Invitations," but can scarcely be called an "illustration." Rather than a mere comic ghost, this cut depicts a curious creature, for the most part a thing of thin, horizontal and vertical lines, a wraith of pen-scratches; but the head contains enough curved lines, which are vaguely sensuous, to suggest something real in the terrible "invitation." This ghost does not threaten death or destruction, but some fate more terrible, through the contrast of the sensuous curves of the head and the ambiguous longings of the great, saucer-shaped eyes, with the insubstantial body.

A similarly strange kind of invitation is offered in the etching, "Jack-o'-Lantern," in the *Omnibus* (p. 265), one of Cruikshank's best experiments with light and shadow, and which again bears only a tenuous relation to the text. More often, the large etchings in these two periodicals—where they are not simply realistic illustrations—tend to be marvelously executed but over-controlled satires, such as "Mr. John Bull in a Quandary" (*Table Book*, p. 237, one of several dealing with the railway panic), in which the demons at John Bull's head are scary, but where symmetry and order are paramount, and the grotesque is largely neutralized by technique. I shall not attempt to explain what seems to me the gradual decline in grotesque power over the remaining decades of Cruikshank's life, for his power of invention and technique rarely flag, and I may well be erecting a personal prejudice as a standard in speaking of any decline at all. In any case, it is certain that the artist's temperance fervor can in no direct way be used to explain the value of his later work. It is true that moral righteousness could cloud his vision: in *Temperance Placard No. 1: A Thing! That Drinks and Smokes. A Man! Who Thinks and Acts* (Cohn 2028, 1853), the supposed "Man" is a

pathetic stereotype of middle-class ideals of virtue, while the "Thing," degraded though he is, is recognizable as an individual. Yet the same moralizing impulses could lead to artistic triumphs which suggest a still growing and developing artist.

The Drunkard's Children (Cohn 195, 1848) is usually cited as an unhappy attempt to repeat the success of *The Bottle* (Cohn 194, 1847), yet at least one plate from the sequel is something rare and new. The final plate (Figure 28), which shows the suicide of the girl, takes the standard Cruikshankian stereotype of young womanhood and transforms it: the body of the girl, falling from the bridge, is not realistic, it is balletic, and takes on an almost abstract quality when considered together with the endless bridge-works. This glyphograph embodies at once a vision of the helplessness of a human being before the impersonal forces of society —a vision expanded by Dickens and Phiz in *Bleak House*—as well as a deeper fantasy of the confused relations in the unconscious of sex and death. Degraded in her life, the girl takes on a kind of perfection of bodily form in death. And the whole painful subject is held in precarious balance by the fineness of the technique (despite the relative crudeness of glyphography as a method of graphic reproduction), the movement of the composition towards the abstract.

A different sort of achievement characterizes the much maligned temperance fairy tales of a few years later, particularly *Jack and the Beanstalk* (Cohn 197, 1854). Here, the child's technique of certain earlier etchings is replaced by the child's *vision* in a quite literal sense. The effectiveness of the etchings of the giant derives from the way the artist has been able to present him from the child's angle of vision. We are suddenly recalled to our earliest imaginings of giants and monsters, not through any elaborate rendering of devouring demons, but by means of a masterly use of perspective and distorted proportions, especially in the last plate, "Jack brings the Giant prisoner to King Alfred," and in the looming cliffs in others. And in *Puss in Boots* (Cohn 199), despite the temperance moralizing, and the charm of Puss, the old fire is still there, in the (literally) Cruikshankian eyes of the lion. Moral passion is not necessarily a less fruitful source of artistic energy than are the more mundane forms of passion, and Cruikshank's art did not suddenly weaken when he became a teetotaler.

210

IV

What I have attempted here is as much the outline of a method for dealing with the grotesque in Cruikshank, as a direct study of the artist. If there is any validity in the notion that our deepest responses to art are governed by the way art simultaneously arouses and manages or defends against anxiety,[19] then surely the grotesque, with its mixtures of fear and comedy, the beautiful and the ugly, should be an artistic realm usefully approached through an analysis based on such an assumption. An artist like George Cruikshank, whose methods and subjects are so various, will perhaps always ultimately elude attempts to fix him critically under any rubric. But given the difficulty of even talking about such a complex creative genius, we must find or invent languages which facilitate such discussion. And I trust that the particular variety of critical language I have developed here will, despite its limitations, have illuminated an important facet of Cruikshank's work, and helped to make further, more intensive studies possible.

[19] For a full-length exposition of this approach, see Norman N. Holland, *The Dynamics of Literary Response* (New York, 1968).

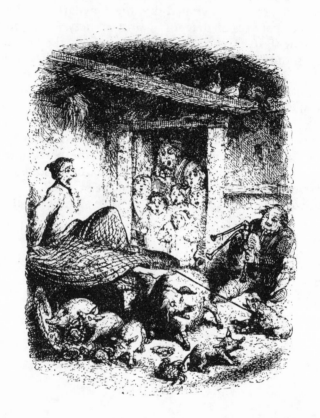

Dickens, Cruikshank, and Fairy Tales

BY HARRY STONE

I

In July 1853 Dickens was summering in Boulogne. He had come there about the middle of June, and except for a few days in London in September, he remained there until the middle of October. When he arrived in Boulogne he was badly overworked. He had been chained to *Bleak House* for a year and a half, still had four monthly parts to write, but in addition (and as usual) had simultaneously been caught up in enough activities to fill the days and nights of several ordinary men. He was, for example, deeply engaged in every aspect of Angela Burdett-Coutts's home for fallen women; he was also writing the insistent installments of *A Child's History of England*, supervising theatrical benefits, overseeing the weekly issues of his magazine, *Household Words*, and whirling through the comings and goings of his frenetic social life.

Boulogne proved to be an ideal prescription. Dickens had never summered there before, but he soon found that the situation, the town, and the routine suited him perfectly. He had rented a charming villa on a wooded hillside. The grounds included beautiful terraced gardens dense with thousands of roses and lush with myriads of other flowers. From his perch high in the hills he could see the picturesque jumble of Boulogne spreading down the slopes before him. The walk to the post office was ten minutes, to the sea, fifteen. In these surroundings Dickens quickly threw off his "hypochondriacal whisperings."[1] A day or two after arriving in Boulogne he found that he was able to return to his writing with

[1] *The Letters of Charles Dickens*, ed. Walter Dexter, 3 vols. (Nonesuch Edn., Bloomsbury, 1938), II, 463 [June 1853]. With a few exceptions which are footnoted directly, all of the quotations from Dickens' letters are taken from the above edition, or, in letters through 1841, from *The Letters of Charles Dickens*, ed. Madeline House and Graham Storey (Pilgrim Edn., Oxford, 1965, 1969). In order to eliminate unnecessary footnotes, I have usually incorporated the date of a letter into the text. In such instances, and in certain other instances (for example, when a piece is short and I have clearly indicated the source in the text), I do not give additional documentation.

"great ease"[2]; two weeks later he had finished Part XVII of *Bleak House*. By 24 July he had finished Part XVIII, and on 1 August he began work on the double number which concluded the novel.

Dickens fell gratefully into the slowed rhythm of his pastoral life, and he luxuriated in his lightened responsibilities. Day followed day in ordered measure. The end of *Bleak House* was now fast approaching. London enticements and London duties were a world away. Yet he still had much to occupy his time. His chief on-going responsibility was *Household Words*, and he contrived (insofar as *Bleak House* and distance would allow him) to maintain his usual surveillance over that periodical—settling makeup, suggesting subjects for essays, titling articles, rewriting papers, correcting proofs, writing his own contributions, and so on. He managed this long-distance feat by having his subeditor, William Henry Wills, send him early proofs of each forthcoming issue. Dickens then went over the tentative number and returned it with his advice, corrections, rearrangements, vetoes, or whatever. Wills also sent on Dickens' customary newspapers and magazines and any items that required his personal attention.

Among the periodicals that Dickens received each week was the *Examiner*, edited by his close friend and confidant, John Forster. In the *Examiner* for 23 July 1853, Forster had reviewed George Cruikshank's latest production, an edition of *Hop-o'-my-Thumb* (Cohn 196) rewritten and illustrated by the "illustrious George." *Hop-o'-my-Thumb* was to be the first pamphlet in a series of similar redactions by Cruikshank, the entire series to bear the title, *George Cruikshank's Fairy Library*. In his review of *Hop-o'-my-Thumb*, Forster lauded Cruikshank's designs, pointed out that he had interpolated social doctrines into the story, concluded that this was perhaps good, and urged readers to support the series. Dickens read Forster's review in Boulogne, and it gave him an idea for *Household Words*. "I have . . . thought," he wrote Wills on 27 July 1853, of an article "to be called Frauds upon the Fairies—*apropos* of George Cruikshank's editing." Then he went on:

> Half playfully and half seriously, I mean to protest most
> strongly against alteration—for any purpose—of the beautiful
> little stories which are so tenderly and humanly useful to

[2] Nonesuch *Letters*, II, 465 (18 June 1853).

us in these times when the world is too much with us, early
and late; and then to re-write Cinderella according to Total-
abstinence, Peace Society, and Bloomer principles, and ex-
pressly for their propagation.

I shall want his book of Hop o' My Thumb (Forster
noticed it in the last Examiner) and the most simple and
popular version of Cinderella you can get me. I shall not be
able to do it until after finishing Bleak House, but I shall
do it the more easily for having the books by me. So send
them, if convenient, in your next parcel.

Dickens' idea and the consequences that flowed from it not only
put an end to his long friendship with Cruikshank—already
seriously strained—but served to epitomize (and in part to
generate) some of his most deeply held beliefs concerning art and
life.

II

When Dickens told Wills his idea for "Frauds on the Fairies,"
he was probably only dimly aware of how deep his feelings on
the subject were. His initial response to Cruikshank's editing
seems to have been a compound of amused incredulity and linger-
ing irritation. But more was at stake. All unwittingly, Cruik-
shank had challenged some of Dickens' formative childhood ex-
periences, some of his fundamental concerns and credos. Dickens
was convinced that the literature he read as a child had been
crucial to his imagination. He was equally certain that the litera-
ture he read as a youth had prevented him from perishing. The
literature of childhood was the source of all his "early imagina-
tions"; the literature of youth "kept alive my fancy, and my hope
of something beyond that place and time."[3] At the center of the
latter period was the blacking warehouse, and Dickens literally
believed that reading, and the imagination nurtured by that
reading, allowed him—but only barely allowed him—to survive.
Dickens came to these conclusions much later as he looked back
on his early years. His books reflect this judgment and his com-

[3] "Dullborough Town," The Uncommercial Traveller, p. 160; from an auto-
biographical passage in David Copperfield, Chapter iv, p. 62. Unless otherwise
designated, all references to Dickens' writings are taken from The Works of Charles
Dickens, 40 vols. (National Edn., London, 1906-08).

mitment. His writings are rich with nostalgic allusions to the childhood literature that soothed and sustained him. By the time of the autobiographical *David Copperfield* (1849-50) he was so certain of the benign influence of that early reading, that he made his own reading experiences a central feature of young David's survival and development. About this time too he turned his own experiences into articles of faith. In a period of early desolation (so his syllogism ran), literature, especially childhood literature, had saved him; in an iron time, literature could help save others. He came increasingly to enunciate this principle. In March 1850, in the manifesto which inaugurated *Household Words*, he reaffirmed this childhood-engendered belief. In that manifesto he asserted his faith in literature as salvation. *Household Words* would "teach the hardest workers at this whirling wheel of toil, that their lot is not necessarily a moody, brutal fact, excluded from the sympathies and graces of imagination." And Dickens ended his declaration by alluding to an "old fairy story" and promising that he would "Go on!"[4]

By 1850, then, Dickens strongly and consciously associated the literature of childhood with the greatest of public ends. The literature of childhood nursed the imagination, ministered to an iron time, and softened dehumanizing toil. What Dickens most valued in that literature was its ability to nurture the imagination. Without imagination (or "fancy," as Dickens often called it) human beings could not be truly human. He therefore set his face against any attempt to make literature serve narrow, anti-imaginative ends. Here again he remembered the lessons of his childhood. For there was a deadly as well as a saving literature of childhood. The deadly literature of childhood was a dreary counterbalance to the childhood literature that had helped save him. His writings are sprinkled with disparaging references to this "other" literature, the off-putting literature of his early years. He abhorred his childhood arithmetic books with their "cool impertinent inquiries"; rejected his spelling books as productive of "weariness, languor, and distaste"; turned away from those "horrible" tracts "which commenced business with the poor child by asking him . . . why he was going to Perdition"; commiserated with students who "abandoned hope half through the Latin grammar"; and despised the kind of literature that "didactically

[4] "A Preliminary Word," *Miscellaneous Papers*, I, 107-08.

216

improved all sorts of occasions, from the consumption of a plate of cherries to the contemplation of a starlight night."[5] This stultifying childhood literature was so distasteful to Dickens that it darkened everything associated with it. Even a name could become tainted by spelling-book connotations. From childhood on, Dickens would always associate "Philip" with direful didacticism. "Philip" would forever sound "like a moral boy out of the spelling-book, who was so lazy that he fell into a pond, or so fat that he couldn't see out of his eyes, or so avaricious that he locked up his cake till the mice ate it, or so determined to go a bird's-nesting that he got himself eaten by bears who lived handy in the neighbourhood."[6] The virtuous counterpart of Philip was equally obnoxious. Dickens abhorred "Little Margery, who resided in the village cottage by the mill; severely reproved and morally squashed the miller, when she was five and he was fifty; divided her porridge with singing birds; denied herself a new nankeen bonnet, on the ground that the turnips did not wear nankeen bonnets, neither did the sheep who ate them," and so on.[7] On the other hand he surrounded the pictures in his childhood geography book with fanciful imaginings, revelled in the wit and ingenuity of *Aesop's Fables,* and associated all that was unforgettable or marvellous in *The Arabian Nights, The Tales of the Genii, Robinson Crusoe,* and similar works, with the comings and goings and responses of his everyday life. The test in all such matters was very simple. He attacked all childhood literature that was given over to dour prosing; he exalted all childhood literature that was wild or fanciful or free.

The literary quintessence of that wild freedom was the fairy tale. More and more through the 1840s and the early 1850s Dickens was coming to regard the fairy tale as a paradigm of imaginative art. The fairy tale was an emblem, at once rudimentary and pure, of what contemporary society needed and what it increasingly lacked. The fairy tale was also inextricably associated with childhood; it shaped the very character of future generations. In Dickens' lexicon the fairy tale was becoming a

[5] "A Christmas Tree," *Christmas Stories,* I, 14; "Ignorance and Crime," *Miscellaneous Papers,* I, 35; *Little Dorrit,* Book I, Chapter iii, p. 34; Nonesuch *Letters,* I, 825; "Mr. Barlow," *The Uncommercial Traveller,* p. 430.

[6] *Great Expectations,* Chapter xxii, p. 190.

[7] *Our Mutual Friend,* Book II, Chapter i, pp. 249-50.

shorthand way of emphasizing a contemporary danger and suggesting an essential solution. The lesson, Dickens felt, was clear. In an age when men were becoming machines, art—and that quintessential childhood version of art, the fairy tale—must be cherished and must be allowed to do its beneficent work of nurturing man's birthright of feeling and fancy.

So Dickens had come to believe when, in July 1853, in his rose-begirt villa high above Boulogne, he leafed through the pages of the *Examiner* and lighted upon Forster's review of Cruikshank's *Hop-o'-my-Thumb*. Given Dickens' attitude toward childhood literature, his response was predictable. The review evoked a powerful array of active and slumbering feelings. His childhood memories of fairy tales, his conviction that he had been succored by early imaginative reading, his hatred of didactic children's literature, his sense of the importance and sanctity of fairy tales—all these elements contributed to his response. But there were other factors as well. Dickens had been Cruikshank's friend and companion for almost twenty years, and the tangled history of their personal relationship added a powerful point to what Dickens soon after did.

III

Dickens and Cruikshank first met on 17 November 1835, shortly after John Macrone, Dickens' publisher, arranged to have Cruikshank illustrate the forthcoming *Sketches by Boz*, Dickens' first book. At the time Dickens was twenty-three and virtually unknown; Cruikshank was forty-three and the pre-eminent graphic artist of the day. In the circumstances one might have expected the younger man to defer, in artistic matters at least, to his famous illustrator. But Dickens soon made clear that his view of their relationship—a view later duplicated in all his subsequent dealings with illustrators—was that Cruikshank should illustrate what he had written. In the case of *Sketches by Boz* First Series (Cohn 232, 1836), virtually everything that Cruikshank was to illustrate had already been published before Cruikshank set to work—so precluding any possibility of interference—but in later works that was not the case, and Dickens, as we shall see, had to establish his ascendancy. Yet even though Cruikshank had to follow rather than lead, he had considerable freedom. Within limits he could

choose which of Dickens' sketches and which episodes within those sketches he would illustrate. More important, he could render Dickens' scenes (so long as he did not subvert what Dickens had written) through his own vision of their reality. This allowed him to be creative in his own right, and since Dickens' vignettes were congenial to Cruikshank's imagination, his illustrations for *Sketches by Boz* are among his best. As a consequence Cruikshank was chosen to illustrate *Sketches by Boz* Second Series (Cohn 233, 1836), and to provide additional etchings for the first one-volume collected edition of *Sketches by Boz* (Cohn 234, 1839). Cruikshank also illustrated or contributed to five minor works written, edited, or otherwise touched by Dickens: "Public Life of Mr. Tulrumble" (in *Bentley's Miscellany* [Cohn 69], 1837), *Memoirs of Joseph Grimaldi* (Cohn 237, 1838), "Full Report of the Second Meeting of the Mudfog Association" (in *Bentley's Miscellany*, 1838), *The Loving Ballad of Lord Bateman* (Cohn 243, 1839), and *The Pic Nic Papers* (Cohn 236, 1841). There was one other joint effort, and this the best known. In terms of wide circulation and of capturing the public consciousness, the great success in the Dickens-Cruikshank canon was *Oliver Twist* (1837-39 in *Bentley's Miscellany*, 1838 [Cohn 239] as a book). Yet this list of joint works, while imposing, is misleading. If one excludes the merely minor, *Oliver Twist* was the second and last work by Dickens illustrated by Cruikshank.

The truth is, there had been intermittent friction between the rising young author and the established illustrator. In part the friction had to do with haste and pressure—late copy, delayed plates, clashing schedules, and the like; in part it had to do with differences over the suitability of subjects for illustration. But these were difficulties more or less common to such collaborations; they were irritants rather than confrontations.

Yet a true and decisive confrontation had occurred early in their relationship. In October 1836, Macrone was busy with plans to publish the Second Series of *Sketches by Boz*. He had arranged for Cruikshank to illustrate this series as well, but there had been a delay with the text, and when Macrone was ready to move forward again, Cruikshank was busy with another work, thus necessitating another delay, this time until Cruikshank was free. After explaining his predicament to Macrone in a letter, Cruikshank added a few remarks: "I did expect to see that Ms. [of

219

Sketches by Boz Second Series] from time to time in order that I might have the privilege of suggesting any little alteration to suit the Pencil but if you are printing the book all that sort of thing is out of the question. Only this much I must say that unless I can get good subjects to work upon, I will not work at all."[8] Cruikshank's comment, though tactlessly phrased, was really a plea for a most limited privilege of occasional suggestion—a privilege which other authors sometimes allowed him. But Dickens viewed the matter in a different light. When he saw Cruikshank's note, he exploded scornfully (?19 October 1836):

> I have long believed Cruikshank to be mad; and his letter therefore, surprises me, not a jot. If you have any further communication with him, you will greatly oblige me by say-ing *from me* that I am very much amused at the notion of his altering my Manuscript, and that had it fallen into his hands, I should have preserved his emendations as "curiosities of Literature". Most decidedly am I of opinion that he may just go to the Devil; and so far as I have any interest in the book, I positively object to his touching it.

Dickens' fury was so great that he went on (quite unreasonably) to question whether the Second Series required any illustrations at all. Then he suggested that if the book did need illustration, Hablot Knight Browne ("Phiz"), who was currently illustrating *The Pickwick Papers*, should be the artist. Dickens eventually calmed down, but he sought thereafter (when not thwarted by heavy work loads and inflexible deadlines) to supply Cruikshank with completed copy, or better still, with proofs.[9] By such means he could forestall Cruikshank's penchant for proffering unwanted advice.

Dickens' reactions are revealing. They demonstrate that from the very beginning he regarded his conceptions and his writings as inviolate; that he would accept no unsolicited suggestions and tolerate no interference. The episode is a comment on Cruik-shank's claim, a claim he advanced publicly only after Dickens' death, that he was responsible for much of *Sketches by Boz*

8 Pilgrim *Letters,* I, 183, *fn.* 1 (11 October 1836).
9 Blanchard Jerrold, *The Life of George Cruikshank* (new edn., London, 1898), p. 175.

Second Series, and that he originated most of the characters and much of the action in *Oliver Twist*. Though Cruikshank was mistaken in this belief, he did sometimes contribute more than illustrations to a work in progress. He liked to regard himself as a creative partner in such a work, and he often plied his co-worker with suggestions and advice. Some authors (such as William Harrison Ainsworth) were glad to have such help and even to follow occasionally where Cruikshank led. But Dickens had a much different conception of the relationship between author and illustrator. He thought an illustrator should graphically render what the author had written. Thwarted by Dickens' intractability on this score, Cruikshank gradually transformed his chagrin—a compound of frustrated desire, baffled will, and unappreciated advice—into a dream of actual achievement. In constructing this fantasy, Cruikshank was simply indulging a lifelong tendency to enlarge and exaggerate his accomplishments, a tendency that sometimes caused him to confuse aspiration with achievement, suggestion with fulfillment, and contribution with sole authorship.

Cruikshank's distortions and delusions belong to a later date, and we shall return to them; but while *Oliver Twist* was being written and illustrated there were other confrontations. In each instance Dickens was dissatisfied with Cruikshank's performance; in each instance Cruikshank bowed to Dickens' criticism. Dickens insisted, for example, that there were good subjects in the later chapters of *Oliver Twist*, and Cruikshank, rereading the chapters, found subjects he had earlier passed by.[10] But this contretemps was only a prelude to what was to follow. Cruikshank was very late with the illustrations for the third volume of *Oliver Twist*. When the volume finally emerged from the press, Dickens was out of town. Consequently he saw a majority of the third-volume plates only upon his return (8 November 1838), and what he saw dismayed him. He immediately had Forster write to the publisher, Richard Bentley, asking that two of the plates ("Sikes attempting to destroy his dog" and "Rose Maylie and Oliver") be omitted from the volume. After making this demand, Forster went on: "I have had some difficulty in prevailing with Mr Dickens to restrict the omissions to these two, which, as they stand now, are a vile and disgusting interpolation on the sense and

10 See, for example, Pilgrim *Letters*, I, 426 (? August 1838).

bearing of the tale, while the evil effects of the others, bad as they are, will chiefly attach to Mr Cruickshank [*sic*] himself."[11]

The next day, Dickens, having recovered his composure, scaled down his demands, and wrote directly to Cruikshank:

I returned suddenly to town yesterday afternoon to look at the latter pages of Oliver Twist before it was delivered to the booksellers, when I saw the majority of the plates in the last volume for the first time.

With reference to the last one—Rose Maylie and Oliver. Without entering into the question of great haste or any other cause which may have led to its being what it is—I am quite sure there can be little difference of opinion between us with respect to the result—May I ask you whether you will object to designing this plate afresh and doing so *at once* in order that as few impressions as possible of the present one may go forth?

Cruikshank tried to save the plate (now known as the "Fireside" plate) by improving it, but Dickens apparently found the improvement unacceptable,[12] and Cruikshank finally replaced it with the equally insipid "Church" plate, the latter then becoming a part of all subsequent impressions and editions.

To all intents and purposes the professional relationship of Dickens and Cruikshank ended late in 1838 with the Fireside-plate fiasco. Yet Cruikshank's illustrations for *Oliver Twist* had been uneven rather than poor. The nullity of the Fireside plate and the stilted woodenness of several other illustrations (mainly those depiciting the "virtuous" characters) were more than balanced by the unforgettable plates of Bumbledom and of the underworld, the latter series being climaxed by the powerfully expressionistic "Fagin in the condemned Cell." Dissatisfaction, however, seems to have triumphed over satisfaction; dissatisfaction, at any rate, was premonitory. In the next few years Dickens and Cruikshank worked together briefly once or twice, but as we have seen, these productions were perfunctory and unimportant.

There seems, however, to have been an informal understand-

11 Pilgrim *Letters,* I, 451.
12 Frederic G. Kitton, *Dickens and His Illustrators* (London, 1899), p. 17.

222

ing that Cruikshank would illustrate the novel which eventually became *Barnaby Rudge* (1841).[13] This understanding probably went back to the days when Bentley owned the copyright of the projected *Barnaby Rudge*, and when *Bentley's Miscellany* was a possible destination for the novel. During this period Cruikshank was working steadily for Bentley and was doing virtually all the illustrations for *Bentley's Miscellany*. But whether Dickens' disappointment with Cruikshank's illustrations for *Oliver Twist*, or Dickens' irritation at Cruikshank's meddlesome suggestions, or Dickens' break with Bentley, or Dickens' decision to publish *Barnaby Rudge* in *Master Humphrey's Clock* (the latter periodical in midstream and already illustrated by George Cattermole and Hablot Browne), whether any or all of these considerations or some other reasons caused him to turn away from Cruikshank, the fact remains that Cruikshank had no part in *Barnaby Rudge* or any subsequent Dickensian work. During the *Barnaby* period Dickens did speak vaguely of collaborating with Cruikshank— possibly as recompense for the *Barnaby* disappointment—but these nebulous gestures never amounted to anything.[14] After an interval they ceased, and eventually they were buried in unbroken silence.

IV

Strangely, during all these vicissitudes, Dickens' friendship with Cruikshank waxed. When the two men met in 1835, they were immediately attracted to one another, and this attraction grew despite some early impediments. It overcame their twenty-year disparity in age, survived their differences concerning *Sketches by Boz* and *Oliver Twist*, and triumphed over their divergent personalities. Cruikshank was gradually captivated by the geniality and high spirits of the young author, who soon proved to have a steadiness and acumen equal to his energy and genius. Dickens, on the other hand, was delighted with Cruikshank's warmhearted zeal, and with his eccentricity and whimsicality as well. Though middle-aged and often crotchety, Cruikshank had preserved a childlike openness and vitality that appealed to Dickens. As

13 Pilgrim *Letters*, I, 589 [?3 October 1839].
14 See, for example, Pilgrim *Letters*, II, 213 (17 February 1841).

their friendship grew, the traditional roles of youth and age seemed to be reversed, Dickens acting the prudent mentor to Cruikshank's wayward exuberance.

The friendship flourished through the late 1830s and early 1840s. Beginning with notes and calls, it progressed to visits and dinners, and culminated with parties, excursions, amateur theatricals, and nights on the town. Paradoxically—or perhaps significantly—the friendship seems to have been closest and the meetings most frequent at the very time in 1842 and 1843 when the two had ceased to work together professionally. If there had been any lingering asperities, they seem to have vanished by then. Dickens regarded Cruikshank as a delightful fellow, someone who could liven a dull party or transfigure a listless evening. Cruikshank, for his part, came to Dickens for advice and aid and comfort, as well as for companionship.

Cruikshank often needed the advice, and he needed the aid as well. He loved the convivial, carousing life, but he drank too much. For years he had had a reputation as a bohemian and bon vivant. In 1833, in the famous series of caricatures which appeared in *Fraser's Magazine*, Maclise had portrayed Cruikshank seated on a barrel in a pothouse, a pipe and tankard by his side. This graphic image was amplified by numerous incidents. On one occasion in the 1840s, Dickens had to wander about London with Cruikshank for the better part of a day because Cruikshank, who had been out on the town all night, and had appeared on Dickens' doorstep early in the morning "smelling of tobacco, beer, and sawdust," could not be prevailed upon to go home and face his wife.[15] On another occasion, an evening in 1846, after drinking at the home of W. H. Wills, Cruikshank went into the streets with two companions. The companions tried for more than an hour to lead him home, but finally gave up and left him climbing a lamppost.[16] On yet another evening, Dickens himself (after a fashion) was the cause of a notable escapade. On 9 July 1842, a group of Dickens' good friends gave a dinner in Greenwich to celebrate Dickens' return from the United States. Cruikshank was one of the company and acquitted himself memorably. In a letter written three weeks later (31 July 1842), Dickens described the incident. "Cruikshank," he wrote, "was perfectly wild at the

15 B. Jerrold, pp. 221-22. 16 B. Jerrold, pp. 222-23.

reunion, and, after singing all manner of marine songs, wound up the entertainment by coming home (six miles) in a little open phaeton of mine, *on his head,* to the mingled delight and indignation of the metropolitan police." In an earlier letter, written only two days after the episode, Dickens recorded some other details. "George Cruikshank came home in my phaeton, on his head— to the great delight of the loose midnight Loungers in Regent Street. He was last seen, taking Gin with a Waterman."

But Cruikshank's alcoholic camaraderie and his wild escapades hid a troubled conscience. He was disturbed by his drinking. He began to fear that it would lead to his ruin and death. His father had been a heavy drinker. As a boy, Cruikshank had sometimes come downstairs in the morning to find his father's drinking companions lying on the floor rolled up in carpets. Indeed his father had reputedly died as the result of a drinking bet. The bet was to see whether he or a friend could drink more tumblers of whiskey. His father had won, but had fallen ill and died.[17] With such terrifying lessons lurking in his consciousness, Cruikshank ultimately turned away from drink. By 1847 he had committed himself to the temperance movement and had decided to use his etching needle in its behalf. In August of that year he produced *The Bottle* (Cohn 194), a direful drunkard's progress in eight plates. He immediately took the plates to William Cash, chairman of the National Temperance Society, who admired them but then asked Cruikshank how he himself could drink with the lesson of his own graphic homily before him. Cruikshank, who had apparently not considered the matter in that light, was staggered by the question. A little while afterwards, he became a total abstainer.

The Bottle was enormously popular. Cruikshank followed it the next year with an equally popular and equally direful sequel entitled *The Drunkard's Children* (Cohn 195). His conversion gave a new impetus to his life. He became totally committed to eradicating drinking from the face of the earth. In private homes and at public banquets, in etchings, pamphlets, letters, speeches, testimonials, and exhortations, he tirelessly preached the fatal consequences of drink. His extremism and his single-mindedness often offended those about him and lost him many friends. He objected not merely to drunkenness but to any drinking whatso-

[17] B. Jerrold, pp. 239-40.

ever. Douglas Jerrold, mildly mocking Cruikshank's obsession, once told him, "Yes, George, I know, water is a *very* good thing— *except on the brain!*"[18] At a private party, if wine were served, Cruikshank might go up to his host and loudly call him a dangerous man; at a public banquet, if a loving cup were passed, he might "go through an extraordinary pantomime before all the company, expressive of his horror of strong drinks. . . . shake his hand angrily at the Lord Mayor, and raise his arms with horror while his neighbour quaffed of the cup."[19]

On one occasion at least, Dickens himself was a protagonist in such a scene. He had given a party in his home, and amongst others, had invited Cruikshank and Mrs. E. M. Ward. At one point in the evening, when Mrs. Ward was about to sip a glass of wine, Cruikshank had come up to her, snatched the glass from her hand, and prepared to dash it to the floor. Dickens was furious. "How dare you touch Mrs. Ward's glass?" he cried. "It is an unpardonable liberty. What do you mean? Because someone you know was a drunkard for forty years, it is not for you to object to an innocent glass of sherry." Cruikshank was so taken aback he was unable to reply. Dickens' allusion to "someone you know" was perhaps an allusion to Cruikshank himself. Cruikshank disappeared for the rest of the evening.[20]

Most persons disapproved of Cruikshank's behavior, but some friends shrugged such incidents off, pointing to Cruikshank's eccentricity and utter sincerity. Cruikshank himself gloried in his display. He lectured friends and acquaintances, appeared tirelessly at temperance rallies, and drew a whole series of graphic testimonials to his belief. He created pledge certificates for the Band of Hope and the Temperance Society, signing them "Designed and etched by George Cruikshank, total abstainer from all intoxicating liquors and tobacco." For a year and a half he labored on a huge oil painting, *The Triumph of Bacchus.* He was certain that it was his masterpiece and that by exhibiting it and selling etchings of it, he would not only further the cause of teetotalism but achieve lasting fame and fortune. But when the

18 Walter Jerrold, *Douglas Jerrold: Dramatist and Wit*, 2 vols. (London, 1914), II, 630.

19 B. Jerrold, p. 257.

20 Mrs. E. M. Ward, *Memories of Ninety Years* (2nd edn., ed. Isabel G. McAllister, New York, n.d.), pp. 85-86.

painting was exhibited in 1863, the public ignored it, and when the etching was issued later, it too proved a disappointment.

The truth was that Cruikshank's popularity had begun to wane seriously by the early 1850s. He strove valiantly to reverse this downward trend. He was full of schemes and projects and enterprises, but nothing seemed to work. He had become a casualty of change and time. The increasing datedness of his style, the flagging in his powers, the siphoning of his energies into teetotal schemes, the narrowing in his interests and sympathies—all these, as well as more personal considerations, and perhaps more imperceptible factors, played a part in his eclipse. But whatever the causes, the consequences of his decline were all too real, and they embittered the last twenty years and more of his life.

V

Cruikshank and Dickens began to drift apart shortly after the middle 1840s. Dickens always seems to have regarded Cruikshank as an "original" to be observed and enjoyed as well as cherished. In the early and mid-1840s, Dickens delighted in Cruikshank and felt true affection for him, but even in those days a slightly patronizing tone occasionally crept into some of his comments about the older man. Dickens drove Cruikshank to William Hone's funeral, and later (2 March 1843) described the journey to a friend:

It was such a day as I hope, for the credit of nature, is seldom seen in any parts but these—muddy, foggy, wet, dark, cold, and unutterably wretched in every possible respect. Now, Cruikshank has enormous whiskers, which straggle all down his throat in such weather, and stick out in front of him, like a partially unravelled bird's-nest; so that he looks queer enough at the best, but when he is very wet, and in a state between jollity (he is always very jolly with me) and the deepest gravity (going to a funeral, you know), it is utterly impossible to resist him; especially as he makes the strangest remarks the mind of man can conceive, without any intention of being funny, but rather meaning to be philosophical. I really cried with an irresistible sense of his comicality all the way; but when he was dressed out in a black cloak and a very

227

long black hatband by an undertaker (who, as he whispered me with tears in his eyes—for he had known Hone many years —was a "character, and he would like to sketch him"), I thought I should have been obliged to go away.

A few years later (17 September 1845) Dickens gave a more direct assessment of Cruikshank, but his attitude and tone were virtually identical. "Cruikshank," Dickens wrote, "is one of the best creatures in the world in his own odd way," and then he added, "he is a live caricature himself."

Despite such judgments, and despite great disparities in attitude and temperament, the friendship between the two men seemed firm. It had survived professional disagreements and professional disappointments, but it was not to survive Cruikshank's total commitment to total abstinence. The friction over temperance matters began very early. Though the record of that friction is incomplete, by February 1848, Dickens was writing very bluntly to Cruikshank concerning his temperance activities. "I think," he wrote, "the Temperance Societies (always remarkable for their indiscretion) are doing a very indiscreet thing in reference to you—and that they will keep many of your friends away from your side, when they would most desire to stand there." But Dickens' disagreement with Cruikshank on temperance matters went beyond such considerations as the tactics of organizations, beyond even the mode of combatting the agreed upon evils of drunkenness: his disagreement with Cruikshank pivoted upon differing analyses of the causes and significances of drunkenness. For Cruikshank drunkenness was a primal evil from which other evils flowed; for Dickens it was a symptom of deeper and graver problems. Cruikshank (so Dickens thought) was obsessed by symptoms and wanted all the world—not just the intemperate— to adopt extreme remedies; Dickens was concerned with causes, felt *they* should be attacked, and felt further that it was an invasion of the rights of the temperate multitudes to punish them for the excesses of the intemperate few. Dickens had set forth his fundamental objections to Cruikshank's position after buying and studying Cruikshank's *The Bottle* (Figures 24, 25, and 26). Dickens had purchased the eight-plate exemplum on publication, and a day or so later (2 September 1847), he wrote Forster

228

an analysis of his response to Cruikshank's message. Dickens thought the scenes very powerful, and the last two plates, despite a few objections, "most admirable." No one living, he thought, could have done them so well. There were touches in the scenes "as good as Hogarth"—from Dickens, the highest possible praise. But the thought behind the art was defective. "The philosophy of the thing, as a great lesson, I think all wrong; because to be striking, and original too, the drinking should have begun in sorrow, or poverty, or ignorance—the three things in which, in its awful aspect, it *does* begin. The design would then have been a double-handed sword—but too 'radical' for good old George, I suppose."

By "double-handed sword" Dickens meant that then Cruikshank's art would have struck at the heart of poverty, ignorance, and the ultimate *causes* of drink, not simply at drink itself. But Cruikshank was moving in a different direction. For him teetotalism was rapidly becoming a way of life. When, in July 1848, Cruikshank issued an eight-plate sequel to *The Bottle* entitled *The Drunkard's Children* (Figures 27 and 28), Dickens decided to speak out. On 8 July 1848, he reviewed the new series in the *Examiner*, using the occasion to discuss both works.[21] Though again praising Cruikshank's "peculiar and remarkable power," his ability to create scenes and images that haunt "the remembrance, like an awful reality," he denied Cruikshank's social analysis. Drunkenness does not begin, as Cruikshank portrayed it as beginning in *The Bottle*, with an idle and motiveless drink. "It has a teeming and reproachful history anterior to that stage; and at the remediable evil in that history, it is the duty of the moralist, if he strikes at all, to strike deep and spare not." "Hogarth," Dickens continued, "avoided the Drunkard's Progress, we conceive, precisely because the causes of drunkenness among the poor were so numerous and widely spread, and lurked so sorrowfully deep and far down in all human misery, neglect, and despair, that even *his* pencil could not bring them fairly and justly into the light." Yet Hogarth's art was infinitely deeper than Cruikshank's. Hogarth was not content to portray results. His art depicted the inception of evil, and his art was profoundly symbolic. Objects, persons,

[21] "Cruikshank's 'The Drunkard's Children,'" *Miscellaneous Papers*, I, 39-43.

229

actions—all the details of his works—commented on the causes of the social disorder they also objectified. Cruikshank, on the other hand, neglected these considerations, and as a result his work was compromised and weakened.

Like all pieces appearing in the *Examiner*, Dickens' review was unsigned. But Cruikshank, who was close to the *Examiner* circle, must have known that Dickens had written the critique, and he must have been deeply disturbed by the sweeping nature of the criticism and by the fact that it had come from a friend. In any case, the encounter was symptomatic rather than casual; the friendship was under stress. For Dickens, Cruikshank's undoubted genius was increasingly hobbled by tiresome crankiness. For Cruikshank, Dickens' stiff-necked disbelief was inexorably turning into assertive opposition. But the clash was still largely subterranean. The two men still saw one another on occasion, and still made common cause. As late as 1848, Dickens asked Cruikshank to join his company of "strolling players," but their relationship was not what it once had been. By 1851 the old friends had drifted apart. In April 1851, Cruikshank wrote to Dickens lamenting their altered friendship. Dickens' reply (25 April 1851) mixed confession with denial:

> I assure you that I have never felt the slightest coolness towards you, or regarded you with any other than my old unvarying feeling of affectionate friendship. A host of those small circumstances that sometimes seem to fly together in busy lives, by a strange attraction, have interposed between us and prevented our meeting; but I have never had in my heart the slightest unkindness or alienation. If I could find it there, I should be grieved by your letter, besides being touched (as I unaffectedly am) by its tenderness. But it is not there, and it has never been there.

> · · · · · ·

> I shall come to see you very soon, when I hope with one shake of the hand to dispel any lingering remainder, if any there be, of your distrust. I am quite willing to admit that I have seemed to justify it (though I don't know how) and that I am to blame (though I have never consciously erred in this regard), but pray believe that I write in the utmost sincerity and without a grain of reservation.

But the friendship was not to be salvaged by the shake of a hand. Private constraint was about to become public confrontation. At the time Dickens and Cruikshank were exchanging letters, the temperance movement was surging ahead. The movement had achieved its primary successes in the provinces, but now it was preparing to conquer the capital. When the Great Exhibition opened on 1 May 1851, the public found that alcohol had been banned from all the refreshment rooms. During the first week in August, a series of giant temperance rallies were staged in London. The demonstrations included a mass procession to the Crystal Palace, and a grand fête in Regent's Park. The latter event, which drew a crowd of 25,000, took place just a few blocks from Dickens' residence in Devonshire Terrace. The profits from these rallies were used to found the London Temperance League, with Cruikshank as one of the two vice-presidents.[22] Dickens' response to the demonstrations and the agitation was an angry article in *Household Words*. On 23 August 1851, he published the piece, entitled "Whole Hogs," as the lead paper in his magazine.

"Whole Hogs" attacked the fanaticism of the temperance, peace, and vegetarian movements, giving most attention and heaping most scorn on the temperance advocates, and referring to their recent rallies and fêtes. Pointing out that most temperance enthusiasts were intemperate both in their proposals (which were for teetotalism rather than for temperance) and in their language, he dubbed such advocates "Whole Hog" fanatics— fanatics who insist that everyone act precisely and totally as they do, that no one deviate in the slightest degree from their prescribed faith. As Dickens put it figuratively in his article, such persons were not content to receive their own proper share of the hog and consume it in their own fashion, they insisted that everyone immoderately accede to their monomania and consume the Whole Hog, "sides, ribs, limbs, cheeks, face, trotters, snout, ears," and "tail," and "sinking none of the offal, but consenting to it all." Dickens went on to satirize temperance officials, temperance meetings, temperance demonstrations, and temperance pledges— especially those teetotal pledges extracted from children, who thereupon became members of "Juvenile Temperance Bands of Hope," the "Infantine Brigade of Regenerators of Mankind."

22 Norman Longmate. *The Waterdrinkers: A History of Temperance* (London, 1968), pp. 134-35.

Dickens concluded his attack with a final flourish of his dominant metaphor. "The Whole Hog of the Temperance Movement, divested of its intemperate assumption of infallibility and of its intemperate determination to run grunting at the legs of the general population of this empire, would be a far less unclean and a far more serviceable creature than at present."

Dickens' attack was consonant with his lifelong attitude. But the acerbity of his attack was new. His ancient aversion for teetotal bullying and teetotal strategy had been inflamed by the increasing agitation and stridency of the temperance movement. Added to this enlarged antipathy was his growing sense of a gathering danger: the movement (in Dickens' view) was distracting attention from the more fundamental problems of society. As early as 1835 in "Gin-Shops" (an essay later collected in *Sketches by Boz* and illustrated by Cruikshank), Dickens had insisted that "gin-drinking is a great vice in England, but poverty is a greater." "If Temperance Societies," he continued, "could suggest an antidote against hunger and distress, or establish dispensaries for the gratuitous distribution of bottles of Lethe-water, gin-palaces would be numbered among the things that were."[23] Through the years Dickens often reiterated this point. It had been the burden of his private complaint about Cruikshank's *The Bottle* and his public complaint about Cruikshank's *The Bottle* and *The Drunkard's Children*. But the error was not confined to Cruikshank or to those who inveighed against the evils of drink. All his life Dickens concentrated on what he conceived to be the real and remedial causes of social pathology—ignorance, poverty, neglect, and despair. Those were the true enemies of mankind. Against those enemies, and against those movements which drew attention away from such problems, he would not stay his pen.

VI

By July 1853, then, Dickens' personal relationship with Cruikshank had partly cooled and partly lapsed. From jovial parties and warm confidences, the friendship had dwindled into divergent interests and antagonistic criticisms. The professional relationship had long been severed, and though each man undoubtedly

[23] Quoted from the first edition—modified slightly in later editions.

respected the other's genius, when each thought of his past working relationship with the other, he must have thought also of friction, frustration, and dissatisfaction. Yet there had been no open break, and in July 1853 each man regarded the other as a friend, albeit an eccentric or an unregenerate friend, as the case might be.

Thus matters stood when Dickens, amidst the roses and the vistas of Boulogne, came upon Forster's review of Cruikshank's *Hop-o'-my-Thumb*. What Dickens brought to that reading on the personal level was a conflicting tangle of emotions and opinions. He mingled positive interest in Cruikshank and admiration for his art with skepticism concerning his views and irritation at his tactics. Yet when he read Forster's review his primary reaction was shaped not by years of Cruikshankian amiabilities and Cruikshankian crotchets—though these played their part—but by larger considerations. His reaction was dominated by his profound conviction (at the moment perhaps an intuition rather than a reasoned argument) that Cruikshank was tampering with the sources of imagination and creativity.

This is corroborated not simply by what Dickens later wrote, but by the disparity between Forster's review and Dickens' immediate response. Forster's review was full of praise and acceptance. He hailed Cruikshank's entrance into fairy land. No artist living, he thought, was better equipped by temperament and skill to be "court painter to Oberon." He then went on to describe the illustrations in *Hop-o'-my-Thumb*. His enthusiasm was boundless. Words such as "delight," "charming," "exquisite," and "genius," sprinkle the page. The illustrations, he asserted, were amongst the best that Cruikshank had ever drawn. He went even further: "more perfectly illustrated such tales never have been, and never again are likely to be." He continued by pointing out that Cruikshank occasionally introduced his own moral precepts into the tale, but this, Forster felt, was no fault. Quite the contrary. Such editing "can . . . do no harm—for such morals are not here obtruded in any dull way—and in the opinion of many it may be very likely to do good."

Dickens took a far different tack. What caught his attention were the intruded morals, their incongruity and their subversiveness. Then and there he determined to protest "half playfully and

half seriously" against Cruikshank's editing, and then and there he wrote, in the letter already quoted, for a copy of Cruikshank's *Hop-o'-my-Thumb* and for an ordinary version of *Cinderella*, so that he could prepare himself for his reply and write it as soon as *Bleak House* was completed. When Cruikshank's little booklet did arrive, it confirmed and intensified Dickens' fears and angers.

As chance would have it, even Cruikshank's cover (all unwittingly on Cruikshank's part, of course) touched sensitive areas of Dickens' inner life. The cover (Figure 41) portrayed a fearsome ogre watching over two scenes of parental abandonment. These scenes, captioned respectively, "The Father proposes to lose the Children!!!" and "They Leave Hop 'o my Thumb and his Brothers in the Wood," depicted parents in the very act of plotting against and betraying their innocent children. Such a cover was calculated to arouse Dickens' profound sympathies and fears. His feeling that his own parents had rejected and abandoned him was perhaps the most shaping emotion in his life. His works are filled with unnatural parents, tender references to *The Children in the Wood* (another fable of parental abandonment), and terrifying evocations of being lost and parentless in roaring streets. But more than this, the figure of the neglected or orphaned or outcast child—another projection of his profound sense of childhood abandonment—recurs with obsessive power in his writings.

Cruikshank's cover was thus a call to Dickens' deepest feelings about the sanctity and violation of childhood, and the fairy tale Cruikshank was about to recount (and indeed all fairy tales) had long since become symbols to Dickens of that sanctity and that threat. More than this, all fairy tales stood quintessentially for the saving grace of childhood imagination and childhood escape, and in a larger perspective, for the saving power of all imagination and art, a power that Dickens held to be sacred and inviolate. Cruikshank's text prostituted that power; Cruikshank (so it seemed to Dickens) manipulated the vulnerabilities of childhood and the privileges of art for narrow and fanatical ends. Cruikshank's marvelous illustrations captured the fears and fantasies and fulfillments of childhood. But the more wonderful the art, the greater the violation in making it serve purposes subversive of art itself.

In *Hop-o'-my-Thumb*, Cruikshank's art was a means of

234

promulgating his text; for Dickens, that text was profoundly subversive.[24] First of all, Cruikshank played fast and loose with the fable itself. He eliminated the central episode of how Hop saved himself and his brothers by tricking the ogre into murdering his own daughters (an episode that had powerfully and fearfully impressed Dickens as a child), imported into *Hop* the "Fe Fi Fo Fum" of *Jack the Giant Killer* (another episode that had fearfully gripped Dickens' imagination), and tampered with a multitude of lesser matters. Alone, these changes would have evoked Dickens' dismay rather than his anger. But Cruikshank had also sprinkled the story with the most prosing moral precepts and examples, the kinds of intruded morals that Dickens had hated as a boy and inveighed against all his life. Nor had Cruikshank limited his advocacy to rules of conduct; he had dragged in pronouncements on religious instruction, popular education, and free trade. It was just the kind of pervasive didacticism that Dickens had always regarded as dreary and deadening, the antithesis of fancy and imagination. Cruikshank was constantly intruding remarks about "nasty tobacco," "betting and gambling," the virtue of "perseverance," and the need "to admit foreign grain" into domestic markets. Cruikshank was remorseless. Hop and his brothers learned to wash themselves "in cold water (which they did winter and summer, because it is most refreshing and healthy to do so)"; to forego "much eating at supper"; and to avoid picking their teeth with a fork. They had also been taught by their "dear mother" to "go to bed early, which they all did, like good children, without any grumbling or crying." And every night good little Hop-o'-my-Thumb was always the first to say, "I'm ready to go to bed, mother."

From Dickens' point of view, Cruikshank's didacticism was doubly subversive. It intruded a prosing note that was totally alien to the spirit and tone of the fairy tale. But more important, it imported into the world of the fairy tale the anti-fairy tale. Enticed by Cruikshank's compelling illustrations, the child would enter the fairy-tale world only to find that it contained the same prosing precepts that nagged at him from the pages of his

[24] For the text of *Hop-o'-my-Thumb* and the other tales in the Fairy Library, I have used a collected edition which seems to have been made up by binding together the four original editions.

insufferable copybooks or his improving moral tracts. To Dickens, Cruikshank's text was a fraud. It would turn children away from the fount of fancy and imagination at the very source.

This was bad enough—in fact it was insupportable—but Cruikshank had gone further. He had infused *Hop-o'-my-Thumb* with an outragous teetotalism. The ideology ran through the entire story. Drink was responsible for the poverty of Hop's father (who had been a rich Count before he turned to drink), for the deprivation of the family, for the abandonment of the children, and for most of the other sins and lapses in the story. Even the ogre's downfall was caused by drink, for he had imbibed so much on the night he had Hop and his brothers in his power, that they were able to escape and ultimately to steal his seven-league boots. The story had a happy, teetotal ending. When Hop brought his father before the King, the King rewarded his old friend (for the King and Count had been old companions) by making him Prime Minister. As Prime Minister, the erstwhile drunkard discovered that "strong drinks were hurtful to all." Accordingly he passed a law to "abolish the use of all intoxicating liquors; the effect of which law was, that in a short time there were very few, if any, criminals in the land; and the only paupers, or really poor, were those sick or aged persons who were unable to do any sort of work, for all the people in the land were industrious, and the country was rich."

This, Dickens thought, was Whole Hoggism with a vengeance. The entire notion would have been ludicrous had it not been aimed at children and had it not affronted Dickens' most profound beliefs. For in addition to violating Dickens' views concerning the crucial role of literature in childhood and the saving power of fairy tales, Cruikshank was intruding false notions concerning the causes of remediable social ills. He was now (to Dickens' way of thinking) introducing to the most sensitive areas of Dickens' belief the errors that Dickens had found in *The Bottle* and in *The Drunkard's Children*. The origins of poverty and crime, the intricate gestation of neglectful or rejecting parents, the ravaging inception of ignorance, cruelty, and despair—all these and more, in the gospel of Cruikshank, were simply by-products of "strong drinks." Dickens' childhood experience and his lifelong endeavor cried out against this notion. And Dickens' commitment to fancy

236

and imagination cried out against transforming the child's bright birthright of fairy tales into prosing homilies and teetotal tracts.

VII

With such feelings and such commitments impelling him (and with perhaps an occasional memory of the old Cruikshank amiably drunk or the new Cruikshank aggressively sober adding ironic relish to his purpose), Dickens sat down in September 1853 (*Bleak House* now completed) to write "Frauds on the Fairies." He had kind words for Cruikshank the artist. Cruikshank was a "man of genius" and "our own beloved friend." He should, Dickens continued, be the last to do violence to fairy tales because in his own art he understands fairy lore "so perfectly, and illustrates it so beautifully, so humorously, so wisely." But Cruikshank's text was another matter. "We have lately observed, with pain," wrote Dickens, "the intrusion of a Whole Hog of unwieldy dimensions into the fairy flower garden." The huge beast was there, "rooting . . . among the roses." Such an intrusion was neither an inconsequential nor a narrow matter. "In an utilitarian age, of all other times, it is a matter of grave importance that Fairy tales should be respected. . . . A nation without fancy, without some romance, never did, never can, never will, hold a great place under the sun." For fairy tales are the "nurseries of fancy." To preserve their usefulness they must be transmitted undisturbed. "Whosoever alters them to suit his own opinions, whatever they are, is guilty, to our thinking, of an act of presumption, and appropriates to himself what does not belong to him."

With his bow to Cruikshank and his manifesto of opposition out of the way, Dickens went on to retell *Cinderella* according to outrageous total abstinence principles, throwing in, for good measure, an abundance of quirky Cruikshankian-type asides on all sorts of social and political issues. The parody was hilarious and devastating. At the age of four, Cinderella, by her own desire, became a member of the Juvenile Bands of Hope ("Central district, number five hundred and twenty-seven"). Five years later her mother died and Cinderella, accompanied by fifteen hundred members of the Juvenile Bands of Hope, "followed her to the grave, singing chorus Number forty-two, 'O come,' &c."

237

The grave was located and regulated auspiciously. It was "outside the town, and under the direction of the Local Board of Health, which reported at certain stated intervals to the General Board of Health, Whitehall."

After a year Cinderella's father remarried. Unfortunately he married a very cross widow lady, but fortunately he did not have to abide her tyranny long. Owing to the fact that he had been "shamefully accustomed to shave with warm water instead of cold," his constitution was undermined and he died. Little orphan Cinderella then commenced her well-known odyssey (teetotal version). She culminated her adventures in the usual way by marrying the Prince, but then undertook innovative measures. "Cinderella, being now a queen, applied herself to the government of the country on enlightened, liberal, and free principles. All the people who ate anything she did not eat, or who drank anything she did not drink, were imprisoned for life. All the newspaper offices from which any doctrine proceeded that was not her doctrine, were burnt down." And on and on with tyrannical fanaticism. Dickens concluded his essay with a Wordsworthian diagnosis and a personal prescription. "The world is too much with us, early and late," he wrote. "Leave this precious old escape from it, alone."

"Frauds on the Fairies" appeared on 1 October 1853 as the opening article in *Household Words*. When Cruikshank read the article he was filled with resentment. Cuthbert Bede, who saw him shortly afterwards, described him as "smarting from the effects of Dickens's article."[25] Those effects included more than an assault on Cruikshank's beliefs and sensibilities, they included the possibility of damaging economic loss. *Hop-o'-my-Thumb* was the first story in a projected Fairy Library which would ultimately consist of a whole series of fairy tales rewritten and illustrated by Cruikshank. If Dickens' article damaged sales, the entire project might be jeopardized. Cruikshank was also about to launch a new monthly periodical entitled *George Cruikshank's Magazine* (Cohn 185). This periodical and the Fairy Library were an attempt by Cruikshank—as it turned out his last really concerted attempt—to recapture his lost audience and his lost standing. The first issue of the new magazine appeared in January 1854, the

[25] "A Reminiscence of George Cruikshank and His 'Magazine,'" *Notes and Queries*, 5th ser., 9 (13 April 1878), 281.

second—and last—appeared the following month and contained "A Letter From Hop-O'-My-Thumb to Charles Dickens, Esq. Upon 'Frauds On The Fairies,' 'Whole Hogs,' Etc." Cruikshank's reply also contained a woodcut illustration showing Hop-o'-my-Thumb driving three enormous hogs—obviously gigantic Whole Hogs—back to *Household Words* (Figure 42).

Cruikshank's reply was rambling and discursive, at times defiant, combative, even abusive, at other times plaintive, humorous, even friendly. Cruikshank, writing in the guise of Hop-o'-my-Thumb, accused Dickens of going out of his way to find fault with him. Dickens was a man of "remarkable acuteness," but he had made a "great mistake" in allowing his "extraordinary seven-league boot imagination" to mislead him as to what the old fairy tales were. Dickens' article was "Much Ado About Nothing." For the text of a fairy tale is not fixed, and to "insist upon preserving the entire integrity of a Fairy tale" is like "shearing one of your own 'whole hogs,' where there is 'great cry and little wool.'" Cruikshank's editing was essential and salutary. He had simply removed the immoral and depraved elements from *Hop-o'-my-Thumb*. As for the temperance coloring, Dickens had an "evident contempt, and even hatred, against that cause." "I take the liberty of telling you," Cruikshank went on, "that it is a question which you evidently do not understand." Cruikshank concluded with a request and a rejection. "I have therefore to beg, that in future you will not drive your 'whole hogs' against us, but take them to some other market, or keep them to yourself if you like; but we'll none of 'em, and therefore I take this opportunity of driving them back."

Cruikshank caused his magazine reply to be printed also as a separate penny pamphlet. When, about the same time, he came to publish the next of his rewritten fairy tales, *Jack and the Bean-Stalk* (Cohn 197), he did not continue the controversy directly, though he did make the giant a depraved individual who drank himself tipsy every night and ravaged the countryside as a result. But in *Cinderella* (Cohn 198), the third installment of the Fairy Library, also published in 1854, Cruikshank alluded directly to the controversy. In a note at the end entitled "To The Public," he admonished Harriet Beecher Stowe for describing him as "an old man, with grey hair"; reproved a reviewer for criticizing his setting of *Jack and the Bean-Stalk*; and advised would-be readers

who might fall into "absurd mistakes" such as the aforesaid reviewer fell into or "such as my friend Charles Dickens has fallen into," to buy and read his penny-pamphlet reply to Dickens. (In later issues of this note, Cruikshank had his reference to Dickens reset so that "my friend Charles Dickens" became "Mr. Charles Dickens.")

As for the text of *Cinderella* itself, Cruikshank seemed bent on out-parodying Dickens' parody. When the King ordered fountains of wine in the streets to celebrate Cinderella's marriage, Cinderella's godmother "begged that his Majesty would not carry out that part of the arrangements," for "drink leads also to quarrels, brutal fights, and violent deaths." When the King replied that such violence is only committed by those who take too much, the godmother replied that "the history of the use of strong drinks . . . is marked on every page by *excess, which follows, as a matter of course, from the very nature of their composition,* and are [*sic*] always accompanied by ill-health, misery, and crime." The godmother then launched upon a page-long disquisition which praised the beneficence of the Almighty in making harmful liquors intoxicating, admonished the King that "so long as your Majesty continues to take even half a glass of wine a-day, so long will the drinking customs of society be considered respectable," and advised the King to "look at Cinderella, who has never taken any in all her life, and who never will."

Cinderella brought the Fairy Library to an abrupt halt. Whether this was the result of poor sales, hostile reactions, or Cruikshank's own decision, is not clear. What is clear is that *Puss in Boots* (Cohn 199), the fourth and last fairy tale that Cruikshank rewrote for his Fairy Library—one suspects that it was conceived like the last two in 1854—did not appear until 1864. In 1865 the four fairy tales were collected in a single volume, Cruikshank retaining most of his earlier addresses and announcements and reprinting a further justification of his editorial practices. The latter defense, originally published with *Puss in Boots* in 1864 and entitled, "To Parents, Guardians, And All Persons Intrusted With The Care Of Children," was based, for the most part, on the 1854 letter from Hop-o'-my-Thumb to Dickens. (The pamphlet version of that letter, Cruikshank explained, was now out of print.) Cruikshank, in effect, was making his controversy

240

with Dickens a permanent part of his Fairy Library. His new reply contained few substantive changes. He reemphasized and reargued his position here and there, and he carefully pruned away all genial references to Dickens.

To all of this, both in 1854 and 1864, Dickens made no direct reply. Yet the aftereffects of his initial encounter with Cruikshank in 1853 were always with him. In that year "Frauds on the Fairies" had intensified and focused his lifelong feelings concerning the importance of fairy tales. The fairy tale now stood at the center of his imaginative and social beliefs; it was a shorthand way of referring to and dramatizing those beliefs. The fairy tale was also a touchstone and an anodyne. When, immediately after writing "Frauds on the Fairies," Dickens suggested (18 September 1853) to Angela Burdett-Coutts that she read the piece, he added that he felt the essay would enlist her on his side—"which is for a little more fancy among children and a little less fact."[26] "More fancy . . . less fact" might stand as an epigraph for *Hard Times*, a book Dickens began a few months after writing "Frauds on the Fairies." And Sissy Jupe, it will be remembered, read all "about the Fairies . . . and the Dwarf, and the Hunchback, and the Genies," much to the consternation of the didactic Mr. Gradgrind.[27]

Dickens never tired thereafter of urging the beneficence of fairy tales and imagination. In editorial policies, novels, essays, letters, and speeches, he illustrated and enunciated his belief. "In these times," he said in a speech in 1857, "when we have torn so many leaves out of our dear old nursery books, I hold it to be more than ever essential . . . that the imagination, with all its innumerable graces and charities, should be tenderly nourished."[28] The idea recurs insistently. In 1858, in another speech, he was again urging the doctrine, the doctrine of "Frauds on the Fairies," of *Hard Times*, and of many additional writings. "Let the child have its fables," he pleaded; "let the man or woman into which it changes, always remember these fables tenderly. Let numerous graces and ornaments that cannot be weighed and measured, and that seem

[26] *Letters from Charles Dickens to Angela Burdett-Coutts, 1841-1865*, ed. Edgar Johnson (London, 1953), p. 235.

[27] Chapter vii, p. 55.

[28] Delivered to the Royal General Theatrical Fund, 6 April 1857. *The Speeches of Charles Dickens*, ed. K. J. Fielding (Oxford, 1960), p. 230.

at first sight idle enough, continue to have their places about us, be we never so wise."[29]

VIII

For Dickens, controversy had led back to art; controversy had also helped him define some of the impulses behind his art. That art, and his reputation, were flourishing. The years following his controversy with Cruikshank were filled with achievement and success. Great novels, influential magazines, increased fame, mounting fortune, worldwide adulation—all were part of his last seventeen years. For Cruikshank, the same years were full of frustrations and disappointments. His public controversy with Dickens had erupted at the moment of his decisive fall and subsequent decline. In the ensuing decade his following and his commissions dwindled sadly. Soon he would be devoting disappointing years to *The Triumph of Bacchus* and to the endless controversies that surrounded that abortive project. Cruikshank's bitterness and eccentricity grew. His faith in total abstinence flourished undiminished, but his faith in other causes and persons decayed. His last years were full of humiliating apprenticeships and rejections. He sought instruction in art from academicians who were boys when he was famous. He was repeatedly denied membership in the Royal Academy. He came to depend on charitable pensions and charitable subscriptions for his sustenance. Long before he died in 1878 he was believed by most of the world to be long since dead.

In 1853 and 1854, amidst Cruikshank's reverses and disappointments, it must sometimes have seemed to him that Dickens was his nemesis. The ill-fated *George Cruikshank's Magazine* and *George Cruikshank's Fairy Library* were commercial failures, and both failures were associated with Dickens' opposition. Confronted by such disasters, it must have been easy for Cruikshank to regard Dickens as thwarting and inimical, as a central figure rather than a brief player in his eclipse. Eighteen years before his controversy with Dickens, when Cruikshank had agreed to illustrate *Sketches by Boz*, he was a renowned artist, Dickens an unknown neophyte. Now their positions were reversed. Dickens was the most famous writer in English, rich and sought after and powerful. Cruikshank

[29] Delivered to the Prize-Giving of the Institutional Association of Lancashire and Cheshire: Manchester, 3 December 1858. *Speeches*, p. 284.

was neglected and forgotten, pressed for money, avoided by former friends, immersed in teetotal monomania. But Cruikshank's opposition to Dickens was more than a reflection of reversed fortune and philosophical disagreement. Cruikshank had grown to believe that he was the unacknowledged author of much of Dickens' early success, that he was the unsung begetter of many of the pieces in *Sketches by Boz* and the unacknowledged originator of *Oliver Twist*. As he put it in a letter to the London *Times* (30 December 1871) written more than a year after Dickens' death, and thirty-five years after the events in question: "I was the originator of the story of *Oliver Twist* . . . I suggested to Mr. Dickens that he should write the life of a London boy . . . assuring him that I would furnish him with the subject and supply him with all the characters, which my large experience of London life would enable me to do." Cruikshank then continued, "after I had fully described the full-grown thieves (the 'Bill Sikes') and their female companions, also the young thieves (the 'Artful Dodgers') and the receivers of stolen goods, Mr. Dickens agreed to act upon my suggestion, and the work was commenced." Dickens, however, had one small reservation. He wanted Oliver to be "a queer kind of chap." Cruikshank disapproved of this modification, but consented to it, "feeling that it would not be right to dictate too much to the writer of the story." After much more in the same vein, Cruikshank summed up his contribution to the novel as follows: "Without going further into particulars, I think it will be allowed from what I have stated that I am the originator of *Oliver Twist*, and that all the principal characters are mine."

On other occasions Cruikshank reiterated or amplified (or sometimes contradicted) his bizarre assertions. One note, however, never changed: he was always the masterful originator. In April 1874, after insisting that *Oliver Twist* was his own work rather than Dickens' since it "came out of my own brain," he went on to describe how Fagin came to be lodged in the condemned cell. "I wanted a scene a few hours before strangulation, and Dickens said he did not like it, and I said he must have a Jew or a Christian in the cell. Dickens said, 'Do as you like,' and I put Fagin, the Jew, into the cell." The eighty-two-year-old artist then added a comment about Dickens that ingenuously described his own sad derangement. "Dickens behaved in an extraordinary way to me," he said, "and I believe it had a little effect on his mind. He was

243

a most powerful opponent to Teetotalism, and he described us as 'old hogs.' "[30]

Many of Cruikshank's assertions concerning *Oliver Twist* are mutually contradictory, others are demonstrably false. But Cruikshank did not stop with inventing literary history, he invented literary personality as well. He limned a literary meekness, passivity, and obedience in Dickens which was ludicrously out of character. That Dickens would dutifully write up to Cruikshank's elaborate suggestions or leave crucial literary decisions to Cruikshank's casual discretion is opposed to every record of Dickens' practices in such matters. Dickens, one may be sure, made no exceptions in Cruikshank's case. One need only recall that earlier, when Cruikshank expressed regret that he would not have the privilege of glancing at the manuscript of *Sketches by Boz* Second Series, in order to suggest "any little alteration to suit the Pencil," Dickens had exploded, called Cruikshank "mad," and observed scornfully that had the manuscript "fallen into his hands, I should have preserved his emendations as 'curiosities of Literature.' " This contemptuous rejection of the very notion that Cruikshank might advise him in his art occurred only a few months before Dickens began *Oliver Twist*. The letters and documents contemporary with the composition of *Oliver Twist* show (at all points where substantiation has so far been possible) that Cruikshank's views regarding his decisive role in the inception and progress of *Oliver Twist* were fantasies and delusions.

Cruikshank had always been prey to delusions, and he was quick to believe that all the world stole from him or secretly appropriated his ideas. On one occasion he tried to walk off with one of his brother's designs, claiming that it was his; on another, he asserted that he had originated one of Laman Blanchard's poems, a claim that Blanchard rejected publicly with an outraged fury that "confounded poor George."[31] In his old age Cruikshank's delusions grew. He believed that he was the unacknowledged originator and principal architect of several of Ainsworth's novels (a claim that exaggerated his true role), that the Russians had stolen the design of their military hat from him, and that he was the chief force behind such achievements as ending hangings for minor offenses, abolishing unsavory fairs, nurturing the temper-

[30] Kitton, p. 23. [31] B. Jerrold, pp. 147, 180-81.

244

ance movement, and much more.[32] His fantasies concerning Dickens fluctuated with his mood. Five months after Dickens' death, he told one correspondent that *Oliver Twist* was "entirely my own idea and suggestion, and all the characters are mine." At the same time he volunteered the additional information—delusion apparently feeding upon delusion—that the "greater part" of *Sketches by Boz* Second Series "were written from my hints and suggestions."[33]

The important point, however, insofar as Dickens' relations with Cruikshank are concerned, is that Cruikshank long believed what he much later published to the world regarding *Sketches by Boz* and *Oliver Twist*, and that his convictions on this score compounded his anger at what seemed to him Dickens' unaccountable and ungrateful opposition. That opposition expressed itself very differently for each man. Dickens' opposition to Cruikshank was primarily a matter of ideas; Cruikshank's opposition to Dickens had gradually become a concatenation of ideas, emotions, resentments, and delusions. By the 1860s the two men were lightyears apart. In 1864, when Cruikshank revised his original reply to "Frauds on the Fairies" for inclusion in *Puss in Boots*, he retained and even accentuated the wild, bewildered tone that reverberated intermittently through his initial reply. In his retouched climax, his sense of baffled injury increased rather than diminished:

And what are these doctrines and opinions [introduced into the fairy tales]? Aye! What I have done? Where is the offence? Why, I have endeavoured to inculcate, at *the earliest age*, A HORROR OF DRUNKENNESS, and a recommendation of TOTAL ABSTINENCE from ALL INTOXICATING LIQUORS, which, if carried out universally, would not only do away with DRUNKENNESS ENTIRELY, but also with a large amount of POVERTY, MISERY, DISEASE, and DREADFUL CRIMES; also A DETESTATION OF GAMBLING, and A LOVE OF ALL THAT IS VIRTUOUS AND GOOD, and an endeavour to impress on every one the NECESSITY, IMPORTANCE, and JUSTICE of EVERY CHILD in the land receiving a

[32] B. Jerrold, pp. 147-49.
[33] Letter to W. J. McClellan (12 November 1870), quoted in William Glyde Wilkins, "Cruikshank versus Dickens," *Dickensian*, 16 (April 1920), 80-81.

USEFUL and RELIGIOUS EDUCATION. And I would here ask in fairness, what harm can possibly be done to Fairy literature by such re-writing or editing as this?

Cruikshank's question shows that even after ten years he was totally incapable of understanding Dickens' objections. He was so fixed on his own espousals and his own endeavors, that everything else seemed inconsequential. It is not hard to understand why this was so. Dickens, in ridiculing teetotalism, had defied the center of Cruikshank's life; in a like manner, Cruikshank, by tampering with fairy tales, by "rooting . . . among the roses," had defied the center of Dickens' life. Artistically and imaginatively the two men had much in common. In certain areas of grotesque humor and satire, in certain ways of apprehending characters, streets, horrors, foibles, and eccentricities, in certain approaches to London and Londoners, they saw the world alike. But in life they had traveled a strangely erratic, collision-bound course. From the asperities of their early collaboration, they had moved on to friendship, then jovial companionship, only to drift gradually asunder, and finally to find themselves, all unwittingly, in mortal opposition.

For Dickens, Cruikshank was never a personal enemy. He was tiresome and irritating in his fanaticism, downright dangerous in his tamperings with the "nurseries of fancy," but Dickens latterly viewed him as eccentric and misguided rather than malicious, as an object of pity rather than hate. By the time their controversy erupted, Cruikshank had drifted out of Dickens' circle and in many ways out of Dickens' ken. The rose gardens of Boulogne were remote from the temperance meetings in Exeter Hall. As Dickens whirled through the wrenchings and the triumphs of his latter years, George Cruikshank became for him little more than an occasional flicker of memory on the fringes of his consciousness.

But for Cruikshank matters were otherwise. Dickens loomed large and inimical and puissant. Dickens was associated with the demise of Cruikshank's *Magazine*, the languishing of his *Fairy Library*, the failure of his attempts to recapture his lost popularity. Dickens had attacked the ideas behind *The Bottle* and *The Drunkard's Children*, had mocked Cruikshank's most cherished beliefs as Whole Hoggism, and had cruelly parodied his editing. Dickens had taken Cruikshank's ideas for many of the pieces

in *Sketches by Boz* and for all of *Oliver Twist* and had made not the slightest acknowledgement. Dickens was petted and rich and famous while Cruikshank was poor and forgotten. Even the old days and the old times with Dickens were a reproach rather than a bond; they reminded him of his shameful excesses before he was saved by teetotalism. In his latter-day disappointment and paranoia, these oppositions and disparities waxed rather than diminished.

When Dickens died in 1870, Cruikshank was seventy-seven years old. He was still alert and vigorous, still valued by a circle of friends, but failure and disappointment had constricted and envenomed his outlook. Dickens now lay in Westminster Abbey, a resting place unimaginable in 1835 when Cruikshank read his first pages by Boz and etched his first illustrations for the *Sketches*. But Cruikshank's memories of Dickens were devoid of reverence or loss. The bright energy of the fledgling author, the triumphs of their early collaboration, the days and nights of boon companionship, the weeks of splendid strolling as amateur players—all were forgotten or of no account. Cruikshank's epitaph for his old companion was brief and unforgiving.

"I so hated the fellow," he said.[34]

34 Remark made to F. W. Pailthorpe on the day after Dickens' death. Quoted by Walter T. Spencer, *Times Literary Supplement* (2 May 1935), p. 288.

"At it Again":
Aspects of Cruikshank's Later Work

CRUIKSHANK makes an appearance in his *Comic Almanack* (Cohn 184, 19 vols., 1835-53) for June 1844 drawn and quartered, torn in all directions by four seasonal figures: a plum pudding on bottle legs, a Bill Sikes morris dancer, an upstanding Michaelmas goose, and a burly landlady (Figure 43a). Typical of his literal reorientations of figures of speech, "Quarter Day" is a punning commentary on an artist divided in himself, split by rival demands and concerns.

At this time Cruikshank's career as a caricaturist was on the wane. *Punch*, founded a couple of years before, was gradually edging him into eclipse. After a period of strain his collaboration with Ainsworth came to a dead end. At fifty-two he was starting to fade as a household name, to become a master of past modes only. Even though the "Great Inimitable" showed no decline in his technique and no lack of ideas, the necessary readjustments were as drastic as those made, just over twenty years before, when he abandoned political caricature and turned to illustration via *Life in London* (Cohn 262, 1821). *George Cruikshank's Table Book* (Cohn 191, 1845) stands as his most sustained and challenging display of virtuosity, from the tip-top study of a family's boots and shoes standing to attention across page 44 to the grand parade of his repertory company across the fireside pipedream of the "Triumph of Cupid," in which he stands, Tom Thumb-size, painting a portrait of his life-size self. And his work as an illustrator continued. In W. H. Maxwell's *Irish Rebellion* (Cohn 541, 1845), he enlarged on the documentary style he had developed in *Jack Sheppard* (Cohn 12, 1839) and *The Tower of London* (Cohn 14, 1840) with formidably detailed reconstructions of alarms and skirmishes.

But already he was piling on the effects, aiming for an exhaustive finish rather than the dazzling short-cut *leit-motifs* of earlier years. The over-dressed episodes of *The Bachelor's Own*

249

Book (Cohn 192, 1844), in which Mr. Lambkin makes a fool of himself "in pursuit of Pleasure and Amusement," are *The Rake's Progress* re-enacted, but so elaborated, so polished off as to leave nothing to the imagination. This was to become still more apparent in the subsequent years when the *Comic Almanack* went through a series of declining changes leading to a brief reincarnation in the form of *George Cruikshank's Magazine* (Cohn 185, 1854), which failed to be a popular draw and folded after two numbers. It appeared at times as if Cruikshank was trying to etch in the new wood-engraving manner. "I cannot bear to see his fine hand waste itself in scratching middle tints and covering mere spaces, as in the Cinderella and other later works," Ruskin lamented.[1]

As his commercial prospects became blocked Cruikshank looked towards the Ideal in one form or another, rendering himself unapproachable, refusing to work for *Punch*, turning down all "unacceptable" offers until nothing but trifles came his way. After 1860 (when Dickens dropped Phiz) the old illustrative means were more or less written off and he had to rely increasingly on commissions from friends and admirers for replicas of his most noted works and for bookplates rather than illustrations. The frontispieces to *Puck on Pegasus* (Cohn 633, 1861) and the 1870 edition of the *Ingoldsby Legends* (Cohn 52) must count as virtual guest appearances. Similarly "Fairy Connoisseurs inspecting Mr. Frederick Locker's collection" (in *The Rowfant Library*, Cohn 498, 1868), used as the frontispiece to Reid's *Catalogue* (1871), shows his wit rendered down into harmless, charming whimsy. The Ideal demanded almost all his energies and absorbed his ambitions: both to achieve respectability as a thoroughgoing fine artist immortalized in oils on canvas on the walls of the Academy[2] (the dream of so many caricaturists and illustrators), and to serving a great cause for the good of mankind.[3] There were also practical advan-

[1] Letter to C. A. Howell, 2 April 1866, in E. T. Cook and Alexander Wedderburn, eds., *The Works of John Ruskin*, 39 vols. (London, 1909), XXXVI, 505.

[2] In 1866 Cruikshank was awarded a £50 pension from the Turner Fund but he failed to become a Member of the Royal Academy save, ironically, through a misprint. He appears next to Frith in *Photographic Groups of Eminent Personages* (n.d., c. 1866) as "George Cruikshank Esq. R.A."

[3] He noted around 1866 that his occupation was "Painting and Drawing to prevent Evil and to try to do Good" (Cruikshank Papers, Middlesex Records, Greater London Record Office).

tages in the Ideal. With his paintings, most of them simply restatements of past successes, he only needed to impress one buyer at a time and was rid of interfering editors, publishers, and authors. The *Disturbed Congregation*, the *Runaway Knock*, the *Fairy Ring*, and, above all, the *Worship of Bacchus* kept him busy when he was short of ordinary commissions.

So, looking back, the "Quarter Day" design represents rather more than a standard comic-cuts predicament. It reflects the crossroads situation at which Cruikshank found himself at the time his powers as a caricaturist and illustrator started to go to seed in an excess of complication and verisimilitude. Engravings like "Passing Events, or the Tail of the Comet of 1853" in his *Magazine*, confirmed that the superabundant detail in some of the *Table Book* plates had been only the start of a long trail of razzle-dazzle attention-seeking devices, virtuoso etchings for etching's sake.

Cruikshank was well aware of the folly and absurdity of other forms of excess. Not simply in terms of drinking, smoking, betting, and umbrella-handle sucking (which disturbed him at this time), but also in fine art. "Oh! my eye, what a GUY!!!" one of his by-standers exclaims in another plate in the 1844 *Almanack* (Figure 43b). "Guy Fawkes treated Classically—An Unexhibited Cartoon" is his comment on the furor which enveloped the series of competitions for the wall decoration of the new Palace of Westminster, begun in 1843 and destined to continue by fits and starts for another twenty years.[4] The Cruikshank cartoon is a fitting mockery of all vasty history painting, a gross memento of the fall-guy who had failed to blow up Parliament in 1605, set in line with *Caesar's Invasion of Britain*, *Alfred and the Navy*, *Una and the Satyrs*, *The Trial of Canute*, *The Death of Nelson*, and all the other eminently worthy and predominantly salty scenes from the more mythological shores of history.[5] Cruikshank "resolved to make it a greater work than had ever before been known." But it wouldn't fit into Westminster Hall. "The Guy's feet were accordingly foreshortened, till I left him, as he appeared when trying to defend himself at his trial, with hardly a leg to stand upon." He

[4] Fresco painting also features in the 1844 *Almanack* as one of the *Humours of the Day*.

[5] See T.S.R. Boase, "The Decoration of the New Palace of Westminster, 1841-1863," *Journal of the Warburg and Courtauld Institutes*, 17 (1954), 319-58.

was not altogether joking: there is a slight air of plaint behind the paradox and parody. "Though I had cramped my genius already to suit the views of the Commissioners, and the size of the door, I found I must have stooped much lower if I had resolved on finding admittance for my work."

Three years later in the *Comic Almanack* for 1847 "Born a Genius and Born a Dwarf" (Figure 44a) shows a painter crouched in his garret in front of an unfinished and thunderstruck Old Testament scene while next door Tom Thumb, the thirty-one-inch wonder of the day, takes his ease on a sofa beneath pictures of a tiny coach and pair, landed estates, and a bijou mock-Gothic Thumb Castle. The artist is B. R. Haydon, snubbed in the Parliamentary cartoon competition, whose retrospective exhibition in 1846, a desperate all-out bid for acclaim, had been a total failure, a crowning humiliation, partly because Tom Thumb, great dwarf, had drawn all the crowds to see him on the floor above at the Egyptian Hall. Later that year Haydon committed suicide; ironically enough achieving the immortality he had so longed for only through his death and his diaries. Meanwhile, it appeared, a man could more easily creep into the Hall of Fame by making a virtue of minutiae. Cruikshank was not up to taking part in the biggest decorative event of the age. His bid for immortality had to rest on his skills as a miniaturist; as a maker of microcosms, as a light, slight relief after all the vacuous wastes produced by the Haydon school. Again however the neglected genius in the *Almanack* who sits with his face half buried in his hands is recognizably Cruikshank himself.

As things stood in the 1840s Cruikshank's only resort was his Cause; far from being a disastrous turn in his career Temperance provided him with a sense of direction and purpose which re-animated his art. Naturally the several aspects of his work remained interlinked. Temperance beliefs seeped, to Dickens' dismay, into his *Fairy Library* illustrations (Cohn 196-99, 1853-64), and the subject matter of much of his later work, the 1851 Exhibition for instance, tended to reappear from time to time with fresh moral underlinings. But the temperance ideas—which were concerned, after all, with every part of mid-Victorian society—did serve to concentrate Cruikshank's mind wonderfully. For the good of the Cause he looked back to Hogarth's guiding, popularizing

252

principles, discarding virtuosity and all thought of art for art's sake in favor of a more straight-forward style; suiting his means to the great end he had in mind. The utter complexity of the *Table Book*, notably the stark, staring shudders of the "Folly of Crime," was rendered down for greater economy and impact in *The Bottle* (Cohn 194, 1847) and *The Drunkard's Children* (Cohn 195, 1848). Admittedly Cruikshank's invention became somewhat stilted under the message-bearing pressures—the *Fairy Library* for instance is a peculiarly sad mixture of fancy-freedom and mawkish uplift—and his circle of acquaintance narrowed until it came to be almost exclusively temperance-minded. The Cause supplied the pallbearers at his funeral and secured his burial in St. Paul's.

Those connoisseurs who considered Cruikshank at his best as the deft illustrator of choice and rare publications were naturally distressed by his change of tune. It "has warped the entire currents of his thoughts and life," Ruskin remarked.[6] The *German Popular Stories* (Cohn 369, 1823-26) had been virtually the only light relief in his Denmark Hill nursery and occupied a special niche in his mind as "the finest [etchings] next to Rembrandt" he knew (a remark calculated of course to astound his gentle reader). When, in 1866, he asked Cruikshank to do some new fairy story illustrations in the old manner, and to include a scene from the *Pied Piper*, Ruskin was thinking back, misty-eyed, treating "the dear old man" as a sprightly enchanter who still might prove fit to pipe children into the foothills of fairy land. But he found the two sample illustrations quite un-magical. "He may still do impressive and moral subjects but I know . . . that he can do fairy tales no more,"[7] he concluded unreasonably. Thackeray, similarly, persisted in regarding Cruikshank as a date-stamped childhood idol,[8] in his case as the nimble designer of the *Phrenological Illustrations* (Cohn 178, 1826) which he and his schoolmates had divided among them, and as the creator of a whole roguish gallery—of dustmen with ducal airs, bolt-eyed spinsters, Artful Dodgers, Fagins—available on demand to illustrate given texts and fill the drawingroom scrapbooks.

6 *Time and Tide*, Letter XII, in *Works*, XVII, 370.
7 Letter to C. A. Howell, 1866, in *Works*, XXXVI, 516.
8 W. M. Thackeray, "George Cruikshank," *Westminster Review*, 34 (1840), 1-60.

The art of caricature being very much a matter of short-circuiting and cross-breeding familiar themes and variants, when Cruikshank became an illustrator he similarly translated literary styles into designs which were virtually hieroglyphic versions of the original letterpress. He had always been an interpreter for amateur men of Ideas and for taskmasters—for Hone or for W. H. Barker, whose strictures on his illustrations to *Greenwich Hospital* (Cohn 53, 1826) sometimes covered every square inch of the early state impressions.[9] His working partnerships were of course governed by shifting give and take circumstances, but though in retrospect his designs have almost invariably outlived their containing texts he was seldom credited with the leading role. "I had to work for others instead of them work for me and my motto was 'At it Again'" he complained in draft notes for his autobiography.[10] He could rarely afford to be his own master. In 1827 he maintained that he had done no drawings "but what were done to order."[11] Throughout most of his career his role was to supply illustration wherever needed. When commissions grew scarce he was more free to do as he chose.

At this point teetotalling gave him fresh vigor, in his anxiety to justify himself, surpass his past, and impress others. Without such devotion his art probably would have fizzled out altogether, expended in droll flights of fancy and costume tableaux. It involved him in fresh concerns, it emphasized the virtue of "Honesty" which, he said, he prized above all others, and it encouraged the argumentative single-mindedness which, though degenerating at times into tedious monomania, was in many ways more fruitful than the bespoke venom, the sparring and glancing blows of the earlier, ostensibly "committed" productions for Hone, which he later, unnecessarily, regretted.

The Cause and Cruikshank's associated service in the Havelock Volunteer Temperance Corps of the Middlesex Militia demanded his pledged faith and loyalties. He both vented his frustration and submerged his sorrows in the true blue patriotism and pure water of these bodies. In addition, from 1847, he revived his childhood

[9] Cruikshank Collection, Victoria and Albert Museum.
[10] Cruikshank Papers, Middlesex Records.
[11] In a draft letter of C.G.G. Wilkinson dated March 1827, in the Cruikshank Collection, Victoria and Albert Museum.

taste for acting by joining Dickens' theatrical troupes and was well received in such minor, heavy-disguise roles as Old Knibbs in *Turning the Tables*. He became a public speaker, a touchy, boisterous soloist with flashing eye, elasticated black forelock, and sudden, violent laugh, picking over his past excesses. In the long run, however, he always failed to maintain any working relationship. "His zeal was of more than an ordinary character," his subordinates complained. He left the Militia in 1868, refused the honorary colonelcy he greatly coveted, and thereafter was reduced to writing pamphlets and battling letters to the *Times*, and to striking a pose so that a model could be made from his design for a statue to King Robert the Bruce.

In this context *The Bottle* was arguably Cruikshank's greatest success since *Life in London*; this time, all his own work. Predictably it brought tears to Dickens' eyes. With sales of over 100,-000 copies in a matter of days it became everyday currency: an invaluable object lesson at a shilling a set. "I put them at that low price," Cruikshank wrote many years later to the editor of the *Aesthetic Review*, "in order that it might be within the reach of the working classes, for when an artist is working for the million, cheapness of price has to be considered and I had them produced by the only available cheap process at that time (now about 30 years ago) and this will account for the roughness of their style."[12] Like Hogarth's *Four Stages of Cruelty*, designed to be produced as woodcuts a year before publication in the more exclusive copperplate version, *The Bottle* was an artless, captioned, all purpose morality play, so compelling that it went through at least eight stage versions and was turned into a waxworks. Cruikshank, for once, was not bothered about copyright and was soon "At it Again" with his sequel *The Drunkard's Children* and, eventually, the *Worship of Bacchus*, his composite view of Victorian England opened up in cross-section like the *British Bee-Hive* (Cohn 957, 1840 and 1867), and accumulating meaning like the "Tax Upon Property" from the *Almanack* of 1844, with every detail telling its story. Society breaks down on all sides. A statue of Bacchus stands on a central plinth in place of earlier images: the "Gin Juggernaut" in *My Sketch Book* (Cohn 181, 1834) or "The Upas

12 Cruikshank Papers, Middlesex Records. I have been unable to determine if the letter was ever published.

255

Tree" from O'Neill's *The Drunkard* (Cohn 620, 1842)—a weeping willow with a trunk of piled barrels raining gin on its devotees.

The painting was designed primarily as a temperance lecture, to be examined in sequence like a battery of lantern slides projected broadside onto a huge canvas. It both exhausted Cruikshank's ambition as a painter and served as a monumental centerpiece, going between the original watercolor design and the engraved end product. "True, the work wants finish," John Stewart remarked, "but this want is most felt by those ignorant enough to confound smoothness and prettiness with finish."[13] The print is the true completion of the work. A tract for Cruikshank's times, a series of awful warnings, it is also a blockbusting history painting, planned, like the *Bank Restriction Note* of 1819, as an act of defiance against all the odds; not so much a masterpiece as a master blow. Sadly, however, the exhibition of the painting and choice examples of the artist's work at the Exeter Hall went more or less unregarded. In public terms the painting did no better than the monstrous "Guy Fawkes treated Classically" or Haydon's labored grand-slams.

Appropriately, when Cruikshank came to designing the ticket for subscribers to a purchase fund set up to secure the painting for the good of the nation (Figure 44b), he showed the Bacchus being trundled by his admirers into the South Kensington Museum,[14] evoking both the "good bold fling" of the Guy cartoon and his "correct view of the Funeral Car of Lord Nelson" (Cohn 284, 1806), one of his earliest published designs. Cruikshank ("the Garibaldi of the pencil," as the *Daily Telegraph* topically described him in 1862, alternatively "more of a Bunyan than a Hogarth" in the *Art Journal*'s opinion),[15] claimed he made converts with it. So, on his chosen terms, the painting was a success. But it was still impossibly unwieldy and now lies in the Tate Gallery cellars, virtually illegible.

However, within the overbearing 13′ 4″ by 7′ 8″ of the *Worship of Bacchus* the individual incidents are very little larger than Cruikshank's highly wrought and impressive watercolor replica

[13] John Stewart and George Cruikshank, *The Worship of Bacchus* (London, 1862), p. 7.

[14] Cf. Lord Leighton's *Cimabue's Madonna Carried in Procession* (1855) and Sir Edward Poynter's slave-slogging epic *Israel in Egypt* (1867).

[15] Quoted in the *Worship of Bacchus*, p. 19, p. 17.

set of *The Bottle*.[16] As far as can be judged the Bacchus is also strikingly similar in technique: Cruikshank's oil paintings are very little different in kind from his watercolors. Even at its biggest and most ambitious Cruikshank's work remains miniature-minded. His gigantic shanty town setting breaks down into compartments peopled by Tom Thumb players. Cruikshank may well have been born a genius, but his horizons were within the bounds of a thumb-nail sketch. He acted as the master of a human flea circus, choreographing Irish brawls and domestic upsets, ordering his players to haul carriages, cartoons, and juggernauts to their appointed resting places. On these terms his bird's-eye view of society could soar up and away until the globe shrank into a plaything. He revived Gillray's image of the world as a plum pudding to be divided between Pitt and Bonaparte, as a ball to be kicked around or spun on the toe of the great Dictator, long before Chaplin took up the idea. It is the world cut down to size.

In the series of glass-engraving designs he made between 1864 and 1873[17] Cruikshank looked back at his childhod as if through a peepshow to recall himself climbing out on a top window ledge high above Dorset Street, watching his father at work on a caricature or seeing George III driving in procession to St. Paul's. Together with these distanced recollections he included several ridiculous views of the world: laid out as a pie with humans crammed inside like blackbirds, and as the hub of a miniature railway system, and turned altogether inside out. Similarly, in "All the World going to see the Great Exhibition" (in Mayhew's *1851*, Cohn 548) he more or less reproduced the humming, brimming earth crowned by Victoria and her armed forces in the *Omnibus*. Among fly-past details in the "Tail of the Comet" he included the Great Globe in Leicester Square which was the showpiece of the year; big enough for crowds to gather inside to examine continents and oceans printed on its inner shell.

Cruikshank's own ideal, his paradise, was a fairy land condensed infinitely smaller than Swift's Lilliput; follies and vices reduced until they became indistinguishable. His humans shrivel from the half-imperial scale of the *Worship of Bacchus* into pin-pricks, matching all those conceptual angel/fairies medieval philosophers used to envisage dancing on the head of a pin.

16 Cruikshank Collection, Victoria and Albert Museum.
17 Published in *A Handbook for Posterity* (London, 1896; Cohn 815).

Cruikshank's ambition passes beyond belief. His words become hieroglyphics scrawled like all his other drafts and sketches across Band of Hope pledges and correspondence and household bills. He buried himself in his art. The live-wire lines, the wandering streams of thoughts and reactions, of liberties with word and image, the riotous medley of impressions defy categorization. Clearly, though, the works from Cruikshank's temperance period mark a resolution of many of his earlier concerns. Beyond humor, beyond the crossroads of the 1844 "Quarter Day," and falling back from the reaches of high and mighty fine art, Cruikshank persevered and survived on the strength of his guiding passions. Earlier a set text, a prepared sheet of copper, had been enough to set a whimsical train of thought in motion. Deadlines had kept the virtuosity, the tendency to over-elaborate, in check. The renewal of passion in his teetotal old age enabled him to go "At it Again," to spy out the world through the eye of a needle. This imagery outlasted both the Cause and the age. It remains truly inimitable. When all was said and done there was no point in Cruikshank's trying to stuff any big dummy cartoon into the yawning portals of the Hall of Fame.

Index of Cruikshank's Works

261

263

264

265